THE NUDE
Perception and Personality

THE NUDE

Perception and Personality

PAVEL MACHOTKA

University of California
Santa Cruz

IRVINGTON PUBLISHERS, INC., New York

HALSTED PRESS Division of
JOHN WILEY & SONS, Inc.
NEW YORK LONDON SYDNEY TORONTO

Distributed by HALSTED PRESS
A division of JOHN WILEY & SONS, Inc., New York

Library of Congress Cataloging in Publication Data
Main entry under title:

Machotka, Pavel.
 The nude.

"A Halsted Press book."
1. Nude in art. 2. Art—Psychology. 3. Aesthetics
—Physiological aspects. I. Title.
N7572.M28 704'.94'21 78-8515
ISBN 0-470-26426-8

10 9 8 7 6 5 4 3 2 1

Printed in The United States of America

To my mother and the memory of my father

ACKNOWLEDGMENTS

I am grateful to a number of collaborators for conducting the research on which this book is based, and wish to give them the recognition they deserve as junior authors, as it were, of this report. They each undertook one of the studies reported here and carried it to completion; the only reward for their faithful labor was credit toward graduation with a bachelor's degree in psychology—credit for the sort of independent work which, in successful cases, is recognized as a senior thesis. If, during the time that we worked together, they may have felt some satisfaction from full participation in a new and active research enterprise, I in turn received from them not only data rich enough to do justice to the place esthetic choices have in the psychic economies of our subjects, but also the stimulation of fresh thought and infectious enthusiasm. The collaborators were Laurie Babka (Chapter 7), Michelle Bier (Chapter 9), Carol Craig (Chapter 4), Nita Eder (Chapter 9), Robert Kubey (the study reported in Appendix E), Laura Morrell (Chapter 6), Charlene Ralston (Chapter 5), Charles Scott (Chapter 7), Loren Steck and Marie Thomas (Chapter 8), and Glen Wilhite (Chapter 4).

That most of the work on which this book is based was given without the usual recompense is a virtue: it resulted in a thoroughness born of caring for the discoveries one was making. But the virtue was also a transformation of necessity; funds for research such as this were limited to rather small grants. For what was obtainable (Faculty Research Funds granted by the University of California, Santa Cruz), I am duly recognizant. Such funds made possible not only the indispensable computer time and minor expenses, but also the expert help of five students who at one stage or another served as my research assistants: Paula Bernstein, Gary Ganahl, Kathy Keesling, Stephen Pollack, and Loren Steck.

I wish also to thank the publishers who gave permission for their photographs to be used as illustrations; they are listed individually in the List of Illustrations. The lioness's share of the typing of the final version of the manuscript was done by Carole Degen, whose patience and care I valued then as much as I do now, while Sandy Crain, Elaine Tringali, and Tricia Wieben contributed their considerable skills to various other

sections of the manuscript. Without Bonnie Baskin's extensive and generously shared knowledge, I would have spent much time in an inefficient search for the originals of my illustrations. I am particularly grateful to Suzanne Reed for having prepared the index.

I am pleased to be able to say that several of the students who had served as subjects in one or another study retained sufficient interest in its subject matter to wish to read and comment on the chapters to which they had contributed; for obvious reasons I do not wish to name them. I do, however, thank them—for accepting and helping confirm my interpretation of their functioning. Finally, several colleagues gave careful attention to the manuscript and helped improve it where it was not beyond repair: Dane Archer and M. Brewster Smith helped with sections of the draft, while Irvin L. Child, Grosvenor Cooper, Ravenna Helson, Eli Hollander and my wife Hannelore Gothe Machotka, read the entire manuscript with care, sympathy, and just the right independence. My thanks for all the support—in many forms—they gave me.

Pavel Machotka
Santa Cruz, California

CONTENTS

Contents

ILLUSTRATIONS

(Permission to reproduce each of these illustrations has
been granted by the institution in which the work is housed.)

THE NUDE
Perception and Personality

INTRODUCTION: THE TWO FUNCTIONS OF TASTE

The nude as a form and subject of art is characteristically Western in its conception. As a symbol it seems well matched to our ways of feeling and thinking, and the match gives it extraordinary esthetic power which one can feel readily—but explain only clumsily. This book attempts to understand the nature of that power.

The studies I report here grew out of personal curiosity about my own esthetic concerns: I wished to explain the profound effect, at once disturbing and reassuring, of an idealized nude such as Praxiteles's *Knidian Aphrodite* (Fig. 1) or Polykleitos's *Doryphoros* (Fig. 2), or of one of their energetic counterparts such as Michelangelo's *Risen Christ* (Fig. 3) or *Heroic Captive* (Fig. 4). Personal curiosity is a good starting point, but it is no more than that. To understand one's own response one needs to consult and compare the responses of others; having begun to understand others, one begins to note the variety of reactions a given nude can elicit in different viewers as well as the many ways of representing the nude which can engage a single viewer's sensibility. And as one succeeds in understanding why a given nude attracts or repels one beings to have a firmer sense not only of the psychology of the viewer but also of the nature of the nude to which he or she reacts. By understanding the functioning of the observer, one comes ultimately to describe the nude—that is, the nude as a symbol of profound psychological experiences and needs.

But the specific aim of this book is to understand the viewer and the functions of his or her taste. Its method is the clinical study of individuals with strong attachments—not only to such idealized nudes as these four but to nudes of other types as well. To accomplish its task it relies on a framework of concepts which both guide the investigation and help interpret its results; that framework, presented in Chapters 1 and 2, is built on what seem to me the most fruitful previous psychological conceptions of the esthetic response. Predictably, none of those conceptions refers specifically to the nude, but that seems just as well: attachment to the nude should ideally be understood in the context of other esthetic phenomena. If the framework proves useful for understanding

Figure 1. Greek. *Knidian Aphrodite.* The Vatican Museum.

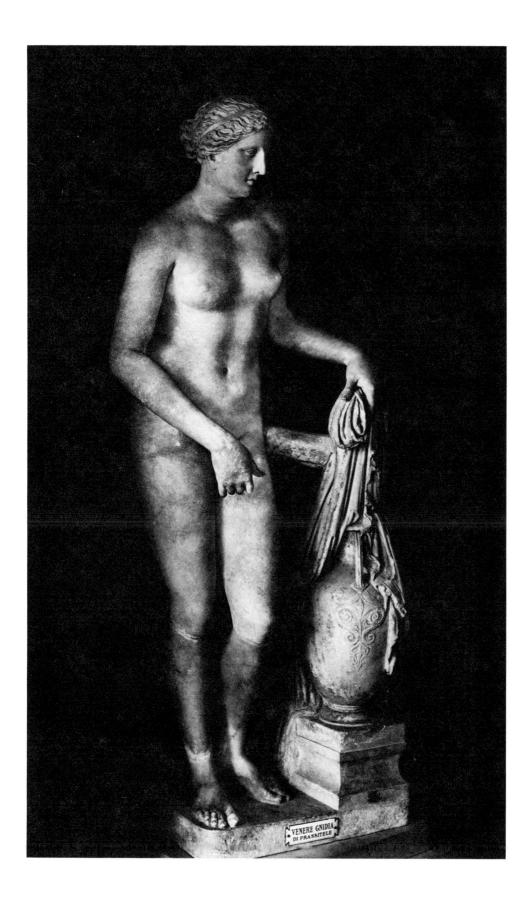

Figure 2. Polikleitos. *Doryphoros*. National Museum, Naples. Alinari—Art Reference Bureau.

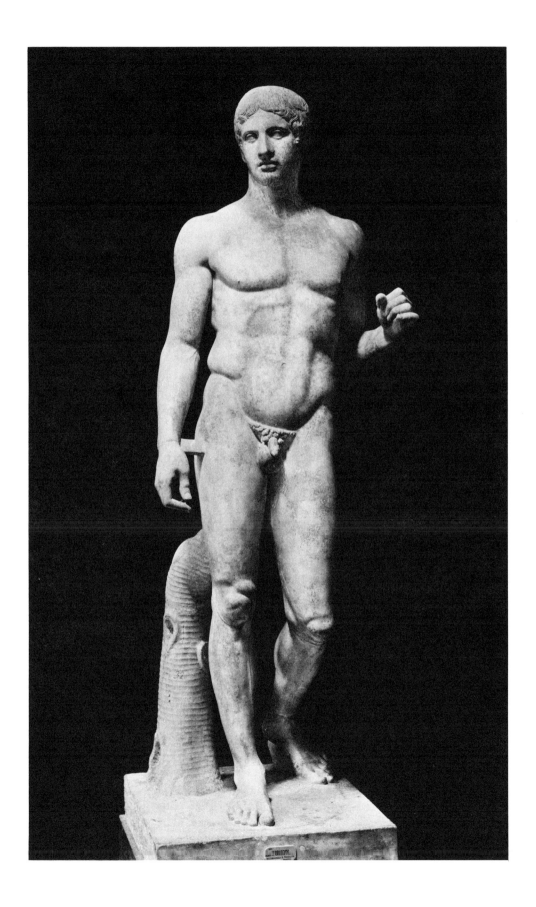

the appeal of the nude, one can hope that it may serve the psychological study of esthetic experience generally. This book therefore has a secondary aim: to point toward a general theory of esthetic attachment and experience.

In a moment I shall need to distinguish more sharply esthetic attachment from other esthetic experiences. But the distinction will make the most sense if I place it in its context—in the context of a division in esthetics which it parallels and which leads to unnecessary misunderstanding and even suspicious rivalry. The division arises from the penchant of some students of esthetics to pay attention only to art objects and for others to show interest only in observers. The former tend to be philosophers or art critics, while the latter tend to be psychologists; I say "tend to be" since the distinction is by no means absolute. In a way both types of students aim ultimately at constructing a complete theory of esthetic response but each manages to neglect some part of what the other finds important. Roughly put, philosophers show their interest in esthetic objects by analyzing esthetic experience as if it were determined only by works of art; such analysis presupposes that the experience takes the same form for all observers, or at least for all qualified and sensitive observers. They turn their attention to such apparently objective matters as esthetic goodness, esthetic form (as against content), stylistic types (tragic and comic, painterly and linear), and subtle distinctions between phenomena normally ignored by less systematic thinkers. Psychologists, on the other hand, show their interest in the observer most clearly in their attempts to understand why people—any and all people—make certain esthetic choices rather than others. There is no harm in such a division of labor, and indeed there is ample reason why the labor of studying esthetic processes should be divided; but unfortunately the division leads to strong proprietary feelings and—worse—to convictions of mutual irrelevance.

Any theory of esthetic perception, evaluation, and choice, whether that of a philosopher or a psychologist, will eventually have to bridge the seemingly objective and the obviously subjective. In the next two chapters I shall attempt to show specifically how a psychologist's conceptions of mental functioning can allow us to study both types of phenomena. But in this introduction I shall seize upon the division that has separated students of objects from the students of subjects and attempt to translate it into something more workable. I shall review—briefly—the reproaches that philosophers have made to psychologists and note the few differences between them which *cannot* be bridged; but at the same time I shall show how much in principle the objectivists and the subjectivists have in common. It is but one step from there to presenting the psychologists's particular contribution: to show that, starting with a functional theory of taste, one can illuminate both subjective functioning and objects of art. In the language of the conceptions I propose here, the subjective functioning is most clearly embodied in esthetic attachment, while objects of art are described by the processes which make possible esthetic judgment, discernment, and empathetic grasp.

Dickie (1968), an esthetician, illustrates the division I have spoken of when he argues that psychology is irrelevant to esthetics. His argument is forceful and to a psychologist provocative. But one can agree with his principal premise: it is true, as he says, that psychology describes esthetic reactions as they are rather than as they ought to

be. If one disagrees with Dickie, it is over the value of this difference—it is over seeing this fact as an advantage rather than as a defect. Describing what *is* has become as legitimate in human affairs as in physics, even though in human affairs we are not compelled to give up the wish that things be other than what they are. But it is one thing for a psychologist to respond that studying what "is" is fully valid; he usually goes further and maintains that anyone's attempt to define what ought to be can be no more than a projection of his own wishes and preferences, no matter how refined and astute. If esthetics is to be prescriptive—tell us what our esthetic reactions ought to be—then Dickie must be right and psychology must be irrelevant to the task. To this extent, then, there is an unbridgeable difference between the philosopher and the psychologist.

But if one stops short of this extreme—of expecting that correct esthetic reactions can be defined with some precision—then psychology and philosophy are not as neatly separated. One can reduce one's expectations ever so slightly and find that psychology has the tools to meet them. If it is impossible to prescribe esthetic reactions in detail, it is nevertheless possible to show that some works of art are more worthy of our esthetic attention than others. And the proof is provided not by argument but by patient and extensive empirical investigation; I shall review the evidence carefully in Chapter 2, but for now it should be said that the research I refer to shows that reliable discriminations can be made between "better" and "worse" works of art. It shows also that those who are capable of such discriminations share certain valuable personal characteristics; more than that, it also helps, with the fraternal collaboration of anthropology, to show to what extent esthetic discriminations are common to peoples with an entirely distinct cultural history. In effect such research has turned into fact what was in 1757 no more than a plausible supposition by the philosopher Hume.

Psychology can therefore assume an objective as well as a subjective position. The objectivism with which it deals is not absolute, of course, since it implies only the belief that *some* esthetic judgments are better than others, not that all art can be arranged on a continuum from good to bad. Goodness of judgment can be defined by a reasonable assumption: where a sufficient proportion of a group of individuals who may be presumed to know what is good in art agree in their judgments, those judgments are good. Thus to a psychologist the goodness of judgment is evidenced by an agreement on the choice of objects.[1] But this definition represents more than just a methodological choice; it suggests also that esthetic judgment can, as a shorthand, be attributed to two different sources. When people disagree, we tend to think of their judgments as being primarily determined by their psychological makeup (whatever that may be), while when they agree, we tend to credit the agreement to qualities in the object of their consensus. With the observer as a starting point we can clearly reach the objective qualities of art just as well as we can attain his subjective experience.

There is little reason, then, to deny psychology its relevance to esthetics; nor would it occur to me to reverse the polemics and ask whether esthetics is relevant to psychology. But if the two fields have much in common—more than my schematic discussion could hope to suggest—the search for the objective and the study of the subjective can retain their separate aims. Here is the workable distinction I had hoped would follow from a

Figure 3. Michelangelo. *Risen Christ.* Royal Library, Windsor Castle. Reproduced by gracious permission of Her Majesty the Queen.

Figure 4. Michelangelo. *Heroic Captive.* Louvre. Cliché des Musées Nationaux, Paris.

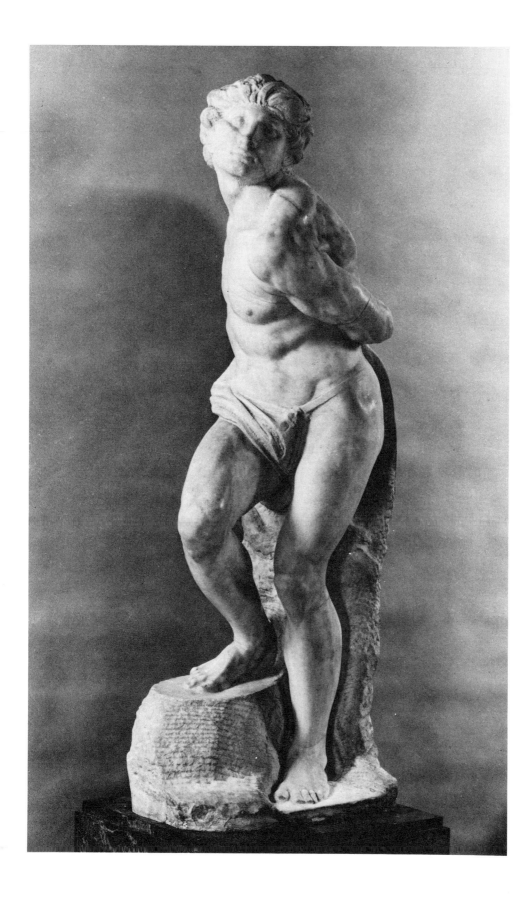

look at the division in esthetics: not only do the subjective and objective represent two different aims of two disciplines in more or less friendly competition; they represent also two distinct but complementary attitudes within the observer himself. He can experience the work as an occasion for the satisfaction of his personal needs, or he can treat it as a thing to be perceived, assessed, and comprehended in its own right. The two ways of experiencing art may be said to represent two psychological functions; or, in the terms I wish to introduce here, for the observer art can be said to satisfy both *projective* functions and *perceptive* ones.

When we speak technically, we mean by projection the attribution of qualities to an object which are not really there but need for some reason to be seen there. Perception is, of course, the "taking in" of attributes which are "really" there, whether one needs then or not. Now when one reads one group of psychologists—of whom Arnheim (1969, 1974) is the eloquent spokesman—one is persuaded that the esthetic process consists primarily of perception, that is, of an awareness, as articulated as possible, of the object's parts and their interrelations. When one reads other psychologists—primarily the psychoanalysts—one is impressed by how much the esthetic process consists of the satisfaction of personal needs. Satisfaction may be obtained in a variety of ways: by selection of objects which are most relevant to the needs, by attention to certain attributes and inattention to others, perhaps in extreme cases by full-blown projection. I propose to call all the latter functions of esthetic objects "projective": they imply the primacy of the observer and his needs, while the "perceptive" ones imply the primacy of the object and its structure. In the first case one puts something into the object, as it were; in the second one takes something from it.

Now it might seem that the latter processes are what philosophers call the properly esthetic, while the former are properly psychological but irrelevant to esthetics. The perceptive functions imply a capacity for seeing analytically and for combining parts; and they suggest an openness to learning new things. But as admirable as these qualities are, it would seem to me a mistake to confuse them with the whole esthetic response. As necessary as they are to the response, they are not sufficient for it; perception, no matter how differentiated, needs to be made relevant to one's personal needs or risks remaining sterile. I am not suggesting that the needs should be primary either; if the esthetic response consisted only of satisfying needs, it would run into a different sort of sterility, that of repetition: of finding in the world only that which one had looked for. It seems to me preferable to conceive of the esthetic response as an interplay between the projective and the perceptive. If one's projective needs at times clash with one's capacity for perceiving form, that seems a small risk to run for the gain of being able to suffuse a rich percept with a deeply felt emotional need.

In the following two chapters I attempt to set the stage for understanding the response to the nude by outlining, as I understand them, the projective and perceptive needs that art serves. My concern is to present needs as they may be seen by a personality psychologist and to remain faithful to psychological observations and theories. Above all, I have tried to do justice to the diversity of observers' personalities (their needs, ego defenses, and even moods) by denying myself the pleasure of adhering to a

one-factor theory. Single theories are seductive not only by their economy but also because they represent the triumph of narcissism over a compliant reality; but ultimately they must distort the observations which they try to explain.[2] The opposite extreme—an indiscriminate eclecticism—is equally unsatisfactory, because it sacrifices clarity to completeness. My choice has been to try to account for what I see as the important phenomena by as few assumptions as would fit without perceptible distortion; in the process I have, of course, betrayed certain theoretical preferences.

The projective functions refer above all to wishes which aim for satisfaction and to the modes by which we deal with them; a study of these functions is in effect a psychology of esthetic attachment. Conceptions of wish (or need) and defense have been better elaborated by psychoanalytic theory than by any other, and my presentation reflects the debt which the study of personality owes to psychoanalysis; but I do not suggest that my examples of needs and defenses are exhaustive. Doubtless sexuality and aggression are crucial needs, but if art can serve them, it can serve other needs as well. Nor can all needs be described by categories derived from psychoanalytic theory, since some needs seem relatively free from defensive distortion; they may escape, at least in large part, the emotional control to which childhood experiences subject aggression and sexuality. In any case, to account for the present state of psychological knowledge, as well as to allow for the incorporation of new phenomena, I must discuss six projective functions: two exemplified by needs made theoretically important by psychoanalytic theory (the indirect discharge of aggression and the symbolic satisfaction of sexual needs), two which deal with defensive strategies (support for the commonly conceptualized ego defenses, and the rather special defense against destruction and depression which has been elaborated by the Kleinians), one which refers to the recently studied need for novelty and arousal, and one which deals with a process indispensable to social psychologists, that of attitude formation through identification. The studies reported in Chapters 4 through 9 are designed to elucidate the projective functions of attachment to the nude.

The perceptive functions, on the other hand, cannot draw as readily on established formulations. My discussion of them proposes three ways by which the observer may turn to art attentively and with his personal needs at bay; I distinguish therefore a need for good form (required for making discriminations of esthetic quality), the effects of engaging a self-image as esthete, and the necessary but not very well understood mechanisms by which emotional and other meaning (meaning "in" the work of art rather than originally "in" the observer) is perceived.

Chapter 1 serves, then, as a theoretical framework which guides the search for functional understanding of the individuals who, by their singular tastes, serve as ideal instances of the operation of projective needs; and it provides a vocabulary by which the findings of Chapters 4 through 9 may be interpreted. Chapter 2 is an indispensable theoretical complement, but its elaboration will require studies of a quite different design.

Notes to Introduction

1. Without further elaboration such a definition is, of course, circular. But I shall try to show in Chapter 2 that it works—that is, that it permits the gathering of evidence which reaches well beyond it.

2. Single-factor theories need not be used as narcissistically as I have implied. When they are presented as truth without the pedestrian need for verification, then my criticism applies; but they can also be propounded as the whole truth only to discover what limits they have. In such a case they represent tentative forays into a unknown reality, and carry with them their own mechanisms of testing and correction.

1. THE PROJECTIVE FUNCTIONS

More often than not, the empirical study of esthetic processes becomes focused on preferences: on what people like and the reasons for their liking. The choice of preference as an object of study is recommended by common sense, since most of us, no matter what the degree of our interest, spend much of the time we devote to art in selecting from what is available. In a museum we ignore some paintings, scan others, and become absorbed by a few, while in a record shop we search the racks or pore over the catalog; if we are wealthy we commit some of our means to purchases in galleries. Perhaps whenever we select something we extend our boundaries by incorporation; but exactly *what* we select, and the reasons for selecting it, are the questions of interest. Not all of the determinants of selection are psychological; some are sociological, economic, or something else again. But the closer we focus on people who are alike in social and economic background the better can psychological determinants explain variations in what they choose. Selecting and preferring, then, are good instances (though not the only ones) of the operation of projective functions, and the functions that a psychologist would be prepared·to find—singly or in some combination—may be conceived as follows.

Needs

Indirect Need Discharge

A tragedy, then, is the imitation of an action that is serious and also, as having magnitude, complete in itself; in language with pleasurable accessories, each kind brought in separately in the parts of the work; in a dramatic, not in a narrative form; with incidents arousing pity and fear, wherewith to accomplish its catharsis of such emotions.

One normally hesitates to abstract sentences from their context, but Aristotle's definition of tragedy can withstand the operation; it, too, is "serious and...complete in itself," and has so influenced thinking that few estheticians have been able to ignore it in comfort. Rather, nearly everyone has had to locate his own intellectual stand in explicit relation to it, a stand which is generally characterized by disagreement with a part of the definition but seldom with the whole. My own interest in the definition has to do not with the structure of tragedy but with the effects on the beholder which the definition specifies, namely, the involvement of the emotions of pity and fear, and the interplay—which psychology has to date been unable to describe better—between arousal and catharsis.

Aristotle says that fear and pity are aroused in order to be discharged; their discharge is the goal, their arousal a means to it. Let us ignore for the moment the insistence on pity and fear as the relevant emotions, and look more closely instead at arousal and discharge. It seems strange to me that Aristotle's rather complex view of the matter has found little echo in classical psychological assumptions—that the latter have held more closely to models of behavior based on discharge than on arousal. It is equally strange that both of the prominent psychological models of the twentieth century should have agreed that need discharge is central, while disagreeing about nearly everything else: I refer, of course, to mid-century learning theory and the early stages of psychoanalysis. The striking fact is that both theories, at least in their better known versions, view man as an organism primarily seeking need discharge; for the one (if I may be allowed a necessary simplification) man is an organism which, in order to satisfy the biological needs, is capable of learning nearly anything, while for the other he is an animal which, in order to satisfy the most pressing needs at least symbolically, is capable of nearly any fantasy. Learning theory has not yet constructed an explicit theory of esthetics, but psychoanalysis has, and, though generally concerned with symbolic need satisfaction, which will be discussed in the next section, the theory also treats indirect need discharge.

It is best to begin with an example, and to choose one that is closer to everyday esthetic experience than tragedy; my favorite is that of detective stories. Where tragedy has its devotees, detective stories have their addicts, and addiction is common-sense evidence of strong psychic needs at work. Seminar discussions of detective stories generally begin with the suggestion that the principal function of reading detective stories is escape from humdrum reality—a statement with which one must agree, but only to point out that there are other forms of escape, and that there must be something special about detective stories themselves. A frequent rejoinder may be that one takes pleasure in following out the clues and attempting to find the solution before the author makes it obvious—which is also indisputable, but incomplete: one needs also to ask whether following the clues leading to a thief is as interesting as attempting to discover a murderer. The answer predominantly favors the murderer and, once *this* discovery has been made, discussion invariably turns to need discharge. In addition to escape and puzzle-solving, then, and perhaps several other functions, it is generally agreed in such discussions that detective stories provide an opportunity for "discharge" of aggressive

needs. How the discharge is effected is not obvious, but one may assume with the psychoanalysts that two mechanisms are at work. The first is identification, which permits one to experience the emotions of the character identified with: in the case of a detective story we may assume an alternation to take place between identification with the murderer—and therefore a sort of participation in the murder—and identification with the detective—and therefore participation in the chase and capture and, much more indirectly, in the punishment. The second mechanism is less intuitively clear and requires an additional theoretical assumption: namely, the assumption that the psychic apparatus contains strong, undischarged needs, derivatives of powerful infantile wishes, whose arousal, even in moderate degree, constitutes partial tension release. If there were no strong need derivatives whose discharge is normally inhibited by internal psychic forces—according to this assumption—there would be no wish for discharge through such indirect channels as murder mysteries.

I am quite aware that what I have said so far in no way constitutes evidence that the experience of murder mysteries constitutes aggressive discharge, but I wish to postpone the question of evidence for the moment and discuss the conditions under which discharge *might* take place. My assumption is that if discharge takes place, it is made possible only when two further conditions (necessary though perhaps not sufficient) are met: the experience takes place under the protection of the esthetic illusion, that is, under the reassuring knowledge that the events, while appearing real, are happening not in one's own world but in an invented one; and the aggression is eventually punished (or, when the aggression is the detective's, it is made legitimate by being in the service of punishment). If the esthetic illusion is insufficient, one may be too uncomfortable to identify with the aggression portrayed; this occurs perhaps more easily when viewing films than when reading novels, partly because of the enveloping darkness and partly because of the visual immediacy of the large, detailed, moving image. But the effect is by no means limited to films; it may occur whenever the esthetic medium strives for immediacy, as in highly realistic writing or in stage portrayals in which the audience is physically barely separated from the actors. And the discharge may be made impossible in the absence of punishment, which, I believe, produces its protective effect not so much by occurring at the end of the narrative but by being anticipated throughout. The punishment is a tribute to the strength of our conscience—a conscience which varies with the individual and consequently allows aggressive discharge from the most diverse levels of esthetic immediacy and merited punishment. Consciences vary enough so that some individuals (those readily made anxious by aggression) find a film such as Roman Polanski's *Macbeth* too gruesome altogether, while others (less queasy about the portrayal of aggression) can tolerate Macbeth's crimes, but only because they are fully avenged; still others (viewers who are broadly tolerant of aggression) may find even the crimes of an opportunist who gets away with every murder a source of aggressive enjoyment.

Even so simple a narrative construction as the detective story appeals to many more motives and levels of identification than this simple discussion suggests, but the involvement in aggression is indisputable. It is another matter, however, to decide

whether the primary effect of the involvement is aggressive discharge or arousal, or some combination of the two. Everyday observation suggests that a quickening of the pulse is as much part of the effect as is eventual quiescence, and psychological theory and research have also moved toward the position that arousal may be as motivating as drive discharge. Freud's late statement about pleasure residing in oscillation between tension and discharge broadens the theoretical base of psychoanalytic theory, while experimental work on brain stimulation shows that there may be a physiological mechanism by which arousal is made pleasurable. But such general recognition of the importance of arousal only shows that psychology has reached—by a more circuitous route—the same position as everyday esthetic observation; it does not, as such, tell us whether arousal or discharge is the primary emotional effects of art. For suggestive evidence we must look at research on the effects of television and film violence.

Curiously enough, the common assumption about the effects of television violence is the opposite of Aristotle's: the assumption is that watching violence is arousing and that it predisposes toward greater violence. Bandura's (1973), Berkowitz's (1962), and Murray's (1973) summaries of the available experimental studies state simply that fantasy participation seldom if ever leads to catharsis. On the other hand, there exists a minority view, represented by Feshbach and Singer (1971), which shows that under certain conditions catharsis does occur. To form an idea of the relevance of these conclusions to Aristotle's view of tragedy, it seems worthwhile to look at the type of evidence on which the conclusions are based.

How does one study the effects of portrayed aggression on a person's motives? The basic laboratory experiment runs somewhat as follows: a group of subjects is brought together by an experimenter and, using one strategem or another, is made angry, while another group is treated in a perfectly decent fashion. Each of these groups is then divided into halves, one of which watches a film portraying aggression while the other watches something quite neutral. We then wish to know whether angry subjects will have their anger reduced by watching someone else 's aggression; if they do, catharsis may have occurred.

Unfortunately, the results are not altogether clear, at least as far as the initially angry subjects are concerned. Some experiments show that their anger *is* reduced when they watch an aggressive film but other studies, apparently more numerous, show that anger is even *intensified*. Of course, the conditions in different studies vary considerably, sometimes in ways that may not be readily apparent, and the disagreement in results can in principle be traced to differences in variables such as level of initial anger, type of subject studied, and type of aggression viewed. Can any of the variables be specified? At present no general answer is available.

Some clarification is, however, provided by studies in which some of the conditions of the basic experiment have been varied. For example, Berkowitz and Rawlings (1963) have been able to vary the subjects' interpretation of the aggression portrayed and thereby influence their subsequent reactions. In their study, as in the basic experiment, one group of subjects was made angry while another was not; both groups then viewed a fight scene from a film about a prizefighter. Now, the fight scene presented Berkowitz

and Rawlings with an opportunity to vary the interpretation of the aggression the subjects were about to see, and it is the interpretation's effect that the authors were particularly interested in. One half of each group were given a synopsis which said that the protagonist was a scoundrel, and it was hoped that they would later conclude that the beating he would receive in the film had been justified; to the other half of each group the protagonist was presented sympathetically, and the subjects were to regard his beating as unjustified.

Our primary interest is in the angry subject, of course, but it should first be said that the subjects who had been treated well were in no way aroused to anger by either interpretation of the fight scene; the nine-minute segment had by itself apparently no power to stimulate. But among the subjects who had been treated rudely, a definite effect was observed: those who had seen a "justified" beating remained angry at the interrupting experimenter, while those who had seen the "unjust" beating showed little anger.

This finding might occasion some surprise; one is not sure one would have expected it—quite the contrary, one might have thought that the sight of a justified beating would have produced a catharsis. And having obtained this result, one is not sure how to interpret it: whether by assuming, for example, that the subjects in the "justified" condition were aroused to further anger, or whether the subjects in the "unjust" condition were in some manner inhibited in theirs (an explanation which I would favor). But whatever the interpretation may eventually turn out to be, one must agree with Berkowitz that catharsis seems not to have taken place; since anger reduction had taken place in students who had witnessed an unjust beating, it is difficult to imagine that they had in some sense warmed up to the aggression more than the group which had viewed it as just.

I have cited this study in detail not so much to suggest agreement with Berkowitz's position (as do all theorists, Berkowitz has a specific hypothesis he wishes his summary to support) but to point out that catharsis is far from a comon effect, and to suggest that Aristotle's theory may be subject to some reinterpretation. But we need not be in haste to reinterpret Aristotle, at least not until the evidence in favor of the catharsis theory has been looked at. The evidence comes primarily from the work of Feshbach (1961, and Feshbach and Singer, 1971), who has carried out both short-range laboratory experiments and long-range field studies; both types show catharsis to occur, but I shall cite the field study because it is more convincing.

Feshbach and Singer's field study is much less elaborate in design than the typical social psychological experiment: it consists of studying the aggressive behavior of boys who for seven weeks watched either a diet of typical aggressive television films or a bland diet of comedies or other shows in which little aggression was present. The study was conducted in several residential schools, both lower- and middle-class, with some students from each school participating in each of the two conditions. Residential staff who were unaware of the purposes of the study kept careful track of all aggressive acts committed. The results are quite straightforward: boys who watched aggressive films committed significantly fewer aggressive acts than the controls, and the difference between the two groups increased over the seven weeks' experimental duration. The effect was, however, confined to lower class boys; middle class boys committed very

few acts at all in either condition.

Having been favorably disposed toward the catharsis explanation from the outset, Feshbach and Singer are careful about jumping to their preferred conclusion, and examine their findings from alternative points of view. Nevertheless, something akin to a catharsis explanation seems inescapable: boys who watched only aggressive programs reduced their overt aggressiveness, while those who watched only nonaggressive programs discharged increasing amounts of physical aggression. From my point of view, the absence of effect on middle class boys presents the theory of catharsis with a serious difficulty, but perhaps one cannot have everything; in view of the prevailing opinion, it is important to have demonstrated at least that catharsis *can* occur.

Let me try to draw these strands together and attempt an interpretation of Aristotle's theory from what we know of indirect need discharge. We must first keep in mind the differences between the social psychological experiment and the more complex setting in which tragedy is likely to be viewed. The differences are many: the audience to a tragedy is likely to have come of its own accord, and therefore be predisposed toward this dramatic mode; the tragedy lasts long enough for the audience to progress from an unremarkable emotional state to one of arousal, and also to form a firm identification with the protagonist; the setting is highly social, that is, the emotions aroused are subtly but pervasively communicated and probably magnified; the protagonist is a man "neither preeminently virtuous nor just" who, through a fatal flaw, moves toward inexorable destruction; if catharsis occurs, it may do so at a psychological level not easily measurable by questionnaires. Finally, all these differences, and perhaps others, make of the social psychological experiment an apparently unwarranted simplification of the complex esthetic experience—and yet one suspects that the experiment cannot be so easily discounted.

Perhaps the principal contribution of an experiment such as that by Berkowitz and Rawlings is the suggestion that anger can be lowered after witnessing agression not by discharge but by inhibition. Witnessing a cruel act which is morally unjustified may arouse anxiety or guilt at the same time as it arouses anger, and anxiety or guilt in sufficient strength will expectably inhibit the expression—or even the awareness—of any further anger. It is possible that such an inhibition operates when viewing a tragedy? It seems to me that there is good reason to suppose that it can, particularly because the tragedy's hero is by his character close to the audience (and therefore invites identification) and brings misfortune upon himself by an error of judgment—something the viewer could easily fear might happen to him. What Aristotle took for a catharsis might actually be a strengthening of one's inhibitions against aggression—a resolve not to make the sort of error just witnessed, or a reaffirmation of one's conscience.

Thus on the matter of arousal or discharge psychological studies are not clear; the very least one can say is that to demonstrate discharge as the primary effect of an actual or symbolic aggressive experience has been very difficult.[1] It seems to me wise to use the term only metaphorically; but, unlike the social learning theorists, I do not see the advantage of abandoning it altogether. To do so would be to deny that the arts can have any other effect on our emotions than that of arousal, and to make it difficult to account

for so obvious an emotional involvment as returning repeatedly to certain themes (as seems to happen particularly with aggressive ones).

If I accept that a literal reading of the term "discharge" leads to difficulties, then I must explain why a metaphorical reading is better than abandonment. Put very generally, the metaphorical reading allows us to continue looking for reasons why, apart from the crucial pleasures arising from good form or splendid performance, observers feel in some sense "better" after vicarious participation than before. The first possibility is the one just suggested: that they have strengthened their inhibitions against aggression. That seems to be a possible outcome but hardly an adequate description of the full experience of the work in process; one simply does not progress by degrees from a state of tension to one of quietness. The second possibility is the opposite: that, as Nietzsche (1910) insisted, good tragedy produces stimulation and intoxication. That, too, has a certain degree of plausibility, as one can verify from the pleasure afforded to the modern viewer by a classical tragedy represented on a wide motion-picture screen in vulgar, violent, mud-spattered, medieval detail. But if that should be the effect while viewing, and *if* at the end of the performance our desire to commit violent acts is no greater than before, then that cannot be all that has happened either. The third possibility must be close in some manner to what Aristotle had supposed: that arousal and relief are experienced at the same time. That is not a hypothesis that an experimentalist would find congenial, since the measurement of simultaneous contradictory effects seems an impossibility; but one should view this as a challenge to refine our empirical methods rather than as an invitation to simplify our hypotheses.

A process in which arousal and relief are experienced simultaneously might take the following form, among perhaps others: as a background we will assume that an ordinary conscience produces guilt about aggressive fantasies, and we will presume as well that such fantasies are ordinarily suppressed but readily evoked by suitable reminders. We may then suggest that, under the protection of the esthetic illusion, guilt about an aggressive fantasy in which one is the protagonist may be relieved by witnessing another committing the same act. To witness such an act (while knowing it to be a pretense) might be relieving by a simple displacement of guilt—on the argument that if it is committed by someone else, than I myself cannot be guilty. At the same time the witnessing may be arousing: it brings our aggressive wishes closer to the surface and even elicits a tolerable amount of anxiety. As an example, the murder of Fyodor Karamazov plays upon fantasies of parricide which, even as mere fantasies, are normally under the tight control of guilt; it arouses our aggressive feelings because Karamazov has been portrayed as vicious and abject, and it arouses no more than a tolerable level of anxiety because to some degree we feel that he has deserved his fate. If we were to measure our response physiologically, an increase in autonomic arousal would surely be perceptible; but by some as yet unspecified measure of displacement our guilt about our own fantasies might be relieved. But our experience is more complex than that; whatever the mixture of arousal and relief through our discovery of the murder, it is again altered by our experience of the three sons' guilt (as we ask whether they are guilty in fact, in intent, or not at all) and finally by our discovery of the suicide of the actual murderer.

When that happens, whatever guilt we may have felt over our temptation to believe the parricide to have been justified may—perhaps by a reaffirmation of our conscience—be relieved in turn.

Without pretending to be an analysis of the complexity of our response to a work such as *The Brothers Karamazov*, the example may at least serve to suggest how arousal and relief may be experienced at the same time. And it suggests more: it suggests that psychological experiments need to attend not merely to a work's overall effects, but to sequences of feelings which are aroused in the process of experiencing it. We must also keep open the possibility that the final effects, apart from representing some combination of emotions, are of a satisfying cognitive nature: that they have helped us sort out certain confused or vague states by clarifying their components and interdependencies.

I have gone at length into examples from the narrative arts in spite of stating that my emphasis was on the visual arts, and I may well be asked whether my discussion is intended to be equally relevant to the latter. It is certainly intended to be relevant, and my use of narrative examples was dictated by their greater clarity as well as perhaps by the greater immediacy of their appeal. But a painting can provide a similar stimulus to one's fantasies. If one gives an observer the opportunity for an unhurried exploration of a painting, as in the context of a leisurely but thorough interview, one can watch him become intimately involved with the subject matter before him. In studies reported by Spiegel and me (1974) just such an opportunity was provided and just such an involvement occurred. The best case in point was represented by an encounter between an aggressive theme and an obsessive subject—a subject who, like other obsessive personalities, was busy controlling his aggressive impulses by incisive analysis. The subject became as enveloped by Caravaggio's *The Beheading of St. John the Baptist* as a film addict might be by Polanski's *Macbeth.*

Symbolic Need Satisfaction

A distinction between indirect need discharge and symbolic need satisfaction may at first seem unnecessary, but I believe it to be useful and shall attempt to say why. When illustrating indirect need discharge, I chose examples of aggression; I think the choice of aggression—rather than of sexuality, for example—was inevitable in the context. Aggression in the viewer was aroused by seeming participation in actions which resembled in *kind* the actions the viewer himself would have wished to engage in; the difference between actual and seeming participation is that in the latter one is protected by the esthetic illusion, that one's conscience may be appeased by the punishment one is witness to, and that the aggression is directed against objects other than those of one's own wishes. But the actions witnessed and the feelings aroused are clearly aggressive, in that they have undergone no transformation or disguise; for this reason I called the

24

discharge indirect rather than symbolic. Aggression seems particularly well suited for indirect rather than symbolic portrayal, although why that should be so is by no means clear. Perhaps aggression is acceptable enough not to be in need of disguise, or perhaps aggression as an emotion is not subject to the incredibly fluid vicissitudes of love: whatever the reason, portrayals of aggression in art have become, as Cézanne might have put it, "horriblement resemblant".

Love and sexuality, however, *are* subject to considerable disguises, whether in the mind of the beholder or in the work of art he is viewing. To the degree that the feeling or impulse is transformed, it seems better to refer to its portrayal as symbolic rather than as indirect. I am not implying that portrayals of love are *of necessity* symbolic, while those of aggression are inherently indirect; I am merely noting a correlation. It is possible for love or sexuality to be portrayed as candidly as is aggression, but the result is for a variety of reasons not readily classified as art; a film in which sexuality was portrayed as explicitly as the aggression in Polanski's *Macbeth* would be classed with blue movies.

When speaking of symbolic transformation of impulse or feeling I also prefer to use the more flexible term "satisfaction" to the more seemingly precise term "discharge." As I have said, discharge may have to be understood as a displacement of guilt onto an external protagonist which results in relief but not necessarily in reduction in impulse; or it may even signify reaffirmation of inhibition. As complicated as the mechanisms of discharge may be, matters are even less clear where the impulse portrayed is disguised. If the impulse is disguised and thereby "toned down," as Freud had suggested, then the appeal to the observer's impulses must be correspondingly weaker; in such a case the term "discharge" would seem in the very least an exaggeration. Without attempting to specify exactly what a disguised impulse does to the observer, I still find it necessary to account for the observer's repeated interest in certain themes, and for the present the more ambiguous term "satisfaction" seems better. Thus *Madame Bovary* is an intensely sexual novel, but only by the intensity of feeling that it implies, certainly not by the explictness of its portrayal; reading it, one can understand how deeply Emma feels, but one is not directly aroused, and one is, moreover, enmeshed in the multiplicity of other motives and actions, all of which distract from mere sexual arousal. (I do no imply that distraction is their function, but it is certainly one of their effects.)

The classical formulation of this function of art is Freud's; although his writings on art (1953, 1959 a and b) are sparse and occasionally wide of the mark, a coherent theory emerges from his suggestions about the specific motives of artists as well as from his general theories of symbolism, dream work, and impulse sublimation. Two passages from his essay "The Relation of the Poet to Daydreaming" describe quite succinctly his view of the process by which ordinary fantasy—the dull substance of everyday psychic activity—becomes transformed into art; when they are read backwards, so to speak, they give us a theory of the process by which the work comes to be perceived:

> . . .*Some actual experience which made a strong impression on the writer had stirred up a memory of an earlier experience, generally belonging to childhood, which then aroused a wish that finds fulfillment in the work in*

*question and in which elements of the recent event and the old memory should be
discernible. . . . The writer softens the egotistical character of the daydream by
changes and disguises, and he bribes us by the offer of a purely formal, that is,
esthetic, pleasure in the presentation of his fantasies. The increment of
pleasure which is offered us in order to release yet greater pleasure arising from
deeper sources in the mind is called an "incitement premium" or technically,
"fore-pleasure." I am of the opinion that all esthetic pleasure we gain from works
of imaginative writers is of the same type as this "fore-pleasure," and that the
true enjoyment of literature proceeds from the release of tensions in our minds.*

It was left to later writers to illustrate this theory with appropriate clinical examples,
and Anna Freud (1923) was able to do so by tracing, in a psychoanalytic patient, the
evolution of an infantile fantasy into an adolescent daydream and eventually into a full-
fledged story. I am certainly inclined to accept that a work of art may be an elaboration
of a daydream which is in turn a transformation of an infantile fantasy; to this extent
there is every reason to follow Freud's lead. Having done so, however, I find that
additional, and in some respects more important, issues come to the fore. The three that
seem most appropriate to this context are the following: one would like to know whether
this chain of elaborations is at the bottom of every artistic production, or whether its
presence is only occasional; one would wish to find out whether the beholder's pleasure
recapitulates this process in reverse, by stimulating progressively deeper levels of
fantasy; and one is curious about Freud's suggestions that pleasure from the form of a
work of art is merely a bribe to involve us in the artist's fantasies.

———

Psychoanalytic theorists who followed Freud elaborated the relations between
private fantasy and the public work of art, and have suggested a clear, even if sometimes
implicit, answer to our question about the ubiquity of infantile fantasy. Just as in
psychoanalytic theory generally the focus of attention has shifted from unconscious con-
tents to the ego structures which deal with the contents, so has the attention of theorists
concerned with the arts—Ernst Kris is an excellent example—shifted from what underlies
the work of art to the process by which the underlying theme is transformed. Kris (1952)
has chosen an illustration which permits a generalization: the example is of a work in
which the fantasy comes through in too undisguised a form, and whose effect is corres-
pondingly poor in esthetic pleasure. Frederick Wilhelm Rolfe's *Hadrian VII* is the story of
an unfrocked British monk who survives plots and conquers enemies and emerges as no
less than the spiritual head of Catholic Christendom, the Pope. The difficulty with the
work is not so much the implausibility of its theme—many themes reduced to this bald a
statement fare no better—but the author's inability to maintain distance from it. The
author involves the reader so much in the egotistical fantasy that he requires him to take
sides with the protagonist; the reader is left with the discomfort, even anger, at having to

take the protagonist's part or of fighting the temptation to do so; at no point can be appreciate the work as such. In effect, the author is using the work of art the way a neurotic uses his symptoms; the work is an undisguised defense against a conflict.

The visual arts provide an even more pertinent example—more pertinent because it concerns an artist with an unquestioned capacity to give form to content. During his mature years Cézanne composed works which, to some observers at least, are almost awesome in the harmony and strength with which they organize their material. But they do not organize all material equally well: still lifes, landscapes, and portraits are disposed in space with a seemingly effortless balance of shapes and colors, yet nudes, particularly the large *Bathers* series, seem often labored and still. One suspects too close an emotional relation on Cézanne's part to the subject matter he painted so awkwardly; and one finds, in reading the poems of his late adolescence, sexual fantasies which are as vivid as his sexual life was inhibited (Reff, 1959, 1962 a and b, 1963). For those familiar only with his mature work, the discovery of his early paintings of bacchanales is a revelation of Cézanne's struggle with fantasies from which he could not gain distance. Try as he might to paint Baroque groupings of nudes, he wound up painting his fantasies. In retrospect, the history of painting was doubtless enriched by the early failure (see, for example, Fry, 1958), but for our purposes the noteworthy fact is Cézanne's discovery that the price he had to pay for his success in wedding form to content was giving up the portrayal of his adolescent wishes and fears.

Part of the answer to the first question is, then, the following: if a meaningful fantasy is to become a work of art it must neither provoke excessive anxiety in the artist nor evoke his strong defenses; he[2] has to gain sufficient distance from the fantasy to treat it critically and objectively. Conversely, it may be suggested that infantile fantasies may not make good material for art, because of their usually close connection to ego defenses; in Kubie's terms (1961), adult fantasies from the *pre*conscious are freer, richer, and more malleable.

Does the viewer reverse the creative process, that is, does he use the work of art to stimulate his fantasy and thereby satisfy an unconscious wish? (I am not asking whether the fantasy stimulated in the viewer resembles that which had inspired the work; such a question seems to me not only difficult to answer practically, but unimportant theoretically.) Our everyday experience of art seems to suggest that a positive answer is plausible, in that representational art which appeals to us does generally treat of themes we find important in our nonesthetic experience. But one should like to find evidence which is more precise and less susceptible to multiple interpretations. I offer first an anecdote from my own teaching experience—an anecdote of which I am fond because it represents a conversation whose ending surprised both participants.

During a discussion of aggressive need discharge, a student asked whether any of the theoretical points I was making applied to painting. I replied, somewhat disingenuously:

"I don't know; what do you think?"

"I don't know either, but I don't think it does."

"Can you think of an example?"

"Well. . .for example, last weekend I went to a flea-market with my husband just to

look around; we weren't going to buy anything, but suddenly I saw a reproduction of a still life and I just had to have it, so I bought it right then and there. Everybody asked me what I could possibly see in it, because it was such an uninteresting painting. And I wondered, too, because there really isn't anything in it."

What do you think you saw in it?"

"Nothing. . .I mean it's just a still life with a pitcher, some fruit and other table things. . .and it's not very well composed at all."

I waited expectantly; the student returned my quizzical look, so I asked, "Do you associate anything to that?"

"You mean like pitchers are supposed to be feminine symbols, and so on? Well, maybe."

The student paused, aware that my question had not asked for a theoretical interpretation; after a moment, she smiled suddenly and went on.

"But come to think of it, I *am* interested in cooking; I mean, I really *love* to cook, in fact, my best times are spent in the kitchen. You don't suppose there is anything in that, do you?"

Because of her smile, I knew she had asked the question rhetorically, as if to kid me about the dawning insight about her real attraction to the painting. I smiled back, and she eventually exclaimed:

"Damn it, the worst of it is that I was really hungry that morning, just as I was buying the painting!"

The laughter we both enjoyed did not require any further theoretical interpretation at the time. In retrospect, however, the example suggests two further comments about the role of needs and wishes in the viewer. The example points out, first, that if the wishes are to be made apparent, the work of art should carry minimal esthetic appeal; in cases where, on the contrary, the work is also powerful as an esthetic object (Cézanne's *Apples and Oranges* come to mind), the appeal of the subject matter may be quite obscured—and in limiting cases, it may even be quite unimportant. Because the student in this example was used to making esthetic discriminations, she sensed an inconsistency between the painting's attraction to her and its lack of real merit; being also fluent in the production of ideas, she lost little time in discovering on her own the needs to which the painting had appealed. But the example also suggests that the needs which motivate a choice such as this one need not be far from consciousness; the only ones evident here are the student's momentary hunger and long-standing love of cooking. If we knew more about her, we might uncover childhood conflicts about orality which find expression in her attachment to cooking and kitchens, but then again we might not. For the time being, all we know is that the *connection* between her needs and her esthetic choice was at the time unconscious.

But there is evidence of a considerably more tough-minded nature for art's appeal to unconscious motives. A study was carried out by Wallach (1960) to find out whether art appealed specifically by creating symbolic sexual arousal in the viewer. Because of the normal defenses against direct sexual expression, Wallach assumed that any appeal to sexuality had to be symbolic, not direct; and he predicted that, on the one hand,

individuals who show greater capacity for symbolic sexual arousal should report greater liking for art, and, on the other, that works of art which arouse the viewer the most should be the best liked. His subjects, all women, listened to three selections from string quartets, and to each selection wrote a brief, imaginative story; each story was then scored by the experimenter for symbolic sexual arousal—that is, for imagery referring to motion, rhythm, peak, and penetration. A few weeks later, the subjects listened to the selections again, and indicated how much they had liked each one. The results showed that subjects reporting the most liking had also written the stories with the most symbolic sexual arousal; in addition, there was a correlation between how much each piece had aroused them and how much they liked it. We must note that the art in question was quite abstract, so that direct sexual protrayal did not enter into the imaginative stories from which the index of arousal had been calculated. Wallach's experiment goes farther, in a way, than Freud himself had gone; where Freud could see direct traces of the motivating fantasy in the finished work of art, Wallach looked for, and found, transformations of sexual motives underlying the most innocent-looking musical selections.[3]

My own conviction is that the evidence for art's appeal to unconscious motives, though somewhat diverse, is quite good. In addition to the sort of evidence of which I have given examples, one would wish to study material from psychoanalytic sessions with patients who bring up esthetic preferences during their associations; such evidence would bear more directly on the infantile origins of the motives involved and supplement the observations of conscious motives which anecdotes such as my earlier one can easily provide. But in a way I suspect that such evidence, when it is forthcoming, will contain no surprises; as I had suggested earlier, my own interest lies less in proving the Freudian hypothesis, which I take as a good approximation to the truth, than in finding out what its limits are. Since I assume the operation of unconscious as well as conscious motives, it seems to me much more interesting to study the interplay, for example, between art as a symbolic need satisfier and art as good form.[4]

Freud spoke of form in art as a bribe. In so doing, he seemed to be specifying a relation between symbolic need satisfaction and good form; the latter is needed in order to permit the former to occur. Since I have set out throughout this book to look at esthetic questions from the point of view of empirical evidence, one might wonder whether I would attempt to specify the sort of evidence that would be relevant to this view of art. Alas, no such evidence can be expected; Freud's statement is more a definition than a proposition, and definitions cannot be proved or disproved. All one can do is to present one's personal view on the matter; mine is that form is much too important by itself to serve as an excuse for content.

But disagreements and definitions need not be fruitless; they can raise interesting questions. Instead of asking which definition is better one can ask whether there are viewers for whom art functions primarily as a need satisfier and viewers for whom art functions differently. One can imagine a sort of continuum, at one end of which would be people who view art only for its content (thus using it as a need satisfier), and at the other end of which would be individuals whose sensitivity to form makes them oblivious

to content; in the middle would be people who derive pleasure both from subject matter and from the form it takes—and perhaps most importantly from their interrelation. One can then ask a number of questions which *are* empirical: If there are such differences between individuals, do they relate to other differences in their personality? Of the two types of viewers to whom form matters, which is in reality the more esthetically sensitive? If one looks deeply enough into individuals who claim sensitivity only to form, is it possible to find a subtle, unconscious relation to content, or perhaps an important defensive rejection of content?

Defenses

Ego-Defense Support

Once more I take as my starting point an aspect of psychoanalytic theory. Symptoms were described by Freud as compromise formations between an unacceptable wish and the defense against it; in a symptomatic act, the wish as well as the defense are visible. To some extent, this formulation seems also to apply to ordinary mental acts—ones which cannot qualify as symptomatic—but one must add to these two determinants a third: that of reality demands. [5] Perhaps the formulation closest to Freud's thought would be the following: the more symptomatic an act, the more it is a product of the conflict between wish and defense alone; the less symptomatic, the more do the constraints and opportunities of reality help determine it, and the more free is the ego in exercising a choice. In practice, it may be said that most mental activities reflect the operation of wishes and defenses to some degree, and that in fantasy and in other impractical mental activities their operation may be quite perceptible.

I have attempted to discuss two ways in which the attachment to a work of art can help satisfy wishes; can one now also suggest that the attachment reflects one's habitual ego defenses? In theory, the suggestion is highly plausible; our task is to see how this would work in reality, and to look for the sorts of evidence that could be brough to bear.

If we return to one of the examples of works of art which produce indirect need discharge, we will note than an assumption about defenses has already slipped into the discussion. Viewers were presumed to differ in their reactions to a violent film such as Polanski's *Macbeth* as a result of varying anxiety about aggression: the most anxious might reject the film altogether, while the least anxious might enjoy all the violent acts, even those which no circumstances could possibly justify. People highly anxious about aggression might employ some of the classical ego defenses against it, such as denial, isolation, or reaction formation; the lesser one's anxiety, the weaker one's defenses, and the greater one's acceptance of aggressive portrayals.

This is a very simple scheme for linking ego defense with esthetic preference. It is simple in two ways: it looks only at one dimension of defense, that is, strength, and

supposes esthetic responses to vary in direct relation to it. It ignores the varieties of defense that people employ, and is therefore silent on the question of relating defense *type* to esthetic choice. It is simple also in that it supposes merely that esthetic choices will be *consistent* with strength of defense; no implication is contained therein that the choices are made in order to *support* defenses. I shall return to the question of support presently, but for the moment it seems important to emphasize that even so simple a model is valuable, and that considerable research evidence is consistent with it.

The evidence begins with the work of Burt (1939) and continues through, for example, the research of Eysenck (1940, 1941) to that of Barron (1952, 1953), Knapp (1957, 1962), and Cardinet (1958). A sample of findings must stand for the whole: Burt finds that extraverts focus on the persons or objects represented in paintings, rather than on the paintings themselves, and value expressive art over formal art, while introverts center their attention on paintings, to the exclusion of what they represent or what characteristics of the painter they might reveal, and on their own emotional or intellectual reactions to the paintings. Eysenck's results indicate that extraverts prefer paintings that are rebellious, colorful and dissident, while introverts prefer paintings which portray noble qualities in somber colors. Presumably the extraverts are emotionally more expressive and can allow themselves pleasure from expressive paintings, while the introverts, emotionally more controlled, find pleasure only from similarly controlled works. Finally, Knapp's work shows that subjects with high achievement motivation—who subordinate, it would seem, emotional expression to something akin to Weber's Protestant Ethic—like green and blue tartans, which seem cooler and less demanding as stimuli, while subjects not so motivated, and presumably emotionally more free, like red and yellow tartans, which are warm and exciting. From all these studies one conclusion emerges: esthetic preference is consistent with level of emotional expressiveness.

Now it is one thing to say that preferences are consistent with emotional expressiveness and quite another to conclude that they serve a function—either to support ego defenses or inadequately expressed needs. A reasonable though not airtight case might be made for the support of ego defenses; one could reason at the very least that those with the strongest ego defenses choose works of art which run no risk of jarring them. But since we have no clear picture of how strong the defenses really are—our evidence only compares one subject with another—we have no clear insight into the defensive subjects' functioning. (Matters are even less clear, unfortunately, with the "expressive" subjects. Their preference for expressive art is not explained by any current theory, and it may even be seen as running against the one theory that is preoccupied with emotional expression. Psychoanalytic theory suggests quite clearly that one turns to art which deals with needs which are strong but not fully expressed. If that is indeed so, then the subjects of all this research who are emotionally expressive have no apparent reason to choose expressive art—unless, of course, the expressiveness is only partial. But we simply do not know, and will not make the mistake of assuming anything until we do: in the studies I report later I attempt to make the evidence adequate to the task of theoretical interpretation.) In the meantime, is there any material which is more directly relevant to the

question of ego-defense support?

Exercises I have attempted with students in seminars point toward the sort of material which would be more convincing. I have asked students to record, over a period of two weeks, their free associations to a work of art of their choice; they were to attempt to record everything they thought of while face-to-face with the work, without attempting to judge its relevance. Only a week after finishing the associations were they to try to make sense of what they had written. Naturally, many of the "associations" were far from free; they were arrived at in some cases quite laboriously. Whether fluently produced or not (something that was not always clear from the written report), the associations seemed to serve varying functions. Some were of the nature of daydreams (of power and sex for the most part), that is, gratifying adult fantasies for which the work of art seemed to serve as a ready stimulus; in such associations no connection was made between the adult fantasy and anxieties, childhood antecedents, or other complexities. Other associations bore a close resemblance to nightmares; in such cases it was not clear what role in the viewer's psychic economy the work of art might be playing, because the role of overt anxiety is so little understood—perhaps the anxiety represents a failure of ego defense or perhaps it represents the viewer's attempt to control his subjectively felt threats by becoming hyperaware of them. Still other associations expressed fully a conflict the viewer was feeling, in that the viewer gave expression both to his wishes and to his defenses against them; in such cases the work of art seemed to stand as a symbol for the ambivalence. Finally, in the few individuals who are of concern to us here, the associations were all of a positive, happy kind, without a trace of the doubt, ambivalence or even anxiety we suppose must underlie them. These are the cases in which we are justified in speaking of ego-defense support; the associations reflect the individual's normal defensive style, and the work of art seems to serve the function of evoking the very strong defenses, thereby supporting and confirming them. I cannot give a better example than that of associations dealing solely with a happy childhood spent in the country with a loving mother; my interpretation of them as defensive does not imply that such memories were unreal, but suggests that their unblemished goodness is a simplification of a more complex reality. One would feel on more secure ground if one knew the individual well, but surely it is of significance that she lived with a prominent congenital deformity to which she managed, I am happy to say, to pay little attention.

For some individuals, then, perhaps those with a strong capacity for denial, works of art may serve the function of ego-defense support, with "support" conceived in a specific, narrow sense. But for others works of art may stand for a readily-aroused anxiety, and in their case it does not seem probable that ego defenses receive support from the work of art. Such conclusions are made possible by an analysis of free associations; if we now return to the statistical fact that people tend to prefer works of art which are consistent with their emotional expressiveness, can we say that such consistency is also a sign of ego defense support?

At the present state of our knowledge it seems to me that whether such an interpretation appears justified or not depends on one's theoretical point of view. If one's manner of understanding mental phenomena is psychoanalytic, the interpretation is highly

plausible: one can argue not only that esthetic preferences must be "permissible" to one's level of defense, but also that in choosing works of art acceptable to one's defenses one is thereby supporting them. If one's psychological world view is based on the control of arousal, it is plausible to argue that esthetic choice serves to keep arousal at optimal levels. If one's theoretical preference runs to dissonance theory, it is logical to interpret the finding as showing only that people tend to be consistent. Unfortunately for psychological theory, these explanations are not mutually exclusive, especially where such a simple finding as this is concerned. Correlational methods—it is clear by now—will continue to show consistency; what is needed to escape this predictable fate is either a change of focus or a change of method. One would be changing focus if one looked at the minority of people whose tastes are inconsistent with their personality; the more one knew about such individuals, the more likely would a plausible interpretation of the function of their tastes emerge. One would be changing method if one studied not the preferences themselves, but the manner in which they are expressed, talked about, and justified. In fairness to Burt, it seems that he had set out to do the latter, but his results are reported too sketchily to permit a critical understanding of his method. Finally, one would be changing method if one attempted to understand his subjects better: if one tried to construct not merely a single index of their defensive strength but to assess instead the impulses against which the defense is erected and the situations which call it out, and to specify the defense's type and intensity. Such an attempt will be made in the studies that follow.

Defense Against Destruction and Depression

Here I shall use the term "defense" somewhat differently than I have so far. Up till now I have used it in the Freudian sense to indicate a mental act by which a wish or an idea is kept under control; repression, projection, reaction formation are familiar examples. I shall now use it to refer to acts as well; to indicate normal as well as pathological phenomena; and to include phenomena not studied by Freud.

I shall borrow heavily from the framework developed by Melanie Klein, (summarized, for example, by Segal, 1952) because it is her followers who have contributed the most to thinking about the connection between esthetics, creativity, and depression. Kleinians move easily, and of necessity, between the world of adult phenomena and determinants from the earliest childhood. For those who do not easily accept such a connection, it should be said that while the Kleinian theories of psychic development do seem to me to enrich our understanding of the adult phenomena and indeed call attention to matters that might otherwise be pushed into the background, one need not accept fully the theories about childhood in order to accept the importance of defenses against depression and destruction in adulthood. Certainly other thinkers have commented on the connection between beauty and ugliness and terror (e.g., Rilke);

whatever choice one makes in the matter of Kleinian theory, I find the theory self-consistent and helpful with esthetic problems involving beauty and order on the one hand and ugliness and destruction on the other.

The concept most relevant to this discussion is that of the "depressive position." At a certain point in his development, the infant changes from relating to people (primarily the mother) as part objects to viewing them as whole objects. Part objects, such as the breast, were barely differentiated from the infant's own existence; they seemed ideally good at one time and overwhelmingly persecuting at another, and they corresponded to all-embracing feelings of goodness or terror on the infant's part—in fact, it would be more correct to say that there existed in the child's perception no distinction between the part object and his feeling for or about it. When the infant comes to perceive whole objects—by then the father and other people, as well as the mother—he becomes aware of their separateness from him. Of course, recognizing their separateness implies giving them up in a way, that is, realizing that they are not part of himself; this is in itself quite a task, one that is never quite accomplished. But matters become even more complicated as the infant at the same time struggles with impulses to possess and to destroy; knowing that the mother is an independent object and that she is therefore capable of disappearing, his sadistic impulses make him fear that the object could genuinely be destroyed. Giving up is difficult, then, not only because it is an actual loss by because one's wishes threatened to make that loss considerably worse. Now for the threat to be felt it is enough for the destruction to have been fantasied; the child comes to believe that he has carried it out, feels the loss of the object he has destroyed, and holds himself responsible for the destruction; the responsibility and guilt represent the "depressive position."

Of enormous consequence for later development are the ways the child chooses to defend against the depression. The unsuccessful solution occurs when the object is seen as irretrievably destroyed and lost; under such circumstances, the protective thing to do is to deny that the good object has been lost and to institute a system of manic defenses which support the denial. One of the manic defenses may have relevance to later esthetic tastes: it consists of idealizing the lost object. But the child can also defend successfully: he may have available to him the countervailing experience of continued love from the object whose existence his sadistic drives threaten, and at the same time be able to experience a wish to repair, recreate and restore the object; the wish to restore may in turn be rewarded by the object's benign persistence. Under these conditions the child may fully experience the feeling of loss: he can experience it—that is, not need to deny it—because his wishes to restore have, in a way, been successful. This solution to the infantile problem—the experience of loss, the acceptance of mourning, the success of the wish to restore—becomes the basis of adult creativity.

It is difficult in so short a space to do justice to the Kleinian view, and even more difficult to be convincing, but because we do not have to accept the developmental explanation in order to recognize the importance of destruction in the adult, a fuller exposition may safely be left in the hands of others (e.g., Segal, 1952, Stokes, 1949, 1965, 1967). Nevertheless, the view finds striking support in the life and work of Marcel Proust, in whom the adult derivatives of the need to recreate and restore are so clear and

prominent as to provide what may seem an outrageously neat example. Proust's capacity to evoke memories of his childhood is popular knowledge, but what is less well known is his conscious dedication to recreating the world he had known. He describes how after a long absence his friends had either disappeared or turned into ruins of their old selves—how they had become useless, ridiculous, ill, or on the verge of death. On realizing the disappearance of the world that had been his, he decides to sacrifice himself to the recreation of the dying and the dead; by virtue of his art, he can give them an eternal life. Such a wish, one might point out, is nothing new in the world of art, but his psychological insight into the wish, his grasp of its many sides and details, is subtle and refined. Not only does he wish to recreate: he realizes that he can create only by renouncing, that is, by acknowledging the loss of the loved ones and experiencing mourning. He makes his character say, "On ne peut recréer ce qu'on aime qu'en le renon-cant."

I am not certain whether Proust's insight into his need to experience loss and mourning represents a necessary condition for the creation of art, but one cannot doubt that it represents an important condition, whether it is universal or not[6]. For my purposes, that is perfectly sufficient; I am not so much concerned with understanding creativity as I am intent on specifying the determinants of taste. And the Kleinian view of creativity, of which Proust provides so convincing an example, has also the virtue of helping us understand some aspects of taste.

Just as in the creative process renunciation makes possible (and necessary) the drive to restore, so in the esthetic process the need for beautiful form presupposes the need to destroy and make ugly. While creation without acceptance of loss is hollow, the beautiful without the underlying terror, destruction, and ugliness is merely pretty. Both shallowness and prettiness represent a manic defense: the denial of the underlying destruction. For Kleinians such as Hanna Segal, it is therefore possible to distinguish good works of art from poor ones; good art integrates destructive drives with creative ones. In the narrative arts, where subject matter and form are relatively easy to separate, an interplay between form and content can provide a clear example of such an integration. Good tragedy, for example, integrates the horror of its content with the goodness of its form, while a good comedy, at the same time as it defends aggressively against depression, acknowledges that which it defends against. Although the proportions of drive and defense in tragedy and comedy seem reversed, one never exists without the other; the psychic world in each seems complete.

Taste, then, implies the ability to make distinctions between good and bad works of art on the basis of psychic completeness; it implies, that is, the beholder's capacity for tolerating his own destructive drives and depressive feelings. If we accept this thoretical position, or if we are convinced by the examples from narrative arts, can we apply the scheme to the visual arts? Segal would argue that we can, by virtue of being able to distinguish between the beautiful and the pretty. The merely pretty is said to be a manic defense, one which rests upon a denial of the horrible and ugly. So much seems clear: it is easy to take a stand against prettiness, to see it as capricious, incomplete, and shallow. But it is difficult to specify exactly how beauty contains within it the seeds of terror,

particularly as so many examples of classically beautiful proportions strike one as calm, rhythmical, and complete.

For Segal there is evidence that beauty does indeed contain terror, but the evidence comes less from works of art than from the beholder's reactions. She argues that one's reaction even to classically beautiful objects is not one of calm admiration, but rather one of awe: of sadness mixed with happiness, of the terrifying mixed with the reassuring. Far from the peace which such works appear to embody, they may inspire fear—the sort of fear that Rilke must have felt acutely if he was able to write, "Beauty is nothing but the beginning of terror that we are still just able to bear."

My own impression is that, correct as these observations may be, it is not necessary to base one's argument solely on observers' reactions to ambiguous works; one can discover the terrifying aspects directly in the work of art, and indeed they must be sought there unless one is content to view the work as a mere vehicle for the projection of one's feelings. But the visual arts do provide ample examples; one way to find them is to study the range of representations of a single object and to try to form an idea of which portrayals work and which do not. Scanning the gamut of portrayals of the nude means discovering how easy it is to portray the human body clumsily or insipidly; by contrast, how moving and authoritative are those representations which come alive. I have discovered once again the incredible postural richness of Michelangelo's nudes, and I find among the most powerful either those which carry an unquestionable moral authority or those which portray the body in a struggle with its limitations. Among the former I count the Christ of the Last Judgment in the Sistine Chapel and of the several Resurrection sketches (Figs. 3 and 27); among the latter are the captives emerging out of their stone matrix, the Crucifixion sketches, and even the Pietá. The one terrifies by its moral authority over the viewer, while the other evokes fear by identification with embeddedness and death; in both cases, the terror is in the work itself, but so is wholeness and perfection.

One could cite other examples, but they would only show what a single example shows: that the beautiful work *can* be terrifying at the same time. No number of examples can prove that it has to be; on the contrary a single negative example can show that it need not be. The delicious *Miss O'Murphy* by Boucher (Fig. 34), the *Baigneuse Blonde* of Renoir, are too happily sensuous to permit the expression of depression, while the women of Rubens and Maillol are too happily robust. Art can clearly satisfy other needs than those on the forefront of the thinking of the Kleinian school. To say so is not to deny the importance of its contributions but merely to point out that they represent only one function of art; their limitation is no greater than that of any other single-factor theory.

We are nevertheless left with a puzzle. Even if we accept—as I am inclined to do—that the simultaneity of the terrifying and the reassuring produces a powerful esthetic effect, how are we to distinguish between works in which the terrifying is absent? How are we to justify our feeling that the happiness of some nudes gives them substance and esthetic worth, while the prettiness of others deprives them? We certainly cannot make a distinction on the basis of their "manic" denial of depression, since they are both

guilty of it. My impression—which must be left to other contexts to elaborate—is that merely pretty works, and works of sentimentality in general, are guilty of more than a denial of depression: they deny the substantiality of feelings of all kinds. They tone down that which is robust and produce a wispy semblance which is intended to be mistaken for the real.

Arousal

Need for Varied Experience

The last four functions had an earnest quality about them. Were they to account for the largest part of our esthetic reactions, the latter would indeed be functional in a narrow, adaptive sense, and would make it difficult for us to explain such obviously lighthearted feelings as esthetic pleasure. Perhaps we might feel tempted to treat pleasure as a very serious matter and attempt to explain it in a roundabout functional manner. Some pleasurable phenomena doubtless do require roundabout explanations, and some such explanations may be elegant and convincing; I have in mind particularly Freud's (1938) view of laughter as a result of a sudden release of energy. But neither pleasure in general nor esthetic activity in particular need be explained solely by reference to the satisfaction of *other* needs.

For a considerable time, American psychology was dominated by a view of learning as an activity performed for the sake of a reward, and in one theory of learning reward was defined explicitly as the reduction of a need. Such a view of learning is functionally equivalent to a view of esthetic activity as indirect drive discharge or symbolic need satisfaction. One of the signs of increasing theoretical sophistication in psychological thinking was the discovery of exploration as a motive in itself—as a motive so distinct from drive reduction that the two motives could markedly interfere with each other. For psychologists who value empirical work, the discovery was all the move important for having been made in a laboratory; and the discovery (Harlow, 1953) consisted in the demonstration that monkeys, who love to manipulate complex puzzles, will fail to take apart a well-known puzzle when in a hurry to reach the desirable raisin hidden underneath.

This and other experiments demonstrated an innate capacity to explore and manipulate, although they of course left intact the conclusion that animals will also do things for tangible rewards; and we may take it that esthetic phenomena may similarly be determined by several motives—motives which may at times be as incompatible as the two which clashed over the hidden raisin. The exploratory motive in monkeys itself provides the model for theorizing about another function of esthetic activity: the provision of varied experiences. I think it is reasonable to assume that an exploratory motive, or need for varied experience, exists in humans; without looking further into the evidence, let us look instead at what its consequence for esthetics might be. Interestingly

enough, the need for varied experience forms the basis of three distinct models of esthetic choice.

In the first model the need for novelty does not stand alone, but is juxtaposed with another psychological principle, that of adaption level. In the original experimental situation to which the principle applies, a subject is asked to judge the heaviness of a series of weights; as he lifts each weight, his judgment, it turns out, is determined by the weights he had recently lifted. If the preceding series had been all light, a moderately heavy object will appear quite heavy, while if the series had been heavy, the same weight will appear quite light instead. Given a series of objects which can be graded on a single dimension, one can calculate, as Helson (1948) has done, the point within the series which acts as the adaptation level against which judgments are made. One can ask whether the principle applies to other phenomena beside judgments of quantity or intensity—for example, whether it applies to the pleasantness of complex objects. McClelland and his colleagues (1953) suggest that the principle is indeed quite broad, and propose what they call the *discrepancy hypothesis*, which says that the pleasantness of things depends on how discrepant they are from an adaptation level. An object—or a class of objects—to which one has adapted evokes a neutral feeling, while an object just a bit different from the adaptation level is experienced as pleasant; however, as the discrepancy increases, the pleasantness of the object is eventually replaced by unpleasantness. One likes just so much novelty. [7]

The hypothesis has not been tested with objects that could remotely be considered esthetic, but it has a certain plausibility and a test of it would be welcome. Let us try to apply it to an example in esthetics: let us suppose that habitual listening to Tchaikovsky or Rachmaninoff creates an adaptation level to two characteristics of music, which are somewhat interdependent—level of emotional directness and complexity of composition (and, for the sake of argument, to nothing else). After repeated listening, how will one judge these and other composers? If I understand the hypothesis correctly, one's habituation will first lead to a certain amount of lassitude, in that the same music will cease to be specifically pleasant, but as soon as one encounters music that is just a bit less emotional and more complex—say, music by Richard Strauss—one will register a pleasant reaction. Beethoven's or Bach's music, with their greater distance from Tchaikovsky's, would at this point not appear pleasant at all. After hearing a good deal of Richard Strauss—after reaching the Straussian adaptation level—Beethoven might seem more attractive, and after long immersion in Beethoven, Bach might be sought out, and eventually Edgard Varèse and John Cage.

But—and this is one of several problems with the hypothesis as presently formulated—the original adaptation to Tchaikovsky should also lead our hypothetical subject to seek out music which is *more* emotional and *less* complex compositionally, such as for example, Broadway musicals. Does that indeed occur? We do not know, but our suspicion is that it does not. Evidence presented by Schoen (1927) suggests that listeners become bored sooner with popular than with classical music; and a common progression in taste in classical music appears to go from Tchaikowsky to Bach (though perhaps only part of the distance), but not the reverse. Of course, we cannot rule the

other progression out; only systematic observation could settle the point. But there are other reservations that one might entertain about the hypothesis: suppose that after adaptation taste changes in *both* directions away from Tchaikowsky. By degrees it will move toward Varèse on the one hand and toward some extremely simple music on the other; what will then happen to all that had been in the middle? That seems somewhat of a puzzle. Equally problematic is the initial adaptation level: can *any* level be established as a result of exposure, or are some levels more natural than others? We do not know at present, but it is reasonable to suspect that some levels are indeed more natural; we have seen previously that esthetic preference is determined in part by personality type. If some levels are more natural than others, is it not possible that the natural ones will be more difficult to move away from? Or take the problem of the multiplicity of dimensions by which any work can be described: on which dimensions will movement away from the adaptation level take place? On emotional directness? Complexity of composition? Brilliance of orchestration? Overall mood? Length? Or is there an underlying dimension which makes these distinctions superfluous? If there is, what could the dimension be in a medium, such as painting, which eludes ready distinctions such as these? And finally, are we really dealing with novelty, that is, surprise, or are we talking instead about discrepancy? These and other questions need be asked, not in order to prejudge the hypothesis, but to point out areas where it needs sharpening. In spite of the difficulties one can anticipate, one feels that over some range of phenomena it must be useful.

While the first model treats of variety relative to a standard, the second model appears to work only with absolute levels, and for that reason is concerned not with discrepancy but with novelty. It may seem strange that the novel should be defined without reference to the habitual, but that is accomplished by a translation from a theory of communication where novelty has a technical meaning, that is, from information theory. The translation is done somewhat as follows: information theory normally works with stimulation that is strung out in sequence, such as telegraphic transmission, language, or even music. An element is informative when it is unexpected or novel, and there is nothing quite so novel as the first occurrence of an event. When an event first occurs, it carries maximum information, but as it recurs it becomes predictable and ceases to carry information. But each time a new element occurs, provided it is totally distinct from any other, it, too, becomes maximally informative. Such a straightforward definition can easily be applied to visual patterns in spite of the obvious drawback that they are not presented to us in sequence: if one takes elements which are totally independent of each other, a large number of such elements carries more information than a small number. If one could construct irregular polygons whose points were independent of each other, polygons with many points would carry more information than those with few. Or if one constructed random checkerboard patterns with varying densities, the more dense would be the more informative. One has now arrived at the point where a complex polygon is more informative and unexpected than a simple one, and a dense checkerboard pattern more so than a sparse one, even though both may be "known" to the observer and not novel in the usual sense at all.

One is tempted to ask whether there is a relation between the informativeness of an

object and how much someone will like it. The question has already been asked, and the polygons and checkerboards have already been constructed, the first by Munsinger and Kessen (1964) and the second by Dorfmann and McKenna (1966). Because the results of the latter study are perfectly unambiguous, they will serve this schematic discussion better. The authors reasoned that among a wide range of checkerboard patterns the simplest would be too uninteresting to be liked, while the most complex would be so informative as to be visually hard to digest, so that the most preferred would be checkerboard patterns of medium complexity. The prediction proved to be perfectly accurate, and a smooth preference curve was obtained with a high point near medium complexity and a gradual drop on either side. Perhaps more remarkable was Dorfmann and McKenna's proof that each individual has his own point of preferred complexity, on either side of which preference diminishes regularly; the smooth curve obtained on the total group was not therefore a statistical artifact.[8]

If one constructs objects which vary only on the dimension of complexity, then, one will find that subjects have a distinct preference among them; every subject has a level of complexity he finds congenial. If we can accept that complexity produced by random elements is a visual embodiment of novelty, then indeed at least one study shows that novelty is sought after—novelty of a certain degree, neither more nor less. This conclusion, in spite of some difference in underlying assumptions, is similar to that offered by McClelland as a mere hypothesis.

There is yet a third way to look at the question of novelty as motive; it is at the same time the most complex and interesting, and the hardest to submit to an experimental test. Instead of assuming that man searches for novelty one can assume that man searches for an interplay between novelty and order. At first sight there may appear to be little difference between the two assumptions, but their consequences are quite distinct: under the first assumption, the search is for a level of novelty, while under the second the search is for an alternating rhythm—rhythm of tension and release, ambiguity and clarity, imperfection and perfection.

Perhaps the most explicit exposition of the third model, as it applies to music, is contained in Leonard B. Meyer's book *Emotion and Meaning In Music* (1956). The book avoids mention of information theory, but subsequent writings by Meyer (1957, 1959) make clear that the model could have initially been stated in information theory terms. The terms "expectancy" and "probability" are important to the theory and Meyer takes pains to specify the many ways in which expectancies are created. Expectancies are formed in part from successions of notes, themes, phrases and harmonies (that is, from the structure of the piece), in part from knowledge of the cultural style within which the piece had been composed. At the appropriate time we come to expect a certain note, the repetition of a theme, a change of key or tempo: when our expectancy is perfectly confirmed, no meaning is experienced, but when the "normal course of stylistic-mental events"—in Meyer's phrase—is disturbed by some form of deviation, then musical meaning arises. Meaning is in a way equated with information; information is by definition that which is novel, so meaning and emotion are embodied in the unexpected.

Meyer carefully avoids saying that information content is equivalent to esthetic

goodness; esthetic goodness has something to do with patterns of expectancies confirmed and disappointed, but it is not a simple function of any one discontinuation. So far, what he says makes perfect sense, and conforms to intuitive understanding of music as well as to technical canons of composition. But if the theory were left at the point of defining meaning as arising from disconfirmation only, it would quickly run into difficulties. Meyer himself is well aware of them, and, after considering some musical examples, modifies the definition considerably. My own impression is that the modification is necessary for musical reasons but that it makes difficulties for information theory; be that as it may, the modification is required because of the obvious fact that our affective reactions are aroused both by unstructured passages which produce tension and by structured passages which allow release—in other words, both by passages which contain the unexpected and informative and by those which contain the expected and uninformative. Meyer's own example is very apt: after an unstructured passage in the development section of the first movement of Beethoven's Third Symphony in which rhythmic organization is disrupted and melodic motion weakened, the arrival of the theme has, in Meyer's words, "tremendous impact."

But if the impact comes from the resolution of tension, how does one redefine musical meaning in terms of expectancy? Meyer proposes a new, more satisfactory definition, though seemingly unaware of its difference from the old: musical meaning arises when an antecedent situation produces uncertainty as to the temporal-tonal nature of what is to follow. As I read the definition, particularly in view of the example from Beethoven, the resolution is the terminus of the uncertainty-producing passage and therefore participates in and confirms the meaning.

One cannot do justice to the complexity of Meyer's presentation in a brief space, nor is there need to attempt it here, but the main point concerning information theory has become apparent: emotion and meaning must be related both to information and to its absence. The many and subtle ways in which expectancy is generated need, of course, to be fully described; the task is not easy, because the expectancies arise not only from the structure of the passage, as I have said, but also from knowledge of style—that is, from knowledge of Western canons of composition as well as any given composer's compositional idiosyncrasies. To test, then, whether meaning is perceived as arising in passages with given information content, we need to know not so much the objective characteristics of the passage but what information each listener himself is perceiving—and this is no mean task. Nevertheless, the task seems to hold the promise of decent reward, mostly because it reintroduces the perceiver into information theory and attempts to link meaning to information as perceived rather than information as sent.

Let us assume that the attempt will someday be successful; there still remains the question of the suitability of such a theory to the visual arts. It has been objected (by Green and Courtis, 1966, for example) that information theory is inapplicable to the visual arts because the indispensable characteristic—scanning the elements in sequence—is absent. When an element can either precede or follow another, or when it is perceived at the same time—so the objection runs—how can one specify its probability

or information value? There seems to me to be no ready answer to this question, and quite possibly we will have to resign ourselves to being unable to define patterns of tension and release in the visual arts unambiguously. But there are other ways of conceiving the interplay between randomness and order which are suggested by Meyer and which may more easily be translated into the visual arts. Meyer contrasts the effects produced by two similar themes, one by Geminiani and the other by Bach, the one smoothly flowing and the other introducing slight unpredictable irregularities, and concludes that the one by Bach is considerably more interesting and meaningful precisely because of its unpredictable kinks. By using information theory in this manner, Meyer provides a new underpinning to observations made long ago in esthetics about the power of imperfection within perfection. In the visual arts one is reminded of the late Ming adage to painters—an adage usually quoted for its charm, but one that can be taken perfectly seriously: never lose your awkardness, for "once lost it can never be recaptured" (Cahill 1971). In a similar vein, and much closer to home, one thinks of Cézanne and the quality of his line: periodically disappearing, only to reappear ever so slightly displaced, as if to disappoint any attempt to take it in smoothly, effortlessly, or gracefully. This willful awkardness—a denial of the merely graceful—strikes me as very powerful, and when used with the restraint that the mature Cézanne can so readily impose, appears to be one of the secrets of his incredibly authoritative statements about visual reality. It seems a perfect example of the right counterpoise between order and disorder, the expected and the novel, the smooth and the rough.

There are, in sum, three ways of looking at the quest for novel experience in art: two of them anticipate a search for works of art which provide a given overall level of novelty, either absolute or relative to a standard, while the third foresees a search for works which provide for an interplay between the expected and the novel. The third model seems in some respects the least precise, but has the indisputable advantage of being close to actual esthetic experience; when one can feel its operation in one's own esthetic perception, one gives it precedence over the greater precision and abstractness of the other two.

Identification

Identification with Significant Figures

Our own experience tells us that our tastes have undergone a process of formation; recent psychological writings have taken us a long step toward making that process—or at least that part of it which can be conceived as taking place within the individual—formal and explicit. [11] There is a pronounced maturational component which makes our tastes at different ages somewhat predictable, but here I am concerned less with processes of change in childhood than with experiences which leave perceptible traces in adulthood; in fact, my concern is even more narrow, in that I am here dealing with interpersonal influence, and at that only with influence as experienced by the individual. I should like to know, given that we learn something from others, exactly what it is that we learn and how we learn it.

In relation to what can be offered as an answer, this is still an ambitious question, but it seems important to offer some thoughts on the matter if only to help make ideas clear and research attractive. We may begin with an extension of the material on destruction and depression; the Kleinian theories made us sensitive to the importance of the past, particularly of attempts to recreate a past that had to be given up. We need to ask whether the observer, somewhat like the creator, does not actively search for esthetic material that recreates a past. How would one recognize such a phenomenon if one encountered it? Only with the willing introspective help of the individual concerned, I should think, and perhaps more obviously with auditory, olfactory, and gustatory phenomena than with the visual or linguistic.

Visual and linguisitic forms seem to me relatively precise, while the others appear more vague.. [12] By that I mean that the visual and verbal memories are more easily recalled and integrated into a system of images and thoughts, while the auditory, olfactory, and gustatory memories are less subject to conscious recall and more often connected with vague moods. But curiously enough, the latter must at times correspond to very specific memory traces which seem quite resistant to changes with time, because they can be evoked by external events with uncanny vividness. It is the latter that may more often be implicated in attempts to recover a part of the past; on a simple, sensory level, one thinks of all-but-forgotten smells which, when encountered, can evoke earlier settings, while on a level closer to that of esthetic organization one thinks of melodies or whole musical compositions which have been heard in childhood and now have a power to move that is disproportionate to their esthetic quality. Just as a composer can seek out melodic fragments from childhood as a way of recreating part of it (Dvorak's *Songs My Mother Taught Me* is an example..)[13] so can the beholder seek out works, or even whole schools of composing, which have been encountered during formative years or which give one a sense of a past recreated. Works which carry such emotional freight from

childhood are for the most part connected to parental figures, though not always to the parents themselves, whether the connection is apparent to the viewer or not; to put the matter briefly, we may therefore say that the first way in which significant figures influence later esthetic choices is by providing experiences with particular works which come to have a powerful *evocative significance.*

I should be exaggerating were I to suggest that the evocation of a past is always connected to a parental figure; there are instances of evocations that have no specific figure as a target. Such is, for example, the recent taste for Nostalgia, that is, for objects evoking styles from the 1890s to the 1950s. On its face, such taste does not recreate a real past—the styles having disappeared before the birth of the Nostalgic beholder—but gives the semblance of a past better than the one that had been experienced in fact. In some instances, the taste may attempt to revive the parents' youth, but in most it revives part of the life style of the grandparents; in neither case has the past ever been "real". But Gordon (1973) has shown successfully that taste for Nostalgia *is* a reaction to an unsatisfactory past, by demonstrating that the past of Nostalgics had been more unsettled than that of people who accept tastes expressive of their own age.

The influence of parental figures is not limited to such general evocations; it can be quite specific, in the sense that the child can learn to like works that the parents had themselves liked. It seems not to matter whether the significant figures had made a conscious attempt to mold the child's taste or whether they had merely made clear what their own preferences were; there are certainly instances—we can each find some in our own experience—where such influence had occurred. This is not to imply that the influence occurs regularly; parents, alas, are much more aware of all the instances where children have formed tastes which are either independent or diametrically opposed to theirs. We should certainly like to know under what circumstances children accept parental tastes, but it seems that theories of learning have yet to reach the sort of sophistication which would make prediction reliable. Nor is psychoanalysis of much help: it can trace back a process of influence through the memories of people undergoing analysis, but the connections it establishes have little value for foreseeing the future tastes of children. I suspect that whether a child accepts some parts of parental tastes or not is part of the broader pattern of his identification with the parents, but the pattern is unfortunately not well understood. Nevertheless, at some future date it will certainly become clear and we shall be in a position to understand the second component of the identification process: the *acceptance and rejection of works* liked by the adults one had known as a child.

Significant figures are not confined to one's childhood, of course, but continue to influence us during adulthood. Little is known—of any systematic nature—about the process as it occurs between adults, at least as far as tastes in the arts are concerned. We do know from sociology that choices in the popular arts and in certain articles of consumption, where tastes change rapidly and perhaps more in response to social influence, are markedly determined by neighborhood opinion leaders (see Katz and Lazarsfeld, 1955), so we cannot doubt that influence on taste in the fine arts is also probable, but we do not know its extent or its agents.

There seem to me two other types of influence that significant figures can exert, both

of which may be more significant for esthetics than the two already discussed, in that they may contribute to the capacity for esthetic discrimination itself, rather than merely determining certain esthetic choices. I have in mind first the likelihood that children[14] may learn *criteria for judging* works of art from choices that parents make. It has become clear from studies of language acquisition that children do not learn all the phrases and sentences which they will someday use, but that they learn rules for constructing them instead; this is not to say that they are taught rules, nor that they can formulate the rules by which they operate, but that they construct sentences which are clearly in accord with rules (Brown, 1973; Slobin, 1971). Clearly children generalize, and generalize rather easily, from a few instances; if psychology had not been hampered by the S-R model of learning it would have made this discovery much earlier. The question for esthetics is whether a similar process might not operate to enable the child to form esthetic criteria.

Although I suspect that some such process may be found, I am skeptical that it will resemble that of language acquisition in detail; it should not be universal, nor should its rules be as clearly definable, nor should such rules as may exist apply to all instances of esthetic choice, nor should they be valid throughout one's life. In the very least, however, the process should include generalizations from a few instances, and in other cases it may include the learning of specifically formulated rules. I have in mind specific rules such as, "You ought to put on red socks to go with the red stripe in your dress (but you could also put on white ones to go with the white stripe)," or "You ought to avoid the primary colors because they are a bit primitive," or generalizations formulable by the child, such as, "I guess my father doesn't like paintings of noble young ladies with their heads cocked coyly to one side," or "I suppose that a painting doesn't have to look like a photograph to be good."

Finally, there is yet another form of identification which may help determine taste. It seems likely that some children *form a sense of security* about their judgments while others remain unsure. We can only speculate about the experiences by which confidence or diffidence is built up, but some of them may include identification with significant figures. It is possible that a child will identify with parental self-confidence itself, or that he will form self-confidence as a result of repeated and self-consistent praise. Whatever the process, the result may be the sort of self-image discussed in an earlier section which stimulates a person to make better esthetic discriminations—or on the contrary the sort of self-image which, while secure, leads one into untold esthetic blunders.

1. Notes

1. Part of the difficulty is with the conception of "drive" as a motive force requiring periodic reduction. I address this difficulty more directly in Chapter 10, but for the present it is important to say that some conception of "needs" is indispensable—needs in the sense of motives which impel a person into predictable and to some extent repetitive actions (esthetic ones as well, of course). Such needs are multiple, but for any given esthetic attachment they appear to be few in number; or so argue the results of the studies presented subsequently.

2. Or she, obviously. I am content to use the generic "he" because it permits simpler grammatical constructions, but I would regret being understood as suggesting that only men are artists or great artists, or that women operate under some inner disadvantage.

3. I am aware that other interpretations could be advanced for Wallach's results. It could be claimed, for example, that the subjects who were presumably showing symbolic sexual arousal were only expressing a heightened but diffuse (nonsexual) excitement. Such an interpretation cannot be discounted at present, although a perusal of representative "aroused" store is (which are illustrated in Wallach and Greenberg, 1960) suggests to anyone sympathetic to psychoanalytic interpretations of symbols that sexual arousal is indeed being symbolized. The most we can say at present is that Wallach's results are consistent with Freud's theory, though they do not prove it.

4. The one theorist who has set out to understand form from a psychoanalytic point of view is Adrian Stokes. Because his contribution makes quite different assumptions from those discussed here, no attempt was made to incorporate it; but the contribution seems to me seminal and of first rank.

5. I may be incorrect in stating that for Freud mental acts have only three determinants: wishes, defenses, and reality demands. Freud did say that the ego served three masters (the id, the superego, and reality), but perhaps his statement does not exclude other determinants. However Freud may have meant it, there must, of course, be other determinants of mental activity, such as problem solving for its own sake (as with crossword puzzles), searching for optimal environmental complexity, and others.

But the point is that if wishes *are* important, then defenses must be, too; and the question for this section is to describe how defenses are employed in dealing with the work of art.

6. One is hard put to fit very robust creators into this scheme. Rubens, Renoir, and Maillol, for example, seem to celebbrate the boutifulness of life without backward glances at losses once sustained, and their work does not thereby become unconvincing. Generous forms, unlike pretty forms, seem not to need a substratum of deprivation and terror in order to appear self-sufficient; which is not to say that Renoir and Maillol do not occasionally stoop to prettiness.

7. A similar hypothesis has been proposed by Berlyne (1971) on the model provided by Wundt. Berlyne and his students (1974) have developed sophisticated measures of complexity and other relaxed variables, and have established a place in contemporary psychological esthetics which my brief mention here can barely hint at. However, while Berlyne inclines theoretically toward the relativist position, most of his empirical work deals with complexity, or interestingness, as an absolute. Since my purpose here is to present three ways in whic complexity may be thought of, Berlyne's better-worked-out, and therefore more complicated, scheme did not provide as clear an illustration.

8. Steck and I (1975) have shown, however, that for auditory complexity the point of preferred complexity is relative. It is stable for a given individual in the sense that if it is located, say, at the midpoint of one distribution, it will be located at the midpoint of another distribution as well; its location varies absolutely, but it occupies the same relative place on different distributions. (See Chapter 2)

9. See, however, also the more philosophical discussion by Arnheim in his *Art and Entropy* (1971). There Arnheim makes fresh distinctions between entropy, information, and disorder, distinctions which are crucial to any serious thinking about the problem. My concern here being, however, with the question of esthetic preference, I have not made explicit use of his contribution.

10. I am not implying that the eye actually follows the outlines of objects; on the contrary, it seldom does so (Buswell, 1935; Yarbus, 1967). But the perceptual effect of linear irregularities or interruptions is independent of eye movements and very much like the effect that would be produced by an eye which actually followed the line.

11. The best theoretical discussion of the development of competence in the arts, with implications for the development of taste, is that of Gardner (*The Arts and Human Development* 1973).

12. There are probably significant exceptions to this rule, if it indeed be a rule; it seems likely that musicians, particularly composers, have a refined capacity to perceive and remember auditory forms. I do not know whether there are individuals who have a comparable grasp of olfactory and gustatory forms, but if there are, I would suspect that adult learning is heavily implicated.

13. I do not know where Dvorak's *Songs* contains actual material from childhood or whether it is meant merely to be evocative; strictly speaking, the example serves to point out Dvorak's impulse but fails to pinpoint his material.

14. I use the word "children" here as mere shorthand. Since children use quite different types of esthetic criteria at different ages (Machotka, 1966), and make different discriminations between paintings (Gardner, 1972), they cannot learn all possible criteria at too early an age. The available evidence suggests that past the beginnings of adolescence, or more exactly after the beginning of Piaget's stage of formal operations, at about twelve years of age, the child can learn essentially adult criteria for judging painting. It is another question whether he applies them in the same way as adults.

2. THE PERCEPTIVE FUNCTIONS

Projective functions—those just discussed—describe how a person comes to select certain esthetic material: to what objects or themes he becomes attached, or to what aspects of the work of art he will respond. The study of projective functions is essentially synonymous with the study of esthetic choices and attachments. In the studies of the nude which I report later I look at the functions served by becoming attached to one or another aspect of the nude, and it must now be clear that because the question is one of attachment, I shall deal only with projective functions; to have dealt with perceptive functions would have required different methods. But since one of my concerns is to lay the groundwork for the psychological study of a full range of esthetic phenomena, the perceptive functions need to be defined carefully as well.

If in a given esthetic contact projection refers to the primacy of the observer's needs, perception refers to the primacy of the object's structure. When perception is engaged, two things seem to happen: the viewer attends to the properties of the object while suspending his own needs, and he learns something from the process of perceiving. I have said that psychoanalysts tend to see projection as primary to the esthetic process while other psychologists, particularly Arnheim as a representative of Gestalt psychology, stress perception. In Arnheim's understanding of the process there are two elements which are not ordinarily acknowledged by others. First, in attending to the object the viewer perceives not its elements as such but its *structural features*: the features may be the natural axes of its length and breadth, the particular curvature of its most characteristic outline, and similar properties by which the object is recognizable as such. Structural features have the advantage that they tend to change more slowly than the discrete elements as the object is transformed before us (as by rotation) and that they therefore permit the object to be recognized in spite of most of its normal transformations. Of course, once structural features change, the object no longer appears the same. The second element of the process is that the viewer becomes aware of the *visual forces* by which its features are interrelated: of the direction of its various thrusts into space, of the balance between its various elements, of the tensions between its solid parts or empty spaces.

This view of the perceptual process is complex enough to pemit us to grasp how it is that form is perceived. Many models of perception are confined to the identification of objects; but identification, while indispensable even in esthetic perception, seems to be only the beginning of a longer process. Or perhaps it would be more correct to say that to the extent that perception reaches beyond mere identification, whether of practical objects or objects specifically designated as art, it becomes esthetic perception, that is, the perception of form. There is no need to assume that all perception should tend toward this state, because the practical need for recognizing objects is too compelling too much of the time. But in circumstances where impracticality is permissible, the perception of form becomes possible.

Since I am concerned in this work with needs rather than with mechanisms, I shall leave this model of perception in sketchy form and turn to a much fuller discussion of what can be called the *need* for good form. My concern will be first to present what evidence I can for the existence of such a need and then to go on to discuss some conditions under which the need can be evoked. Finally, I shall attempt to outline a process by which one attends to objects' meaning, but I shall treat this process as perceptive rather than projective.

Need for Good Form

There are two principal sources of evidence for the existence of a need for good form. On the one hand it can be shown that there is considerable agreement among people of diverse origins on the "goodness" of colors and certain simple shapes. On the other it can be shown that more complex shapes—objects one ordinarily calls works of art—can be judged as better or worse quite reliably, not only by certain well qualified Westerners, but also by artists and artisans of unrelated cultures.

The classical studies in the field of form preference were carried out by the founder of experimental esthetics, Gustav Theodor Fechner (1897). One of the problems he set out to investigate was the beauty of the golden section,[1] long thought to be the secret of esthetic proportion. He proceeded, for example, to show to subjects a fairly large selection of forms, which included one based on the golden section, and to ask them to choose the most beautiful or pleasing. In many instances—among isosceles triangles whose base-height ratio varied, and among crosses whose horizontal arm varied in placement and length, for example—the golden section was not the most frequently chosen, but among rectangles the one whose sides were in the golden ratio was indeed preferred; there was a smooth drop in preference with increasing distance from the golden ration. Fechner also proceeded to study the proportions of rectangles in actual use, such as the frames of paintings (he measured some 10,000 paintings), the dimensions of printed pages in books and visiting cards of different types and playing cards of different nationalities. The dimensions of paintings were disappointingly broader than

the golden ratio, but the other forms were fairly close, and whether thinner or plumper, they averaged close to the ideal. Later students replicated the results on rectangles, and added the finding that subjects, when asked to subdivide a line into unequal segments, tended to locate the dividing point near the golden section. Thus, in spite of some variability and in spite of only partial success among rectangles in actual use, a conclusion is permitted: among German and American samples of the nineteenth and twentieth centuries, the golden section rectange is judged the most beautiful.

An equally interesting regularity in choice comes from studies of color preferences. One would be tempted to assume that colors would be particularly subject to variability in liking; or even that no agreement on liking could be reached. But the results of 26 studies carried out in different cultures argue otherwise: in spite of various testing methods, the mean order of preferences across cultures is Blue, Red, Green, Violet, Orange, Yellow (Burnham *et al.*, 1963). Guilford (1934) has shown that varying value (lightness) does not change the result, that is, that the preferences remain substantially the same when several degrees of lightness are chosen, provided the same lightness is chosen for all six colors.

These studies are not the only ones to show considerable agreement on the attractiveness of colors and shapes, but they can serve as illustrations of the point that *some* forms are generally preferable to others. It might be objected that agreement on abstract rectangles and single colors is of little practical significance for the more complex constructions we call works of art. I think such an objection would have merit, although I would defend the results at least on the grounds that they indicate regularities where none had been presumed to exist. But regularities in attractiveness can be shown for combinations of colors (Granger, 1955) and for works of art as well. The methodology for studying preferences for color harmonies resembles that for the study of preferences for single colors; the subjects are essentially unselected (except that they tend to be college students) and they are asked, in an orderly fashion, to choose colors that harmonize best with a given color. To test for harmonies along the dimension of hue alone, subjects are given a hue on a color chip, under standard illumination and with a standard background, and are then asked to select from among twenty chips of different hues the chip that forms the best harmony; they then proceed to the next best, and so on. The noteworthy fact is that subjects agree significantly on the hues they consider harmonious: no matter what hue one starts with, the most harmonious is its complementary, that is, the color located at the opposite point on the color circle. There are similar regularities in the choice of saturation and value harmonies; in effect, then, under laboratory conditions there is some agreement on harmonies along all three dimensions of color.

Works of art differ from each other on so many dimensions that comparisons of the type made by Granger's subjects are difficult, although in theory dimensions of comparison could be defined and works of art made which differ by degrees on a single dimension at a time; but no one to my knowledge has tackled this Herculean task. One way to obviate this difficulty is to proceed as Child has (1965): to select pairs of works of art, submit them to trustworthy judges, and retain for a test of esthetic judgment only those

51

where judges agree that one member of the pair is the better work of art. This is the second type of evidence for the existence of good form. Such an undertaking sounds simple, but when done well it is time consuming: Child asked students to locate works of art—slides of paintings, drawings, even furniture and household objects—which in their judgment were as alike in subject matter and style as possible but in which one appeared clearly to be the better work; such initial screening yielded about 3,000 pairs. All of the pairs were then submitted to fourteen expert judges (fine arts faculty and advanced graduate students) who judged, after a brief exposure, which of the members of each pair was the better work. The results were quite remarkable: on a full third of these pairs (1,260) judgments were unanimous or nearly so, with at most two judges disagreeing. Given such high agreement, one can then assume that these pairs constitute a test of esthetic judgment—that subjects who under similar testing conditions agree with the experts possess esthetic judgment. I should quickly add that in practice a subset of eighty to one hundred pairs is usually employed in testing.

Were it not for considerable further research with this instrument, I would be inclined to agree with the objection that such a test measures only agreement with a small group of Westerners with common training and frequent communication with each other. But Child has marshaled considerable evidence which indicates that the test has broad validity. First, the personality of high scorers differs systematically and repeatedly from that of the low scorers; second, the personality of the high scorers is what one would expect of good judges of art: they have a greater capacity for complexity, accessibility of childish experiences, and independence of judgment. Third, the personality of good judges among Japanese university students resembles closely that among American students (Child and Iwao, 1968). Child's test therefore suggests that esthetic judgment has definite personality underpinnings and that the latter are similar in at least one other culture. But the evidence does not stop there: in a search for further intercultural agreement, Child and Siroto (1965) have also obtained rankings of the esthetic quality of a series of photographs of African ceremonial masks from judges such as those who had standardized the test of esthetic judgment, and then presented the same photographs to a group of African mask experts (mask makers and ceremonial leaders.) I wish to emphasize that the Western judges were unfamiliar with the masks in question, and that there was little possibility of the two groups having in some manner communicated their standards to each other or of having obtained standards from a common source. Nevertheless, the mean rankings of the two groups were very close.

Cross-cultural agreement extends to objects which are similar to those of Child's test of esthetic judgement as well. Child and his collaborators (Ford, Prothro and Child, 1966) have shown a selection of representations which had been chosen similarly from the Greek Islands. These groups were unfamiliar with Western art objects, but on the other hand were skilled in the practice of arts and crafts important to their own groups. If the practice of the arts engaged or developed similar perceptual skills in artists who otherwise have no history in common with the Western students of the fine arts there should be some agreement with the choices of the Westerns. Signficant agreement is indeed found, although it is by no means perfect. However, the agreement is much higher

than that obtained between groups which are untrained in the arts, such as university students of American, English, or African origin (Child, 1962 and Lawlor, 1955) or Australian students and aborigines (McElroy, 1952).

In sum, studies such as the few I have reviewed show that among unselected subjects there is agreement on the goodness of some simple shapes, and on liking for colors and color harmonies. Among subject selected for their expertise, there is agreement on the goodness of complex works,[2] and the agreement in some cases bridges unrelated cultures. Among American university students the better judges of art show consistent personality characteristics, and the consistency is rather emphatically underscored by the similar personality traits of good judges among Japanese university students. One is justified, I think, in saying that there is such a thing as good form—or, until a more rigorous definition of good form becomes possible, that some forms are better than others. In saying this, I wish to make clear that no claim is made that *all* forms can be distinguished from each other on goodness; were that possible, it would result in an exact definition of goodness. Such a result seems not only improbable but also undesirable. But it seems to me sufficient that some forms can be distinguished from others—that, as Child's test seems to show, good art can be distinguished from art that is merely skillful. The evidence would doubtless have pleased David Hume.[3]

It is one thing to say that there is good form, and quite another to say that people have a need for it. In physiology, needs are defined by the activities of organisms deprived of satisfaction, and no one disagrees that organisms deprived of oxygen, food, water, or elimination show unmistakable needs for regulating these and other examples of intake and outflow. In psychology, needs are more variously defined and agreement on what they are is not easily reached. Not the least difficulty in psychological theorizing is the broadening of the defining criteria to include "growth" motives (such as self-actualization) as well as the more obvious "deficit" motives. A need for good form could be a type of growth motive, in that it seems to arise most forcefully when deficit motives have been satisfied, and as such is subject to the same reservations as might be entertained about the need for self-actualization. But the reservations would certainly be no greater; and I think one may advance in its support the observations that (a) all people look actively, although sometimes only symbolically, for good forms among biologically necessary objects such as sexual mates, (b) *some* people, at least, search actively for good forms among biologically useless objects such as works of art, and (c) *some* people, at least, are made quite unhappy by being deprived of good forms, whether biologically useful or not. Although I would be the first to admit that the need for good form may be variously strong, if one accepts these criteria for the existence of a need, one cannot deny that it exists.

Self-Image as Esthete

One is on uncertain ground when discussing self-image; the concept is not sharply defined and its effects have never been clearly specified. Nevertheless, self-images exist in the sense that people not only *are* themselves, but that they also think about and define themselves; they see themselves as weaklings or athletes, heroes or villains, unloved or loved, revolutionary or conservative—and perhaps as esthetes or insensitives. Their self-definition may also reflect groups or classes to which they belong (membership groups) or with which they identify (reference groups): Republicans and Democrats, the working class and the middle class, the John Birchers and the Black Panthers. The question social scientists have often asked concerns the consequences of being a group member or a reference group member.

Many opinions and attitudes undeniably have a group basis, that is, there is some correlation between, for example, social class and political opinion. There is some question, however, about how one explains the correlation. Some maintain that the group requires or invites a certain amount of conformity, and that it provides certain common experiences and definitions of the world which make that conformity fairly easy to attain. Such an argument has some force particularly where the choice of group membership was not made by the member, as in groups into which he had been born. But in other cases group membership is freely chosen and may be seen as an extension of the member's self-image. Even in cases of predetermined membership, there is some freedom of choice over the degree of one's conformity. If membership in the group is part of one's self-image, the individual is more likely to hold opinions that the group holds; if it is not, the member's opinions may be quite independent. These assumptions seem reasonable whether one assumes that self-image is in itself a product of group membership or whether it precedes it.

It is probable on *a priori* grounds, then, that self-image has some effect on esthetic opinions as well. But what is the effect? I am not aware of any studies dealing with it, and propose instead to offer several ways of conceiving the effect so that it might become the object of study.

A good question to start with takes us back to the discussion of Child's test of esthetic judgment. Let us assume that in taking the test the subject can answer either from the point of view of an esthetic judge such as an art critic, or from his own personal view. Would these two different self-images produce different judgments? Would the subject with the "esthetic" self-image make more refined discriminations? Would he tend to reject the superficial, the merely pleasing, in preference to the more challenging and profound? In different studies Child has given his subjects different instructions for taking the test, but to my knowledge he has not reported differences obtained on one and the same population. If positive differences were found, they might be interpreted as indicating that the appropriate self-image is an aid in locating good form.

A more compelling example might be provided by an actual art critic. To study the effect of self-image as such, one would wish to study the critic's apprehension of a work of art when he is functioning as a critic and when he is merely enjoying himself. When he assumes the stance of a critic, does he look more carefully at the elements of the work, both positive and negative, so as better to describe them? Does he look more for the negative elements, so as to confirm his role as critic? Does he, as he looks, mentally rehearse phrases and sentences which might be useful in writing a criticism, and thus occasionally fail to perceive unexpected but important elements or relationships?

A quite different set of questions might be asked about differences between art critics and art historians—and, particularly, about people who assume both self-images at different times. Let us take as an example art about whose quality there is some controversy, such as art which had been produced within the last several months. May one assume that the art historian will take a more generous attitude toward such productions than the critic? One would suppose that unlike the critic, whose business it is to be critical, the historian, concerned as he is with the place of all new art in the sequence that unfolds before him, would forego making judgments about its quality. This is a reasonable supposition, but its reasonableness does not exonerate us from attempting to prove or disprove it.

Yet another type of question arises about particular areas of the self-image which might become engaged by the work of art as one apprehends it. Here one is searching less for the effects of a shifting self-image than for aspects of a stable self-image which might unexpectedly be brought to the beholder's attention by the work he is viewing. Let us imagine a person receptive to a variety of esthetic objects he deals with an allows himself a lively emotional response to them; his perception is at the same time differentiated and emotionally open. The sort of esthete would seem capable of paying such even-handed attention to so many different objects that he might qualify as the embodiment of the philosophical abstraction, "the ideal esthetic observer" (Duncan, 1970). But suppose that he is viewing the portrayal of some part of himself: a portrayal of his minority status, some incident he had successfully forgotten, a weakness with which he struggles, or something similar. Will his esthetic perception remain articulate and open? One may doubt it, not only on the basis of common observation, but also on theoretical grounds: the very openness which we suppose indispensable to his esthetic perception may imply a vulnerability to certain themes. Aspects of the self-image may come to interfere with the normal esthetic process.

But the issue may not be altogether one-sided. One could also suppose that the observer might be alarmed at his vulnerability to a given theme and his consequent rejection or misunderstanding of it and, calling upon his self-image as an esthete, attempt to gain distance from the sore point and compel himself to perceive the theme genuinely. We obviously do not know how people in such circumstances will act, and can only hope that this question will be studied; but, speaking still hypothetically, if the observer were to act this way, be would be illustrating my contention: that his self-image may help him locate good form or perceive it more adequately. Thus the self-image may predispose toward better esthetic judgment or toward worse, depending on which self-image is

engaged; the task for psychological research is to create conditions which bring one or another self-image into play, and to study their effects on esthetic judgment. The outcome should be—but is not guaranteed to be—that self-image as "esthete" or "esthetic judge" should help engage capacities which permit better esthetic discriminations to be made.

Of the two functions that I believe predispose toward perceiving form—the need for good form and the need to act in a manner consistent with one's self-image—it would be my guess that the former is the more powerful. The need for good form, or in the very least the capacity to recognize it, seems to have a solid personality substratum; self-image may engage the substratum, but it would be a surprise if self-image could produce esthetic judgments in the substratum's absence. I do not wish to discount the possibility altogether, especially as curiosity about outcome is a better spur to research than premature convictions; it could be argued that esthetic judgement can be learned easily and that learning combined with the engagement of the right self-image could suffice to produce good esthetic judgments. But on the present evidence (Child and Schwartz, 1966, 1968) the role of learning is not prominent; while certain procedures can gradually improve a subject's esthetic judgment, they cannot bring his judgment up to the level reached by some subjects quite independently. At least such is the conclusion reached from studies carried out over short spans of time; long-range developmental studies are lacking.

But not all perception of art is perception of form. We do not grow from attention to meaning to absorption by form, unless we wish to lose touch with all that is emotionally threatening or gratifying.

Perception of Meaning

Not every esthetic object is sought out beforehand. To one who allows for surprise in life, a stroll through a museum, attendance at a concert, or the unplanned purchase of a record, may provide the unexpected discovery of a new esthetic experience. The experience may be altogether profound.

Has such a discovery been accounted for by what has been described so far? In some cases, probably yes: that the discovery was unplanned may in no way alter its fitting into one's balance of needs to be gratified and defenses to be respected; and the fact of discovery may provide just enough surprise to guarantee an optimal amount of varied experience. The apparently new experience may in reality be an old one in disguise—as psychoanalysis so amply demonstrates with symptoms and character disorders.

Yet the new experience may be genuinely new. This is not to say that psychoanalytic theory would have difficulty accepting it, since the capacity to experience newness is implicit in the difference between health and neurosis. Nor is newness as such my con-

cern; it provides a particularly clear example, but my emphasis is on the ability to perceive meanings which are unrelated to previous needs and to experience new learnings, quite irrespective of the origin of the object which may give rise to them. It is fair to confess that little is known in this area, but one can borrow once again from a related field with profit. I have in mind formulations of the creative process, formulations which emphasize the capability of the healthy individual to create images and metaphors which are free of conscious or unconscious constraints. I am in this instance less concerned with showing something to be the case than I am with offering a plausible discussion of a process which may be supposed to exist, both on theoretical grounds and from experience.

In the passage I had cited earlier from Freud's paper on the poet, the early psychoanalytic position was made clear: the ultimate source of a work of art is an unconscious fantasy, the proximal source is an impression or an idea to which it is related but which is close to consciousness, and the work of art itself consists of a skillful transformation by which the idea is made accessible to the public. I had agreed that many works were apparently produced by this process, while also giving examples where such a process might fail. Put succinctly, there are two inhibitors to creativity: on the one hand excessive control by conscious processes which attempts too much screening and too orderly a construction, and on the other, the primacy of the unconscious fantasy which by its nature has old scores to settle and is always repetitive. The successful case is one where some middle process operates, but conceptualizing the middle process has not proved easy. One could say, with Kris (1952), that in the creative process a benign regression to unconscious material takes place—a regression which is permitted by the ego because it arouses no more than an acceptable level of anxiety—and that the material is then elaborated by the ego, that is, by essentially conscious processes. Or one could say, as Kubie has done (1961), that in the creative act the principal agency is the *preconscious*, to which two processes are usually attributed: the transmission of material which is not deeply repressed, and the metaphorical transformation of this material as well as of material perceived from the outside into condensed and interesting images. The images which occur in dreams are most often of this sort.

Both ways of talking about the creative process are metaphorical, and it is difficult to judge to what extent they oppose each other in substance. It is nevertheless certain that unconscious material can be highly repetitive and constricting and that some semi-automatic processes operating near awareness may be rich and metaphorical. The contrast between the two processes may be better brought out by illustration than by definition:

In the late eighteenth century a talented sculptor named F.X. Messerschmidt gradually developed paranoid symptoms and eventually lost his appointed position. He moved in with his brother but continued to sculpt prolifically. That period of his life is remembered for the production of some 60 busts representing various emotions, such as those of a man just saved from drowning, a man suffering from constipation, a hanged man(!), a shrewd man, and many others. Anyone looking at the surviving collection (which is reproduced in Kris's book) is struck by two characteristics: all the busts, in spite of variations of hair and dress, are of the same person (the sculptor himself), and all

the presumably different expressions are basically the same: eyes and lips very tightly closed, the corners of the mouth usually turned downward, as if the man had just bitten into a lemon. An analysis of Messerschmidt's fantasies of the time shows him to be defending against the fear of a homosexual attack by the devil. A sculptor of talent is overwhelmed by unconscious material which he can no longer handle, and his art serves as a rigid defense against fantasy which has come too close to consciousness.

An entirely different example of portraiture, one which respects the individuality of the object while involving preconscious processes, is cited by Kubie:

> Another woman, an artist, painted a series of individual Christmas cards, each of which was for her a single flashing image out of a dream. She painted only at night; and she painted swiftly in a state of intense concentration and abstraction. To a matriarchal and spinsterish mother she gave an Archangel; the Annunciation to a brother-in-law who was a notorious woman-chaser. With her tongue firmly planted in her cheek she painted the Virgin and Child for an Amazonian sister; and she painted a sad and clownlike self-portrait for her analyst. She did not plan any of these gifts. Yet as she finished each painting, with a subtle mixture of compassion and unconscious irony she knew at once for whom it was intended. In another dream some months later, a cyclopean, one-eyed clown, with a whitewashed and blinded eye-socket, appeared in the role of the analyst to complement the latent meanings of her painting.

The second example shows succinctly that meaning is not confined to self-referring emotional processes and that it can respect outer objects while giving them a personal significance. It is seemingly an example of creation rather than mere perception, but it turns out on inspection to be close to what we are looking for: the ability to derive meaning from objects which are not extensions of one's character.

The example cited suggests that meaning derived from an esthetic object consists of something like metaphorical reverberations—a resymbolizing of the object by condensations of one's own. I can understand how such a process might operate in the narrative arts, where the understanding of various characters requires an adequate grasp of their essence and meaning; I can understand how it operates in the visual arts where there is intent to represent; and I can understand its operation in abstract art, whose images can arouse meaning if one only bothers to look passively and perhaps freely associate. I have greater difficulty in seeing its applications to music, whose formal construction and technical execution, when fully attended to, may make symbolic transformation difficult or even unnecessary. Yet even if I cannot feel that I understand it, I appreciate that a mature, nonprojective, perception of music is possible.

Perhaps the contrast between the projective and the perceptive derivation of meaning is best pointed up by an analogy: like one's first love, the projective apperception of meaning satisfies remnants of early needs and distorts its object by attributing to it qualities which it may barely possess; like one's later loves, mature perception recognizes the object's independence while freely admiring even the ways in which it is irrelevant to old needs. Yet the love may no longer be the same; and one may look back and wish one could be as fully consumed again.

58

Partial Synthesis

The nine functions of art I have discussed in these two chapters are not entirely distinct from each other. Some seem to be united by a sort of opposition, such as between the projective group and the perceptive group generally, while others may work in concert—as might symbolic need satisfaction and indirect need discharge. Still others may merely modify each other in complex ways whenever chance brings them together, as might a particular balance of need satisfaction and ego-defense support with the need for good form. In this section I shall juxtapose some of the functions whose interrelations are known; I do so in order to illustrate some of the many interconnections which can exist, not to suggest that they are the principal ones. Nevertheless, underlying my theme, and some of the research I report later, is the tension between the projective and perceptive.

Some resolution of this tension is suggested by a reinterpretation of psychological studies I have already cited in some detail. It may be recalled that all of the studies of the relation between esthetic preference and personality point toward one conclusion: people like works of art which are consistent with their level of emotional expressiveness, or, conversely, with the strength of their ego defenses. I confess to some surprise at the unanimity of this outcome; if one is to accept it at face value—and apart from a few methodological reservations there is no reason not to—it suggests that people on the whole do not look for much surprise or novelty in art works, preferring instead works with which they easily feel comfortable or works which by their character in some sense confirm the character of the viewer. This search for congruence suggests to me that receptivity to whatever may be in the work is not as important to the usual subject as proponents of the perceptive functions would like to see; on the contrary, it seems to me that most subjects select works into which they can project some part of themselves.

The suggestion has its limits, however, limits which are imposed by the methods used in this type of research. The correlations established between esthetic preferences and personality may reflect merely the characteristics of subjects at the extremes of the distribution; a small number of, say, extreme extraverts with a very consistent preference for colorful paintings and extreme introverts with a pronounced liking for traditional paintings would suffice to produce a significant correlation. Subjects in the middle of the distribution may, at least theoretically, not relate their preferences to their personality at all, and these methods simply do not tell us whether the phenomenon is true for large numbers of subjects or only a few.

One may also ask whether, apart from individual exceptions, there might not be numbers of subjects who like works of art which *contrast* with their personality. In some of the research I report later, contrast effects do occur alongside congruence effects, but they remain in a minority; there are also some relations which cannot be viewed as examples of either contrast or of congruence. But no matter how preference is linked to

personality, as long as there is a link, projection remains important: *any* stable choice of esthetic objects on the basis of personality betrays the projection of some aspect of the person. I fear that, apart from the reservations I have mentioned, projection is important to the ordinary subject of research.

But there is a simple remedy to this one-sided state of affairs. The ordinary subject of research is a person unselected for his esthetic competence; most frequently he is highly educated, but not in esthetic matters. One might suppose that the person untrained in art would make different demands on the art he views than would the esthete—that he might be less concerned with form and its meanings than with content and its meanings. If this were true, one should find the untrained person choosing works of art much more on the basis of their closeness to his personality. And this is precisely what one does find: in research preliminary to that reported here, unselected college subjects showed certain pronounced correlations between their personality and their preferences among representations of the human figure, while art majors—similar to their counterparts in every respect but their major of study—showed none. For my present purposes, I interpret these findings as suggesting that projection is the less important the more one is concerned with esthetic value.

Support for this suggestion comes also from Child's (1965) studies of esthetic judgment. Defining esthetic judgement as agreement with the judgment of experts in art, Child found that the better a subject's esthetic judgment, the more likely was he to be tolerant of unrealistic experiences, ambiguity, and complexity. One can interpret this finding as suggesting that the good judge of art is more open to outer experience—or, in the present terms, that he uses better his powers of perception.

Thus there are different lines of evidence to suggest a rather compact conclusion: that as one becomes a good judge of art the importance of perception increases, and the relative importance of projection decreases. I think that the conclusion is *grosso modo* correct, although the evidence for it is so far indirect. One limitation on the conclusion is suggested by evidence already at hand: Child's studies show that the better judge of art is not only more open to outer experiences, but also more aware of the complexities of his inner experience; he scores more highly on a scale measuring regression in the service of the ego, that is, the capacity for psychic playfulness and awareness of childish emotions. In addition to being a better perceiver, then, the good judge of art also brings to bear a greater wealth of emotional experience. Whether, in a more direct test of the interplay of these needs in good judges of art, one would find attention to emotional experience to be primarily projective or principally perceptive, remains to be seen.

———

If the relations between perceptive and projective needs seem to be in opposition, what can we say of the relations between the several theories of need for varied experience? Two of the models that had been presented were contradictory: one proposed that the search for level of variety was absolute, while another proposed that it was

relative—relative to the level of variety or complexity one had adapted to. The experiments supporting each theory had been so designed as to be unable to provide evidence for the other. But such a design is not inevitable, and Steck and I have been able to set up a study in which the outcome could favor either the absolutist or the relativist theory (Steck and Machotka, 1975). The crux of our study was to "compose" a broad series of musical snatches which varied in complexity only, and this was accomplished by having a computer generate tones of various lengths and combine same-length tones into ten-second "compositions." Within each composition the notes varied in pitch, but some compositions consisted only of very short notes (.06 sec.) while others consisted of long ones (2 sec.), with a full distribution of lengths in between; the total series consisted of sixteen compositions of increasing complexity, those with the shortest notes being the most complex and those with the longest being the least complex. With a total series this long, subseries could be extracted from it for separate testing: a subseries consisting of the 1st through the 8th compositions, one consisting of the 3rd through the 10th, and two others consisting of the 5th through the 12th and 9th through the 16th. As did Dorfmann and McKenna, we found that each subject had a distinct point of preferred complexity within each series (each series being presented to the subject randomly, of course), but unlike them—since they were not looking for it—we found a most pronounced adaptation effect: each subject's point of preferred complexity was located in the same relative position on each scale! If the preferred point was, say, at the most complex and of the full scale, it would remain at the most complex end of each of the other, highly different, scales. Steck and I conclude that preferences among music-like objects varying solely in complexity depend reliably on the range to which one is exposed.

━━━━━━━━━

But if preferred complexity is related to context, it might also be dependent on the subject's personality; that is, some of the personality dimensions that we know help determine preference among paintings might also predispose toward given levels of complexity. Eysenck's introversion-extraversion comes readily to mind, as does Barron's simplicity-complexity: one is curious to know how preference for complexity will be determined if these two dimensions are combined. A study by Bryson and Driver (1973) uses subjects who are extreme on each these dimensions and results in findings which are of interest not only in themselves but also for esthetic theory. Their extraverted subjects react to complexity in much the same manner as most unselected subjects in the studies referred to earlier: when judging stimuli differing in complexity, they tend to prefer those of medium complexity; but whether the subjects themselves are simple or complex is irrelevant. Introverts, on the other hand, differ according to whether they are simple or complex; simple introverts prefer the more complex figures, while complex introverts prefer the more simple.

This result comes as a surprise, because we had come to expect congruence, not contrast, between personality and esthetic preference. I do not propose for now to

attempt to make sense of this paradox, because the attempt would take me too far afield, and in the absence of corroborating evidence would have to remain speculative. The study does at least show that the congruence model is not equally valid for introverts and extraverts, and it suggests something about the difference between the approach of extraverts and introverts to the work of art. For the extraverts, inner complexity is not a determinant of preference; this suggests that their projective choices satisfy needs other than that of handling their own complexity, and (probably) that the projective determinants are quite similar in most of them. The introverts, on the other hand, use art's complexity to handle their own.

There may, of course, be other ways to explain this difference, but the suggestion that extraverts and introverts approach visual objects differently is already contained in the work of two authors discussed earlier, that is, Burt and Wallach, and may therefore be a promising distinction to explore. Burt had discovered that extraverts, when looking at a painting focused on the persons or objects represented rather than on the painting as an arrangement of forms or as a stimulus to the evocation of a mood. Because he had also classified his subjects as stable or unstable, he was able to specify the varieties of the extraversive use of the art work: thus unstable extraverts, more emotional to being with, liked dramatic events, vivid colors, stong contrasts, muscular activity, and the like—not because they felt themselves stirred up, but because the excitment seemed objectively to exist in the painting and its subject matter. Stable extraverts were equally attracted to paintings by their subject matter, but their insistence was upon realistic treatment or upon the utilitarian value of the work; associations evoked by the painting were cognitive rather than affective, objective rather than emotional—centered on the lives of the people portrayed or the circumstances of the scenes, not on the feelings shown, of which there were in any case few.

The introverts, on the other hand, appeared to base their judgments on their reactions to the picture. The unstable ones among them liked supernatural, mystical, dream-like subjects; Burt's impression was that they used the paintings they liked to realize some private daydream. The stable introverts adopted a more intellectual attitude toward the works, judging them by their form rather than their content, and being attracted more by line, drawing, and chiaroscuro, than by color; though outwardly their standpoint was cold and critical, Burt discerned in them an attempt to convert into esthetic value what at some level would have been an emotional reaction.

Both groups of subjects satisfy projective needs when they make choices among the works of art, but the extraverts needs seem closer to the surface—or not easily invested in art. Introverts, being more inhibited, search for a mirror of their own inhibitions or for daydreams they can never realize. How close are the latter to Wallach's anxious introverts, whose imaginative stories are so full of symbolic sexual imagery, and to Freud's hypothetical observer, who finds in art that which inner predisposition forbids him to enjoy in reality!

Not only is there, then an interplay between introversion, stability, and esthetic preferences; a close look at evidence such as Burt's and Wallach's suggests that for different individuals art fills quite different functions. For the unstable introvert, art

serves primarily the function of symbolic need satisfaction; for the stable introvert, ego-defense support seems primary, with need satisfaction following *sotto voce*; for extraverts of both types, such needs as may be satisfied seem not to be related to repressed fantasies.

We do not know to whom the other functions of art matter. But this broad question, though important, needs in this work to be relegated into the background, as we turn to the multiple appeal of the most powerful of art forms: the nude. The vocabulary of functions discussed in these two chapters will serve as a broad framework for speculating about the needs served by the infinitely varied representations of the human form; and if the general framework at times appears lost to view as we focus on details, it will nevertheless remain present as a structure to which the detail will from time to time be attached, and to whose clarification it may help contribute.

2. Notes

1. The golden section is a ratio. Two lines a and b are related by the golden section if a is to b is to their sum; or, $a : b = b : (a+b)$. A golden section rectangle would have a shorter side a and a longer side $a + b$; such a rectangle seems fairly long, as its sides are in ratio of about 1 to 1.618.

2. It is possible to choose esthetic objects in such a way as to insure experts' disagreement, as has been shown by D.A. Gordon (1956). Gordon showed to a group of ten experts (their expertise was not sharply defined) ten paintings by students, and found that the criteria the experts used were so varied that next to no agreement existed in their judgments of the paintings' merit. But the paintings were probably much closer to each other in merit than those of Child, and certainly the experts' disagreement cannot be taken to mean that *no* works of art can be reliably considered better than others.

3. Hume had argued in 1757 (see Hume, 1965) for the existence of a standard of taste because he had observed that some artists retained their value through time. he was as aware as are we of two sources of difference among men's judgments—what he called humors we call personality, and what he referred to as manners and opinions about our age and country we simply label culture—but perceived good taste as persisting in spite of them.

3. METHOD IN RELATION TO THEORY

When a set of interconnected statements permits deductions which can be empirically verified, the set is called a theory. To construct full-fledged theories is the aim of most present-day psychologists, and there are good reasons why such an aim should exist and motivate our endeavors. But the aim should not become a standard by which all theoretical endeavors are judged; there are other ways of advancing knowledge. When the construction of testable theories is taken as the sole legitimate goal of scientific work, a discipline runs the risk of becoming precise too early and, as a consequence, being pulled apart into fragments which are internally verifiable but externally incoherent. At a certain stage of knowledge it may be just as important to find out what are the phenomena of interest, and for that purpose the testing of theories, by focusing attention too narrowly and exclusively, may be counterproductive.

An alternative is to construct what are usually called "theoretical frameworks." Such frameworks have the advantage, on one hand, of going beyond the mere collecting of discrete facts, and, on the other, of guiding our search for new facts. A tight theory guides such a search, too, but it does so at the risk of wearing blinders, while a framework, because it is not preoccupied with testing only certain propositions, remains open to phenomena which appear on the periphery of one's vision. And at the same time as it guides further work, it provides a vocabulary for grasping that which it searches for. Chapters 1 and 2 should be seen as having just such an aim.

But my primary goal is to understand the nude, that is, the nude as a form of art which, by fulfilling certain psychological functions, becomes an esthetic object. The framework may be seen as a means to that end; if it has served its purpose well, one may also wish to explore its usefulness for esthetics in general, but that will not be attempted in this book.

In this chapter I should like to discuss questions of methodology as they apply to the study of these and similar esthetic questions. My aim is to show that traditional correlational methods tell us rather little and that we have to adopt procedures whose results allow for meaningful interpretation. The example I am choosing for criticism is my own; it is that of several studies designed to specify the personality correlates of

preferences for various types of nudes. The example is unexceptionable methodo-logically but one finds in its results little that can be understood clearly.

The initial step, the construction of a useful test, was successful; the test was used unmodified in the studies I report in the succeeding chapters as well. Since it is important to understand how the subjects of the eventual studies were selected, the test needs to be described here (a more technical description can be found in Appendix A). No matter how the test is to be used, it must be able to answer two questions: How much or how little does a subject like the nude? What is it about the nude that attracts him? Because of its greater complexity, the latter question seemed the more important from the start, and a test needed to be designed by which it could be answered.

The general strategy for designing it was the following: a decision had first to be made as to whether to use photographs of nude bodies or of art works representing the nude. Art works were chosen over real bodies because they offer multiple ways of looking at the body: not merely whether it has certain attributes, but how the attributes have been selected and represented. Thus while a body's beauty or ugliness is its own, a nude's looks are the artist's creation and intent. The viewer understands the intent, or presumes it, and the presumption becomes part of the work's effect. Nor is beauty or ugliness the only quality that the viewer can discern: the nude can be the embodiment of a host of psychological, political, and certainly ethical values.

A large number of photographs of paintings, drawings, and sculptures of the nude was therefore gathered, and the initial collection was designed to represent a wide variety of historical periods, body types, poses, emotional qualities, and even esthetic merit (it should be confessed, however, that a special effort had to be made to find obviously insipid or unsuccessful nudes; fortunately, they seem to be underrepresented in public collections). For convenience of presentation, slides were prepared from the photo-graphs.

We can easily find out which of these works a person likes and dislikes, but we need to know which qualities matter to him. To ascertain how each work is perceived, the slides were presented to ten graduate students in art history with the instructions that they rate each slide on a number of descriptive dimensions which had been chosen for them beforehand. These dimensions were intended to represent fairly exhaustive descriptions of each work; they were very numerous, but were later reduced to a manageable number by appropriate statistical techniques. The highly discrepant judgments of two of the judges were eliminated, but the mean of the eight others then became the desciption of each work. Thus each nude was at first described by forty-six dimensions, but most of these could be subsumed by cluster analysis in five clusters (Appendix B lists them all, as well as two additional clusters created artifically). This un-wieldy number of characteristics was never used in practice, if for no other reason than that they overlapped considerably; in the early correlational studies a subset of 24 was worked with, including the seven clusters and some dimensions which were independent of them or needed to be treated as such, while in the clinical studies which form the substance of this book five were studied thoroughly.

The works of art were too numerous and had to be reduced to manageable numbers

as well; this was accomplished by individual decision rather than by mechanical techniques. A work which had failed to receive extreme scores on the bipolar characteristics was too bland and, if it figured prominently in the choices of a subject, would not have revealed which of its qualities were attractive or repugnant; it was eliminated, as were works whose qualities were duplicated by others. The resulting group of 212 slides was still too large to present to subjects; it was randomly divided into two versions of 106 each—versions which were tested for equivalence, but of which only the first was used in the research reported here. In all the studies that follow, subjects are tested by being asked to express the degree of their liking for each slide by a number; it is convenient, but not indispensable, to ask for seven possible degrees of intensity.

I have already said that the present focus is on projective functions; for that reason the choice of "liking" as an index of the subject's reaction needs no further justification. It is probable that liking and disliking is as basic a component of an esthetic response in the critic and esthetician as it is in the philistine; it is not only people who know nothing about art who know what they like, but also those who know a great deal. From the point of view of research strategy, perhaps the only disadvantage of studying liking is that it does not allows us to uncover ambivalence—that level of reaction in which competing claims of opposed feeling make a person unable to decide what the object's overall affective value might be—or changes of mind. No one can say at present how prevalent a problem that may be; to the extent that it is frequent, it will eliminate from further study a number of potentially interesting subjects.

But all those who are not profoundly affected by ambivalence can tell us, by their choices, not only what objects they like but also which qualities determine their choice. The procedure for converting the raw liking scores into indices of valued characteristics is simple: for each subject correlation coefficients are calculated between his professed liking and the characteristics of the figures determined earlier. Thus each subject's liking can be expressed as a series of coefficients, each of which expresses how much each quality of the nudes in the test matters for his choices; for the dimension perfect-imperfect, for example, we find out to what extent a subject likes perfect figures, imperfect ones, or hovers in between.

Given these indices, we can proceed to use them in several ways, the first of which constitutes the negative example which I wish to introduce. If we can obtain a measure of some appropriate personality characteristic of each subject at the same time as we test his esthetic preferences, we can in turn correlate the personality measure with the indices of preference. We can then ask questions which are analogous, for example, to those asked in previous research in personality and esthetic preference: are any of our preference indices related to the ease with which a subject expresses his impulses? And given the uniformity of the previous results—congruence between personality and preferences—we can make certain highly likely predictions. If we adopt as a measure of constriction of impulse a scale designed to be an index of "superego strength,"[1] then we can predict that subjects with strong superegos will like figures that are ascetic rather than sensuous, shy rather than exhibitionistic, unattractive rather than attractive, and with the pubic area covered rather than uncovered. It should be noted that we are predicting that preferences

will be consistent with strength of ego defense, but that we cannot specifically conclude, if we do find the consistency, that such preference has the function of ego-defense support.

The table which lists the correlations between superego strength and several of the 24 characteristics of the nude is presented in Appendix C, but its details may be presented verbally quite simply: the results on the 67 female undergraduates surprise us by showing no correlates of superego strength whatever, but the preferences of 56 male subjects are consistent with the prediction. Somewhat varying with whether we are looking at the results on male nudes, female nudes, or both, we see that males with a strong superego are attached to ascetic bodies and austere and nonsentimental poses, one in which the sexual parts are indeed likely to be covered. They also like unattractive figures, unappealing works of art, and intact sculptures, that is, sculptures that had not been damaged by the passage of time. The converse is, of course, also true: to the extent that the subjects' superego is weak, they tend to prefer the opposite qualities.

Because of the important of a concept such as superego strength, it is indispensable to attempt to replicate the results with another measure. Instead of taking a paper-and-pencil questionnaire, 86 subjects in another study underwent a semi-structured interview whose purpose was to elicit information about their mode of perceiving art, as well a their recognition of impulses and feeling.[2] The interviews were conducted by graduate students who knew nothing of the subjects' preferences; they were tape-recorded and subsequently analyzed. Of several personality dimensions on which each subject was scored, the prinicipal one of interest here is the one also called superego strength,[3] which is defined as a global assessment of the subject's inhibition of feeling and impulse.

The preference correlates of this measure are listed likewise in Appendix C, and the results, happily, are close to those just cited. Males with a strong superego again like ascetic and austere figures whose genital area is covered; in addition—something not seen in the previous study—they also like masculine, dramatic, and unidealized works. The reasons for the latter three correlates are not immediately clear, but the principal findings are at least replicable even with a radically different personality measure. Using this measure one also obtains a few preference correlates for women subjects: women with strong superegos like shy figures, a fact which suggests that impulse inhibition is applied more by them to bodily modesty than to its asceticism; but quite unlike their male counterparts in the previous sample, these women also like damaged works.

Now these results are consistent internally, congruent with those of previous research using similar correlational methods, and statistically significant. They may at first view seem to be rather global, in that the concept of superego strength comprises many forms of inhibition against many different impulses, but that is only a temporary disadvantage. I shall show that if one breaks the concept of superego strength into several components the results become more interesting but still open to the main criticism: their interpretation is uncertain and they do not add up to a functional understanding of esthetic choice.

With this end in view, the material obtained in the interviews of the second study

was scored in other ways as well: superego strength was replaced by two of its conceptually clear components, namely the control of heterosexual and of homosexual impulses, and one could then ask whether esthetic preferences would be consistent in their own manner with defenses against these different impulses. Tables in Appendix C present the results fully, and if we confine our attention first to male subjects, we may interpret the results shown there as follows: males who show strong controls over heterosexual impulses tend to avoid the *sensuality* of figures—particularly of male figures, which they prefer ascetic, emaciated, austere, and generally unattractive—while males who show strong controls over homosexual impulses tend to avoid *femininity* and be attracted to masculinity instead. The controllers of heterosexuality are, of course, easy to understand, in that their avoidance of sensuality seems to parallel their sexual inhibition; but the controllers of homosexuality are more of a puzzle, because it could be supposed that a male's best defense against homosexual impulses would be an exaggerated liking for femininity.

A more complex mechanism must be assumed to operate. It may be suggested that the dynamics of the authoritarian personality described by Adorno and others (1950) come closest to providing a plausible account. The authoritarian personalities were conservative politically and possessed a harsh, punishing superego with whose help they projected their unacceptable impulses onto the outside world; they not only feared their homosexual impulses but they also feared their femininity, and overstressed, as a reaction, the "masculine" virtues of uprightness, inflexibility, and harsh morality. If the subjects who are judged as overcontrolling of their homosexual impulses are similar to Adorno's authoritarians, then their preference for masculinity may be understood.

Direct evidence for this interpretation is actually contained in other ratings made on the same subjects. Among them was a score reflecting the subject's suspiciousness, or as we preferred to call it, paranoia. If the "authoritarian" interpretation of the preference for masculinity is correct, the preferences of subjects judged paranoid should be similar. Appendix C presents the data in detail, and here it may be said, in partial disappointment, that while the preferences of the male subjects go toward asceticism, modesty, and unattractiveness, as expected, the hoped-for liking for masculinity does not appear. On the other hand—and significantly so in view of the very few feminine correlates we have seen so far—women judged as paranoid like masculinity in figures of *both* sexes, as well as liking nonsentimentality and modesty. In addition, they like attractiveness in figures, and this apparently paradoxical result is explained, after examining the components of attractiveness, by their liking for the figures' majestic qualities—again an authoritarian dynamic.

We find, then, that restrictions on different impulses have varying consequences for esthetic preference; such a result moves us a little beyond similar research done by earlier investigators. In general, one can be encouraged to believe that as one's methods for assessing personality variables become refined, one's correlations will become more complex and offer more room for subtle interpretations. But it is precisely at this point of encouragement that one should ask whether one has not exhausted the method's possibilities, or, more modestly, whether one has not already enjoyed all the advantages it

may have to offer.

Perhaps I have betrayed my answer in the way in which I have asked the question but my answer is based neither on an *a priori* judgment of what methods are appropriate for the social sciences nor on a personal preference among them; it is based rather on an attempt to gain understanding through a method I knew to be successful for others and the sense that by using it I had not discovered quite what I was after. Part of the difficulty lay in my finding that while I had come to understand something about the phenomenon under study as far as groups of people were concerned, I had little understanding of any individual's participation in it. No single method can do everything, of course, and my expectations in this matter were no more excessive than was justifiable. But I did have to ask the question whether, in reaching for the sort of generalization that a correlation coefficient implies, I had not created variables which were too isolated from each other, and at too high a level of generalization, to enable me to comprehend how they work in the case of any one individual.

But there were other reasons for my wishing to change my strategy as well. A correlation is determined most strongly by cases at the extremes of a distribution—by, for example, the individuals who have both the most consistent preference for austere figures and the strongest superegos. The association between these variables is due to the fact that individuals who score very high on one will likely score very high on the other (and similarly for individuals who score very low); those in the middle on either variable will show a much less consistent relation to the other. When using any method that requires considerable time and resources, the study of individuals who are near the middle is therefore wasteful. But not only is such a use of resources inefficient: because it requires that one's methods be standardized for all individuals tested, it limits one's findings to the variables for which provision had been made beforehand and leaves therefore no room for unanticipated data. When a theory has advanced to the point where the testing of specific hypotheses constitutes the best contribution, then unanticipated data are in principle not needed; but I have disclaimed any such ambition for my own study, and am not sure whether in the near future the social sciences in general will be in any better position to dispense with the benefits of the unforeseen.

But the most serious reasons for not continuing with the correlational method have to do with the "meaningfulness" of the data thus obtained, that is, with the sense that one has, or lacks, that one has understood an important aspect of the phenomenon under study. In the first place, not only do I feel that I have not understood any single individual; I feel I have not come to understand the dynamics of even the abstracted idealized subject. A correlation, once found, still has to be explained: the explanation can be sought in reference to a preexisting theory, or it can be sought in its consistency with other relevant facts. Neither condition, unfortunately, prevailed at the conclusion of this research, any more than it had prevailed in previous research in the field. In the second place, I had no understanding of the variety of individual relations to the esthetic object. This is, of course, a difficulty faced by anyone using the correlational method: if he finds, as we had, that paranoia and superego strength contribute to the liking for ascetic figures, what can be concluded about their role in any single case? Do both

attributes have to be present at the same time, at least in some measure, for the preference to show itself? How intense are the ego defenses of the more constricted subjects, and how free is the expressiveness of the less controlled? In the ones are there prominent wishes operating alongside the defenses, and in the others are there inhibitions constraining the apparently free impulses? Put most generally, it is one matter to have abstracted the personality attributes that correlate with preference, and quite another to have understood their functioning in the context of a individual configuration of thoughts, feelings, and actions.

If the research just finished could not be adequately interpreted either by a pre-existing framework or by reference to a context of an individual's functioning, the next task became twofold: to construct a theoretical framework which took into account the state of knowledge in this field, and to shift to methods which would be appropriate to using, expanding, and modifying the framework. In this book the framework was, of course, presented at the outset, in its logical if not its historical place; for the research itself a method was chosen which would preserve some of the indisputable advantages of generalization while allowing for the understanding of the individual case.

Attempting to meet both goals meant choosing a sufficient number of subjects for study so that regularities would emerge, and studying them in enough depth so that individual dynamic configurations could be at least glimpsed. It meant, as well, abandoning the evenly focused, and therefore scattered, attention to all aspects of the nude that appeared susceptible to psychological explanation, and thinking through which of the phenomena deserved detailed study; as a consequence, this meant a return to the question posed originally, that is, to explain the appeal of such characteristics as idealization, and an abandonment of the ultimately distracting search for ever more refined measures of "personality." It meant, too, a shift in the ways in which one allowed oneself to think about "personality": no longer as a collection of discrete variables, but as an intersect of characteristics which could be observed in their interrelation in the individual case. Such a shift was admittedly consonant with my predisposition, but it could not be solely justified by it; and while it resulted, as will be seen, in occasional speculative reconstructions of the dynamic process, the speculations will remain distinguishable from the findings and corrigible by more detailed findings of future research. And finally, meeting both goals meant having the freedom to adapt the search for psychological explanations to each of the problems studied, and remaining open to the discovery of unanticipated facts.

What I have said so far is abstract and designed to show in a general manner how the search for appropriate method evolves. In the present instance the new method took a fairly simple shape: it meant isolating a certain number of individuals with extreme preferences for specific aspects of the nude, and submitting them to quite close scrutiny in an open-ended interview. The strategy was based on the reasoning that if one studies individuals for whom one aspect of the nude is overriding, an explanation of their interest will apply, in a more attenuated form, to the majority whose interests are more eclectic. Whether that reasoning is correct is a rather complex question, one not easily decided by empirical work, but there is no evidence at present to suggest that it is not;

nor are other methods, such as the correlational, any less vulnerable to the possibility.

The choice was made, then, to study only certain aspects of the nude. They were chosen in each case on the basis of their promise for rich dynamic involvement of needs and defenses, and in some cases because of specific curiosity on my part. The final list is not meant to be exhaustive, but neither is it exhausting: *masculinity-femininity* was chosen because of its probably involvement with symbolic need satisfactions, *exhibitionism-shyness* by virtue of its possible relation to narcissistic body needs, *calmness-drama* for the possibility it offered of studying overall need expression and suppression, *sentimentality-nonsentimentality* because of its possible relation to the Kleinian defense mechanism of denial of depression and destructiveness, and *perfection-imperfection* because of curiosity about the interplay of sexual needs, self-images, standards for behavior, and other as yet unsuspected functions.

Each of these aspects of the nude formed, in a way, a separate study. The aim of each was to ascertain how the psychological functioning of the individuals determined the tastes that they had shown; we looked simultaneously at what the individuals had in common, so as to be able to generalize, and what qualities each possessed uniquely, so as to be able to understand the specific dynamics. Each study was entrusted to a separate investigator—in most cases a senior psychology student for whom the project served as a thesis contributing to graduation requirements. Investigators who were working on studies simultaneously met jointly with me to prepare the conceptual and methodo-logical ground, that is, to become acquainted with the functional framework, to receive training in interviewing techniques, and to decide on the content of the interviews.

Of these preparations the one requiring the most judgment, and therefore presenting the greatest risk of error, was that concerning the interview content. One can ask a nearly infinite number of questions concerning psychic functioning which could turn out to be of relevance to esthetic tastes; given obvious limitations in time, the task was to select those that appeared most likely to give us relevant information, and since the decisions could not be made on the basis of previous experience—on the contrary, this research might serve that function for future studies—it had to be made on the basis of assumptions inherent in the theoretical framework presented already. As far as it went, the choice turned out to be good, in that each study uncovered a number of psychological functions of interest (which is not the same as saying that no functions were left unex-plored). Thus of the following variables—all described in greater detail in Appendix D—one or another invariably turned out to distinguish the subjects: the handling of love, intimacy, and sexuality; the handling of aggression; the history of upbringing with respect to these variables; the relations, past and present, among family members; closeness to parental values; current plans and goals. These areas were naturally covered by multiple and varied questions, and subjects were encouraged to expand their answers freely. Each investigator in addition formulated a number of questions relevant specifically to his area of investigation; these additional areas reflected hunches and hypotheses sharpened during the training sessions and they generally contributed substantially to the length and content of the interviews. It will be seen somewhat later that each investigator also formed impressions of his subjects for which he had been

unprepared but which eventually proved to be fruitful.

Certain precautions were taken to minimize errors of recording or judgment. To make it unlikely that the investigators would magnify artificially any real differences between the contrasting groups by imposing on them their unwitting expectations, the esthetic preferences of their subjects were not revealed to them until after the data had been gathered, transcribed, and coded; the subjects were therefore chosen for each investigator by someone else (this precaution was not adopted, however, until three studies had been completed, but each of these studies was replicated on a fresh sample by another investigator). To ensure a sufficiently homogeneous and extreme sample, subjects were chosen from a large pool—no more than three groups of 20 from a pool of about 200 subjects tested for preference. Most studies, especially those whose main results had not been predicted in detail, were replicated on a second sample, in such a way that the second study permitted the same variables to be explored again, while adding new questions of potential interest. All the interviews were tape recorded and subsequently transcribed.

The strategy of this phase of the research may be summed up rather briefly: a group of subjects will reveal the personality characteristics which underlie its esthetic preferences by being contrasted with its opposite. Thus what is relevant to a preference for masculine figures, for example, will be shown in what is common to those who like them and different from those who dislike them; the latter, of course, have expressed a liking for feminine figures. Similarly, the preference for dramatic nudes will be illuminated by the contrast with a preference for calm ones. Not all relevant characteristics will necessarily be seen in all subjects; some may be of an either-or variety, thus allowing ahead of time for the possibility, so often considered bothersome, of different "effects" having the same "cause." Because the subjects are chosen for the one-sideness of their preference, projective functions will naturally predominate over the perceptive ones; there is no way to study both types simultaneously, since the one requires choosing subjects whose tastes are one-sided, while the other dictates the choice of subjects whose tastes—in the area under study—are broad.

3. Notes

1. The Superego Strength scale was developed by Child (1965) and found to be a negative correlate of esthetic judgment.

2. The subjects wree tested and the interviews were analyzed by Georgia Griffin, Lesli Min, Steven Pollack, and Peter Spofford, for whose help I am very grateful.

3. This rating scale as well as the subsequent ones were adapted from Prelinger and Zimet (1964). Mr. Spofford has analyzed the interrater reliability and found it in the .70 range for the scales reported here.

4. MASCULINITY-FEMININITY AND OBJECT-CHOICE

*In primitive societies the individual does
build up all his social ties upon the
pattern of his relation to father and
mother, to brother and sister.*

—Bronislaw Malinowski, *Sex and
Repression in Savage Society*

In this chapter I ask why some people choose masculine and others feminine figures as their preferred esthetic objects. Because it seems so unrelated to genuine esthetic concerns—to concerns about the esthetic worth of various representations or the symbolic value of body presentations and facial expressions—the question may at first appear trivial. As against such concerns, is not a preoccupation with one sex or the other banal, and of more psychological than esthetic interest?

The concern seems to me neither banal nor trivial; if we find subjects for whom the nude's sex is very important, their esthetic choice becomes a phenomenon to be explained, not an error to be explained away. Nor can one qualify such subjects' choice by calling it a problem for psychology rather than one for esthetics: I have argued above that a full esthetic response consists of an interplay between projective needs and perceptive ones. The choice of masculinity or femininity must surely be a particularly pure example of the operation of a projective need, one which we can here attempt more fully to describe and whose antecedents we can try to recapture. But, of course, the satisfaction of a projective need alone is not a fully esthetic act, and it must be admitted that, while it is important to understand the projective need by studying clear instances of it, one's ultimate hope is that other methods will eventually provide a more exact sense of how it articulates with perceptive needs. In any case, the value of understanding the projective need should not be taken lightly: the symbolic value of a body presentation is itself in part dependent upon the figure's sex.

The choice of masculine or feminine figures seems of particular interest because it can help illuminate the esthetic problem of object-choice. Strictly speaking, the term "object choice" refers to an erotic choice, but I shall use it here to refer to choices made for other reasons as well—to satisfy aggression, avoid anxiety, strengthen an identification, and others. The esthetic question is one of studying how real object choices are related to symbolic object-choices; in the case under discussion, the question is to understand how a subject's choice of male or female figures mirrors the development of his relations with men and women. It should be recalled that we have no clear precedent for predicting what that relation should be. Of the three possibilities we can only discount the first, namely, that there will be no relation whatever: we already know that something akin to authoritarian personality traits is correlated with the choice of masculinity. But as to the other two possibilities—that choice of symbolic objects will be congruent with or complementary to that of real objects—we are unable to predict clearly. On the one hand, we have the precedent set by earlier work in empirical esthetics as a whole, that esthetic choices are congruent with personality traits, specifically with apparent freedom of impulse expression. On the other, we have the theory, supported by the clinical observations of psychoanalysts, that viewers need the symbolic need satisfactions permitted by art because their needs are never quite satisfied in real life. Both statements cannot be true at the same time, at least not on a surface level, and if we suspect that there is a level at which the contradiction disappears, we are nevertheless required to search for the evidence which would make the disappearance plausible.

Let us look at the contradiction more closely and clarify ahead of time how we would reason about the various facts we might anticipate uncovering. Let us take as an example a male viewer who chooses male nudes as his preferred objects; we shall ask him about his relation to his father and mother, and about his relations to males and females currently. Suppose that we find his relation to his father to have been strained and distant, while his relation to his mother was close and loving; we will then be inclined to say that his symbolic object-choice compensates for an unsatisfied need (for the father's closeness, in all likelihood). Suppose we find, on the contrary, that he values and admires his father while denigrating his mother as cold and distant; we will then have reason to conclude that his symbolic object choice is congruent with the choice of real objects—although we will probably wonder what the "need" for such a congruent choice could be. But is either outcome probable? I should be inclined to think not, if only because ordinary self-observation, not to mention observations of a clinical nature, attest to greater psychological complexity; but I could foresee the possibility of one or another outcome if one's methods of search are restricted enough—if, that is, one pays attention to only a few discrete facts. If, on the other hand, our observations are thorough enough, we may find that he admires his father in spite of his father's distance from him as a child, and that he has never felt close to his mother at all. We are then faced with a more complex interpretation: we may suppose his distance from both parents to have set the stage for a compensatory relation to works of art representing humans in general, and his admiration for his father to be at once a reflection of the father's admirable qualities and of the boy's need to make up for a real distance by forming a

symbolic closeness. If our data reveal an outcome of this order of complexity, then the two contradictory predictions merge: the admiration for the real father is congruent with the symbolic object choice, but only in appearance; the symbolic choice itself is just as compensatory to an unmet need as is the admiration for the real object. It should be noted, by the way, that an outcome such as this would also free us of the burden of trying to explain congruent choices in general; we would have discovered a genuine need, one which can be understood, and one which makes speculation about the usefulness of congruent choices unnecessary.

Other outcomes could provide the information necessary for resolving the contradiction as well, but it is not necessary to anticipate everything; the facts will hopefully be rich while capable of speaking for themselves. The facts were gathered in this manner: 20 subjects were chosen from a pool of about 200, all of whom had taken the Human Image Preference Test; these 20, males and females in equal numbers, had scored at the extremes[1] of a distribution of preferences on the dimension masculine-feminine, which means that they consistently chose male figures or female figures as their preferred objects, as well as generally choosing the more masculine or feminine exemplars of each sex. Each subject then underwent an interview whose content was sketched in the last chapter, and the tape-recorded results were then analyzed by the interviewer and subsequently by the author. As part of the interview the subjects discussed their reactions to several of the following male or female nudes: The Roman *Portrait Statue of a Ruler* (Fig. 5), Chassériau's *Sleeping Nymph* (Fig. 6), Maillol's *Youth* (not shown), Valadon's *Two Nudes at Their Toilet* (Fig. 7), Ingres's *Venus Anadyomene* (Fig. 8), the fifth century Greek *Bearded God of Histiaia* (Fig. 9), Michelangelo's *Dying Captive* (Fig. 10), Pontormo's *Unfinished Sketch of a Nude Woman* (Fig. 11), and the *Hercules* presumed to be by Lysippos (Fig. 12). The findings of the study were quite clear, but because the esthetic choices of each subject were known to the interviewer beforehand, a replication was carried out a year later by another interviewer with new subjects from a new pool. The replication presented an opportunity to explore some areas more thoroughly than before and to ask additional questions; it also gave us the chance to attempt to assess the role of a strong perceptive capacity in highly projective choices. The latter was made possible by choosing subjects only from classes in art or art history, after screening for esthetic judgment by means of Child's test (described in Chapter 2); thus from about 400 subjects, 200 were chosen because they scored above the mean on Child's test, and from these 200 the actual subjects were selected in the same manner as in the first study. The results of Study I and Study II[2] were closely congruent, making it possible to present them simultaneously.

Given the interviews' emphasis on male-female relations and their derivatives, it will cause small surprise if most of the variables on which the groups were contrasted show a pronounced difference. I shall discuss below the subjects' relation to their fathers and mothers, birth order within the family, their handling of heterosexual and homosexual impulses, the role of bodily tone and attractiveness, conceptions of male and female roles, and, for the subjects of Study II only, the role of art in their lives. It will be seen that men and women like the different figures for essentially the same reasons—that

is, that the reasons for their choice of a given sex are parallel, rather than opposed, as one might have thought—but for purposes of presentation, so that each sex may be understood clearly, the results on men and women will be discussed separately.

Men

Relation to Father

The masculine preferrers without exception identify with their fathers, and most describe them as strong, clearcut models of masculinity. They see themselves as more similar to their fathers than to their mothers, and while they may choose quite varied attributes for this comparison, a perceived similarity is important to all of them. Some share with their father—as they see it—a sense of practicality, others their strength of opinion and dislike of stupidity; one perceives himself as living up to his father's expectations, while another shares a common astrological sign—not surprisingly, in view of its symbolic value, the sign Leo—and still another is both sensitive and controlling of emotions.

The identification may shade into idealization, but in any case it nearly universally includes admiration. Thus a father may be called "know-it-all, calm, collected, and wise about life," conservative, successful, honorable, and very masculine; another father may be described as a true military man, moralistic, authoritarian, and very masculine; still another, whom the son admires and wishes to emulate, is seen as extraverted, traditional, articulate, outgoing, and intellectual.

The admiration is not without its basis in reality, although reality—that is, the father's objective attributes—cannot explain the whole of the relation. The sons see their fathers as having masculine jobs and, by implication, identities; the subjects of the two studies differ somewhat in their class origins and admire somewhat different jobs as masculine, but they agree that masculinity is in question: in the first study the fathers' occupations included a fundamentalist minister, an Episcopalian minister, a policeman, and two farmers (their masculinity being therefore one of authority or physical strength and independence, or both), while in the second study the occupations included a salesman, two engineers, a military man, and a CIA agent (the masculinity of authority being supplemented, therefore, by that of extraversion or preoccupation with physical things).

It is not only the occupations that matter, of course, but also the sons' perception of their fathers as having been successful in them. But that perception and its attendant admiration both struggle against, and are supported by, an incompletely accepted submission to the father's authority. Evidence for such an ambivalence comes from the second study rather than from the first, because the second could profit from the ground broken earlier; but it is possible that the ambivalence would have been observed from

the start had it been searched for. The ambivalence takes the form of overt resentment or more or less conscious fantasies of struggling with the father. Thus one man says that he dreams frequently of having "knock-down-drag-out" fights with his father, and that for quite some time his other dreams used to be violent and military; another clearly describes his conflict between dependence ("I know that I can always call Daddy and Daddy will take care of it,") and resentment of his father ("I wished my father dead many times as a child"); a third was so angry when his father divorced his mother that he would not see him for several years; still another remembers "getting angry and not being able to say anything."

It seems to me that we are here dealing with more than the usual ambivalence inherent in growing up with a father one needs both to admire and grow away from. We observe first, of course, that the negative feelings are very strong, but we note that the current admiration seems overdriven, too; if the strength of the latter is proportional to that of the former, we suspect that it may serve as a defense against it—that is, that the admiration is so strong partly because it serves as a defense against incompletely accepted and integrated anger. Nor is our suspicion merely a reasonable conjecture from clinical work, or from such research as Adorno's on the authoritarian personality (1950); it is also supported by the manner in which some of the subjects themselves link the two sides of the ambivalence. The subject who so resented his father after the parents' divorce that he would not speak to him nevertheless called his mother a fool for letting the father go, while another subject who was physically punished by his father so strongly identified with him as to lose his own perspective on the punishment: "We looked forward to his punishment because he was a very powerful man and he was afraid of breaking our bones."

These men identify with their fathers, then, in part because of their fathers' qualities but in part also for defensive reasons. A defense against anger is the most apparent, but another defense seems equally important and universal, although it is less clearly verbalized: a defense against emotional distance. All of the sons had been emotionally distant from their fathers when growing up and continue to be so at present. There is good reason to suppose that in identifying with his father, sometimes in idealizing him, the son is also attempting to bridge a distance which had been too great; it is as if, by becoming so much like him, he took him inside so he could have him.

One subject comes close enough to a conscious statement of his dynamic to permit me to use him as an illustration but although his history is unique in certain features, or perhaps more extreme than that of the others, his statement clarifies, by exaggerating it, the defense that we may take to be characteristic of the others as well. Because his father took an interest in him only insofar as he behaved as a disciplined, young military man should, his emotional distance from his father had been chronic ever since he could remember; the situation was then exacerbated by the parents' divorce, when the father's periodic absence from the home became permanent. Until the divorce the father had been the son's model, with the son firmly decided upon a military career beginning with West Point; after the divorce the son searched for other male models, and because his stepfather was unsatisfactory, the models became teachers, scout leaders, and other

Figure 5. Roman. *Portrait Statue of a Ruler.* Museo delle Terme, Rome.

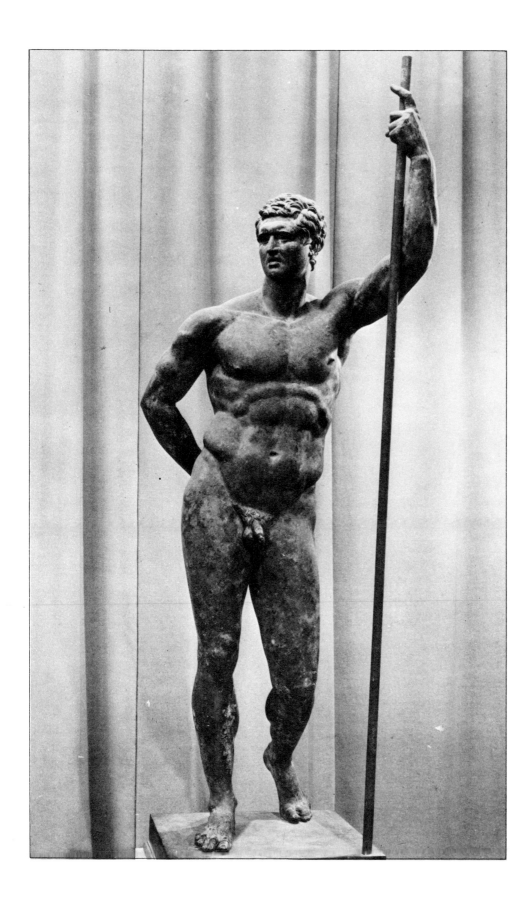

Figure 6. Chassériau. *Sleeping Nymph* (Alice Ozy). Avignon. Bulloz—Art Reference Bureau.

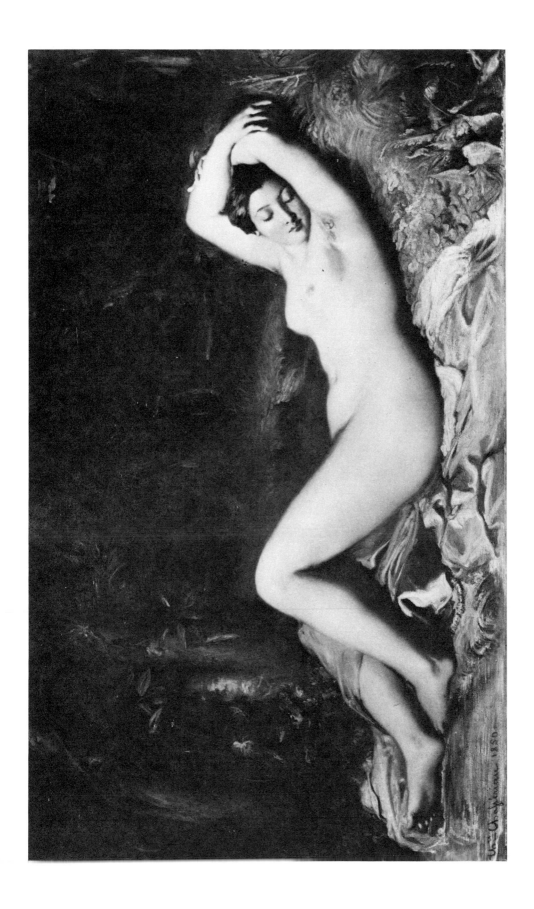

Figure 7. Valadon. *Two Nudes at Their Toilet.* Musée National d'Art Moderne, Paris. Cliché des Musées Nationaux, Paris.

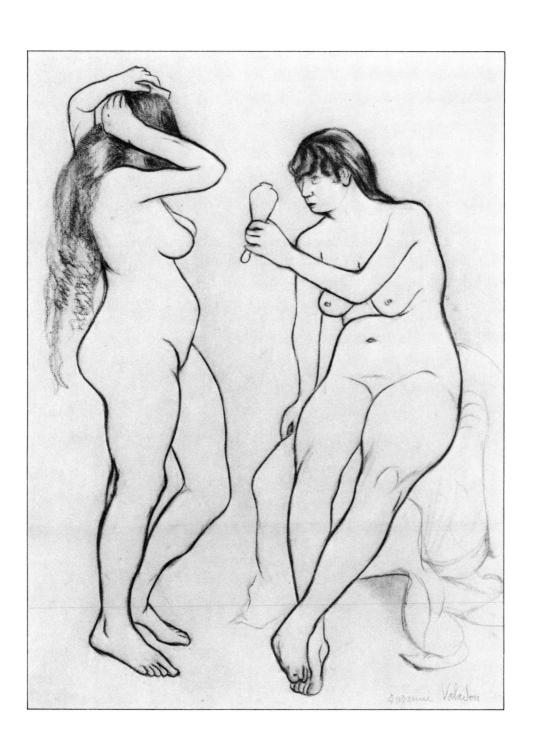

suzanne Valadon

Figure 8. Ingres. *Venus Anadyomene.* Musée Condé, Chantilly. Giraudon.

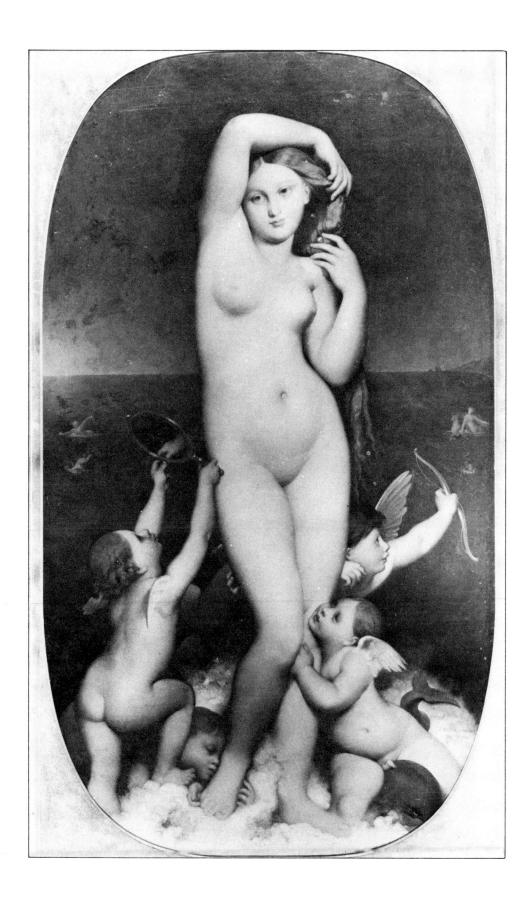

Figure 9. Greek. *The Bearded God of Histiaia*. National Archeological Museum, Athens.

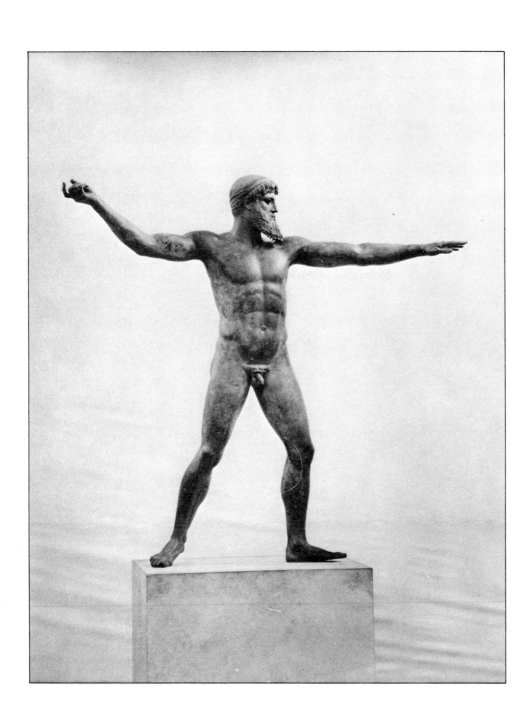

Figure 10. Michelangelo. *Dying Captive.* Louvre. Cliché des Musées Nationaux, Paris.

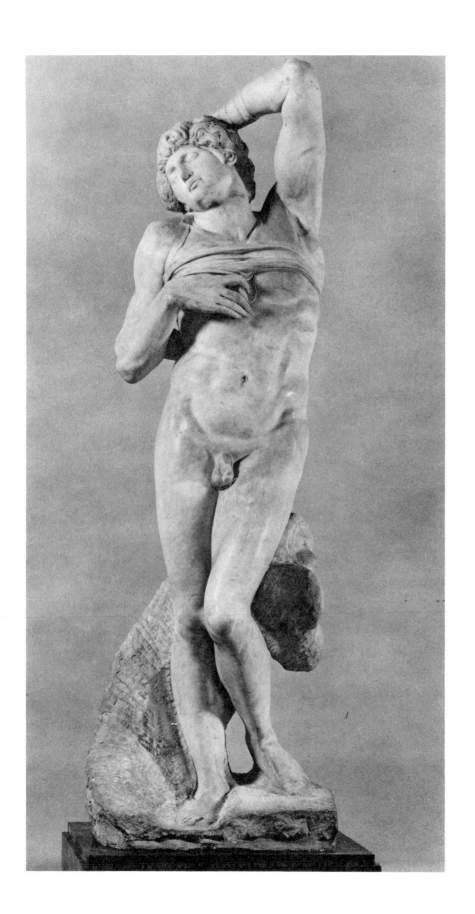

Figure 11. Pontormo. -*Unfinished Sketch of a Nude Woman*. Uffizi. Gabinetto Fotografico—Soprintendenza alle Gallerie.

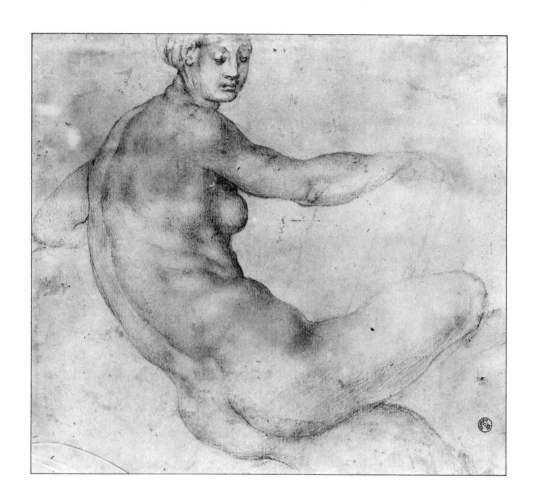

Figure 12. Hellenistic. *Statuette of Hercules.* Museo Nazionale di Chieti.

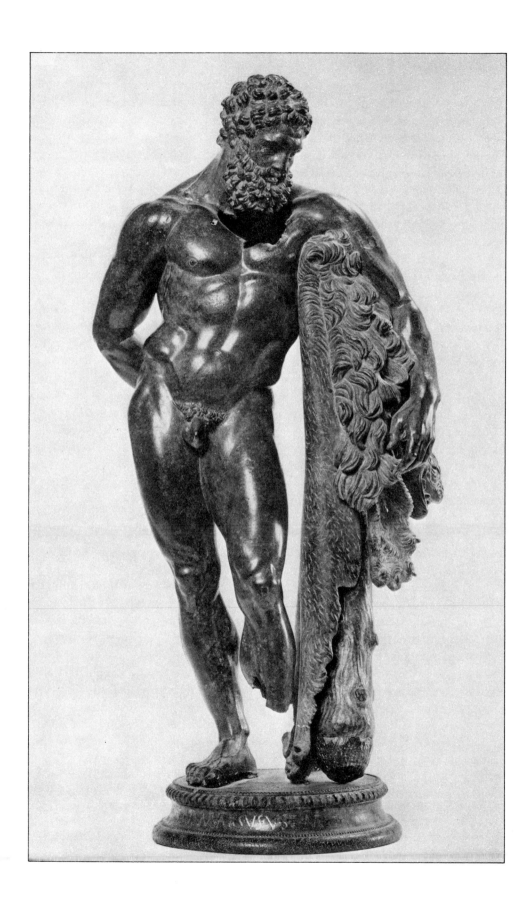

males. But not only does the son remember a search for models; he remembers as well a search for affection and attention, and mentions with pleasure that an uncle and a grandfather filled the emotional void. The one seemed always to be there to give help when the father was not, while the other tended to spoil the boy as grandfathers often do. The boy's feelings are expressed even now in a statement which refers to the period before the divorce as much as to the time after, "I missed a father. For a long time I didn't have a father." But as ineffective as the father eventually proved to be in reality, the son's relation to him made him the effective model in fantasy: even now his "fantasy models are warriors—Zorba the Greek, Indians. . . .It goes back to my father but it's more real; now I want to be a Renaissance man."

One subject, of the ten, is undergoing psychotherapy and speaks of his father in more complicated terms. His identification with the father is now more of a problem than a solution, in that while he sees himself as similar to his father he aspires to being different. The father's admirable qualities are undermined by his passivity, inhibition, and tendency to act the martyr; yet the son's recent discovery of these imperfections exists side by side with his image of masculinity as a "strong, heartless man," and of femininity as embodied in a "helpless but beautiful woman." The son's drive to be successful, social, and manly is, by his own admission, a reaction to his father's overdriven but fragile masculinity; this represents a defense, it seems to me, which coexists with that based on identification as a way of overcoming emotional distance.

Nine of the ten men show, then, a simple *identification with their fathers which is based in part on the fathers' real qualities and in part on a defense, the latter being directed as much against an emotional distance from them as against a strong anger toward them.* The tenth subject is similar but more complicated: his defense is unsatisfactory and he is making attempts to reject it.

The feminine preferrers, on the other hand, relate to their fathers in quite a different manner. None of them express an identification with them, and although they may see points of resemblance, those remain isolated within a fairly separate identity or, occasionally, even a sense of closer resemblance to their mothers.

Where the masculine preferrers' identification was based as much on the fathers' "masculine" professions as on the sons' need to admire and even idealize, the feminine preferrers' greater sense of separateness is also as much a function of the fathers' characteristics as of the sons'. The fathers seem less "impressive" to a growing boy: mechanics, accountants, managers of a store, farm laborers, house painters, and even the Jamesian twice born: a musician turned plant manager, and a commercial artist turned student of psychology. These occupations seem unimpressive to the sons even now; while they do not speak of them with disparagement, they give no sense of seeing them as an occupational image to live up to. Only one of the ten sees his father's profession as a standard to follow (photography), but the standard is not without ambiguity, because the father had sold his photography business when it was doing most well.

But, once again, the fathers' characteristics explain only part of the sons' weak identification. Most subjects reproach their fathers with having been the less dominant,

more passive parent, and one even feels keenly a sense of betrayal by his father who, upon his wife's death, married a woman who "poisoned" the father's mind against the son. The same father had the misfortune of immigrating to this country and being able to maintain only a marginal living; the son is very much aware of the inadequate status, perhaps all the more so as he had emigrated with the father as a little boy. *The feminine preferrers therefore speak of their fathers in much more mixed terms than did the masculine preferrers, feeling free to make critical remarks, to note weaknesses, to express anger, to see their fathers as complex.* One says, "My father acted on the surface like the perfect man—virtuous, strong. [But in reality] he felt he was the opposite, "while another observes, with affection and empathy, "He's better off now [since the divorce]—the pressures are off. I don't resent it—I don't blame him. He's a human being too with more problems than I've got." Some of the men feel a partial identification with their father's passivity, a trait which they may dislike, but which, in the more successfully handled cases, appears to give them an awareness of their father as process rather than as an object: "[In attempting to do art, I am] going through the same trip as he did; he doesn't know anything about art but he can create things."

In Study II, where these matters were explored at greater length, it becomes clear that the sons were raised less strictly and with a lesser emphasis on achievement than their masculinity-preferring counterparts. Perhaps as a result of this difference, they do not give evidence of fighting, or having fought, a battle with their fathers over dominance; it is not as if they had become dominant, but as if a battle had never been declared. They may discuss situations in their childhood where they had faced up to hostility or established themselves as independent of their peers, but they give little evidence to the interviewer of rebellion or of its counterpart, conformity; it is as if the dimension did not matter. But if they are freer from authoritarian submission, they seem also to have fewer guidelines for their own identity development, and as a result seem to the interviewer more worried and less happy than the more extraverted masculine preferrers.

Relation to Mother

To the masculine preferrers the mother seems less important as a focus of feelings and images than the father. As a consequence, the ten men differ somewhat in their relation to her, just as the ten feminine preferrers varied in their relation to their fathers. In Study II, all five men make clear that they feel no genuine love for their mothers; four resent them quite openly. One describes her as emotional, sentimental, simple, nervous, timid, and afraid of things, and deplores the degree to which he is emotional himself; another is offended by his mother's coarseness, overprotectiveness, lack of etiquette, and her "ranting and raving" when angry; a third dislikes his mother's strictness, aggressiveness, emotionality, and an uneasy combination of henpecking and expecting the son to be the man of the house; the mother of the fourth is described as dominant and

expressive of emotions but not compassionate, and the son's dominating fantasy of her (uncovered during previous psychotherapy) is that of nursing at her breast and being poisoned by her milk; the fifth is at best laconic in his description. Of the five men in Study I, four describe their mothers in similar unenthusiastic terms, and while none are as negative as the men in Study II are, they indicate that the mother is perceived as less of a clear and important figure than the father.

The pattern among these nine men is that they vary in their view of their mothers from outright hostility to faint praise, but that in all cases their identification with their fathers overshadows their relation to the mother. As a rough generalization, one can suggest from what has been presented so far that for some of these men *their strong and defensive identification is a sufficient condition for the choice of their esthetic objects, while for others the choice is also supported by a dislike of femininity.* The tenth subject, somewhat at variance with the others, provides in a way a test case of the power of the identification: his description of his mother is enthusiastic ("Mother was an outstanding person, completely outgoing, always giving a lot to the kids") and his father is remembered with anger ("I never cared for Father; he's a mental case. He used to drink and threaten and beat me and my mother unbelievably"), but he has spent most of his life surpassing the harsh standards by which his father had always judged him. Although he says that his mother had influenced him more, his life seems to have found its purpose in reaction to an inner representation of his father—a representation at once disliked and accepted: he has succeeded in fighting his father's conviction that he would never do anything well by managing the large family farm on his own after the parents' divorce, participating in every sport his high school had to offer, and succeeding in being the class valedictorian—on three to four hours' sleep a night. And he had become, in his own household, the undisputed master that his father attempted to be in his.

When we turn to the feminine preferrers' relation to their mothers, we must avoid the temptation to suppose that by some mirror-like mechanism their esthetic choice will be a function of a comparable and defensive feminine identification. While it turns out that they all demonstrate a strong "need" for women, what they need from women varies and the need itself has arisen from varying experiences. It may be said that the nine men on whom we have information (the recording of the interview with the tenth is incomplete) speak of their mothers in positive terms; but this generality, while correct, seems to me of less interest than the specifics.

One group of men shows an unencumbered and affectionate relation with a mother who is admired. Thus one subject, remembering his childhood as happy, describes his mother as feminine, artistic, physically affectionate, and as the more dominant of the parents; he identifies with her domestic, affective, and spiritual side, seeks out people who are like her, and believes that she could not have been better. Another feels closer to his mother than to his father, portrays her as a compassionate, deeply religious woman who expresses physical affection easily, and enjoys his "mellow" conversations with her. Still another, consciously identifying with his mother, describes her as passive and un-aggressive, loving and compassionate, and values the sense of security and closeness that his relation to her gives him. Yet another, who lives with his mother and manages a

business with her, indicates that he feels a similarity in their character. For all four there seems to be a partial identification with their mothers, but in contrast to the masculine preferrers' pattern, the identification is not, as far as we can tell, predominantly defensive. It should be recalled, however, that these same men have fathers who make weak or undesirable models: their occupation is unimpressive to a boy and their character is withdrawn, or they have been absent from the home since a divorce, or they are brutal and threatening of the son's masculinity. While the son's closeness to a loving mother requires no further explanation, the character and behavior of the father seems to have driven the son in her direction.

But there are men whose need for femininity in art as in life is more complex. Three have lost their mothers in one manner or another before they were grown up: one through death at age eleven, another by moving out of the home in early adolescence, and a third by first losing his father, through death, and then losing his mother for several years by being shuttled between various boys' homes. All of these men may in some way be overvaluing femininity in order to make up for an earlier loss; and their esthetic choice is part of that defensive process. The first of these men, insecure by his own admission in his masculinity, dreams of a life of security; the second who confesses that his one weakness is girls, makes clear by his behavior that the values more his girlfriend's ability to provide comfort than her—still untested—ability to relate to him sexually; the third likes corpulent women, reminiscent of his big-boned mother, and lives with a woman who has already proved her motherhood by having three children by a previous marriage.

The two remaining men, both of whom had grown up with a mother, present rather special instances of overvaluing of femininity. That they had grown up in intact homes did not prevent them from a genuine sense of deprivation: both their parents were a disappointment. The father of one was a bookkeeper whose conservative, authoritarian, anti-social, and miserly personality had placed tight restrictions on the son; the mother, more social but passive and overprotective and with a very limited horizon, receives the blame for the son's feeling of mediocrity. The boy's dislike of sports, competitiveness and aggression, and his sense of himself as passive, unambitious, and unsuccessful with girls, leads him to seek the security of an independent and competent wife. The father of the other is described as authoritarian, aggressive, and even brutal, but withal insecure about his own masculinity; his mother, also insecure as a woman, was passive and overprotective as a mother. If the son (an adopted boy) hates his father for his immaturity and emasculating cruelty, his fantasies then turn toward wishing that his otherwise likable mother had been less neurotic: he remembers that throughout his life he had fantasied a "perfect mother, virtuous, emotional and warm"—and physically resembling the women of Rubens. He has gone through periods of picking women only for their sexual attraction in order to support his sense of masculinity; now he has a girl whom he considers perfect, that is, a cross between a model of Rubens and one from New York.

In sum, three types of relation to the mother have been observed here, each with its own consequences for later esthetic choices. In one, *an affectionate relation, with a partial identification, leads to liking women* in toto; in the second, the *loss of a mother*

leads to an overvaluation of the sort of security that woman can provide; and in the third, a poor relation to both parents, as well as the attendant unsatisfactory self image as a male, leads to a *defensive attempt to alter the self-image by a successful attachment to a woman*—as if that attachment served as proof of one's masculinity. It seems that although all three avenues lead to overvaluation, only in the second and third does one observe an occasional buoyant transformation of the early security needs into an idealization of sexuality and sexual attraction; but even that idealization remains in part defensive, given its capacity to reassure.

Birth Order

We had found the masculine preferrers to identify with their fathers and the feminine preferrers to be either diffuse in their identification or leaning toward their mothers. It will therefore cause little surprise to find that the order of birth supports this pattern: the nine masculine preferrers on whom data are available are all first-born, while among the feminine preferrers only two are; two more are only children. The first borns, one may surmise, are more likely to be treated by their fathers as the future embodiments of the fathers' position and character, and to have ample opportunity to practice their identification on their more immature siblings.

Heterosexual Drives

Because of the masculine preferrers' strong identification with an authoritarian father, we might be tempted to assume in them a firm masculine identity and easy relationships with the opposite sex. But the facts would not support such an assumption.

The range of adjustments to needs for sex, love, and intimacy is considerable, but on the whole it reveals constraints and difficulties that might not have been expected of a college-age population of its time. Two of the men are married, but the marriages seem not to have met the three needs equally well. One—the one who had striven to show his father how competent he could be—has what appears to be a loving relation with his wife (our evidence from the first study is fragmentary) but makes clear that the relation has to be based on inequality: in his household it is understood that he is the man and has the last word, and disputes are thereby prevented. He believes that his wife sees him as good-looking, hairy, and fairly muscular, but when asked about her appearance he makes clear that while she is fairly attactive, she is more lovable inside than beautiful outside.

One is tempted to suggest that his narcissism keeps rather narrow bounds, requiring as it does that his wife serve his needs without herself being an object of physical admiration. The second man was raised in a rigid, moralistic family and during his adolescence suppressed his fantasies about sex to the point of wishing to become an astronaut so he could become self-sufficient and independent of sex and women. Now married to a pleasant but outdoorsy-looking woman, he finds that she is helping him loosen up and become more easygoing; their relationship appeared good, but required her enjoyment of playing the role of housewife.

Only one man acts in accord with what is now considered the norm for his time and place: this is, he has a girlfriend with whom he has a sexual relation. He claims a good bit of promiscuity as well as a broad appetite for all physical types, and reveals that his present girl is a loner who is not around very much; his emotional relation to her seems almost inconsequential. Another man has a stable though only occasionally sexual relationship with a girl who had been his girlfriend years ago but is now referred to as his best female friend; women play a small role in his life, too. A pattern in which women are meant to appear important but in reality serve as undifferentiated objects is illustrated by yet another masculine preferrer, who boasts of having had 200 sexual relationships and of feeling completely at ease with sex, having watched it in animals ever since he had been a little boy; but he expresses belief simultaneously in equality between the sexes, the double standard for sexual conduct, and the disgusting nature of the Women's Liberation movement. Finally, four men have no sexual relationship at present and three of them are still virgins.

This range of modes of handling heterosexual impulses suggests two generalizations about the masculine preferrers: on the one hand, they *feel quite strongly the paternal prohibition against sexual activity* or they *defend*, for reasons which we have been unable to clarify, *against intimate relationships;* and on the other they give every evidence of not needing women very profoundly—on the contrary, a number of them *strive to be quite completely independent of them.* It is as if in identifying with their father they have taken into themselves the father's authority but not his sexuality (whatever that may have been); and perhaps we can understand why that should be so, when we recall that the identification seemed to have as one of its aims to bring closer a father who had been good enough to emulate but too distant for the most elementary intimacy.

One man has not been discussed, but the omission was necessary; he is a homosexual, and as such forms a bridge to the section which is to follow.

If the masculine preferrers varied in their relation to women, their female-oriented counterparts are consistent in theirs: all but one have a steady sexual relationship, with either a spouse or a girlfriend, while the remaining one, though at the time without a sexual partner, has had stable sexual experiences. It may be said by way of generalization that all of the men display a need for women, but the varieties of ways in which the need is expressed are of greater interest than the abstraction itself.

It would be an error to suppose that they find relations with women easy or without problems, but on the whole their dealings with them show a greater acceptance of sexual

impulses, and a greater readiness to speak of sex and affection in the same terms. Many of them recount having had hard times meeting girls when they were in their teens, but unlike their masculine-preferring colleagues they did not attempt an outright denial of their sexual needs; rather, they were frequently shy and as a result quite frustrated. One recalls that "girls were really strange. They were alien; I made friends with the wimpiest, outcast male friends. I never had any girl friends." But the reasons for their inability to enter into early relationships with women may have to remain speculative; we shall see below that they saw themselves as physically small and inadequate, and it is quite possible that this reason by itself could have explained their difficulty. But it is also likely that some were hampered at the same time by the very strength of the need they wished to satisfy—whether that need showed itself as primarily sexual or dependent—or even by the idealization with which they occasionally favored women. Two men are aware of an idealization which is never to be satisfied: one says, "I haven't known women close enough to make a general statement about women. I may be looking for an ideal woman, comparing her to my mother," while another, after a long search, found a girlfriend whom he considers perfect, but with whom, owing to their difficulties with sex, he has a "more mental than physical" relationship.

Of the two men who are married, one quite clearly speaks of past sexual relations as designed to affirm his sense of masculinity, while the other is disenchanted with a wife who has grown disaffected with being a housewife and mother. Neither wife is praised specifically for her attractiveness, although neither husband has any complaints about her physique either; rather the dimension of evaluation, after a basic minimum of attractiveness had been met, appears to be that of being a good housewife. Two other men live with their girls, of whom one finds it difficult to accept his mate's imperfections in view of his parent's ideal relationship, while the other, though happy in his relationship, comments on his girl's avoidance of social contacts outside their home; that she brought her three children to this relationship suggests the need for a close, home-like atmosphere. The remaining six men have girlfriends but choose to live separately from them; they idealize them, depend on them, but have an uncomfortable sexual relation with them.

What is common to these men, and therefore to the dynamics by which they relate to nudes, is an overvaluing of women. But to understand the esthetic choice we need to look at the various processes by which the valuing is accomplished; *what is in question is not the "need" for women as such, which in other men might lead to realistic satisfactions, but an interplay between need and the impossibility of discharging it fully.* We note that some men were attempting to make up for past loss and valued women for the emotional security they could provide; it is not farfetched to suggest that a need established through loss is insatiable no matter who the partner may be, nor is it out of line to presume that the men who have experienced it here cannot, as a result of a self-image which seems to them insufficiently masculine, feel the confidence which would reassure them that what they need is within their reach—if not with one partner, then with the next. Other men had a close and affectionate relation with their mothers, but likewise a problematic one with their fathers; while our evidence on the childhood dynamics can in

no sense be complete, we may suggest that some simply ran to their mothers for warmth, while others experienced a certain amount of seduction as the mother's preferred male, while still others had ample reason to fear their fathers and then men in general. Any of these experiences, singly or in combination, would transform a "natural" need for the opposite sex into a need based in part on defense and therefore never capable of full satisfaction. That the man who in his words puts women on a pedestal and has a very strong need for sex should also characterize his current girl only as someone who loves *him* illustrates that the flow of supplies has only one direction—and no apparent terminal point.

Homosexual Drives

In view of their esthetic choices and strong identification with their fathers, it may seem a paradox that eight of the ten masculine preferrers are emphatic in their rejection of homosexuality. Some adopt a rather moralistic stance toward it, or condemn it on grounds of unnaturalness, calling it an illness, a disease, or even a moral degeneration; others simply cannot stand homosexuals, or are "turned off" by them. Five of the eight remember having been approached by homosexuals and recount the experience rather vividly though with distaste; this contrasts with only two mentions of a homosexual approach among the feminine preferrers. While it is unclear, and probably immaterial, whether the masculine preferrers have been approached more often than might be expected by chance, the vividness of their memory testifies to the importance of the issue. The ninth man, though rejecting homosexuality for himself, feels fully comfortable with affectionate contact with male friends; the interviewer was struck, however, by his apparent wish to prove himself a fully formed being in all respects, and while she does not question his facts, she notes slight distortions through this desire to impress.

A similar attitude toward homosexuality on the part of men who identify with their fathers and hold up masculine virtues as standards for conduct was encountered by Adorno and his co-workers (1950). He noted that his authoritarian males had to repress their normal homosexual feelings for their fathers because of the unsatisfactory and distant relations they had had with them; a relation based on dominance and submission rather than on affection would prohibit an affectionate display toward a male, and the prohibition in turn would transform any approach into a sort of storm warning. To Adorno's explanation I would be inclined to add the rather exaggerated need that I would expect a boy to feel who had found his father unapproachable; and from the point of view of esthetics, the *simultaneous rejection of homosexuality and need to incorporate the father's image and its strict standards of behavior seem perfectly con-. sistent with a choice of males as the preferred symbolic objects.*

The one subject who is homosexual is, of course, an apparent exception which requires careful interpretation. It is not enough to be tempted by the suspicion that opposites have met here; that may be a correct intuition but it is not an explanation. It

should first be noted that in many respects this man resembles his colleagues closely: he idealizes his father—literally: his two ideals are his father and Barry Goldwater—whom he describes as extremely intellectual, strong, authoritarian, rational, and emotionally guarded, and sees himself as resembling his father particularly in the guardedness. He describes his mother as a "fool for having let her husband go" when the two divorced. He accepts society's prohibitions and while he has finally broken through the disapproval of homosexuality, after three tries at engagements with girls, in his fidelity to one partner he conforms to the social expectation of monogamy. Like his colleagues he also dislikes his mother—in this case for her coarseness and overprotectiveness—but unlike them he does not hesitate to describe the feeling as one of hate. In spite of reluctantly accepting that he resembles his mother in some respects, he is also engaged in proving that he us unlike her: her lack of etiquette is contrasted with his being an interior designer with a flair for style, precision, and perfection. Perhaps it is the excess to which he carries the traits that he shares with his colleagues that pushes him in the direction of a homosexual object choice; but, however likely that explanation might be, it leaves unanswered the question of his esthetic choice being identical with it. Perhaps the homosexual object choice does not do justice to the idealization of the father (he says, "I respect my father the most, I'd like to be like my father") or perhaps his symbolic choice of males is strengthened by an avoidance of females (he suggests an overt seductiveness on his mother's part in the statement, "My mother was very sexual)" but we cannot know with certainty.

The feminine preferrers again stand in contrast to their counterparts: all but two *accept homosexuality in others and admit homosexual feelings in themselves while prizing feminine aspects of their being.* "I think everybody has homosexual and bisexual traits. It's natural in a given context, but the context isn't very natural," says one, expressing the views others were less explicit about. They often have men as close friends in whom they can confide, and they report being able to touch other men freely. Some—perhaps in response to a question that was too pointed—say that they would easily accept homosexuality in a close relative, such as a brother. None, however, have had homosexual experiences of their own or expect to.

The two men who refuse to accept homosexuality form an exception to this tolerant majority; each in his own way is considerably more rigid than his fellows, one perhaps because of his Catholic background and loss of status through emigration, the other perhaps because of a conservative, strict, and frugal upbringing. I have the impression that their disapproval has more to do with their conservative standards than with their relation to their fathers, neither of whom was at once an object of admiration and of dislike.

Body Image and Attractiveness

The masculine preferrers show a concern with strength, speed, muscle tone, size, and, occasionally, appearance. Not all use all of these criteria to judge themselves, but each uses one or another; nor do they necessarily come out well in the judgment. Some had been athletes in school, a few had been weak and sickly; nevertheless, the criteria by which they evaluate themselves are nearly identical. The subjects of Study I are unanimous in valuing muscle tone, which some had achieved but many had missed by a wide margin ("I am ridiculously out of shape," but also "I will begin exercising soon"). Some in Study II wish very much to dominate, and translate the wish into an image of man as taller than woman, or of themselves as quicker than others (as a compensation, for example, for being smaller than a brother).

Interestingly enough, given women's relatively low importance in their lives, they have very few criteria for women's physical attractiveness. Three men from Study II disclaim having preferences, while one—the one who laid claim to 200 sexual conquests—most readily fantasies a Raquel Welch or a Brigitte Bardot in bed but would not be seen with them on the street, for reasons unspecified; and the other the homosexual, has a physical image of the ideal partner (tall, strong, masculine yet sensitive) and of the cultured woman (Grace Kelly or Elizabeth Taylor). The men of Study I are nearly unanimous in preferring good muscle tone in women to any other physical attribute, and such muscle tone is best embodied in thin and tall women with small breasts; indeed, one man makes clear that the ideal torso is found in flat-chested Oriental women, the impression one has of most of the masculine preferrers, then, is that *they judge women by the standards which they set for themselves; fleshiness and maturity, in particular, are repellent to them,* and one is tempted to see in this preference a derivative of the dislike of their mothers as well as a general fear of the feminine.

The feminine preferrers, on the other hand, have relatively *poor images of their own bodies* but for the most part *the appearance of women is a matter of some concern.* Of the eight on whom the information is precise all had been unathletic, slight in build, and even cowardly; they remember that in comparison with others of their age they generally came off badly. At present some are noticeably over- or underweight, but several have either accepted their bodies in their current shape or have brought them to a level with which they can rightfully be satisfied. The bodies of women, however, are for the most part subjected to a certain amount of scrutiny. While two men claim no physical preference and judge women by personality above all, the others mention or reveal fairly unambiguous, if not necessarily rigid, criteria for attractiveness. Some simply say that they like their women to be attractive, while others operate comfortably within a range with which an impartial observer might find it hard to differ("not to fat, not too thin, nice size breasts"). Two men are both explicit in

the criteria they use and insightful about their origins: one likes the type represented by blond Playboy bunnies (and notices the resemblance of the description to his Scandinavian mother) and another, by now well within the reader's memory, likes the Rubens ideal (and remembers having throughout his adolescence fantasied an ideal mother).

While I shall return at greater length to the relation of these differences to esthetics, some observations on the development of criteria for sexual attraction ought to be attempted in the present context. I have emphasized in an earlier section the somewhat overdriven nature of the need that these subjects—in both groups—bring to their relation to one or the other sex, and have attempted to show that it is the need's inherent incapacity for being satisfied that makes it relevant to symbolic objects such as nudes in art. The differences we have just observed suggest that whether one develops criteria of attraction or not is in itself dependent upon whether the objects matter in the first place; the masculine preferrers' identification with a father creates, for example, criteria by which one's own body may be severely judged and which are then, not entirely appropriately, projected onto the opposite sex. A more complex mechanism may be assumed to operate in those who have demonstrated a strong need for women, both symbolically and in reality: we note that their need for the security and warmth that a woman can provide is apparently translated into a need for an attractive woman, and we may well ask why it should be so. Perhaps because these men have rather poor body images themselves, they are predisposed to look for symbolically more satisfactory bodies of the opposite sex; or perhaps because attachment to a woman, however brief, serves to reassure them about their own masculinity, they seek out partners who in public eyes would be the most unambiguous symbol of that reassurance; or perhaps again because a barely recollected memory of the first object to which one was warmly attached is in part visual and thereupon transposed to women in one's present. Our methods were not directed originally at elucidating the relation between the need for an object as such and the need for that object to be beautiful, so these possibilities must remain speculative; but the puzzle remains of interest, in real life as much as in esthetics.

Male and Female Roles

Once more, in view of what we know about our subjects already, we are faced with an apparent paradox. We wish to know the extent to which masculine and feminine preferrers hold traditional views of male and female roles; and we might be inclined to thing that the masculine preferrers, being more authoritarian, view the role of woman as subservient to man. But the facts are otherwise: of the ten masculine preferrers, seven are quite egalitarian in their outlook, easily accepting to theory or (when tested) in practice the view of a woman as an equal partner to man. They perform household chores such as cleaning and cooking and can imagine helping raise children; they can similarly accept a woman's decision in favor of a career. They are quite explicit in agreeing with most of the aims of the Women's Liberation movement.

110

But before one's emotional sympathies become too aroused, it should be pointed out that not all who profess these attitudes have had the chance to put them into practice; we cannot tell in advance how they would behave when confronted with the actual choices themselves. Nevertheless, their attitudes are expressed clearly enough, and some have indeed been proved in action. Of greater import are the reasons which permit them to hold these views: one has the impression that they can afford to be "generous" with the opposite sex primarily because it matters so little to them. We recall their striving for self-sufficiency and their admiration in women of physical traits that are usually considered masculine, and we can easily imagine that they view women as dispensable, or in the least as valuable only when they resemble men. *Their liberal views, while admirable from one point of view, are made possible by an attitude which borders on indifference.*

Three men hold entirely traditional views, however, and we must attempt to understand them as well as it seems that we understand the majority. One is the sexual athlete with innumerable past conquests; we may venture to guess that the sexualizing of his relations to women shows in one way just as little need for them as does the more obvious indifference of some of his peers; he gives one the impression that it is not the emotional relation to a woman but rather a sexual conquest of her that confirms his masculinity—and at the same time his emotional independence. A woman who best satisfies these needs is under his control emotionally and sexually. The second idealizes his women at the same time as he fears them: he is the one who remembers a fantasy of being poisoned by his mother's milk and appears to fight against this fear as well as the memory of his father's submissiveness by an idealized image of a subservient and even physically small woman. The third has so consistently fought his father's unrelenting criticism by his unabating displays of competence that he appears to have little emotional room left for accepting any wife other than one who allows him to be the full man he has been proving to the world that he is.

The feminine preferrers, on the other hand, illustrate the obverse of the paradox of the egalitarian masculine preferrers. While they value women—indeed, may be said to need them—their views of women's role are very authoritarian. If I am right in my interpretation of the views of the former, then it should not be difficult to understand the attitudes of the latter: *given their strong need for women's capacity to provide nurturance and security, they should find ideal those who can cater to their needs.* They may profess a belief in equality, they may claim that they have never given the matter of sex differences much thought, and they may even find themselves attracted to strong, competent women; but in the matter of having their own needs attended to, some complementarity between male and female roles is always discovered. But it should be noted that there are differences between the men of the two studies: those of the first, more working class in origin, are straightforward and consistent in their views and actions, while those of the second, more middle class and more highly educated, hold complicated views while permitting their simpler needs occasionally to peer through them.

111

In summing up, we have found that men who choose masculine figures nearly exclusively are engaged in an extension of a defensive identification with their fathers, while those who choose feminine figures are satisfying a strong bond with their mothers which is maintained in part by defensive idealization. As we now attempt to understand our women subjects, we are faced with two possibilities: that they will be the mirror images of their male counterparts, with female feminine preferrers resembling in all essential psychological matters the male *masculine* preferrers, or that they will be identical to their male colleagues. In part, I have given away the answer already, of course—we found that they were identical except where the valuing of one's own or the opposite sex was concerned—and we must now attempt to see in detail why that should be so.

Women

Relation to Father

As I have done with the men, I shall discuss first the women who prefer masculine figures and then those who prefer feminine ones. One rather simple formulation may be offered for the female masculine preferrers: they both like and admire their fathers, and in this respect they differ from their male counterparts, whose admiration was mixed with hostility. Of the nine women on whom our information is complete, eight speak of their father's with affection and admiration, while that of the ninth had died before her birth and was therefore not remembered.

Because the masculinity-preferring males had grown up with fathers who were imposing and impressive by their occupations, we might ask whether the women's admiration was similarly based. But although we find the father's positions to have been competent for their social class (working class in Study I and white collar or professional in Study II), the women do not mention them as a standard by which the fathers are evaluated; and in any case, the fathers of the feminine preferrers were very similarly placed. The admiration must therefore be felt for other reasons, and it may occasion no surprise to find that they have more to do with the father's relation to his family and to the daughter than to the occupational world at large. In Study II, where our data are complete, the fathers were the dominant figures in the household and the daughters remember them accordingly: as strong and rational in one case, as big, heavy, strong but sensitive and sweet in another, as a "very good person," or "cool," or "neat" in still others. The latter epithets—more characteristic of the women in Study I—are not informative, at least about the fathers' qualities, but where the descriptions are specific they testify to a sense of strength which the daughters continue to find imposing.

As with the men, it is more accurate to speak of the women's relation to their fathers as one of idealization rather than mere admiration; one is justified in doing so where the

relation goes beyond what the father's qualities would justify. For example, one woman's interview simply opened with praise for her father; the praise included his European origin (a quality her mother had been awed by), his unpermissiveness, his being a "good man, and above all an abiding sense of closeness that he permitted his daughter to feel toward him; and she revealed later that her husband has many of the qualities she had admired in her father, including his authoritarianism and even his occupation. Other women also show by their choice of husbands how important their fathers' qualities had been: strength, size, sometimes affectionateness, are frequently mentioned.

But one senses a difference from the men's idealization: here it is not easy to see it as, among others, a defense against psychic distance; on the contrary, *most of the women specifically mention feelings of closeness to their fathers.* While I wish very much to avoid shaping the data to fit theoretical needs, I am puzzled at the overevaluation of the otherwise meritorious father, and I am equally unable to explain why males should be the only symbolic object choice in the women's preferences among nudes. In a way, of course, the two questions are one: by answering the first we would also answer the second.

The women differ enough from each other to require somewhat individual answers to the question. One answer, which holds for three of the women of Study I, must reflect the normal position of a father in a working-class household: he is the decision-maker and shares few tasks with his wife. The three women in question were particularly close to him and, although not distant from their mothers, formed a partial identification with him; they accept the dominance of males in a family and one of them indeed specifically wishes to be dominated by the man she eventually chooses. They accept at the same time his rather conservative sexual standards and see it as the natural order of affairs that they would choose males as objects of attraction and settle upon one to provide security and social standing.

But this construction, as plausible as it is in view of the data on hand, may seem relatively uncomplicated from a dynamic point of view. One other instance of idealization presents a rather special configuration whose strength is more easily understood. The fourth woman in Study I (the fifth, never having known her father, will remain unexplained) is quite explicit about identifying with her father, who has had the greater influence on her upbringing and whom she resembles in her temperament; her identification is expressed in part in her choice of a profession usually defined as masculine—that of police science. But the identification is of course only partial, and combines in her with object choice: her ideal man is like her father, someone whom a woman can lean on as her mother had earlier and who is strong, patient, intelligent, and good-humored.

Another, quite different, pattern is presented by a woman in Study II whose father, although very much the disciplinarian in the family which we have come to expect, was quite distant and uncommunicative. His daughter is quite perceptive of his character and speaks of his weaknesses as well as his strengths, although she sums up her relation by saying that she admires him as a father. But two facts of importance to her developing a relation to males stand out from her history: the first is a fear by which she used to be terrorized as a child—that of her father dying. The fear was evoked by the father himself,

who used it to control his family: he would frequently ask everyone what they would do if he died, and fear of their destitution used to obsess our subject. One may suppose that it also had in the long run an effect comparable to that intended by the father in the short run: to make the male appear indispensable. But if the effect may be termed an over-valuation of males, it was very much strengthened, it seems to me, by the confining closeness that the family presented to the children as a model; the parents having no friends themselves, and making the children's formation of friendships difficult, they gave our subject a model which she follows in her exclusive and close relation to her husband.

We have, then, an understanding of several of the masculine preferrers' admiration and idealization of their fathers. There is still a third pattern, shown by the remaining four subjects, but it requires an understanding of their relation to their mothers, the description of which awaits the next section.

In the meantime we turn to the feminine preferrers and draw a contrast in their relation to their fathers. Here a configuration emerges rather simply: for nine of the women *the father is a disappointment by being either emotionally distant* (though sometimes dominant in the family), *or passive* (though sometimes emotional), or, alas, both. Thus in Study I, three women actively dislike their fathers, one for his distance, another for his distance and excessive drive, still another for his distance and weakness in relation to an overbearing wife, and the fourth likes him but remembers him as a totally ineffective alcoholic; in Study II, all five of the fathers were distant emotionally, and one managed by his traveling to be distant physically as well, for periods of up to two years. (The tenth woman, who likes her father, remains an exception which I am unable to explain.)

The feminine preferrers had ample opportunity, then, to learn either not to respect men or not to rely on them emotionally; to this extent one can see why they would not lean in their direction as symbolic objects either, but we shall also see presently that many had several positive reasons for choosing women, in reality as in art. To me the clearest example of the power of emotional distance to affect later object choices is given by the woman who says that she loves and admires her father and that he had spoiled her "rotten"—and who shows later in her interview that he was an authoritarian who had not touched her affectionately since she was a little girl. The good masculine image that she says her father had presented to her must be contrasted with her statement that the two had never shown affection for each other; the combination appears somewhat like that of the male masculine preferrers, that is, with a strong resulting masculine identification. Her even greater distance from her stepmother left her with the defense of self-sufficiency, for which her feminine esthetic choice may serve as a confirmation.

Relation to Mother

I had said above that four of the women of Study I seemed in their choice of masculinity to be reflecting the expectation of their social class; that they liked and admired their fathers revealed no particular psychodynamics, but rather a healthy relation which helped transmit the "normal" expectation that men were strong, dominant—and the right erotic and social choices. No peculiarity therefore characterizes these women's relation to their mothers: on the contrary, all three like their mothers as well. (The fifth, in her fifties, had never known her father and was unfortunately not asked about her mother.)

But the women of Study II, being from a class with more complex expectations and having been interviewed in greater detail, offer information whose consistency cannot be attributed to social patterns. Four of them were clearly distant from their mothers throughout their development while the fifth, close to her mother emotionally, began to feel closer to her father during her adolescence when her energies turned to more intellectual and abstract questions; at that time her father and she began to attend films and similar events together, and her father began to reveal himself as a person with his own past life and unmastered unsecurities; she has felt close to him since then. Thus the admiration for the father that we had noted before had more than the father's qualities, or a daughter's expectable affectionate direction, at its root; it was made doubly likely by emotional distance between mother and daughter. In three women the distance was reactive: they felt "loved to death" and could not accept either the excessive physical attention, the stuffy emotional atmosphere, or the prying into one's emotional affairs; the effect of all these ministrations was a sense of distance similar to that produced by coolness.

Why these women should make only masculine choices among nudes now seems clearer. I shall recall the problem: we wish to know why a woman who had had an affectionate and admiring relation to her father should have enough "need" left over to affect her esthetic choices. In view of her relation to her mother, the answer now seems relatively simple: the woman is simultaneously avoiding the symbolic equivalent of her mother. We shall see, as the data unfold further, that other needs come into play as well, but that they seem added to this psychological "base" which the women of Study II have in common.

When we turn to the feminine preferrers, we find two types of relation to the mother which, as will be recalled, must be understood in the context of a quite universal distance or passivity on the part of the father. Three of the women in the sample felt that they had been close to their mothers—one of them had the chance to enjoy her mother's sole attention during a two-year absence by her father—and it would seem a natural consequence of such a constellation if men failed to play any significant role in the subjects' later life. All three of the women have stable partners, we shall see later, but the partners are—rather uncannily—very closed off emotionally, and this distance in turn elicits no complaints.

But six women have mothers who provide no more closeness or support than the fathers, and one rather suspects that such a situation leaves them with little to turn to by way of satisfying adult needs for intimacy. Indeed, five of the six have no friends, and give one the impression that they are self-sufficient, as much out of choice as by necessity. While I shall have occasion to describe their relations with others in more detail somewhat later, here the attempted self-sufficiency may be seen as the closest motive linking them to their esthetic choices: it is *as if the choice of feminine figures served to reaffirm their aloneness and defensive self-completeness.*

Birth Order

Because there is no clearcut pattern of identification with either the father or the mother—with first-born females having no specific reason to emulate either parent, unlike the first-born males—birth order proves to be an unimportant variable. There is some tendency for the masculine preferrers to be first-born or at least the first daughters, but all the other facts we have about our subjects seem so much more important that it would be out of place to attach much meaning to a difference which is at best suggestive.

Heterosexual Drives

We may say about eight of the masculine preferrers that, irrespective of their social origins, they are rather conventional about sex. They feel the need for a relationship with a male and they understand that relationship to be exclusive; the younger ones among them, all in Study I, have a single boyfriend and all but one have a sexual relationship with him; the remaining one values sexual compatibility in marriage but her religious upbringing will not permit her to experiment with sex before that. The married ones are all from Study II, and they disapprove of sex in any context other than marriage; some mention having fantasies about relationships with other men they know, but they are certain that they will not yield to temptation. It should be emphasized that they value their husbands and that all three in fact describe them as dominant, competent, and strong; perhaps it may be said that they value masculinity more than they value sex. And perhaps it is not too farfetched to suggest that their valuing of masculinity, in art as in life, is a way of *affirming their sense of femininity.*

Two of the masculine preferrers present a rather different picture. One is the woman who had turned to her father during adolescence, as much for intellectual support and development as for emotional closeness; she does like men and has had a few lovers. Her adolescence was intellectualized and included a rather severe loss of weight; her eventual loss of virginity was welcome because it proved that she could be attractive to males and reassured her that she was not lesbian (a point about which she is still not certain). In a

somewhat different manner, then, her choice of male figures among nudes serves a reassuring function with her, too. The second woman whose configuration is unique had lost her father at four years of age through divorce and still resented her mother's action; she had always felt distant from her mother and hated her stepfather, with the result that she idealized her father to a point not seen in any of the other women. She has recently dreamt of trying to seduce her father and murder his wife; to have dreamt such a dream made her happy and reassured her that she was normal.

Among the feminine preferrers, there is a variety of adjustments to the needs for love, sex, and men, but of greatest interest to us is the near uniformity of their solution to the problems of intimacy: even the three who have a husband or steady boyfriend seem to have chosen him for his *capacity to remain distant*. Thus the one who is married sees her husband as perceptive and understanding—but also self-contained, silent, uncommunicative, and not relating to his family even when he is at home. The woman whose father traveled for long periods of time has a boyfriend who tours the country as a musician; and one who has had a boyfriend for three years accepts his infidelity (and his intolerance of the slightest independence on her part) and appears unconcerned that he should love his car more than he loves her. But all three women had been raised by a mother to whom they had felt close; the six women who had an affectionate relation to neither mother nor father appear to find any kind of stable relation of intimacy too taxing, and prefer to strive for an emotional self-sufficiency.

I have the sense that, although it was necessary to abstract from the life histories and individual configurations of experiences, wishes, and fantasies, I have left out the occasional odd fact which would illuminate the force with which maleness or femaleness must be accepted or rejected in life; consequently I cannot hope to have been fully convincing when discussing how art supports or extends the defenses by which life is made agreeable or tolerable. A case need not be typical in order to be convincing; and so it seems to me appropriate to mention the details of the life of a woman who up till now has been made to appear merely to share her colleagues' attributes.

> Harriet (a pseudonym) was born to parents considerably older than herself and her description of them is marked by what is felt to be unalloyed but quietly firm praise; but the praise, as it continues, masks a darker kind of tone which says, without intending to, that the very happy childhood was at times depriving and quite anxious. She remembers a lot of fear connected with her fundamentalist upbringing, deviation from which meant damnation; some of her absolutely felt prohibitions included sex, as one might expect, and although she struggles with them at an adult level, they are still felt and in a way accepted—as is a generally religious attitude toward life. The parents whom she describes as warm were in fact physically quite distant, and she recalls that her father had never kissed her; on the other hand she remembers his taking a lot of interest in her and her brother's upbringing. The strict upbringing and the conscious aceptance of the parental standards have in all other cases been typical of masculine preferrers, both male and female, so one notes with surprise

that she is in fact attracted to females in art. The explanation of this paradox has to do with rather severe anxieties which she had experienced as a child, some of which seem very justified under the circumstances, while others remain unexplained. There was first of all a fear that her father would die, which had a basis in reality in view of his much greater age and past illnesses, and then there was anxiety about her brother being killed, for which there had been no realistic provocation; she also feared her own death at the hands of a man, partly as a result of the murder of a childhood friend and an experience with near-molestation which had terrified her. The mixture of experiences and fantasies cannot be unraveled from the information provided in a single interview, but that fantasies, and wishes that may underlie them, help maintain her current relation to males is clear from the flashes of terror she sometimes experiences that her boyfriend will kill her. There is nothing in his behavior to suggest it, and the fear must be seen as an instance of her pervasive fear that she might be killed; in her own words, she continually thinks strategically and sees herself as an army of defense. Her turning to women as safe esthetic objects seems fully understandable and illustrates the degree to which a symbolic choice may be dictated by anxiety. Nor is the choice as unique as her excessive fears would imply: all of the women in her group dislike aggressiveness, particularly in its overt, masculine form, and their esthetic choices may represent avoidance of aggression as much as they confirm their femininity and self-sufficiency.

Homosexual Drives

In acceptance or awareness of homosexual feelings there is a sharp difference between the two groups which neatly parallels the division between males. The masculine preferrers—all ten—see something wrong with homosexuality but, unlike the masculinity-preferring *males*, neither quite condemn it outright nor call it a disease; and they worry about the presence of such impulses in themselves, by which they suggest a greater degree of awareness than the males who deny them. The women are surprisingly frank about acknowledging the fears they have experienced and in their openness help us grasp additional reasons for their esthetic choices. Their feelings range from statements such as "I don't know whether it's a disease or not; as long as it's not in me," to candid admissions such as "I'm afraid of being a lesbian; I don't want to be. I feel after I've had more heterosexual experiences, then I can be a lesbian."

The idealization of males shown by these women may now be interpreted more complexly. We know already that a precondition of it is a satisfactory relation with an admired father; the women in Study I who also had a satisfactory relation with their mothers seem simply to accept males' dominant masculinity as an unquestionable fact of social life. I must confess that I would be happier if I knew more about these women's fantasied and actual relations to their parents, since it seems important to me to show why they should have an "excess" need for males, that is, a need that must be satisfied by

symbolic choices as well as real ones. But for most women the theoretical problem does not exist; their admiration for their fathers is magnified by their mothers' emotional distance. We had also noted that the distance was produced sometimes by the mother's coolness, and at other times by the daughter's rejection of her excessive intrusiveness; in the one case we may suppose that the daughter had never had the chance to test out, and find acceptable, the feelings of warmth toward a mother which she would have normally experienced, while in the other we presume that she learned to ward off a closeness which she may have experienced as seductive. In both cases *feelings for the same sex would have become unassimilated into her view of herself,* and their presence would be magnified by the anxiety with which they are greeted. A turning toward males—expected by society in the first place—would serve as the appropriate defense.

By contrast, the feminine preferrers (eight of them) are very much more accepting of homosexuality, either of their own impulses, or of physical contact between women, or of the possibility of closeness with a known or hypothesized homosexual. Of the two remaining women one finds homosexuality unnatural and the product of special childhood experiences, but does not take a moralistic stance toward it, while the other, although viewing closeness between women—as expressed, for example, by exchanging clothes—natural, is distinctly repelled by homosexuality. Their views range from genuine tolerance for homosexual friends ("You know that they are not sick so you come to the conclusion that it must not be totally awful because they're people you respect") to tolerance of their own feelings ("I can see some of these tendencies within myself but I have not overtly practiced it," or "I've never worried about homosexual tendencies within myself. The only thing that bothers me is if I was too scared to do it"). They are, as one would expect, much more at ease with other women and have closer friendships with them.

Body Image and Attractiveness

The female masculine preferrers emphasize physical appearance almost as much as the men do. The most striking similarity between the men and women is not so much in the details of what they value but in the fact that standards matter to them. The men had valued strength and muscularity in themselves and to some extent in women; the women make a distinction between femininity and masculinity, and value the former in themselves and the latter in men. Like the men, they criticize themselves above all: they seem to be saying that women should care how they look, and by that criterion they do not always come off as well as they should like. Because facial features are somewhat beyond one's control they may be excused from helping define femininity, but bodily grace and poise may not. Unlike the men, to whom women seemed to be of lesser importance but who were nevertheless valued when they met certain masculine criteria of body tone, the women are often generous toward the men in not holding them up to a standard of physique: and while they can define masculinity quite readily when asked, their definition is not necessarily physical.

The feminine preferrers appear to find standards a dispensable luxury, and in this respect differ sharply from their male counterparts, to whom the attractiveness of women was a matter of concern. This difference is expectable, since the men very much valued the opposite sex while these women do not; thus although the femininity-preferring men resembled the women in the greater flexibility of their standards, female attractiveness was the one exception. Many of the women can readily mention points of dissatisfaction with themselves, just as could the stricter masculinity-preferring women, but their attitude toward them is not as critical. Perhaps most characteristic of them is that such dissatisfaction as they feel is not focused on the form of specific body parts but rather on the body's overall weight or size; thus their standard of comparison is not, say, the Playboy bunny, but someone who is not conspicuous by her size. And while in a better world they might take their fantasy of altering their size more seriously, their one wish in the real world is that they lose their concern about themselves altogether. Some women simply do not claim to have any criteria of physical appearance at all, but instead define ideal masculinity and femininity by character and behavior.

Male and Female Roles

So far, preference for masculinity had similar roots in men and women, at least as far as the relations to parents were concerned and as far as the conservative handling of heterosexual and homosexual impulses went; for that matter, masculine preference also was connected, in both sexes, to stronger criteria for judging the body and its appearance. But in the matter of defining male and female roles, men and women reverse themselves, that is, it matters more to them whether they are interested in the same or the opposite sex, rather than whether they are interested in males or females. Put simply, the males who value women resemble the females who value men.

Thus it is the female masculine preferrers who hold the traditional views of male-female roles and masculinity and femininity. In essence, the interest they have in the opposite sex necessitates that they see the sex as complementary to them; one possibility is to accept the definitions that are current in society, which is the solution adopted by the women of Study I, while the other possibility is to rethink the question in relation to one's needs, which occurs more often among the women of Study II. In the first case one obtains contrasts between what is masculine and what is feminine: big muscles versus considerateness, standing firmly for what one believes versus retiring petiteness, or the ability to handle any situation versus gracefulness. In the second case one occasionally obtains a view of the sexes as similar in all essentials, but notices nevertheless an underlying sense of difference: four of the five women either admire in the men to whom they are married, or wish to have in those they are yet to meet, an ability to dominate them. This criterion exists side by side with admiration for the Women's Liberation movement and for a professed belief in the equality of the sexes; one senses a simultaneous identi-

fication with a dominant father and a wish to be dominated by someone like him.

By contrast, the feminine preferrers appear less certain of what male and female roles should be, and as a result are less consistent as a group. They generally agree that looks do not define masculinity or femininity, and they dislike the helpless, dumb, well-dressed sort of femaleness; and they are more reluctant than the masculine preferrers to think about ideal forms of behavior or appearance. Beyond that they vary: they may insist that a woman should not cook if she doesn't wish to but they may value cleaning; they may value being independent or, if married, dominant, but also prize chivalry and being cared for.

The Subjects' Relation to Art

Masculine Preferrers

In Study II the subjects were queried at some length about their reactions to works of art representing the dimension to which they were sensitive; they were also asked about their esthetic preferrences in other media and engaged in a conversation about their creative activities. Because they had all been tested originally in large classes in art history we knew that they had an interest in art, and because they scored better than average on Child's test of esthetic judgment (the average for college students being about 50 per cent) that they possessed at least a minimal capacity for discriminating good works of art from poor ones; in fact, of course, some of the subjects had scored quite high. Inspite of what appeared to be a common background, the masculine and feminine preferrers differed very clearly in their relation to creativity and esthetic judgment, and these differences, combined with the functions of esthetic choice that we can abstract from what we know of their psychodynamics, illuminate the manner in which they relate to art. That the men and the women should be even more similar to each other in the uses to which they put art than in some of their psychological antecedents argues that the esthetic preferences have a common function, and allows us to present their results together.

The masculine preferrers are concerned quite simply with "culture" and care little about the creative process. Those who are still fulltime students tend to major in art history rather than in art. Among the males two examples must suffice: one male now majors in art history but had come to the field through the study of history itself; at first "it was more the costume and period; when I first got interested in history it was more political and military—since college I switched over to culture." His interest had developed without any prodding or example from his parents, but it is consistent with his standards for himself: not interested in doing anything artistic, he has a fantasy of himself as an Oxford scholar and aspires to be a Renaissance man. Another male, a

psychology graduate but very well informed about art and mostly self-taught, does do some drawing and sculpture, but has always believed that he was uncreative; his parents had so little interest in art that he had to hide in his room to listen to classical music, with the result that art represents for him a way of establishing himself as independent of them—which, of course, he is where his general interest in art is concerned. But his specific taste in masculine nudes ties him to his parents in ways that he is unaware of, as does his *own* ambition to be a Renaissance man.

Among the women with a masculine preference art history is also the prevalent interest, but the interest is more pervasive and highly honed. Unlike the males, these women had in some cases been brought up in homes where art and taste mattered, so they do not appear to use art to assert their independence; rather, it may be suggested that their interest in art and their excellent taste serve as one of the few avenues by which women of a conservative bent but with a need to achieve may excel. That they excel in taste is shown by their scores on the test of esthetic judgment, where they made on the average only six errors on thirty items, while the other groups, all of whom had been picked for their high scores, it will be recalled, made nine or ten.

Thus one of the women had grown up "surrounded by culture" and was encouraged to take an interest in it through visits to museums with her father. Her tastes in art and classical music are well defined but, like most of her colleagues, she does not consider herself creative and has never done any painting or drawing. Another woman, likewise an art history major, had started majoring in art but found that there was too much competition: "I was afraid to hang my work up. I don't like to be attacked in front of the whole class; I'll practice at home first." One senses in her statements a conviction of the importance of standards and a consequent fear that she might not be able to meet them; she, too, is certain that she is not "naturally gifted in art," but her interest in it leads her quite naturally to art history. In this field she has what one senses to be a sort of objective guide which protects her against the vicissitudes of subjective expression; when she discusses esthetic judgment, she makes a remark that places objective standards above personal ones: "I find it hard to separate my feelings of what I like from the work of art. I think I shouldn't like something which is not good."

Thus it may be said that none of the masculine preferrers, including those who have not been mentioned individually, view themselves as creative; they apply themselves to viewing and judging art rather than to making it, and they give one the impression that they value taste—a capacity to discriminate—more than they value emotional satisfaction. If we are to attempt a general formulation of the functions that art serves for them, we need to understand these facts and integrate them with what we have come to know about the subjects' psychological functioning.

It seems necessary first to clear up a misimpression which the subjects have themselves brought about. They speak of art as if it served their hunger for culture and their need for making discriminations, but it would be an error to understand them as viewing art without emotion. In the first place, emotion may enter into the very need for making discriminations, as for example when one of them symbolically revives a closeness that was felt to exist when her father accompanied her to an art museum, or when another

"undoes" the lack of culture represented by his mother by becoming very cultured himself; subsequently, of course, the discrimination itself is most likely a perceptive exercise, devoid of the satisfaction of personal needs that usually involves the most emotion. In the second place, the specific preference which had brought them to our attention itself represents the engagement of considerable emotion, albeit well filtered through ego defenses and maintained through time by integration with other needs, actions, and thoughts. Thus their statements about art are misleading about the role of emotion, although their other reports and actions are clear enough when taken in the aggregate.

But what are the emotions that animate the masculine preferrers when they engage the human nude? Here, so as not to blur real differences, we need to speak of the men and women in separate terms. Among the men it is nearly impossible to divide symbolic need satisfactions from ego-defense supports because the one never seems to occur without the other. Thus emotions such as anger and dependency, which I would be inclined to view as the most prominently involved with the men's esthetic choices, are engaged only through the defense against them, namely idealization. The preference for masculinity seems most clearly to reflect the idealization of the father; but because the idealization is only in part justified by the father's real qualities, it must be viewed also as a defense against strong anger against him and an unmet need for closeness with him. In the theoretical terms of this book the preference serves above all the function of ego-defense support, with idealization as the primary defense. But three other functions are discernible as well, all of which work in close conjunction with the first while retaining separate origins. I am unclear as to whether they can be ranked in order of importance, but among them I would certainly count another instance of ego-defense support, in this case a defense against intimacy by an affirmation of one's independence and self-sufficiency. I would also include, as separable from the others, a dislike and fear of femininity—again in the esthetic choices an instance of ego-defense support—which is closely paralleled by the dislike that the men express for their mothers and perhaps explained by the mothers' emotional distance during the boys' development. Finally, the functions would have to include one where in the esthetic sphere symbolic need satisfaction predominates over ego-defense support, while in behavior the relation is reversed, namely a just perceptible expression of homosexual needs. The needs in real life are, of course, denied by all but one of the men, but we may presume them to take on a prominence they would not have if they were more satisfactorily integrated into their functioning.

The women seem less monolithic in the functions that they serve by their esthetic choices, but in them, too, ego-defense support is closely tied to symbolic need satisfaction. We know that they also idealize their fathers, but we see the idealization as prominently defensive only where it was supported by the mother's emotional distance or where it served to make up for the actual or threatened loss of a father. Indeed it will be recalled that one subject lived in dread of her father dying, while another, the one who idealized her father the most extremely, had lost him through divorce when still a child; in such instances one is justified in speaking of ego-defense support as a primary

function. But in other women the idealization represents symbolic need satisfaction above all, while still others satisfaction and defense appear equally strong: the satisfaction seems related to the acceptance of the male role as dominant, and to the need, expressed consistently, for a dominant partner with whom one has an exclusive relationship. That the need may have as its underpinning a distant relation to one's mother is quite possible, and it would then be correct to see the need itself as in part defensive; but it would still be a reasonable shorthand to speak of the esthetic choice as serving a need at least as importantly as it serves a defense. As a third function one can discern the need to avoid the feminine, which can be seen as serving as a defense particularly in the cases where the mother was excessively close and prying. As a fourth function, one which we can see clearly in the woman who saw her choice of masculinity as reassuring her that she is not a lesbian, we can distinguish the confirmation of one's femininity; but while the function is clear and conscious in the one case, it is probably present in most of the others as well, although in a slightly different form. While one subject may be reassured by perceiving herself as making a heterosexual choice, which is a reassurance about her drives, others may be reassured, although more tenuously, that their attraction to a valued male figure makes them in turn more desirable to males.

My emphasis on the role of ego defense in esthetic choice seems to be a justified construction from the information the subjects had supplied, but it is also consistent with the impressions of the subjects' personalities that the interviewer had formed while analyzing the interview contents. She singled out certain characteristics as salient and rated all her subjects on them. The masculine preferrers turned out to differ from the feminine preferrers on most of them by rather decisive ratios; thus the masculine preferrers are seen as perfectionist (9:1), achievement oriented (10:0), conservative (8:2), competitive (8:0), and psychologically on the defensive (8:0).

Feminine Preferrers

In contrast to those who prefer male figures, nine of the feminine preferrers major in or practice art while only one majors in art history. As a consequence they are quite aware of the degree to which art serves a directly expressive function. Thus one male, identifying with his father's creativity in working with his hands, values the creative process so much as an end in itself that he cannot formulate a purpose to his art; he says, "I just do it." It turns out that he paints bodies abstractly and in a highly distorted manner that is designed to shock the viewer and bring him down to reality. Another male recalls that his lonely and suppressed childhood pushed him into artistic expression: "The only means I had to express myself when young was telling stories or drawing"; he now uses painting "as an expression of my feelings and my ideas." A third male, who had grown up in a home marked by suppression of any but loving feelings, recognizes in himself an

intolerance of violence and wretched love affairs in narrative art, and says this of art: "To be involved with art is all emotion. I like childhood emotion as opposed to adult emotion. Most adult emotion that I've seen has done so much destruction that I prefer [the cupids in *Venus Anadyomene*]." Still another male had experienced a home marked by the diametrically opposed emotional climate and his sculptures portray the violence he had been exposed to there: in one of his sculptures he portrays a violent father putting his fist through the face of a smaller figure, and says, "The idea behind it was that of feeling so keyed up that you have to smash something."

The women are all art majors also but they differ from the men in a perceptible manner: they seem to be less singlemindedly insistent on using art to express emotions, and they give proportionately more attention to art that has been done by others. But apart from this difference of degree, emotional expressiveness is valued; thus one woman says, "I like lots of colors and that's why I am painting. I like blotches of colors; I like blues. Now I'm into orange," while another, though insisting that conscious awareness of intention (what she calls "the ego" or the "I am") has no place in art, believes that it is appropriate for art to express what is inside the artist so long as the expression is unconscious: "I don't always project my feelings on the art; a lot of me comes out in the art and a lot of the world comes out, too. I paint unconsciously and watch what comes out."

When I attempted to integrate the psychological functioning of the masculine preferrers with their insistence on the primacy of esthetic judgment over preference or expression, I cautioned against the assumption that emotion had little to do with the actual uses to which preference was put. With the feminine preferrers I face somewhat the opposite situation: I must caution against assuming that their esthetic preference reveals the expression of emotion—symbolic need satisfaction—to the exclusion of ego-defense support. On the whole need satisfaction has a relatively more prominent place with them, but the role of ego-defense support is also substantial; and that is true of both men and women, although the configurations are different enough to require separate discussion.

Among the men we had seen invariably a family constellation in which the father was subordinate and often quite passive, and his role served as a precondition for a turning toward femininity which, however, took different forms depending on the boy's relation to his mother. Thus in the cases which are dynamically the easiest to understand, they boy had lost his mother through death or other separation and now overvalues women for the comfort and security that they can provide; we understand his current esthetic choice to be an instance of symbolic satisfaction of a need which is inexhaustible. Perhaps dynamically similar are the cases of boys who had grown up with both parents, neither of whom was satisfactory as father or mother: the men, grown up, fantasy the security of a competent woman or the bountifulness of a physically opulent one. However, the need satisfaction which they symbolically achieve is not their sole motivating force; we note in them also a distinct physical and emotional passivity and a sense of inadequacy. A successful relation to a woman, and to an extent even a symbolic one in art, therefore, serves to support their masculinity. Now of that much we are

certain, partly because one of them had told us so, but whether to understand the choice of woman as an instance of need satisfaction or ego-defense support is less clear. Because "masculinity" is a self-concept achieved later in life, and because it represents here a simultaneous threat that unless it is shored up it will dissipate, it would seem appropriate to lean in the direction of ego-defense support; but perhaps it is not necessary to insist on a clearcut decision in the matter. But there is a third relation to the mother as well, which is rather benign, in that the mother was affectionate and is remembered with admiration and warmth. To understand the grownup boy's strong valuation of women we need to take into account the domination of the household by the mother and the inadequacy, absence, or even brutality of the father; we may then presume in the boy both a defensive turning away from masculinity and a natural, partial identification with femininity: the mother is idealized partly because she is dominant and warm and partly because the boy has no one else to turn to. Here, too, symbolic need satisfaction appears prominent but allied firmly with the support of an ego defense against an inadequate male image. We must also not omit noting that the feminine preferrers have less exacting standards for all sorts of behaviors, as shown for example in their tolerance for homosexuality; here it appears simple to decide that, in general, owing to a less strict conscience, they are accepting of all sorts of need satisfactions and that quite conceivably these find their way into art as well. Finally, there are two individual configurations which indicate the operation of other functions, not encountered heretofore: two of the men make very clear that in art they prefer the positive, optimistic, affirmative, and loving, which I have called in the introductory chapter a defense against destruction and depression. That in one of them, the one who had sculpted the father's brutal relation to the son, the defense should operate only in choices among other people's art but not in the production of his son, is a paradox we need not here attempt to understand.

In the women we note similar functions but in different proportions. The invariant precondition is present in them, too, in that their fathers had been emotionally distant, or passive in the household, or both, with the result that now the women either do not respect men or refuse to rely on them emotionally (or both). How they relate to men subsequently depends on the relation they had had to their mothers: where they had been close to their mothers, they have found the family bond attractive enough to form a stable relations with men themselves, but they have in every case chosen husbands who need, and therefore permit for their wives, considerable emotional distance. These women's choice of feminine figures seems to me above all an instance of ego-defense support, in that it supports their manner of avoiding intimacy with and emotional dependence upon men. The women who had been raised by mothers from whom they had felt as emotionally distant as from their fathers face a more difficult situation, in that they had had no parent to whom they could turn; it comes therefore as no surprise that they (that is, five of the six) avoid forming a stable relation with a man, be he boyfriend or husband. They seem to make a virtue of necessity by striving to be self-sufficient, and their esthetic choices seem but a confirmation of that striving—again, supports of an ego defense. Indeed, in their desire for self-sufficiency they find common ground with a group to which they had been psychologically opposed in most of the respects we have

studied, that is, the masculinity-preferring males; and they share with them the prevalence of this particular form of ego-defense support. They differ from that group, of course, in not relying on idealization; here they once more come closer to their natural psychological allies, the femininity-preferring males. They share with them a very liberal attitude toward standards—expressed, for example, in their acceptance of homosexuality in others and homosexual impluses in themselves—which permits a wide latitude of need satisfactions in actuality and perhaps, with the exception of the specific esthetic choice in question, in esthetics as well. Finally we encounter one instance of rather terrifying fear of death at the hands of males, a fear which is unique in its strength and origins but which only exaggerates the fear of aggression that the other women share, and to the extent that it motivates a rejection of masculine figures, it is of course an example of ego-defense support. In instances where it leads the viewer into sentimental choices it would constitute that special case of ego-defense support that I prefer to call defense against destruction and depression.

My emphasis on ego-defense support among the feminine preferrers is perhaps excessive; I suspect that it applies quite well to the specific choice I was investigating, which was by definition narrow, but that it applies less well to the wide range of other esthetic objects to which these people are probably open. In any case, the interviewer's ratings of these subjects' personalities are much more consistent with my assumption of breadth than with my analysis of ego-defense support. They differ from the masculine preferrers by wide margins on the remaining dimensions on which they had been rated: they are seen as impulsive (9:0), natural with the interviewer (9:3), politically liberal (8:0), and oriented toward experience rather than achievement (9:0).

4. Notes

1. In statistical terms, the subjects had scored more than one standard deviation from the mean, for that pool. Not all extreme scorers agreed to serve as subjects; those refusing were replaced by alternates picked beforehand from the same extreme group.

2. Study I was conducted by Glenn Wilhite, while Study II was carried out by Carol Craig. I owe them warm thanks for their patient gathering of the data, thorough transcriptions, and patient analysis.

5. EXHIBITIONISM AND REBELLION

. . .Clothes resemble a perpetual blush
upon the surface of humanity.

—J. C. Flugel, *The Psychology of Clothes*

We are born naked and as children we enjoy exhibiting ourselves. As adults we spend most of our time complying, without much further thought, with unwritten rules that specify the parts of our body others may see and the occasions on which they may see them; and if there are occasions on which we can present ourselves fully naked, they are rare and always marked with a tag saying "special." Only in viewing art are we allowed, in the most solemn places in full daylight, a full and pleasurable look at the human body—or, better, at idealized versions of it.

As a starting point for understanding the symbolic value of shyness and exhibitionism, can we suppose that a taste for shyness represents the acceptance of conventional rules while a taste for exhibitionism betrays some return to childhood pleasures? Such a view is tempting by its simplicity but doubtless incomplete because of its simplification. It is probably correct to speak of shyness, or a taste for shyness, as an instance of rules of modesty successfully applied, but exhibitionism may be a more complicated matter.

Not all of us are brought up under unexceptionable rules about exposure or exhibition; the rules are variously strict and our acceptance of them variously faithful. To the extent that we have pockets of permission in our prohibitive atmosphere we may have been given license ahead of time to take pleasure in symbolic objects. But as soon as such permissions are noted, the theoretical question with which each study in this book is concerned arises with clarity and insistence: do we like exhibition because it has been permitted or in spite of its having been prohibited? The question translates, of course, into the language of the research tradition of which these studies are an offshoot: is a preference for exhibition congruent with a permission to exhibit, as we might expect

from the sum total of past results, or does it satisfy needs which, by virtue of an interplay of wishes and defenses, cannot be met in reality? We are in a fortunate position: in the absence of individual differences, we might have been tempted to explain esthetic choices by unprovable generalizations, but the rich variety of projective reactions to the nude promises ample information about the dynamics of these tastes.

There is another simplification we must try to avoid. Although the clothing we wear serves to cover, it serves to reveal as well: by the choice of body part to be left exposed, by the selection of apertures for approaching the skin (if only symbolically), by the tightness of fit by which the covered body is emphasized, by the opaqueness or transparency of the disguising material, and by the disposition of color and ornament, the body takes on as it were another boundary which is carefully managed so as to present the wearer to public view. Selections along all these dimensions have to be made every time the body is clothed, and the complexity of the choice tells us that its function is as expressive as it is defensive. If the blush on a face indicates the simultaneous embarrassment at being caught in an act of exposure and the pleasure in being able to expose, then Flugel's aphorism is apt, indeed.

If the management of the outer boundary onto which we have transposed our narcissism as well as the defense against it is an important concern, then the naked body can stand for much more than the state of being stripped of defense or propriety. By the disposition of the limbs about the trunk as well as by the apparent purpose attributable to a figure's nakedness the body itself can take on the function of managing the compromise between exhibitionism and modesty—the naked body can become the symbolic vehicle for the same concerns which govern the presentation of the person in a clothed state. When the naked body is our own, then we have to manage it before others; when the body is an object we are looking at, and particularly when it is presented to us as an esthetic object and given symbolic legitimacy, then its management becomes important to us as we identify with it or treat it as an object of erotic or other fantasy. To the extent that its management of exhibitionism and modesty matters, to that extent our own solutions to these needs become engaged in the process of viewing.

Thus the "symbolic revival" of childish pleasures is in fact a complex process—or so we may assume it to be even before our evidence helps us specify it. We have other reasons to view it as complex besides those already adumbrated. If we may assume in children a natural need to exhibit their bodies or their genitals, we must also recognize that adults may employ that need purely defensively, as a way of expressing apparently unrelated needs or coping with specific inadequacies. Clinical attention has focused on the male need to exhibit his genitals, where that need takes precedence over, or altogether the place of, sexual intercourse: in such cases it is viewed as a reassurance against unusually strong fears of castration (Fenichel, 1945). In the woman, a need to exhibit her entire body may perhaps serve a reassuring function as well, though of course against a broader sense of inadequacy; but my own informal evidence, gathered in small-scale studies conducted by students, suggests that it may have a strongly aggressive and controlling component as well: in the stripper, for example, it may serve to pay men back against past wrongs, real or fantasied, and to control them by manipulating their sexual

arousal. But these are only two examples of exhibitionism used defensively: I do not mean to suggest that in subjects with a strong preference for exhibitionistic nudes in art such defenses are prominent, but I expect to find them in an attenuated degree here and there, with other defenses, as yet unspecified, used by others. It must be remembered that the subjects are not exhibitionists themselves, nor shy to the point of never allowing themselves to be seen; but they are sufficiently singleminded in their preference for nudes which have been rated either as exhibitionistic or shy to make it likely that their needs will stand out clearly.

This study reports on 20 subjects who were chosen from a pool of volunteers who had no specific sensitivity to art; among the 400 or so subjects who took the Human Image Preference Test as described in the last chapter about 200 had either been recruited from psychology classes, and therefore were assumed on the whole not to have specific interests in art, or they had come from art history classes and failed to score above the 50 percent cutoff on the Test of Esthetic Judgment. The ten men and women who had the strongest preferences for exhibitionistic nudes, and ten who showed the firmest liking for shy nudes, were chosen from the 200. Nudes are called exhibitionistic if they flaunt their nudity in some manner, particularly by displaying their torso and genitals, and they are called shy if they cover them with their limbs; examples of the former are the Greek *Sleeping Satyr* (Fig. 13) and most of the *Bathers* by Renoir (Fig. 14), while instances of the latter are *Nude Seated Before a Curtain* (Fig. 15) and the Hellenistic *Aphrodite, Eros and Dolphin* (Fig. 16). It was originally intended to replicate the study with subjects who are esthetically sensitive, but because this study had already profited from the methodological lessons learned earlier (in particular the need to keep the interviewer ignorant of the subjects' preferences until the coding of all the data had been completed) and because its results were sufficiently clear, it was allowed to stand by itself.

As in all the studies reported here, the subjects were ignorant of the reason they had been selected, and for the most part did not even suspect—unless they were preoccupied with the issue—the dimension of esthetic preference which mattered to them. Nor did the lengthy interview to which they consented focus narrowly on the psychological issues raised by their preference; on the contrary, it was broad enough to mask the specific areas of greatest interest to the interviewer.[1] The interviewer covered, in addition to the basic topics outlined in Appendix D, areas of potential relevance to shyness and exhibitionism. Because all those studies are intended to explore as many psychological connections with esthetic attachment as might appear, and because they had only in part been guided by hypotheses made plausible by the theoretical approaches of others, they erred on the side of breadth. The topics inquired into included parental characteristics, identification with parents, parental standards and patterns of privacy, and the parents' expressiveness and permissiveness with regard to sexuality, nudity, affection, and aggression. They also included the subjects' current handling of the latter four needs, as well as their self-image and body image, with a particular focus on their modes of self-presentation and appreciation of the presentation of others: the functions of dress and nudity, and the importance of the physical appearance of others. Their religious and political attitudes were also studied, as well as their ideals for others' behavior; finally,

Figure 13. Greek. *Sleeping Satyr*. Staatliche Antiken-sammlungen und Glyptothek, Munich.

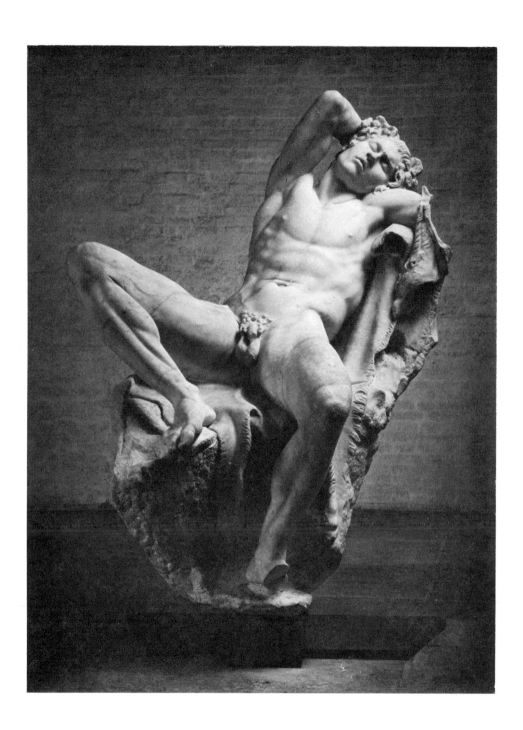

Figure 14. Renoir. *The Bathers.* Philadelphia Museum of Art: The Mr. and Mrs. Carroll S. Tyson Collection.

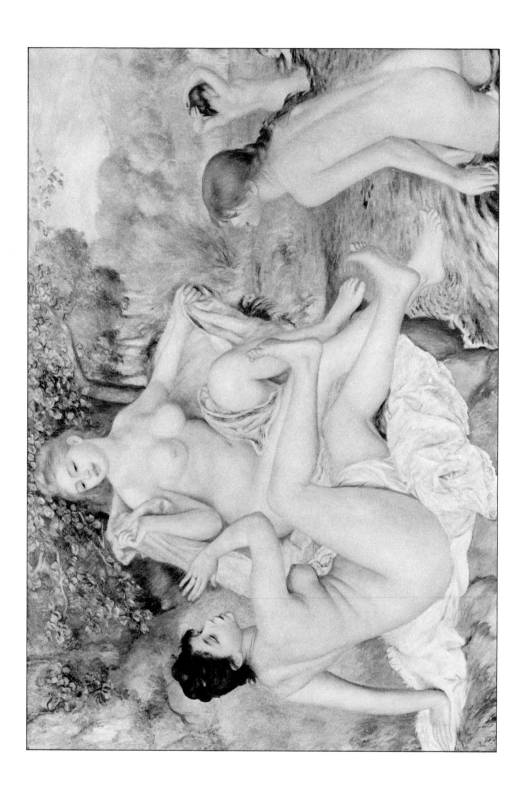

Figure 15. Picasso. *Nude Seated Before a Curtain*. The Museum of Modern Art, New York.

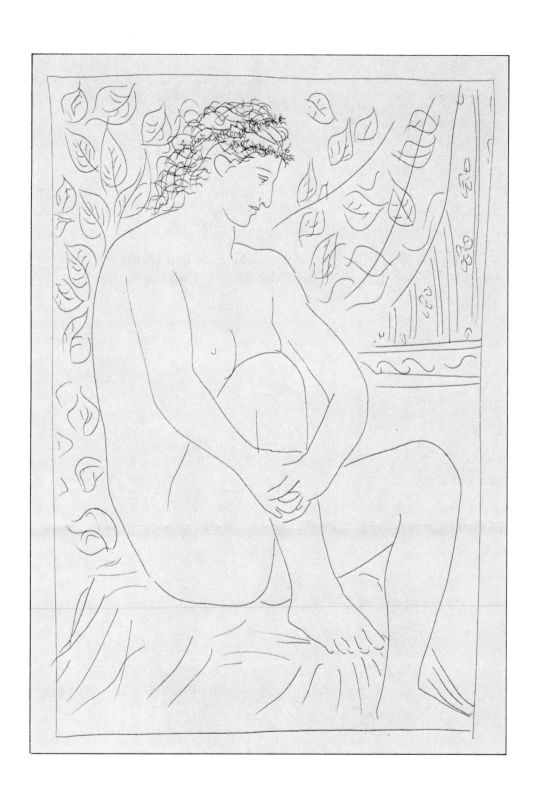

Figure 16. Hellenistic. *Aphrodite, Eros and Dolphin.* Louvre. Cliché des Musées Nationaux, Paris.

their relation to art was looked into both historically and in the present.

One does not know beforehand how these several variables may be connected; the more one variable depends on another, the greater the unity of the resulting differences between the two contrasting groups. For the sake of presentation, the seemingly discrete topics may be grouped under four headings, each of which allows a contrast between the groups to emerge clearly: impulse inhibition, adolescent rebellion, sense of masculinity or femininity, and body presentation in reality, fantasy, and art. Although the men and women are once again quite similar, the concreteness of experience which each sex brings to its esthetic choices is best preserved by presenting the results separately.

Men

Impulse Inhibition

In one guise or another, a variable resembling "superego strength" recurs in every study in this book: whenever subjects are contrasted in their esthetic preference, one group turns out to be more inhibited than the other. But we have a choice of either emphasizing what the studies have in common or noting their differences. The advantage of stressing the common, "underlying," variable of superego strength is parsimony and abstraction, since one explanatory principle is made to serve many purposes. But it seems to me that such an approach has the vice of its own virtue, because in arriving at the simpler abstraction one loses the very particulars which make it possible to understand why a specific esthetic choice has been made. "Superegos" are established by different processes and directed against different drives, and the specific prohibitions and the ways in which they have been accepted have different consequences for esthetic choice. It seems to me preferable to be able to distinguish, for example, between a "superego" which leads a subject to choose masculine nudes and one which leads him to choose shy nudes; the former is established by a strong identification with a dominant father and has as its contents a series of images of what defines masculine behavior, while the latter is established by accepting standards from an inhibited parent of either sex, irrespective of authoritarian dominance, but whose content centers on inhibition of expression. To confuse the two is to lose sight of the objects or drives which are prohibited, and consequently to lose one's grasp of the esthetic objects which can serve the superego's interests. In this chapter we shall see, then, that the shy preferrers are generally more inhibited than the exhibitionistic preferrers, but we shall also note that the difference is smaller than one might expect and that it does not suffice to account for the opposed esthetic choices; rather, we shall have to take note of each subject's ambivalences and the ways that he has chosen to cope—not with his drives only—but with the superego itself.

To begin with the simpler problem, we note that the shy preferrers are an inhibited lot: their preference for shy figures serves to support a broad array of defenses against drives and affects. The parents who serve as the original sources of the inhibitions may be unassertive and inhibited themselves, or on the other hand quite dominant and at least as inhibiting as inhibited. We cannot search for the source of the subjects' inhibition in the parents' qualities only: one subject notes that he has accepted, without any pronounced questioning, most of his parents' values; another was raised by an erratic, tyrannical father who enforced his strict rules in minute detail; yet another was raised by a father who was alternately a weak drunkard and an authoritarian, but the son speaks of him with sympathy when he notes the father's guilt about his alcoholism and his occasional capacity to be loving. The fourth subject finds his father withdrawn and without courage to cope with problems, but realizes that in these respects he resembles his father; his unwillingness to criticize the father more severely that he does appears related to his feeling guilty for having received so much more attention than his older brother, as well as for his mother's denying herself for her two boys. If the parents vary to this extent, our focus has to be on the unassertive, compliant, and guilt-prone nature of the son, whose guilt feelings are produced either by acceptance of inhibitions from a dominating parent, by identification with the parent's guilt, or by the evocation of guilt through a parent's sacrifice. The fifth subject sums up the configuration rather succinctly when he says that "in elementary school, I was a goody goody—'here, teacher, I can do this'—the basic all-American kiss-up. Which freaks me out—my parents didn't demand it."

One source of the tendency toward inhibition is the ordinal position of three of the five males: they were the youngest in their families. While it is difficult to judge to what extent this proportion is significant statistically (none of the exhibitionistic preferrers were the last-born), the birth order is felt by the subjects themselves to be significant psychologically. Thus one subject, although on good terms with his two older brothers, remembers that he viewed them as somewhat awe-inspiring: "I never fought with either of my brothers; they were so much bigger than me they could have killed me. . . . I still have some fear of them. I mean, they are still physically superior to me in size and strength. It is interesting that John, although he is the friendliest, he is also the most violent: when he's got mad he's really done some rash things." That his fear of their aggression inhibited him when he was growing up is made clear in his statement that "when I was little, I was super shy, super non-confronting, and I still don't confront. In my family I am not the instigator most of the time; I really like to seek the peaceful thing." The other subjects were less emphatic about their fears of older siblings, but they noted that the older one was the rebel in the family while the subject on the contrary got along well with his parents.

Religion played its role in strengthening these inhibitions as well. It is noteworthy that all five of the shy preferrers considered religion important to them both in the past and at present, while none of the exhibitionistic preferrers did. The specific religion did not matter (Catholics, Protestants, and Buddhists are represented), but the current importance of spirituality over materialism or sensuality does.

143

It will come as no surprise that when asked how they view themselves, all five of the shy preferrers state simply that they are followers rather than leaders, subdued rather than dominating, quiet rather than loud, and dependent rather than independent. This self-image is consistent with the manner in which the outside observer might view them: they are as inhibited in their expression of aggression as in their assertiveness in sex. Their inhibition in sexual matters is part of their view of themselves: they are frank in calling themselves inhibited or in discussing their sexual frustration. But their lack of assertiveness has been integrated into their lives, if not completely then with a minimum of discontent, in the sense that they (three of the five, as against none of the exhibitionistic preferrers) have chosen to make privacy an important part of their lives and to enjoy being alone.

In many respects, but not in all, the exhibitionistic preferrers present a contrast to those who like shy figures. The contrast has for the most part been made explicit already: none of them are religious at present, and only one of the five sees himself as a follower or as a controlled person; none of them value privacy, nor are any comfortable when alone. Thus they are more extraverted, dominant, and expressive; that is, they need the company of friends, they easily take a leading position with them, and they express their feelings (sometimes anger, sometimes sex or affection, at times both) more easily.

But there the differences end and the similarities begin. It should first be noted that where differences are observed they are not always of the all-or-none variety; for example, where none of the shy preferrers see themselves as independent, two—but not more than two—of the exhibitionistic preferrers call themselves independent; as against five subdued shy subjects, four of the others are also subdued; and in comparison with no shy subjects who call themselves loud, only one of the others sees himself as loud. Thus their expressiveness is greater only in degree, and a significant amount of need inhibition seems present as well.

It is important for my later theoretical interpretation that the similarities I am making note of be fully presented, because I shall shortly point out differences in certain modes of behaving—differences which for the most part were apparent already in the subjects' adolescence—which are thrown into relief by the commonness of the past context. The differences in degree which I have mentioned are in a way remarkable, not because they should be greater, but because there is reason to think they should be smaller: there is so little difference in the two groups' upbringing that one would expect them—if parental upbringing were everything—not to differ in their present characteristics at all. Three of the exhibitionistic preferrers come from conservative religious backgrounds (two Catholic and one Jewish) and two come from fairly liberal backgrounds in which religion played at most a minor role; this is at best slightly more liberal than the upbringing of the shy subjects. The rules by which the exhibition-preferring subjects were brought up could be as restrictive in their details as those of the others: some of the restrictions were sexual, as in being allowed to see a girl no more often than once every three days, and to make sure that a parent was always present in the case of a house visit; other restrictions were pervasive in an authoritarian atmosphere in which all

impulses—save perhaps those of anger—were suppressed and respect for authority demanded, with the result in one family, for example, that one son followed the father's precepts and became a policeman, while the other became a politically liberal student—and our subject.

To understand the process by which boys from similar family atmospheres could develop adult personalities which differ at least in part, and esthetic tastes which on the dimension we are studying oppose each other diametrically, we need to look at the manner in which the subjects reacted to their upbringing.

Adolescent Rebellion

Given the slight edge in strictness of upbringing over the exhibitionistic preferrers, the shy subjects had more to rebel against—and yet their adolescence was characterized by acceptance of the parental standards. In answer to a straightforward question, three respond in the following manner: "No, not really, because my parents actually gave me more trust than I trust myself. . . .They really do trust my decisions; that's what they've been telling me since I was 13." "No, I got along fairly well with my parents compared to my brother." "Yeah, for about six months, and then I mellowed out." The two remaining subjects are more complex, but by their indirection they illustrate equally well their reluctance to rebel. One replies by saying that he *had* rebelled ("My freshman year in high school was a disaster; I was outspoken and different, I was getting into the Beatles thing and had my hair long"), but then makes clear that the problem resided neither with his parents nor with his insistent adolescence but with an unsupportive environment instead ("so I transferred high school and from there everything was really good"). The rebellion of the last subject has to be judged from indirect evidence, and the evidence suggests a rebellion which is more symbolic than real: in response to one of the pictures he was shown, he is reminded of the importance of his own hair by the resemblance of the picture to Samson, whom he admires for the freedom and strength that his hair bestowed on him.

The exhibitionism-preferring subjects reply quite differently to the same question. Of particular concern are the three whose upbringing left something to rebel against: "Yes, with my mother. She wanted me to choose my friends, I thought, and told me who not to see. In retrospect her decisions were probably correct, but at the time I couldn't see that; so I was kind of rebellious and sneaked out of the house and smoked cigarettes and drank booze." "Yeah, I sure did. I used to say I was going to the football game and then I would stay there 30 seconds just for my conscience and then I'd go get drunk. I used to go to school drunk more as rebellion against my parents. . . .I fixed my own school records so the cuts wouldn't show. . . .I like to be alone and do what I want to do. I know where

that comes from, because I was very restricted when I was young. I don't like any restrictions—that's why I have an open marriage." The third subject recounts his parents' attempts to restrict his choice of friends and mentions as a precipitant of his rebellion their refusal to accept his friendship with an older man with whom he "hung around." When he called them, as agreed, to say that he and the man had safely arrived at their destination out of town, the parents demanded that he return immediately; he said that he wouldn't and wrote them a letter saying that "I've been deceptive for years and if your shame of me is grounds enough—you know, it's like I told them it was a conflict between my independent spirit and their imposition—if that was grounds enough to disown me, to get on with it. I think I can handle it." He found that they did not disown him after all.

The other two subjects were raised in a manner that did not explicitly invite rebellion and as a consequence rebellion does not figure in their narrative. One plainly shows a confusion about the meaning of the term, and an ambivalence about accepting parental guidance and standards, when be claims, on the other hand, an independence of action and ethical thought ("I've been able to ignore everything and do exactly what I wanted to and justify it morally"), but on the other reveals a capacity for putting his parents' interest ahead of his own ("That motorbike: I'll sell it soon, because it will just kill my mother if I ride around on it"). For the other subject overt rebellion was never an issue, so it cannot claim a role in determining his esthetic preferences; rather, we shall see that instead of struggling with the external demands of parents he struggles with the internal inhibitions of which he is only too conscious: he is fond of acting on the stage as a source of symbolic gratifications not available to him when he is his "real" self.

Given these differences between the shy and exhibitionistic preferrers, I can attempt an initial formulation—to be refined by differences yet to be presented —of the function of their esthetic preferences. The shy preferrers have been raised in a manner which inhibits impulse expression and they have accepted the inhibitions imposed on them; they are shy and introverted as adults and, while they may not be altogether happy with their current balance between impulse and control, they are sufficiently identified with the controls to wish to support them. As a consequence, their esthetic preference seems to serve rather purely the function of ego-defense support. The exhibitionistic preferrers present a contrast to the shy subjects not by virtue of the permission they had received to gratify their impulses, but by their assertion of a right to impulse expression. Such impulse gratification as they permit themselves indicates that their esthetic preference serves needs symbolically; but the assertion itself is a defense against their prohibition, and must therefore be seen as defensive in the same measure as it is expressive. Such a formulation applies to three of the subjects only, because for the others rebellion was never an issue; we shall have to search for an understanding of the exhibitionistic preference of the others elsewhere, just as we now need to look at other facts about our rebellious subjects in an attempt to understand why exhibitionism should have been chosen as the means of their rebellion.

Sense of Masculinity

Our information is clear on four of the shy preferrers, but on the fifth only factual information had been adequately recorded (the interviewer, having discovered a technical problem with the recording, wrote out copious notes at the end of the interview, but the notes cannot capture the idiosyncrasies of expression which reveal attitudes unambiguously). A sense of masculinity is here judged physically only, and reflects satisfaction with one's body, a sense of oneself as capable and competent, and a sense of confidence in being able to relate to women; the definition may appear restrictive, but it follows the direction of the subjects' dissatisfaction with themselves. By this definition the shy preferrers have an uncertain sense of their masculinity. Three have a very inhibited sex life—two have never had sexual relations and one has given them up for religious reasons—as well as an unsatisfactory body image and a sense of themselves as ineffective and perhaps inferior; the fourth appears a little more buoyant but characterizes his sexual activity as moderate. All of the four speak of their preference for spirituality over sexuality in their relationships with women and one idealizes his relation to his girl as a perfect Christian one in which sex no longers plays any part. It is of interest that they seem at ease describing themselves in this manner to the interviewer; they give the impression that shyness and inhibition are so clear a part of their self-image that they have no reason to dissimulate or boast. The fifth subject—whose father was perhaps the most tyrannical of the group—seems to stand up to his inhibiting influence by a degree of self-assertion (by maintaining financial independence, for example), but his statement that he has several sexual relationships at present may be inaccurate or misleading; in any case, it is imperfectly consistent with his refusal to discuss any aspect of his relation to women and with his strong valuing, in concert with the remainder of his colleagues, of spirituality over sexuality or appearance.

But if the shy preferrers show their concern about masculinity by admitting it freely, the exhibitionistic preferrers betray theirs by more varied means, including that of protesting too much. Three have become rather preoccupied with relations with women— a preoccupation which dates from junior high school years or earlier—and the relations are always characterized by the male's attempt to dominate. One of the subjects says that he "was never as close with men as I was with some women in younger grades. That's why I had a girlfriend. I was always closer to a girlfriend than a male friend. I always thought the camaraderie among men was kind of false." But one would like to know why the camaraderies should appear false; and while the subject does not offer extensive information on the question, he does suggest that he has difficulty being affectionate with men on the one hand, for fear of being considered feminine, and being assertive on the other—for fear of being too imposing; with women, who do not fight with him for dominance, he can be imposing quite easily. But his women want intimacy from him, or at least a recognition that they are his girlfriend, and this he is unable to give. As a result, his relations with them have become increasingly sexual and emotionally guarded, and what may have begun as a sexually expressive love life has turned into what he wryly

calls a disaster. Another subject, also unable to confide in males, has turned to women since finding a girlfriend in seventh grade; asked about confiding in women, he replies, "To think of that makes me insecure because I know I really need them. . . .Women are just a little more sensitive, I think, with feelings and things. Men are overwhelmed by just self-importance, or whatever." And yet he is not free from the criticism he had leveled against his fellow males, as he makes clear in his description of his current relationship: "This girl I am thinking of, she's really insulted by my kind of domineering position, and I am contemptuous of her for some reason or another for—I don't know—because she's not allowing me to be domineering; but that's something I am ashamed of. . . .With her I couldn't assume the position I am used to assuming—a kind of macho, ego-type thing." The third subject seeks not only to dominate, but also to have relations with as many women, in addition to his wife, as possible; he describes his father as passive and as a model from which he has always tried to escape, but his mode of escape has varied since his early years. Having had a girlfriend since the age of seven—but with very little intimacy offered to the partner, no matter who she might be—he had gone through a period where his masculinity was defined by being mean to others and belonging to a hoodlum motorcycle gang; but more recently, as he puts it, "I discovered in myself that being stern and outwardly authoritarian didn't mean so much to me." Instead, he has turned all his attention to women and adopted toward them the role of a kind of collector; not of stamps or pelts, perhaps, but of sexual experiences.

The fourth subject—interestingly enough one of those with a liberal upbringing—reveals his infirm sense of masculinity without indirection. Responding to a question about confiding, in his parents or high school friends, for example, he says that it was impossible and then adds, "If I had said I feel insecure because I can't get myself a girl-friend, they probably would have laughed and not known how to handle it. . . .What I couldn't confide in others were mostly negative feelings about myself and sexual feelings." He is clear that he picked up some of his insecurities from his father, but he has not yet found a way to fight them: "Even now, I am really still scared about getting into a sexual relationship; I am not very experienced." The fifth subject does not make sex the focus of his life—the focus neither of problems nor of solutions—and has had satisfactory and steady sexual relationships up to the present; but he shares with his fellows a need to dominate women ("I tend to take a chauvinistic point of view") and a concern about masculinity in a more general sense; talking of models for his behavior, he says, "One person comes to mind. . . .He's a friend of my father's. I really respect him because he seemed to me totally honest and above board and also totally masculine, like a symbol of anything a man should be. I sort of respect that, although I am not like him really. He's very quiet, very soft spoken. He's just ultra-masculine, which to a point people say I sometimes am, but I don't really know."

I think that these observations make it possible to refine the formulation I have attempted so far. An uncertain sense of masculinity is noticeable in all the subjects, whether in the shy or exhibitionistic column; the shy subjects have accepted the controls they have imposed on their impulses—in spite of some dissatisfaction with the manner in which they apply to their relations with women—and use their esthetic preferences as

further support for the control. The exhibitionistic males appear to be of two types: one type is exemplified by the three who rebelled against their strict upbringing and struggle concurrently against an insecure sense of masculinity, while the other is illustrated by the two men who, in the absence of a need to rebel, are attempting to come to terms with the problem of masculinity only. Of these two, one had dominated women but shied away from their demands for intimacy and responsibility, while the other has been simply frightened of them; in either case, the conflict itself, rather than the specific mode of handling it, seems to be engaged in the esthetic preference under study.

But at this point in our knowledge we can do no more than observe the connection between masculinity fears and the exhibitionistic choices; we cannot yet specify why the connection should have been made. It is fairly easy to understand why the three rebels against parental authority should find themselves up to the struggle with their uncertain sense of masculinity as well, but the two who have not had to rebel seem not to have made a habit of asserting themselves. If we are to understand why their mode of defense should be an exhibitionistic one, we must find out whether their sense of masculinity is tied in some manner to their body's appearance—to the manner in which their body is to be presented to others, in reality as well as in fantasy.

Body Presentation

The subjects were asked about the manner in which they dress, the importance of physical appearance, their and their family's attitudes toward nudity, daydreams and night dreams they have had recurrently, and fantasies elicited by the works of art illustrated at the beginning of this chapter. All subjects—exhibitionistic or shy—revealed an ambivalence about presenting their bodies to others. The issue was joined not at the most intimate boundary—that of the skin—but rather at the next one outward from it, that of clothes: the subjects were aware of, or betrayed, both a wish to show off and a defense against the wish. Their ambivalence could be shown in an uncertainty about whether to dress so as to conceal or reveal, or in a conflict between the way they dress in reality and the wishes they reveal in fantasy, or between two opposed fantasies; and while it is correct that in their behavior the shy subjects opted for the "shy" solution and the exhibitionistic men for the opposite one, I am more impressed by the continuing sense of ambivalence than I am by any definiteness of solution.

Representative comments from several of the subjects will best present the nature and importance of the issue. The first shy preferrer shows an ambivalence about the function of clothes when he makes this reply to a quesiton about whether he dresses primarily to conceal or to reveal: "I don't wear things to reveal, although people swear I do when I wear my tennis shorts, but they're just damn comfortable. A lot of people

would say I dress to be revealing. I wear fishnet T-shirts, but to me I don't think it has to do with being revealing; it's basically a matter of comfort." One is tempted to suggest that the subject has found a way to have his cake and eat it too, in that he can give vent to a certain amount of exhibitionism while retaining the conviction that he is modest. Another shy subject is clear that his body should be presented in a controlled manner: "I am really self-conscious even when I am walking about—my hands should go someplace and they're just hanging there. I guess I dress usually to conceal all of myself. Sometimes I start from home wearing more things than I need to; I don't like to reveal anything." But his most important daydream represents one of the wishes against which he normally defends: "A lot of times I wish I was in a rock-and-roll band. I think that's my major daydream. Just having a lot of people around. Not so much the power, but being the center, being up on stage and people being attentive to you." When making up a story to illustrate the events protrayed in Picasso's *Nude Seated Before a Curtain*, he engages his defense once again, but also tells us that the source of the defense was his father: "This is a story about a young hunter named Alexander who is also inclined toward writing prose; his father and family were going out hunting that day and Alexander showed disdain for the fox hunt, so his father banished him to a far kingdom where he is forced to live in a high tower with one window, closed off forever from the world, living on bread and wine and writing his prose."

While the first subject's ambivalence was focused on an uncertainty about the function of dress, the second subject's conflict was seen in the opposition between his modesty and his dreams of stage success. In the third subject the ambivalence is located at the level of the fantasy itself. His story about the happenings in Renoir's *Bathers* starts with an objection whose aim is ambiguous, since it could be directed either at exhibitionism or at the prohibition against it; as the story evolves, his identification also wavers, shifting as it does from the bathers to their strict keepers: "This is the one I like least. This must be medieval times and these ladies are from a nearby castle and they came down here to bathe because they don't have hot and cold running water. And it's fairly private—at least they think it is—and they take their baths and maybe splash around in the water a little bit and bask in the sun. And it feels good for them to get out of their clothes. They have to be covered up in the castle all the time. They're pretty strict about nudity and how a lady should be." The fourth subject centers his ambivalence on clothes once again, first by making clear that their function is to present the person to the outside ("I can learn a lot about a person from their physical appearance. . . .I have a lot of clothes for different moods. Sometimes I dress to please other people, sometimes I dress just to be comfortable. I am a lot more conscious—well, maybe other people are, too—of what I am wearing. I really decide what I am going to wear rather than whatever falls on me"), then by drawing up a series of restrictions on their use ("I think the idea of dress, the way I see it, is to draw attention to one's face rather than to one's body"), then by showing that the reprehensibility of drawing attention to the body is a defense against wishes that are only too easily aroused ("I tend to admire that kind of dress rather than dress that draws attention to a hidden part of the body, like the breasts that you can never really see—leering—sort of tantalizing kind of thing"), and finally by choosing a

turn of phrase which suggests the underlying fantasy so clearly as to constitute almost too neat an example ("I'd rather see dress moving up to—drawing up to—their face, because that's where who they are is going to be expressed the most").

If the shy preferrers allow us a glimpse of their exhibitionistic wishes, the exhibitionistic preferrers make them perfectly clear. The three rebels are busy in their revolt against the prohibitions with which they had grown up, so it will not cause any surprise if their exhibitionistic wishes are tinged with ambivalence as well. The first subject provides sufficient illustration; for example, early in his interview he remembers an incident that revealed to him a little of his father's attitude toward nudity: "I remember for some reason that once I gave my dad this sculpture of a man and woman embraced and I don't know if they were naked or not. I don't know exactly what they were doing. It wasn't any questionable act or anything. They were passionately embraced or something. He got mad at me for giving him that thing. He yelled at me, 'Goddamit, I see naked people every day; I don't want to see this in my house.' " We need not suppose that this incident formed the first revelation of the paternal attitude, nor that the son in choosing such a gift was innocent of a certain amount of pointed humor, but the example is clear enough; and it also suggests that the boy may have put a rather particular construction upon it, since the people whom his father saw naked constantly were patients in his urology practice. As an adult the subject grew to prefer revealing clothes, if not on himself then on women, but the exhibitionism had certain limits: low necklines and short skirts were very much valued, but tight clothes were considered offensive. As for himself, his emphasis on neatness in clothes is contrasted vividly with his enjoyment of streaking—of shocking college officials by running naked through the most solemn ceremonies.

The two subjects who had much less to rebel against appear to use their own exhibitionistic acts differently: not to shock but to affirm a sense of masculinity. One of them claims that in matters of dress he is completely careless but adds that his father is very clothes conscious and vain, and so makes us suspect that in spite of the apparently indifferent attitude toward clothes he finds them potentially important as definers of masculinity. His subsequent statements bear out the suspicion quite well; for example, shortly after describing his father's penchant for clothes he says, "Sometimes I wear costomes or slight costumes—a little bit of a slight costume—every day. . . . People say 'You're wearing an open shirt so people can see the hair on your chest and the St. Christopher.' But I say that I didn't know that, because I usually button my shirt all the way up." But he is not always so apparently unaware of a wish to exhibit himself, because when discussing his comfort at going naked in the college dormitory he adds, by way of self-description, "I am an exhibitionist, just because I enjoy being in front of a crowd or a couple of people. I don't like doing it overtly; I like doing it in a subtle way, I guess I always like attention; I kind of crave it." The other nonrebellious subject craves attention too: not only does he value fashionably attractive clothes for himself and revealing clothes on women, but he enjoys acting. In his words, "Acting is the one thing I really like. I do acting all the time. It is interesting for me to try to get into a different role. Act demon-like, or like a villain. . . . To a certain extent I don't know how much is me and

how much I can call acting. When I am acting debonair, that's really me." But perhaps he would allow us to doubt him for once: acting debonair may be something he does off-stage as well as onstage, but it is still acting, because he has been candid enough with us to say in another context that he is very much afraid of women.

The various strands may now be brought together in a formulation which, although it may justly be seen as incomplete in view of the further questions which it raises, advances our knowledge to a sufficient extent. The shy preferrers are easy to understand and—I trust I will not be misunderstood in saying this—theoretically of little interest. They show general impulse inhibition which they have come to accept, an uncertain sense of masculinity, and an ambivalence about exhibitionism in which prohibition has the upper hand; their esthetic preference may be seen as an extension of their control over the ambivalence. The exhibitionistic preferrers are theoretically a more complicated group: having been brought up with comparable inhibitions and having formed a fragile sense of their masculinity as well, they have found ways of defending against parental inhibitions by rebelling and against their sense of uncertain masculinity by exhibiting—usually symbolically, in the form of clothes, but in one case directly. Their exhibitionistic tastes are defensive, too, partly because they signify an affirmation of their masculinity; and while one cannot by the nature of the investigation find the castration fears that psychoanalytic theory would expect, one finds their more general equivalent in the infirm sense of maleness.

I cannot help but be struck by the difference between these subjects and those who had chosen the masculine or feminine figures; where those who had made a firm object-choice had in a way settled the conflict with which they were coping, the subjects whose conflicts move on this dimension seem engaged in an active process. And the process itself is not altogether different in the seemingly contrasted groups—as can be seen not only in the descriptions which have perhaps already run into too much detail, but also in the inability of some subjects to guess correctly the group to which they belong: they all found the question natural in view of their interest in the dimension, but a few had made a guess which was firm but wrong.

Women

Clinical information is interesting to me in two ways: it allows me to search for what people have in common, and it invites me to try to understand each individual as a functioning whole. Obvious limitations make it impossible in a work such as this to communicate my interest in individuals, but by appropriate quotes here and there I can hopefully hint at some of the particulars that make each individual a unique case.

Impulse Inhibition

The women who prefer shy figures are, like the men, the more inhibited group: they all consider themselves subdued, four of the five consider themselves controlled, and only one sees herself as independent; four of them value their privacy and feel comfortable when alone. Thus like the men they are more introverted and unexpressive as well as unassertive and self-contained. But once again, since the upbringing the shy and exhibitionistic subjects had received did not differ substantially, these differences are not simple products of parental efforts. Four of the shy women, as against two of the exhibitionistic preferrers, were raised in an atmosphere judged as restrictive, a difference which is noticeable but not decisive; but perhaps the parental influence made itself felt more subtly, in that none of the parents of the shy preferrers ever admitted being wrong, while the parents of three of the exhibition-preferring women did. Their impulse inhibition has various sources, then: as among the men, there were three youngest children who felt the dominance and assertiveness of their older siblings, but in other respects there was a variety of inhibiting influences ranging from complete prohibition of nudity in childhood and premarital sex in adulthood, through a prohibition of aggression by a violent-tempered father, to an inhibition of any assertiveness by an impatient and neurotic mother. But I should not give the impression that the shy preferrers grew up to suppress all impulses; rather they are wary of expressing them in unfamiliar situations, but some can be expressive—exclusive of aggression—in intimate settings.

The exhibitionistic preferrers differ in the manner I have just implied, but the difference is one of degree: three see themselves as independent, two as loud, three as controlled; only two come from homes where the parents were never wrong or where the atmosphere would be judged as generally restrictive. Similarly, only two value privacy or admit to feeling comfortable when alone; and four are first-born, and hence more capable of practicing their assertiveness on younger brothers and sisters. But these differences are not large, or, better put, they are not sufficient to explain the opposed tastes that the groups show. Just as the men demonstrated a greater difference in their reactions to their upbringing than in the upbringing itself, the women turn out to differ considerably in their handling of adolescent strivings for independence.

Adolescent Rebellion

I had noted when discussing the males that although the shy preferrers had experienced the sort of upbringing against which one might naively expect an adolescent to wish to rebel, they had accepted their parental values with at most a brief dissent. In fact, of course, a consistent upbringing which stresses impulse inhibition and guilt is hard to rebel against in any overt manner; and so it is that the women confirm the difference found earlier, with none of the shy preferrers making mention of rebellion in adolescence and all of the exhibitionistic subjects affirming their sense of separateness. Their rebellion was not always an armed clash—a pattern that seems more typical of rebelling males—but even in its milder forms it constituted a distinct striving toward separation. A subject who withdrew when her attempts at overt resistance failed provides an instance of the milder form: "My sister and I were together and when we got mad at people we just left the rest of the family alone. . . .We had this strike where we didn't do the dishes, but it didn't work;so I just sort of withdrew and never said anything for a long time to my family." On the other hand a subject who had been used to asserting her independence already as a child fairly exploded against her mother as an adolescent: "I once wrote them I was pregnant. I wasn't, but they had written me this note when I was first living with my boyfried that said, ' 'Is there anything that we should know in advance?' It was such a strange, nonspecific thing that I got mad and wrote this letter home that my boyfriend was homosexual, that we were having bisexual relations, and that we were married and I was pregnant. They were super upset and called me up right away. I was hysterical and started laughing. My father thought it was funny after a while; my mother was hysterical."

The tentative formulation about esthetic choices that I had offered at the comparable point in my discussion of male subjects is applicable here as well, but not without modification. The shy preferrers present once again the theoretically simple picture, in that they are supporting prohibitions which they accept firmly though not without occasional grumbling. The exhibitionistic preferrers who rebel against restrictive upbringing are behaving defensively also, in that they are engaged in an assertion of impulse against prohibition—that is, in that they attach themselves to a symbolic representation of their rebellion. But this formulation does not cover those whose upbringing was not obviously restrictive, or at least restrictive in the sense of consisting of firmly imposed prohibitions. One can understand quite easily that their preference should support the rebellion which they have described, but one is unclear why the rebellion was necessary. That there might exist a more subtle sense of inhibition, or a more focused one, against which rebellion would seem justified, is a possibility; but it is also possible that some concerns akin to the males' uncertainty about masculinity play a role in pushing the subjects toward a symbolically exhibitionistic defense.

Here the presentation of the results on men and women must take separate paths. For the males it was possible to distinguish between a fragile sense of masculinity and

issues dealing with the presentation of the body—indeed, the subjects themselves did not connect the two areas of conflict—because masculinity as the subjects saw it was a question of initiative and efficacy in dealing with women. But for the women issues of body presentation seemed inseparable from those of "femininity" more abstractly defined; while I am unable to say whether such a connection is characteristic of women, there is good evidence that at least for these subjects exhibitionism is a dimension on which much of their experience of themselves was organized.

If a separate discussion of the sense of femininity is unnecessary, a somewhat fuller integration of body presentation (again in fantasy and in reality), body image, and esthetic experience is desirable. To attempt such an integration, and to preserve some of the warp of individual experience, a brief discussion of case examples seems preferable; to put the varying strengths of parental prohibitions into perspective, it seems best, in the shy group as well as in the exhibitionistic one, to choose one subject with a restrictive upbringing and one with a relatively free one. In very much the same manner as the men had, each subject will be seen to display ambivalence about exhibitionism (as against a clearcut solution.)

A shy preferrer, Rosanna (a pseudonym, of course) is near the middle of a large family raised by hard-pressed parents. Her mother is very controlling of her behavior and restrictive of her impulses; and her stepfather is severe, distant, and authoritarian; as Rosanna puts it, her mother is rigid and not at all open with her children, and they find themselves unable to talk about important matters with her. For example, Rosanna has had a boyfriend for quite some time but until recently has not dared tell her mother; the truth finally came out during one of her visits home, when in a discussion between Rosanna, one of her sisters, and her mother, the mother asked point-blank. Rosanna could not attempt an outright denial and told her mother the truth—and was surprised that her mother not only did not show the expected shock, but knew the boy already. Neverthless, though she found him to be a "nice" boy, she would not allow Rosanna to bring him home for an introduction: that would mean a readiness for marriage.

Rosanna's experience at college is of course diametrically opposed to the atmosphere of home: since at college she is unsupervised, free to act as she pleased, and free to talk about anything with anyone, while at home someone is always saying, "Here comes Mama, shh!", she feels that she is in two different worlds and going out of her mind.

The parental restrictiveness was felt in all realms, it seems. The parents never admitted any wrong; their word was law and whenever a problem occurred it was the children's fault. Even the usual roughhousing and name-calling was forbidden; once when in an argument one of the children called another a monkey, the stepfather overheard, seized a broom, hit the child, and berated her for "not having any respect for anyone." At other times, as

Rosanna puts it, "My stepfather would hit us for nothing at all, and that was really bad; I am very sensitive, and sometimes I would cry and cry."

Her coming to college has been the single independent act of her life; but it, too, was not accomplished without major encouragement, in her case that of a high school counselor who, against a good bit of last-minute resistance, persuaded Rosanna to go through with the plans Rosanna was feeling so ambivalent about.

Being at college allowed her to open up a bit, not only with her new friends but with her parents as well. She surprised herself when she discovered, in response to her counselor's encouragement, that she really did want to go to college—and that she was capable of an independent decision. The experience has been good, and Rosanna's view of it is that it has made her a "totally different person, because I never stood against my parents on anything. I've never contradicted my parents; I am more open with them now. I really feel more relaxed, and I think they feel more relaxed around me, too. I feel I can breathe easier." She has responded, too, to the more permissive sexual morality of the campus, and had started having sexual relations with her boyfriend; but all of her upbringing having been against that, she felt less and less comfortable about it and eventually was released from her conflict by her boyfriend, who offered not to ask her to sleep with him anymore.

Thus the current experiences, while they may be expected to have an effect on her, cannot altogether reform the structure of her conscience; nor can one say that her being the first of her family to go to college is an act of rebellion, since it was after all accomplished with a good deal of sympathetic help from others. Her preference for shy figures is a natural support for the long and consistent list of prohibitions with which she struggles—but the sense of struggle is there, not only in what I have already described, but also in the matter of body presentation. She is normally modest and attempts not to stand out, but her answer to the question about how she dresses begins with a knowing giggle (and ends with a reaffirmation of the usual state): "You know, it's really strange. Sometimes I get up in the morning and I feel like dressing up, like wearing a dress and nylons and so on. And I do it, and I really feel comfortable, I really feel good—I don't feel that way too often—and I get a lot of compliments that way. But most of the time I put on pants—something I am comfortable in."

The same ambivalence—again weighted toward shyness—is expressed in her reactions to the pictures which illustrate this chapter. She sympathizes with the *Sleeping Satyr* for example, insofar as she can perceive him as giving in to his feelings in private, but she adds that she would not like to see him in public in that pose. And she identified readily with the *Nude Seated Before a Curtain*, saying, "I like this. She seems to be alienated and remote, which is something I can relate to." But nowhere is

the combination of wish and defense so clearly shown as in her description of the *Aphrodite*: "I like this one, too, because she is revealing her body but at the same time she isn't. She's covering herself but she doesn't have anything on. It reminds me of a conflicting value in myself."

Her taste in nude figures, to put the matter more exactly that I have managed so far, serves at the same time a supportive function for her prohibitions and as a symbolic expression of needs against which the prohibitions are successfully deployed: the defense-supporting function seems stronger and would, in purely correlational research, make her appear as a shy person congruently preferring shy poses, but the ambivalence is made clear to us. Perhaps it might even be said that the ambivalence gives her esthetic choices their life.

Katie, another shy preferrer, was brought up in a home whose restrictions, though present, seem neither prominent nor remarkable. Her life with several stepfathers, and the consequent frequent moves around the country, set the tone for the impression she makes on her interlocutor: that of a person whose movemented experience is reflected in her unclear sense of self. I have chosen to speak of her because her ambivalence takes on a particular cast, that of not always knowing what she is feeling, and as a result making statements which easily contradict each other.

Katie's prominent feeling, as expressed from the start of the interview, is her love and admiration for her mother. There are two dimensions to her strong feeling: the gratitude for a continuing sense of support no matter how turbulent the life situation, and an indentification with the mother's good looks and ideal femaleness. This feeling exists side by side with some strongly worded criticisms, but the latter do not produce in Katie any pronounced sense of ambivalence; rather, the positive and negative are kept apart. One might have expected her mother's disapproval of all her friends to be one of those continuing irritants which would give a growing child an easily recognized ambivalence, but here it is subordinated to the strong identification.

It is not perhaps a total contradiction for one to feel at the same time expressive and shy, but Katie sees herself quite strongly as both. After describing her mother as self-contained, she draws a contrast with herself: "I'm really a very emotional person. I express my emotions a lot. I cannot remember at all ever being told to calm myself down or stop my emotions from showing at all. . . . I always felt that emotions are the richest part of our make-up and that you should tell people how you feel about them." But in groups she is an introvert; in her words, "in a group I just try to melt in. I don't try to push myself forward, especially in sexual competition. If somebody tries to move in on me, I just back off. . . . I try to stay at peace with

myself; I don't want to get all excited and go off on tangents. I am a very mellowed-out person—for example, I don't like really loud music." And in response to questions about confiding in people, she makes clear that she finds it hard to do, and prefers to keep areas of her experience entirely to herself.

Whether Katie's view of herself is contradictory or not, it is certainly not tightly consistent; and similar inconsistencies may be observed in her relation to bodily narcissism and exhibition. Nudity, for example, is not only accepted by her but enjoyable: she suns herself in her backyard and works there nude, and it doesn't bother her at all that all of her boyfriends' buddies have seen her nude or that she has seen them nude as well; to be able to do this, however, she has had to accept consciously the plumpness of parts of her body about which she used to feel hesitant. During her childhood her mother had set an example of modesty in the household, but Katie felt free about nudity herself until—as she perceives it—her stepfather became sexually aggressive toward her; at that point she started being careful. When it comes to dress, she is more particular, in that she dresses to conceal the plump parts and to achieve a neat appearance; and in a way she connects dress with the condition of the body when she says, "I don't see any reason for letting the body deteriorate in clothes that are deteriorating." Her relation to mirrors is similarly ambivalent: having sworn some time ago that she would never have a mirror in the house, she has begun regularly to look in the one she has in order to see if she is holding the correct posture and to watch her hair grow out from its present too closely cropped state. While convinced that she doesn't use the mirror for narcissistic self-confirmation, she does admit that she and her boyfriend look at mirrors very often.

Part of the vaguenesss in her experience is reflected in her dependence on her boyfriend for definitions of her own interests; she is very close to him and finds her relation to him a most important part of her life, but she cannot help but notice that her own needs and wishes are defined by that relation. While I am unclear as to who is the protagonist in the pair, I note that many of her current tastes and preferences seem validated only by being shared. The sense of incomplete distinction from another person was observed already in relation to her mother; her sense of identity with her is reflected in the comparison she makes in their relation to their men: "I see her in me. When I am interacting with Tom, I see the way she is with Jack, her husband. And when we go visit them, it's really strange, because I see her doing the same things I do with Tom—but I know I got it from her, she didn't get it from me."

In esthetics her experience is as ambivalent as that of all the other subjects of this study, but ambivalence is a luxury one can well afford in the arts; and in the dimension under analysis, ambivalence appears to be indispenable. Thus the exhibitionism of the *Sleeping Satyr*, while apparently

contrary to her tastes in general, is made acceptable by being denied and integrated into her own experience of sunbathing: "I don't know if this guy's really cocky and it doesn't look to me as if he's trying to show off his sexual organs, but he's just sprawling there in the sun. So I appreciate that's he's not restraining himself." But modesty is the virtue in the *Aphrodite*: while professing irritation at Aphrodite's covering her body with her hands, she first excuses the action because it is unintentional, and then relates it to her own fantasy: "The cherub might have come into her room and she is trying to hide herself from him so he won't go and tell all the people she is really quite fat."

Now if I have emphasized Katie's vagueness it is because vagueness pervades her experience; I have not done so to suggest that it forms the specific context of her esthetic tastes but rather to show that it underscores an ambivalence I believe to be general on this dimension. Like the other subjects she vacillates between modesty and exhibition, but unlike them the vacillation is part of her experience of her whole world. The issue of modesty and exhibition goes back at least to her sexualized perception of her stepfather's presumed aggressiveness, and is handled at present by an apparently uninhibited nudity—and a modesty in her self-disclosures and shyness in her esthetic tastes. Nor is the ambivalence absent from her attempts to guess whether her tastes among the nudes run to the exhibitionistic or the shy: she actually guesses wrong when she says, "My preference would be for the subjects to be proud of themselves, not to try to cover themselves up, but whatever they are, just to let it show."

When one looks at the self-perceptions of the exhibitionistic preferrers, one finds that they guess wrong about as often; their guesses argue, as did those of the males, that a very similar ambivalence is animating their experience of these works of art. Nor can one find pronounced differences in the fantasies which the works of art have inspired: both groups can take pleasure in exhibitionistic and shy displays at the same time, the only difference residing in the preference they eventually express. I have tried to show that among the males the exhibitionistic choice was dictated either by a rebellion against parental prohibitions or an assertive defense against an uncertain masculinity, or both, and have shown so far that the women had proclaimed their independence equally firmly. But is their femininity involved in what might be termed the "exhibitionist protest" as well? I think that the evidence will show rather clearly that it is, albeit in a manner which seems more diffuse than that of the males. I have chosen to present two cases which vary in the strength of the parental restrictions, but have in common an assertion of self—either a bouncy one, established early in childhood, or a withdrawn and tenacious one, established reactively. The subjects are useful for purposes of

illustration by the clarity with which they can fantasize about works of art, but in the outlines of their development, as well as in the engagement of their body image, they are representative of their colleagues.

Maude is the daughter of parents who had firm standards for her behavior. The standards were pervasive but not crippling, and they were applied in the context of an emotional closeness and intellectual stimulation which by the time she was an adult was warmly appreciated. But the rules of behavior were quite detailed and ubiquitous, pertaining as they did to table manners, parietal hours, and other areas of family life, and they were manners, parietal hours, and other areas of family life, and they were enforced by spankings; the child might also be lectured to and reasoned with, but an additional spanking would be applied just in case. Her reaction was the following: "At the time I hated it, but looking back I know that a spanking was the only way to keep me from doing it again, because I have a mind of my own and when I was very young I started exhibiting it. And when I wanted to do something, I would do it, and only physical punishment would stop me." But though an old child, she was not alone in her rebellion: she and her father had always felt very close and were known to take sides against her mother, so much so that when her mother would get angry at her and slap her, she would complain to Daddy and Daddy would pronounce himself on her side.

There grew up then a very strong bond between father and daughter which is felt even today. While capable of detecting qualities in him which she does not like, such as his rigidity and conservatism, she holds him as an ideal: "I am super close with my father. I try to overlook anything that disturbs me. . . . I find that he's a very good person, very kind, warm, understanding person; he's extremely intelligent, and I look up to him for that. I think everything I look for in a male is an attribute that belongs to my father." Her feminine ideal, curiously enough, is not her mother but one of our own shy preferrers. But if her mother is not fully her ideal, she does love her, objecting only to her similar conservatism and rigidity, but admiring and identifying with her extraversion: "She can meet people quite easily. . . . She's funny, and when things are bad she can always perk up a person. . . . I am like my mother in that I can make friends pretty easily, and I am like my father in that I like to think things out and really give time and consideration to thoughts that interest me."

Her upbringing with respect to modesty was rather lenient—which is perhaps surprising in view of the exactitude of other standards—but that did not prevent Maude from formulating anxieties about bodily exposure. The household atmosphere is easily described: "I go around nude even when I know my mother is there and even if my Dad's there, but I don't go around to where he is sitting. My mother gets out of the bathtub and walks around the

house, decides what she is going to do, and then she puts a bathrobe on." But
nudity outside the family made her very uneasy; she recalls, "In seventh
grade, the first time you have to take physical education with a bunch of girls
and take showers, at first I really felt embarrassed. . . .I was dreading just
having to take my clothes off and having all these people around me. . . .It
was very traumatic." And even today she is easily embarrassed by being
asked to do something in public which she finds easy and pleasurable in
private, such as expressing herself by dancing to music. Her view of herself as
extraverted is circumscribed—for the outsider—by these hesitations and
embarrassments, just as it is limited by her acknowledgment that she has
always been shy with boys; with the boyfriend to whom she is very close she
is gradually becoming expressive, but the progress is gradual and confined to
the one relationship; nor is it necessarily stimulated by her boyfriend, who is
very shy himself.

Part of her public inhibition has to do with her very negative view of her
appearance. In response to how she feels about her body, she replies, "I hate
it. It's the one hangup I've always had. . . .I've always felt rotten and I've
always felt too fat. [Because of a women's studies class where we explore how
we feel about our bodies] I've come to the point where fatness and thinness
isn't the main thing but I really haven't come to what *is*. I guess I don't have an
awareness of my total self; I think of myself in parts." Her view of her body in
turn influences her way of dressing; while she will occasionally dress up to
impress a male, she is normally not comfortable doing so; when she wears a
dress or a skirt, she feels afraid that people get the wrong impression of her,
thinking "Oh, she's out to get the boys." In a way she has given up either
trying to reveal her body in clothing or to conceal it: "I am big on top and I
am big in the hips and it's really hard for me to find something that will
conceal both. I just say, 'forget it.' I am going to wear what I feel comfortable
in."

But her fantasy, whether elicited by art works or not, can give
expression to her exhibitionistic wishes quite clearly. The wishes are fairly
inhibited as far as women's bodies go, because—in her insightful view—she is
dissatisfied with her own body; thus she does not like Renoir's *Bathers* for its
subject matter, but when asked to make up a story about the women she gives
them the capacity to fulfill their wishes in a manner she cannot permit
herself: "They're flaunting themselves, feeling very proud of what they are
doing, and having a good time." Her powerful embarrassment fantasies can
only reflect the strength of the exhibitionist issue which underlies them: "The
only way I daydream of being embarrassed is being caught without my
clothes on by a bunch of people. I have a friend in another dorm, and the
bathtub on the floor doesn't work, so she has to go down to the men's floor.
She said that the door doesn't lock and that a couple of guys will come in
looking for someone or something, and they open the door and she is lying in

the bathtub stark naked. I've daydreamed about that and I think I would just want to sink down under the water." But, as she demonstrates in her reaction to the *Sleeping Satyr*, her wishes show no comparable inhibition where men's bodies are concerned: "I like it because I really think. . . .it's very expressive. I am just trying to capture what expression it is. I guess I like it because it's explicit, and I am attracted to it—physically, mentally, and emotionally. . . .I think it's very powerful." But—and such is our condition altogether too often—she feels the need to disguise her interest in the Faun's body by inquiring about his facial expression.

I think it is possible to suggest that Maude's taste in exhibitionistic nudes is the product simultaneously of wishes and prohibitions: prohibitions which are obvious, wishes which are both natural and defensive. The defensiveness seems to represent a reassurance about her attractiveness to males, and is made possible by identification with an extraverted (and bodily uninhibited!) mother, as well as by her own childhood assertiveness. And of course, the defense is not stifling; on the contrary, it seems capable of giving pleasure, in the very least at the level of fantasy. But in the next subject, whom I shall call Jane, some of the pleasure is absent and the power of the prohibitions seems never quite dispelled; I am not sure whether to attribute the greater seriousness of her struggle to her strongly internalized religion or to a less emotionally satisfactory childhood.

Jane's parents were considerably older than she, interested in their work, and absent during their working hours; she used to think that her family had been close, but in retrospect it had not, or at least it had not been warm. Her parents had psychological problems that Jane can see plainly now, so they were largely ineffective as parents, and Jane and her sister "stayed away, kept our distance, and didn't let the parents annoy us. Both my sister and I have shut my parents off and said we loved them but didn't like them." Overt affection was, however, embodied in a relative who lived in the household and became the effective mother and taught the children that expressing love was permissible. In the absence of the parents' active involvement with church, religious education was provided by a church school, and the education received there made Jane want to be religious and go to Mass regularly on Sundays. Eventually, however, the children saw that the parents' behavior contradicted their precepts, and their attendance at Mass became more purely formal and eventually stopped altogether; but their drift away did not occur until the children were older, and the lead was always taken by Jane's more independent older sister. In matters of sex and bodily exposure, of course, the parents were extremely conservative; nudity was never permitted, and even menstruation, about which Jane was once informed at school, was denied as a process which might occur in the foreseeable future.

Jane sees herself as inhibited and is not sure she can entertain the hope of breaking out of her shell. "I am fairly subdued. It's confusing— what I am and what I want to be. I see myself as being introverted and that's when I get into bad places—just depression; and it's almost like the depression comes from seeing myself as introverted. . . .I don't like being quiet, because I consider that stupid. You know the sort of person who sits in the room, says nothing, and you get the impression that either she's mellow or she's a dolt with nothing to say; that's how I see myself a lot of the time. I am afraid to just come out and talk, because I am afraid of being judged." It is small wonder that her ideal is to avoid this fate—or its opposite, which she had also tried. "I would like to feel good about myself, to be able to come out when I needed to or to be able to not have to always be performing because I've done both. I have tried performing and wasn't happy with that at all."

In her adolescence she formed two ideals for her behavior: "When I was going through the religious phase I just wanted to be holy and love everybody and never do anything wrong. And for a while I wanted to be a loose woman type of person who didn't have any character." She could not decide between being friends with the people who could go off and smoke dope and being conscientious and wanting to keep the teachers happy—and in this respect she reminds me of one of her fellow exhibitionist preferrers who, though brought up in a fundamentalist household, worked for a while as a GoGo dancer.

One might ask why Jane did not fully accept the parents' and the Church's precepts and become happily inhibited (and, in parentheses, almost certainly a shy preferrer). One cannot be definite about this, but it seems likely that her sister's independent example, and her parents' self-contradictory one, provided the necessary escape route. Of necessity, the escape was only partial, and Jane is both inhibited and unhappy with the inhibition; and her ambivalence is reflected quite succinctly in her attitudes toward her body and its decoration.

When asked what she likes and dislikes about her body, she says that on the whole she feels quite good about it because it is healthy; but as far as its appearance is concerned, she often doesn't like its youthfulness. "A lot of people react to me as a little girl child, and that frustrates me. [Of course], I give that impression; when I need to approach somebody, I come from below, as a child. So I guess I almost ask for it. And then sometimes it scares me, the womanness in my body—just being approached by men. I feel dirty, I guess—eye raped and so on." A similar oscillation between the fear of being too immature and too womanly occurs at the level of dress which, again, matters to her in a basically healthy way, but arouses in her a fear of her own attraction: "I do dress for occasions or to fit situations. . . .When I am feeling good I usually dress to emphasize or reveal. When I am proud of

being womanly I can dress like a woman, and then it gets to a point all of a sudden when I feel that I've gotten into something— yeah, pretending to be a woman—I guess accenting my sexuality, then I get scared when I realize what I am doing."

Knowing these facts about Jane, one would have reason to suppose that her taste for exhibitionistic nudes in art would support her wishes to be freer of the restrictions of her conscience. Janes's descriptions of the art works shown her makes such a wish perfectly clear when, in the first quote, she fantasies a full acceptance of her body, while in the second she wistfully comments on the knowledge and freedom which had been kept from her. She says this about Renoir's *Bathers*: "This one is neat because it looks like they are all having a good time together and they are not putting on airs or having to pretend that they are not enjoying their bodies. It's that feeling of being around other women where it's all right to talk about yourself in a good way. I've been in so many situations where it's 'I am fatter than you are; I am uglier than you are.' It's being able to—without sounding vain, without being afraid of being vain—she's expressing that she's better that this woman who's boasting or something." And about the *Aphrodite* and her covering arms she says quickly: "That's almost depressing, because she's keeping something from the child that I saw being kept from me. It's almost like he's asking a question and it's being held back in a gentle way: 'Wait until you grow up.' It's like she's expressing her inhibitions but doing it tenderly: 'I am doing this because I love you.' "

As I return to the thoughts expressed at the beginning of this chapter I am struck, first, by the surprising congruence between the explanation of exhibitionism as an instance of psychopathology and the dynamics we have been able to see in subjects for whom it is only a means of symbolic and defensive expression. That subjects of both sexes used their tastes to bolster their sense of maleness and femaleness seems well documented; we did not find castration fears in the men, but our methods were inadequate to the task; the search would in any case have been unnecessary, since it could not have told us much more about the defensive function of this esthetic preference than we have already found out. And I am struck, in the second place, by the uncanny resemblance between the exhibitionistic and shy preferrers; it is not so much that opposites have met, but that the two preferences are the sides of a single coin, the one side showing inhibitions which have been accepted, though with ambivalence, the other portraying inhibitions against which a battle is being fought. Third, I am struck, and pleased as well, by the occasional freedom from compulsion that the exhibitionistic defense can show; while most subjects seem as locked into their protest as they are by the inhibitions which have given rise to it, some, such as Jane, seem perspicacious about both sides of their conflict and capable of making an effort at solving it.

5. Notes

1. Charlene Ralston conducted the interviews and analyzed her data; for her competent handling of all aspects of the study, including the indispensably tedious ones, I am most grateful.

2. Body presentation is a term John Spiegel and I employ to designate what is more usually called body communication; the reasons for our use of the term are discussed in our *Messages of the Body* (1974). It is useful in the present context for indicating all manners of handling one's body before others, that is, the management of display and concealment, protection and exposure, whether by selection of clothes or arrangement of limbs.

6. SENTIMENTALITY AND THE CONTROL OF DEPRESSION

He has one aim, to sentimentalize and beautify.
Little wonder then that what is Gothic in the brothers
Grimm is splendid and opulent in Disney. Nor
is it surprising that his vision of nature is grand and
harmonious rather than operational. Disney's art
defines a world without the rigors of cause
and effect, where we all live on that big rock-candy
mountain, and time stands still.

—Peter Michelson in *The New Republic*

Sentimentality is not a matter of esthetic indifference; for estheticians and critics it is incompatible with esthetic worth, while for at least one school of psychologists it is symptomatic of psychic ill health, and therefore of stunted creativity. In this respect sentimentality is not treated as generously as, for example, a taste for masculinity or exhibitionism might be; the latter are viewed as matters of personal preference, while sentimentality is seen as an esthetic error.

I have no quarrel with that view, but in agreeing with it I speak as a private individual with personal views rather than as a psychologist with an obligation to understand. My function here, and my wish, is to place the taste for sentimentality in the context of the individual's psychological functioning, and to contrast the taste for sentimental nudes with a taste for nonsentimental ones. In so doing I wish to avoid taking sides for or against one or the other taste, and I am aided in that wish by the suspicion, founded on the results of the studies presented already, that any extreme taste will serve the needs of ego-defense rather strongly—even a taste for nonsentimental nudes. The subjects who kindly gave the interviewers of their time may have the satisfaction, if they come upon this report, of knowing that they have contributed to the elucidation of mechanism

167

present in weaker form in people whose tastes are less consistent; but they ought to know that they were not submitting to an elaborate form of criticism.

Everyone can spot a sentimental picture, but it is less easy to define just what sentimentality consists of. In the most obvious instances, a sentimental pose includes a smile and a slightly cocked head; the feeling is one of tenderness rather than robust love, and the impression one has is of robut love bleached to the level of mere sweetness. But a sentimental pose can be tender in other ways as well, as by presenting mere sadness in place of anxiety, terror, or grievous loss: hence the sentimentality of pictures of little girls mourning tiny dead birds, or of angels—usually big girls—mourning ordinary-sized dead people. But if a sentimental picture can represent either happy or unhappy emotions, it has the distinguishing aim of denying their rough edge and intense degree; small wonder that it accomplishes the aim so often by choosing small versions of big events— little children in adult settings. Now if this characteristic defines sentimentality, there must be two ways to be nonsentimental: either to avoid emotion altogether or to face emotion without flinching. In the usual sense of the term, nonsentimental people are thought to be of the former kind, that is, dry and direct, but clearly those who accept unrelieved emotions (who might be termed "wet and direct") must be called nonsentimental, too. In speaking of the group which opposes those with sentimental tastes, then, I will adopt the briefer term "direct."[1]

The one school which has been concerned with explaining sentimentality, at least in the creation of works of art, is the Kleinian school of psychoanalysis. I have presented the portion of the views of Hanna Segal which is of most central concern to us in Chapter 1, and need only summarize it here; her views provide a direct framework for the study of sentimental tastes as well. Two variables are of central importance: the destructive urges one feels as an infant toward the mothering figure, which are universal, and their consequent turning inward against oneself, which is ubiquitous as well. (From our point of view there is no sense in searching for either the urges or their fate, since both are present in everyone's life.) But it is the manner of handling the inwardly turned destruction which differentiates people: those who accept the outcome experience depression, which, though unpleasant enough, has the advantage of motivating one toward acts of "reparation" for the destruction wreaked by the urges in fantasy, while those who do not accept it feel an artificial euphoria which is termed by the Kleinians "manic denial." The first group has a foundation for creative acts, while the second engages only in a defensive denial of an unpleasant reality; it is the latter which has a taste for the superficially pretty. The former group can appreciate the genuinely beautiful, which carries within it the traces of destruction and depression which have been its source in the first place.

Now there are aspects of this analysis which cannot be tested by us and which can therefore be considered irrelevant from the present point of view; we can never have insight, for example, into our subjects' earliest affective lives, all the more so as we have found it difficult to look adequately into their later childhood. But the earliest handling of aggression should set the stage for later handling, and we should expect a denial of depression to be characteristic of sentimental preferrers in their adulthood as well. Or we

might reason about the matter purely from the adult's point of view, without implying the existence of a similar mechanism in infancy: we might simply assume that any denial of depression will lead to a taste for sentimentality. And because a denial of depression seems necessary only if one is afraid of the destructive urges to which it gives rise, we should also expect the sentimental preferrers to deny aggression, or to feel anxious about it—whether it originates in them and is directed outward, or whether it comes from the outside and is directed at them. As far as the direct preferrers go, the Kleinian theory allows us to make one clear prediction, namely that they will accept depression—not only accept it in principle, but feel it from time to time in reality. But because we have good reason to assume that direct preferrers are of two types, those who prefer to experience emotion fully and those who prefer to deny it, we cannot expect uniformity beyond the acceptance of depression; we must expect some to accept their aggressive drives, others to accept their affectionate ones, and still others to accept both or neither.

The subjects for this study [2] were drawn from the same pool as those of the preceding, that is, from the 200 or so who had scored below the median on Child's test of esthetic judgment. The core of the interview in which they participated was standard, of course, but two areas were explored of specific potential relevance to sentimentality: the handling of depression (events one considers depressing, the severity and frequency of depressions, steps taken to alleviate depression), and the management of feelings of dependency. The management of aggression was explored more thoroughly than usual, with more questions covering its acceptance, expression, and symbolic use, and an exploration of the range of the subjects' anxieties was attempted. Toward the close of the interview the subjects were asked to comment on examples of sentimental and non-sentimental nudes, which included Canova's *Three Graces* (Fig. 17), a Hellenistic *Gladiator* (Fig. 18), Manet's *Bather* (Fig. 19), Falconet's *Nymph Entering Bath* (Fig. 20), and a Roman *Orator* (Fig. 21). Because the interviews had been carried out without knowing the subjects' preferences, and because the analysis was itself blind, the study was not replicated; the results are based therefore on twenty interviews (of which one turned out to be inaudible on tape, thus reducing the sample to nineteen), and, there being no noticeable sex differences, the results will be presented with the sexes combined.

Aggressive Drives

If one asks subjects whether they can express anger, one finds them saying "yes" almost as a matter of course; in circles which are conversant with modern psychology an ability to express anger is considered healthy and appropriate. But if one looks at less direct indices of the experience and expression of anger, the image of anger expression is no longer stereotyped, and one notes among the sentimental preferrers a greater

Figure 17. Canova. *Three Graces.* Hermitage. Alinari—
Art Reference Bureau.

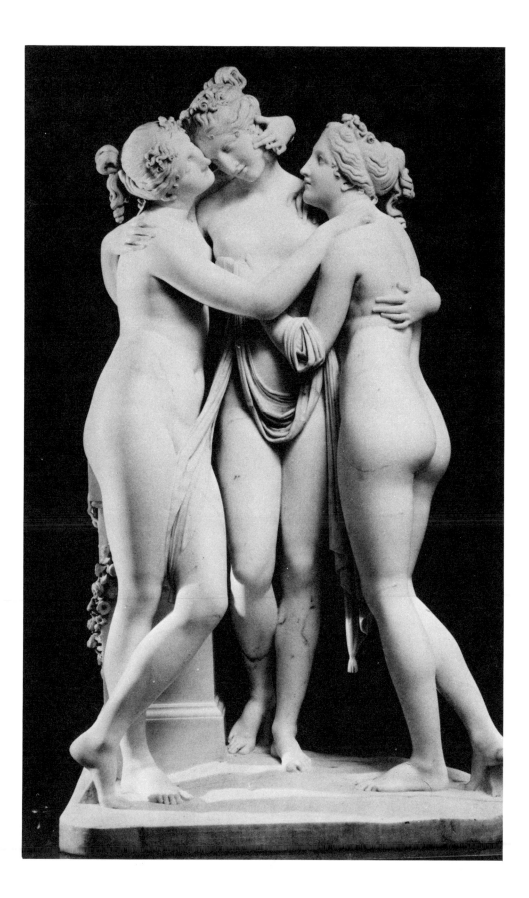

Figure 18. Hellenistic. *Borghese Gladiator*. Louvre.
Cliché des Musées Nationaux.

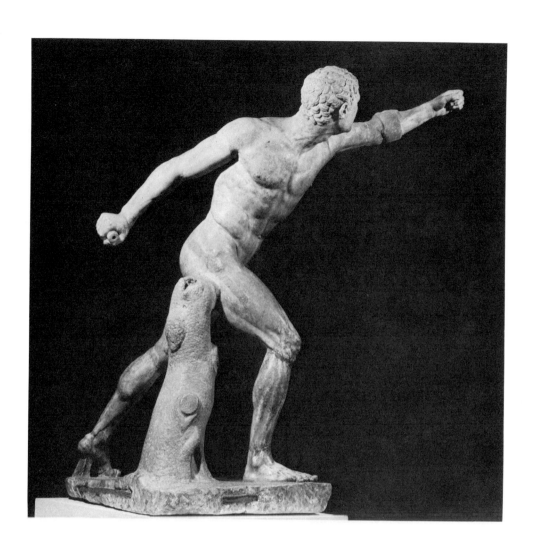

Figure 19. Attr. to Manet. *Bather*. Museum Boymans—van Beuningen, Rotterdam.

Figure 20. Falconet. *Nymph Entering Bath.* Louvre. Cliché des Musées Nationaux, Paris.

Figure 21. Roman. *Roman Orator.* Louvre. Cliché des Musées Nationaux, Paris.

difficulty in experiencing and showing anger than among the direct preferrers: only two of ten, for example, can find anything to criticize in a parent toward whom they have expressed affection and admiration, only two tolerate violence in symbolic form (as in films), and only four report that they are capable of experiencing aggression as a physical feeling, as in wishing to strike someone; and when it comes to a decision between noticing others' bad points or ignoring them, six say that they prefer to gloss over them.

Their difficulty in expressing aggression is illustrated by statements such as the following: at one end is a subject who rarely even experiences angry feelings ("I get angry very rarely"), closer to the middle is the subject who does not experience anger often and feels his inability to be a deficit ("I don't experience negative feelings enough; I shut down and shut my family out"), while the most typical are those who experience anger occasionally but prefer to control it ("I am not inclined to feel anger against people; I sometimes feel physically angry but something occurs to me. It's usually a very vague feeling; I don't look at someone and thing 'I'd really like to clobber you.' What do I do about it? A lot of physical activity, like weight lifting; it takes a lot of it away").

But it would not be correct to imply that the fate of anger among the sentimental preferrers is repression: rather, with some exceptions, they are capable of feeling anger but would prefer not to. Their distinguishing characteristic is anxiety, either about anger or the consequences to which its expression might lead, rather than a complete elimination of it. The girl who readily admits to occasional but strong feelings of anger illustrates the anxiety more clearly than her somewhat more controlled colleagues: "Sometimes I say, 'Ooh, I really want to kill somebody'; I feel like grabbing someone like that, just going like this to them. Sometimes I wish I could hit my head, just to make it go away." That anxiety about aggression is the problem rather than repression is also emphasized by the number of sentimental preferrers who had experienced parents' anger as children and grew to fear it; in the experience of one subject, the fear is easily pinpointed ("When I was younger I was afraid of my dad because he was big—a person who controlled my life style; you're afraid to totally let loose on a person when he's boss"), while in the life of another it is more diffuse ("I avoid arguing because I have experienced a lot of it [on the part of my parents]. And I fear explosions; I used to be afraid of balloons because they would pop and explode outward"). In the clearest report the anxiety was felt about one's own wishes to retaliate and the destruction they were likely to cause: "For some reason I had a heavy trip about never saying I hated them. I remember saying it once to mom—I thought she would die. It's something I learned when I was little, maybe at church; I used to go to church a lot." And the fear that the anger would kill developed in spite of the mother's attempts to make her daughter a self-assertive person, one who would not easily be victimized by others; it is quite likely, of course, that what the mother succeeded in teaching was her own fear of victimization. In any case, the daughter's primary fear now is of the dead: "I fear anything occult, anything having to do with evil. Spirits that are dead, witches, black magic, ouija boards. I had a series of bad experiences: I was told by people that I have those powers, and that scares me. I believe in the under world, the dead world; those people need to settle things in this world, and they need to use you." But it is characteristic of the sentimental preferrers that

she would prefer not to assume ill intentions, even on the part of the dead; she goes right on to say, "They don't mean to hurt you, but they can. I don't want to mess with the unknown at all."

The direct preferrers, on the other hand, are more tolerant of aggression and less anxious about it, but that is not to say that they express it readily. They are more ready to criticize parents even when their predominant feeling is one of liking (five of the nine do so, while only two sentimental preferrers had), four tolerate violence in symbolic form, and fully eight can experience aggression as a physical feeling; and seven prefer to note bad points about people rather than ignoring them.

But the difference is one of degree, not kind, and by itself hardly explains why these subjects' tastes should be direct rather than sentimental. Certainly substantial control over aggression is exercised by most of the subjects ("No, my aggression is controlled; reading music and practicing [drums] is really an outlet for me and then I don't think about anything else"), and some anxiety is felt about it by at least a few ("I feel guilty if I get dad excited, because he could have a heart attack; I have to stifle my feelings so I won't get him upset. But with others I can get angry"). But if by these criteria a number of the direct subjects, resemble the sentimental preferrers, it should be noted that all but one of the nine can accept symbolic portrayals of dominance, forcefulness, and even aggression in art, as long as it is not violent ("I like the force, the blind force of the *Gladiator*"), and that four subjects, as noted, can even accept violence; the view of all but one of the nine is, in the least, that aggression can serve an important function in art provided that is it integrated into a broader framework of intent, while the four who go further can even experience limited acceptance of, and at times attraction to, violence which serves some other end than itself. Two subjects go well beyond the limits accepted by the sentimental preferrers when they indicate that the experience of violent feelings is inescapable: one can accept them if they serve desirable social ends ("I could definitely get angry to the point of violence over some social problems, but as far as being a physically aggressive person, no, I am really not; I have the potential, but I am really not"), while the other has experienced them in relation to her own family ("My relation to my mother is very violent; we pound on each other").

The difference between the sentimental and the direct preferrers in the handling of aggression may be expressed in the following manner: the sentimental subjects are anxious about it and prefer to suppress it, while the direct subjects range from those who suppress it as a matter of course to the few who can express it on occasion. But all but one of the direct subjects can place aggression into some acceptable context, either in art or in life; they seem more readily able to admit that it exists and that it requires some expression. Aware of a more complex psychic reality, they at least attempt to understand it ("I don't have the really strong feelings of people who watch violent things like football, but I can understand the feeling"), or they may find a useful place for a toned-down version of it in their own lives ("My roommate and I absolutely can't stand each other; it doesn't bother me in the least").

Expression of Affection

Because sentimental representations so often portray sweet affectionateness among people, one might expect—certainly on the congruence model of esthetic preference—that sentimental preferrers would be as expressive of affection as the pictures they enjoy; and such an expectation would be backed by a body of research respectable both for its size and methodological care. To maintain the opposite expectation might seem an instance of blindness to facts and irrational adherence to Freudian theory.

But we have seen already that tastes which appear congruent with personality may be congruent on the surface only, and reveal complexities of impulse and defense for which the simple model can be altogether inadequate. I have not turned around, of course, to maintain on the contrary that all tastes are compensatory; the theoretical picture which the findings permit to sketch so far only allows me to insist on some degree of "surplus" or unmet need, existing on top of a need which may be satisfied, which makes an esthetic choice necessary.

It comes as a surprise, then, that none of the sentimental preferrers find it easy to express affection. Many of them say that the expression of affection is a particularly difficult task; whether they had had an affectionate parent or not—several of them had mothers whom they characterize as warm and loving—they are themselves quite inhibited. Their inhibition ranges from a quite total one ("I have the hardest time of anyone in my family in expressing affection") to a partial one ("I really like being with people and getting close to people; but I guess [in fact] I keep too much to myself sometimes"). Without detailing further instances we find the picture surprisingly uniform, and in marked contrast to the liking for affection in *symbolic* representations: five of the sentimental preferrers very much like romantic stories while none of the direct preferrers do, and all ten seem very pleased by the close contact, gentleness, and love which they see as the dominant feeling in Canova's *Three Graces*.

The search for affection in sentimental art is then clearly compensatory to the inability to express affection in reality and—a point on which the subjects are also clear—to a distinct wish that affection might come easier. It is perhaps not necessary at this point to understand why, in spite of occasional affectionate models, these subjects should feel inhibited, although I shall attempt to do so presently; but it is important to note the compensatory relation, as it is necessary to point out that by other methods—for example, correlational ones—the compensatory relation would not have been noticed. The simple fact is that by the correlational method the expression of affection and the need for its symbolic representation appear unrelated: the direct preferrers have, with two exceptions, just as much difficulty in *their* expressiveness as the sentimentals. Our reasoning had certainly prepared us to find some direct preferrers inhibited and others not, since we expected some to reject all emotion and others to prefer

direct expressions of it; while we had not anticipated the majority to be inhibited, we were prepared for the variety that was, in fact, observed.

I must make clear why, in the case of the sentimental preferrers, I would defend the position that their need for affection symbolically represented is compensatory when, by the use of another method, I might have concluded that it bears no relation to affection as actually expressed at all. I do so not because I reject the correlational method; on the contrary, it has an indispensable place in social science generally and in the psychology of esthetics in particular. I do so because the correlational method, when applied to differences between individuals, can only tell us how two variables are related externally, that is, in the group that one is studying. That is valuable knowledge, and one that I rely on heavily whenever I find differences between groups. But the method cannot tell us how the variables are related internally, that is, within the internal structures of the individual; it cannot tell us whether a difficulty in expressing affection may be related *either* to sentimental *or* to direct tastes, because that relation is here judged from the evidence of internal coherence rather than external connection. The difference between the one conclusion and the other is a matter of which connections one chooses to attend to; and there is nothing in any broad view of social scientific method to suggest that only one set of connections is the real one. It seems best to me to look at the matter broadly: if an external connection is found, then one is obliged to assume internal coherence and do one's best to find it, but if the external connection is not apparent, an internal coherence may still exist. But, naturally, one does not go shooting in the dark, looking for internal coherence whenever an external one is absent; one is usually first alerted by an unusual observation, such as that almost all of one's subjects experience problems with affection when in the population at large quite a number of people must express it satisfactorily— or that all the subjects whose preferences lie on the dimension of exhibitionism and shyness experience modesty as a problem—and from this remarkable fact one searches for further internal evidence which would establish a functional dependence.

Now I have not made this second and indispensable search on behalf of the sentimental preferrers as yet, and I must do so. But the attempt will be easier after I have reviewed the fears which our subjects have unexpectedly revealed, and because their discovery was unanticipated, I shall discuss them after I have presented the difference in the acceptance of depression for which we have been prepared.

Handling of Depression

A taste for sentimentality is explained in Segal's formulation as the effect of denying depression. Our subjects illustrate her prediction very well in one sense at least, in that almost all of them—the sentimental preferrers, that is—dislike depression in art; the one

exception will be discussed later. To them Manet's *Bather* looks unhappy and depressed and they dislike that; but it is not only depressed nudes which they dislike, it is also narrative art such as the movies. A number of them commented on their dislike of *The Last Picture Show* and other films whose depressingness they found it hard to tolerate; on the contrary, almost all of them prefer comedies because they entertain and permit the subjects to leave the theater in another mood than depression, and almost all also like romantic love stories such as the recent viscous prototype, *Love Story.*

But this intolerance of depression in art is not necessarily matched by a "manic denial" of depression in life. Our data are clear on eight of the sentimental preferrers, and of these only four report that they dislike depression or try to fight it when it occurs; the remainder experience depression perceptibly, even if only occasionally, and appear not to strain to avoid it. In fact, it must be said that, contrary to what I would expect from Segal's description, none of the sentimental preferrers are strangers to depression; if they defend against depression, it is at a conscious level, after experiencing it at least in part. Nevertheless, where a defense is mounted against depression, it is unmistakable, active, and pervasive: one subject, when asked about what sorts of things he avoids in life, replies, "Ideological conflicts; I would like to see society one way but it's another, and I can't do anything about it, which depresses me; so I avoid that," and when queried about the type of art that he likes, says, "I dislike art which expresses depression because I don't like it in myself, and I don't like to see it in other people. It scares me; I try to keep it out there. I worry about feeling that way and I try to protect myself from it." Another subject, who appears not to feel depression very often himself, has a close relationship with a girl who is depressed frequently and intensely; to her feelings of worthlessness, unattractiveness, and loneliness he responds by constantly hugging her, telling her that she is beautiful, and generally emphasizing all that is positive. That the process should be time consuming may be readily imagined; and that it may serve to mask a depression of his own seems highly probable.

As far as the tastes of subjects who try to avoid or control their depression are concerned, it seems justified to see them as a support for defenses which they employ normally: the avoidance of depression in art supports its avoidance in life. But since four subjects use the avoidance defense only in art, while in life they allow the experience of depression to occur, art clearly holds for them a rather special psychological status; it is as if it were the only effective defense against depression which they had found. If this formulation is correct—and in the absence of other instances, I cannot be more than tentative—then it may be necessary to broaden my conception of ego-defense support to include instances of original defense as well as the more familiar supportive defense. As far as I can tell at the moment such a special status is reserved for art only in the defense against depression; it has not been encountered where the other affects are concerned. And, by a curious coincidence, this original defense gives us our only other instance of esthetic taste as a compensation for something inadequately handled in reality.

Now the direct preferrers are very easy to describe: not only do they almost universally tolerate, or even seek out, depression in art (the two exceptions are important enough to be discussed later); they also experience depression in reality—this time

without exception—and do not attempt to avoid it. Quite apart from the nonsentimentality they search for in nudes, they can appreciate the depiction of depression in narrative art. In the words of one, "Right now I would prefer a gloomy mood in a picture, because of the mood I am in—it's the weather, maybe," and in the experience of another, "Right now I get a kind of hopeless, despairing feeling from Manet's *Bather.*" That both subjects should put their observations into the immediate present suggest that they are attentive to their depressions and accept them as they are; and perhaps their experience of depression in art is in itself a sophisticated defense, since it enables them to relive by proxy, and appear to solve in fantasy, a problem which they experience in actuality.

In effect, then, although their handling of it differs, all the subjects experience depression, and one would be curious to know whether this universality is in any way unusual. Unfortuately, I know of no comparable data which would make a meaningful comparison possible, but perhaps the relative incidence of depression is not the important issue; one can ask instead whether there is something relevant to sentimental tastes about the depression's content. The interview results favor us with an unexpected finding which clarifies both the type of depression· experienced and the earlier noted strong need for affection, which for want of another term, I call a fear of loss of love.

Loss of Love

In varying strengths, but without ambiguity, the sentimental preferrers confess to preoccupation with loss of love. Unlike the other samples in this book, all the subjects of this study were asked about what sorts of things they feared, and the question turned out to be surprisingly fruitful. Either in response to it, or in response to a query about the sources of any depressions they might have, all the sentimental subjects, as against only three direct preferrers, mention something which ranges from what one calls "a basic social insecurity" to a rather serious fear of the death or loss of loved ones. At the less intense end is a rather frequently mentioned dependence upon others or a fear of their rejection. A subject remarks, for example, that he finds it hard to reach out to people and make contact; he is scared of his difficulty and attributes it to a fear of rejection; or another notes that he struggles with dependence in that he needs people but is afraid that they might dislike him, and in any case he doesn't want to be a burden on them; still another is afraid that he will not be able to establish a strong relationship with a girl because his apparent coldness—as his friends perceive it—has prevented him from doing so up till now; yet another shows a strong social sensitivity when he says that he cares about people's feelings and seldom hears that he has been inconsiderate—and when he does, his feelings are hurt. A more severe degree of such a fear, and a more incapacitating one, is represented by the subject who says, "I am scared to get close; I will get close and

185

try to be honest, but not as close as I really could be; I have a very deep fear. It's hard to believe that people care; I ask myself, why should they care? Do they really care? . . . I can get extremely depressed thinking about how alone people are. Other people care only for selfish purposes; I think that nobody cares." The dread of not being loved seems to be quite closely related to a fear of the death of a parent, particularly when the parent has always been the subject's only source of support. "I am afraid of somebody in the family passing away—well, Mom. I know it's going to happen [someday], but I don't want it to." And a strong dependency seems to be related to a fear of swift punishment for unspecified fantasies, which one subject recalls when discussing her dislike of the *Gladiator:* "Looking at it makes me tense. It's really strong, pushing. I guess I feel a little bit, too, like the hand is going to come down. I have a fantasy where I'll be thinking about something, and all of a sudden a hand will come down and smash me; it scares me."

Now I think there is no question about the importance of these fears to the sentimental preferrers: they are very much less frequent among the direct preferrers, and they relate by their theme to the one taste which had brought the subjects to our attention. Whether they are experienced as anxieties or as depressions is immaterial; they are the substratum of a pervasive motive force which requires a constant coming to terms. The mode of handling—sometimes in life, as when the subject tries to evade depression, and almost always in art, as when he or she rejects depressing art—is the insistence on the pretty, the positive, the warm; above all, the loving and the embracing. The effort to achieve the unattainable state is often quite willful (not at all unconscious), as when a subject describes himself in these few words: "I try to think of myself as a positive person; it's a kind of creed I am adopting. It affects my answers in that I try to see something good in every painting, I try to see what a painting is saying, even when it shows brutality for example, as a positive experience"; or when another, one of the many who find it hard to make contact with others, says about himself, "I am sentimental; people affect me sentimentally—two people who are in love, people in need of contact."

These observations, although not identical with what Segal's position would lead us to expect, are nevertheless quite close to one part of it: while the denial of depression is not universal, the sense that one may lose what one loves most, or never attain it, resembles the infantile fear that one's aggressive urges have actually accomplished their aim and destroyed the objects they had been aimed against. We do not know to what extent aggression underlies the depression. We have only indirect hints, but they are inconclusive: four of the sentimental subjects had had aggressive, even brutal, fathers, who had quite early been removed from the family by divorce, death, or desertion; but the resentment which their children still feel toward them is not as unconscious as one should expect, nor am I clear whether it is directed at the aggression or the desertion. Still, the seeds of a mechanism such as that discussed by the Kleinians are present in some of our subjects' early lives.

I think it is appropriate to introduce at this point a complexity in the mechanisms by which sentimental taste is created which might have appeared puzzling if presented earlier. The complexity is forced on us by the one subject who tolerated depression in art

as well as in life. If she tolerates depression in reality and in symbols, why are her tastes sentimental? Part of the explanation is suggested by what we have just discovered, namely that the avoidance of depression seems no more important to sentimentality than the handling of anxiety about loss of love; thus an intolerance of depression is not an indispensable precondition. But there is more operating in the experience of a sentimental work of art than an affirmation of love as against depression or anxiety, and a close reading of this subject's statements, as well as those of three of the others, makes it clear: the experience can be as much a facsimile of depression as it is a reassurance of love. The point should have been obvious from the high regard in which the film *Love Story* was held, but my theoretical attention at the time was directed elsewhere; in any case, the experience our subjects seem to value is the evocation of an irreparable loss of a perfect love. I cannot determine whether they seek to control their fears primarily by seeing them realized in the lives of fictional characters from whom they are separated by the esthetic illusion, or whether the loss is sensed as a confirmation of the perfection of the love, or whether yet reassurance is obtained from the relief that a loss once sustained cannot recur. But, apart from the mention by both sexes of *Love Story's* attractiveness, four women mention in some manner the simultaneous attraction of sadness and happiness. Thus one says with a kind of wistful emphasis, "I *liked* 'The Way We Were'; it's so sad," while another changes mood from one sentence to another when describing her perception of Manet's *Bather:* "I don't like it, because I can't see the face. And it brings back memories of the way I get when I get sad—I like that." Yet another does not even need art to experience the height of bittersweet melancholy: while art helps her fantasy herself as a romantic, alluring, and elegant woman, even reality allows her to experience the quiet sadness which for her defines romanticism. She can feel the quiet sadness when "sitting in bed in a romantic situation with a glass of wine; I think that is really nice, it fits into a perfect fantasy."

If I have given so much attention to the sentimental preferrers it is because they seemed more complicated to explain. The typical direct preferrer, on the other hand, shows neither a defense against depression in life and in art, nor an overt concern about loss of love. The admission of depression is, of course, one of the instances of these subjects' directness, but the apparent unconcern about lack of love may be defensive. I cannot know, of course, whether the typical direct preferrer is concealing such fears or whether they are less intense: his or her apparent difficulty in expressing affection may suggest their presence, as does the occasional use of such terms as "insecure" and "afraid of people," but the situation seems less drastic. But if the fears are present in at least some degree, the defense against them is quite different: not sentimental tastes, but an engagement with the experience of others' depression and aggression in art, and with the complexities of everyday experience in life. One subject has never gotten over having been ugly in grammar school and having wished as a result not to be noticed; she now seeks after a breadth of experiences is art as well as in life, articulates her problems in her writings, and feels critical of any superficial intellectual analysis. Another subject, who also feels insecure, depressed, and afraid of people, experiences a wide variety of affects in and from art and dislikes hypocrisy; still another has fantasies that seem as

187

devastating as those of the most anxious sentimental subjects—she has feared the dark since she was little and fantasied clowns who turn into creepy old men leaning over her bed and throwing little swords over her, which just miss—but she seems to show no fear of experiencing a variety of feelings or understanding those whose feelings may be different from her own. Thus she appreciates a roommate who is as unlike her as one can imagine, and considers the accident that had brought them together a good experience; and her view of her sensitivities is summed up in this characteristic manner: "I don't like the fact that I am so sensitive, but sometimes it's a good thing while at other times it's a pain in the ass. It's better to try to understand things instead of getting hurt." In addition to these defenses, two of the subjects are mistrustful of others, including the interviewer and her possible purposes; the mistrust seems to build on a base of chronic difficulty in expressing affection and to be exacerbated by later experiences, as in the instance of a subject who says, "A messy relationship with a girl left a big impression on me; it makes me very wary of getting involved. I feel like I should really check somebody out first."

But the typical direct preferrer not only defends by an active engagement of affect and intellect; he or she may also use a defense which I have not yet presented, namely, an unabashed and compensatory liking for warmth and romance in art. Such a preference may at first seem too similar for comfort to that of the sentimentals, but it differs in two important respects: it is not tied to the bittersweet experience of loss and sadness and thus it retains the directness which we would expect, and it is only a part of a gamut of experiences which are valued. And it is part of the subject's self-awareness: in the words of one who likes romantic movies such as *Romeo and Juliet* because "it would be nice if guys were that romantic," "I feel overly physical in romantic situations; I want too much affection. I guess it's an overcompensation because my father is so cold."

But there is another type of direct preferrer, one which constitutes the exception I had noted earlier. It is exemplified by two subjects, neither of whom tolerates depression in art—an exception which seems rather major in view of the generalizations I have made so far. It should be said first that the substratum of this intolerance is similar to that of the most anxious sentimentals, that is, a strong fear of loss of love; one of the two subjects is very depressed when he does not have a girlfriend and anxious about losing her when he does—as well as jealous, dependent, and vulnerable. The other has many fears, which she mentions readily, the principal of which is that of people dying (for example, her boyfriend), and which in their entirety are summed up as a fear of whatever might happen next. With such a substratum, one would wish to know in what sense these subjects' tastes may be considered nonsentimental; and one's suspicion turns to the theoretical introduction in which it was presumed that some subjects would have nonsentimental tastes by virtue of avoiding feelings—"sentiment" in the broad sense—altogether. That turns out indeed to be the case: the first subject, the son of artistically sensitive parents, responds only to form to the exclusion of content; his capacity to respond to form reflects the sort of perceptual differentiation to which he had been exposed, but his inability to respond to feeling in art is consistent with his fears and inhibitions in life. He is quite aware of his reactions when he says, "I'm not so much concerned with the feelings of the people in the picture. I don't do that; I don't

intellectualize about the people in the picture." The second subject, who does not have the benefit of exposure to formal analysis, avoids feelings just as consistently; she prefers Picasso's *Three Graces* (not shown) to Canova's, for example, because they are more rational, and because "such affection [as in the Canova] wouldn't be a spontaneous thing for me." Interestingly enough, her philosophical outlook is a fatalistic one, in that she believes in predestination: "Whatever happens is supposed to happen; there is a plan, things have to have a reason. I try not to worry about stuff or regret actions, because whatever you do, that's how it's supposed to be." If she had not told us that she fears "whatever might happen next," we would not necessarily guess that her belief in predestination serves to control those fears.

These, then, are the principal emotional dynamics underlying the tastes of the sentimental and direct preferrers. They argue for the power of the interpay of need, or fear, and ego defense in determining the role which one will allow art to play in one's life; but, as one gathers from the subject whose capacity to attend to form allowed him to escape emotional involvement with art, they do not quite exhaust the observable differences between the subjects. I turn therefore to a brief discussion of three areas of functioning which play into these tastes as well: religion, interest in art, and cognitive complexity.

Other Differences

The sentimental preferrers are religious, not only in their upbringing—nine were brought up in a religious atmosphere, of whom six are Catholics who for the most part went to religious schools—but also in their current beliefs; eight believe in God at present. The preponderance of religion in their upbringing is clear, but its role in their sentimental tastes at present is not; we may speculate that religion conveys the sorts of prohibitions against expressions of anger and affection that we had found important, or that religion tends to deny the negative sides of existence and emphasize the positive and uplifting, or that religion—Catholicism in particular—conveys its moral messages by sentimental imagery, but we cannot be certain on the present evidence; probably several of these influences, as well as others, are at work.

The role of art in their lives is, on the other hand, clear: they are quite uninterested in art either as consumers or as producers. It is perhaps for this reason, at least in part, that they respond to art primarily for the subject matter is portrays and feel unable to discuss it in a formal sense; neither a present interest nor a past exposure leads them to attentiveness to form. But I think it would be an error to assume, as one might, that only the lack of past exposure to art leads them to "retain" sentimental tastes; because, as well be apparent shortly, most of the direct preferrers were also untutored in art as they grew

up, the choice between sentimental and direct tastes seems more a matter of correspondence with personal dynamics than of mere exposure to art. And that choice is also consistent with the subjects' predominant style of thought: the sentimental preferrers seem noticeably simpler in theirs, and not only in their reacting to art works by content alone. They are, for example, less detailed in their responses to the interviewer's questions, more inclined to judge nudes by their conformity to ideal proportions, and, perhaps most important, intolerant of that which they cannot readily understand. When asked about likes and dislikes in art in general, one subject replies, "I dislike fuzzy things, things that are semi-realistic or semi-abstract," while another says, "I like to have things presented instead of having to think; when I go to a movie I like to be entertained." An attitude such as the latter characterizes nine of the subjects; the remaining one shows himself a complex thinker in most areas of his involvement, but in the one matter of self-image he does prefer the relative simplicity of seeing himself as a purely positive person.

In all three characteristics the direct preferrers are quite different from their sentimental counterparts. Only their religious backgrounds show some similarity—six of the nine have religion in their upbringing, but only one was educated in a religious school—but their current beliefs are certainly different: only three believe in God at present. Again, I am unclear about the role that the absence of religion, or a break from religion, plays in their direct tastes; at the very least it is consistent with their refusal to emphasize the positive at the expense of the negative, as well as with their greater cognitive complexity. The subject who was raised in a religious school and was quite inspired by its rituals at ten years of age provides a type of test case: at thirteen she became disillusioned and after a conference with one of the nuns turned away from organized religion altogether. She is one of the two who value the contrast between themselves and their roommates for the complexity of experience that it provides.

As I have implied, the direct preferrers are also more cognitively complex. Not only can they better distinguish between a work of art and the thing that it represents—seven of the nine readily make such a distinction as against only two of the sentimentals—but they are more ready to give detailed answers to the interviewer, they do not criticize the nudes for their bodily proportions, and they give some evidence of preferring cognitive challenges. (The two direct preferrers who are judged as cognitively simple are also intolerant of depression in art; it will be recalled that they also altogether avoid the experience of feelings through art.) Some of the evidence for their complexity is gathered from what they say about themselves in general, as in "I like going places, because it's something unknown—a challenge," but more often it is seen in their manner of talking about art; and it should be noted that their complexity is judged not from their habit of applying well-rehearsed distinctions, but their ability to adopt multiple points of view in quick succession. Thus one subject distinguishes between what attracts him and what he judges to be of value when he says, "I like this one [Falconet's *Nymph Entering Bath*]; the way the eyelids are partially closed is very graceful. There really isn't much to it, it doesn't really impress me, but I do like it." Another subject remarks about the nudes he had seen in the preference test, "I am happy that on the test all were not Venus types; there are so many different kinds of beauty," and later indicates both a tolerance for his

own complexities and an attraction for the unclear when he comments, "That [Manet's *Bather*] I like, I am not sure why. It's not consistent with what I said about three-dimensionality and realism, but this kind of thing I could really put a lot of thought into. There is so much in the shadow, the way she is sitting, what she is doing. I could really associate a lot of things to that." Now some of this complexity appears consistent with the greater interest that the direct preferrers show in art; four engage in the visual arts or music, while another two were brought up in homes where art was valued. But the consistency is only partial, since some of the subjects who show the greatest complexity of thought have never practiced any art, and one of those brought up in a cultured home is one of the simpler thinkers. And finally, among the complex thinkers there is a dislike of indirectness, dishonesty, and hypocrisy: they are repeled, for example, by the drapery in the Falconet *Nymph* and in Canova's *Three Graces* because it is too artfully conceived and placed, and because it serves no intrinsic purpose—only the extrinsic one of satisfying public opinion.

In schematic form, the sentimental and direct tastes of the subjects studied here are determined by the following interplay of need and defense: the sentimental preferrers are anxious about aggression, unable to express affection, and vividly concerned about loss of love. Their defense against these inhibitions and fears is a denial of depression—sometimes in life and almost always in art—and a willful affirmation of the happy and positive with an occasional savoring of facsimiles of depression through tragic losses of ideal loves. The affirmation of happiness in art serves a clearcut compensatory function, one which for some of the subjects is consistent with their compensatory defenses in life; but for those who cannot deny depression in life the only compensation is art. The defenses are mounted sometimes, but not always, against a turbulent and unstable home situation which involves the loss of an aggressive father; at other times the insecurities have other origins.

One subject was singled out because, unlike her colleagues, she disliked comedies and seemed attracted to depressing subject matter; her sentimental tastes turned out to be of the bittersweet rather than the merely happy variety. Perhaps it could be added that her depression seemed more severe than that of the others and that as a consequence a simple denial of depression in art might have flown in the face of too insistent an inner reality.

The direct preferrers are more diverse; we may speak of a core of dynamics with two variants on them. The core is constituted by a difficulty in expressing affection, an acceptance of aggression in at least some contexts (symbolic and real), a tolerance of depression in art as in life, and a cognitive complexity. I am unable to say whether the complexity is an innate predisposition or whether it has origins in psychodynamics, but I can affirm that it serves as an effective defense: it enables the direct preferrers to experience their aggressive and depressive feelings more fully and to appreciate diversity in the world around them. But in a minority of the subjects the useful defense is joined by one which is quite limiting: a mistrust of fellow men.

One variant is exemplified by two subjects who, although alike in all other respects to those at the core, find it easy to express affection; they are closest to the hypothetical

type described at the outset, that is, to people who do not need sentimentality because they can experience feelings directly. Their affective experience of works of art is rich, and their cognitive grasp of their experience is complex.

The other variant is located on the opposite side of the core and includes the two subjects who differed from their fellows in an inability to tolerate depression; but this defense, as similar as it is to that of the sentimentals, leads them to an avoidance of all feeling in art altogether. For reasons which are unclear, these two subjects are also the only ones judged as cognitively simple.

6. Notes

1. I had originally called the direct preferrers "nonsentimental," and abandoned the term because it easily becomes cumbersome with repetition. But "direct" should not be understood as referring to easily expressed needs and impulses; it does imply an awareness of aggression and depression, and a greater attentiveness to inner states, but that is all. The direct preferrers are full of defenses, too, but they apply them above all to affection—not only do they find affection hard to express, but they also fail to recognize it or accept it.

2. The study was capably executed by Laura Morrell, to whom I express my warm gratitude. The interpretations in this chapter differ in some details from those advanced in her report, as is the case in the other chapters as well.

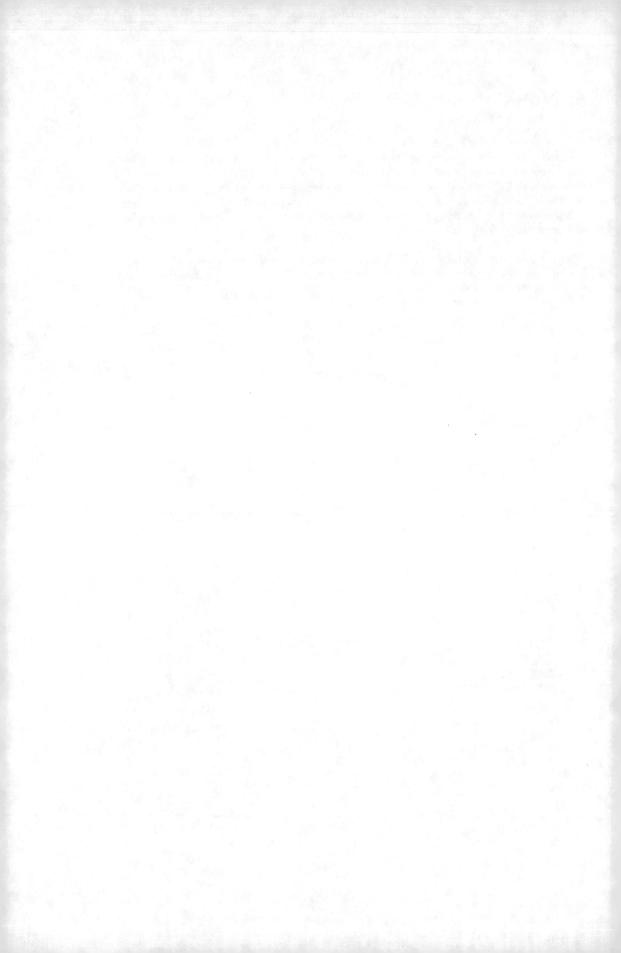

7. CALMNESS AND AROUSAL CONTROL

And, beyond this geometircal harmony, there is,
in her whole bearing, a harmonious calm, a gentleness even, much
at variance with the amatory epigrams
she inspired. . . .

Energy is eternal delight; and from the
earliest times human beings have tried to imprison it
in some durable hieroglyphic.

—Kenneth Clark, *The Nude*

The chapter headings of Jules Verne's novels give away their contents, and when reading them as a child I used to feel both relieved from anxious uncertainty about the hero's survival and disappointed that my tension was over. Verne resorted to rather long sentences ("Chapter XXII, In Which Passepartout Finds Out That, Even at the Antipodes, It is Convenient To Have Money in One's Pocket"), but in a work such as this even a brief phrase may have the same effect. The risk is that, in choosing a title which is meant to be helpful, one has given away such mystery as there might have been. Fortunately, even the best-chosen phrase leaves out something important, so that knowing roughly where one will arrive does not destroy one's interest in getting there—as, indeed, knowing beforehand the solution to a mystery story did not deter Chinese readers from working their way through the plot.[1]

If one is asked to picture a classical nude one will think first of a body in a calm pose. If the figure is female, she is almost certainly an Aphrodite who, although the goddess of love, embodies harmony, control, proportion, and moderation; if the figure is male, he is in all likelihood an Apollo, the poised representative of light and reason. That such an image of the Greek nude is simplified is perhaps excusable, since the simplification is a sin

committed by well-informed people in ages other than our own—as when the otherwise incredible draftsman Ingres could mistake, in his study for *L'Age d'or*, an insipid flaccidity for control and harmony (see Fig. 22). But a simplification it remains, since calmness is not all that the apparently calm nudes convey; there is a sense in them as well of contained energy or impending action, just as in Cezanne's ordered brushstrokes there is a charge of energy awaiting release. And history confirms our perception of the Greek nude and the Cezanne still life: the underlying passion bursts forth in Greek nudes portraying energy or pathos, just as Cezanne's motive force finds its way, before his discovery of the power of control, into his early rape scenes and *bacchanales*.

But if one can sense the passion as well as the control, and if one can respond to them in this combination or singly, what is the appeal of control uninformed by passion, or of passion unbounded by control? Or, translated into the language of the methods used here, what is the character of those who respond only to one or the other? The congruence model is always ready with a suggestion: control appeals to people who are themselves controlled, while passion appeals to those who are already passionate. And the suggestion is, from a statistical point of view, a very plausible one; its only limitation is that it leaves unexplained why art should serve needs which are already well served in reality.

The task defined by this chapter is, then, to attempt to assess the role of control in the lives of subjects who value calmness, and to evaluate the role of expressiveness in the economy of subjects who value drama ("dramatic—calm" is the dimension on which the nudes had originally been rated). My reasoning is here, as it has been in other chapters, that if I can find control or expressiveness in the subjects' lives to serve the needs of ego defense, then I will understand why they need them in art as well; and my hope is in addition that I can find subjects whose tastes run counter to their usual defenses and thus provide something which life cannot. It is not that I need to carve a special niche for art or to prove art to be in some manner unique; it is that I need to find out why people need it at all.

The findings reported here come from two studies, the first of which used subjects who were untutored in art while the second studied subjects both interested in art and capable of making esthetic judgments of it; they had scored above the mean on Child's test, as had the subjects of Study II in Chapters 4 and 8, and were selected from the same pool[2] The results of Study I were clear and in little need of further elaboration, but the interviewer had known the preferences of his subjects beforehand; the replication which seemed therefore necessary was taken also as an opportunity for studying subjects with a demonstrated taste in the visual arts—and, as it turned out (with one exception), with a profound interest in them. The interviewer of Study II based her questions on the results of Study I but explored in greater depth each subject's manner of relating to others—parents, acquaintances, friends, lovers—as well as the role of his or her art or taste. Some of her findings are therefore unique to her study; on the other hand, the greater simplicity of the subjects of Study I—as concerns their relation to art—produced certain contrasts which are also unique. As in the other studies the subjects were unaware, until the close of the interview, of the purpose of their selection, but they

understood that they were contributing to an understanding of the personalities of the people with consistent tastes. The interviewers, having learned well the areas they wished to cover, were able to lead the conversation quite naturally, follow up the subject's own concerns, and avoid an obvious focus on the topic of expression and control. Toward the end of the interview the subjects were asked to discuss, in their own terms, several reproductions of nudes embodying calmness or drama: Falconet's *Nymph Entering Bath* and the Hellenistic *Borghese Gladitor* have been encountered already in Chapter 6, while Raphael's *Study of David* (Fig. 23), Rodin's *La Danaide* (Fig. 24),, Montorsoli's *Bozzetto for a Fountain Figure* (Fig. 25), and DeRibera's *The Martyrdom of St. Bartholomew* (Fig. 26), are new; they were shown to the subjects of Study I. Michelangelo's *Ressurection of Christ* (Fig. 27), and Eakins's *Female Nude* (Fig. 28) were shown to the subjects of Study II, as were Maillol's *Youth* (not shown) and Montorsoli's *Bozzetto*.

The title of this chapter is, indeed, a rough summary of its contents: the calm preferrers control their drives and emotions, while the dramatic preferrers achieve some expression. But the summary loses all that is important in the details of the control, its childhood antecedents, the occasionally defensive nature of hyperexpression, and the need for cognitive arousal or quiescence, and it ignores the few subjects whose tastes contrast with their handling of impulses and feelings.

Control of Drives

While it would be fair to say that the calm subjects—the term represents a useful shorthand—control all their basic drives, the point is most convincingly made by describing the handling of aggression, sexuality, affection, and intimacy in separate terms. As far as aggression goes, all of the nine men keep a strict control over its expression. In the first study one finds subjects who have almost made control a focal point of their lives, as in the case of a war veteran whose experiences have turned him toward mysticism, pacifism, and vegetarianism (whose emotional import is summed up in his phrase, "I don't eat flesh"), or one who has converted to Christian fundamentalism and now avoids aggression, sex, alcohol, and excitement. Others, in both studies, merely control aggression as a way of meeting the demands of their consciences; they had known aggression—this is an important point to note—in their fathers or in themselves but have set up strong defenses against it. Thus one man, a conscientious objector, has reluctantly begun to recognize in himself the aggressive ambition that had brought his father to the top of his company, but finds the recognition alien and prefers to avoid aggression even in the visual arts: he is repelled by the *St. Bartholomew*, which he puts down quickly after saying, "Oh, well, another downer, a bummer; it's like hanging a picture of a baby

Figure 22. Ingres. Study for *L'Age d'Or*. Courtesy of the Fogg Art Museum, Harvard University.

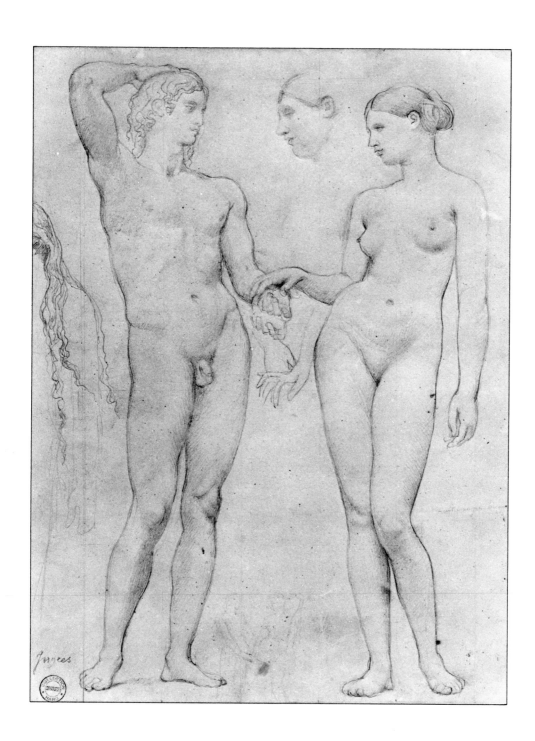

Figure 23. Raphael. *David After Michelangelo.* The British Museum.

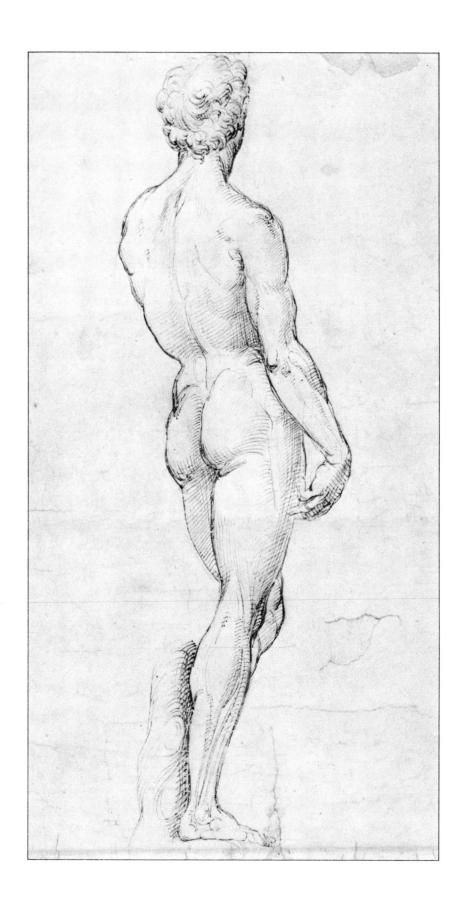

Figure 24. Rodin. *La Danaïde.* Musée Rodin, Paris.

Figure 25. Montorsoli. *Bozzetto for a Fountain Figure.* Skulpturengalerie Berlin (West).

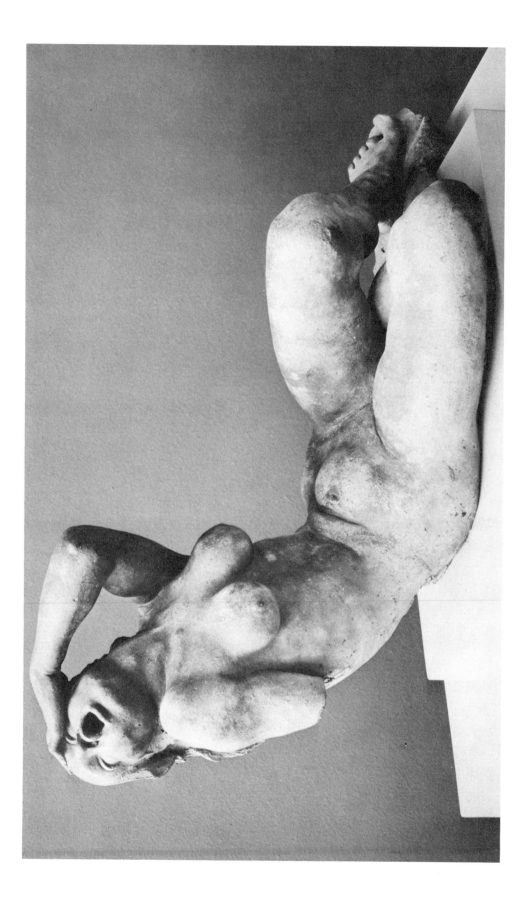

Figure 26. De Ribera. *The Martyrdom of St. Bartholomew.* Museo del Prado.

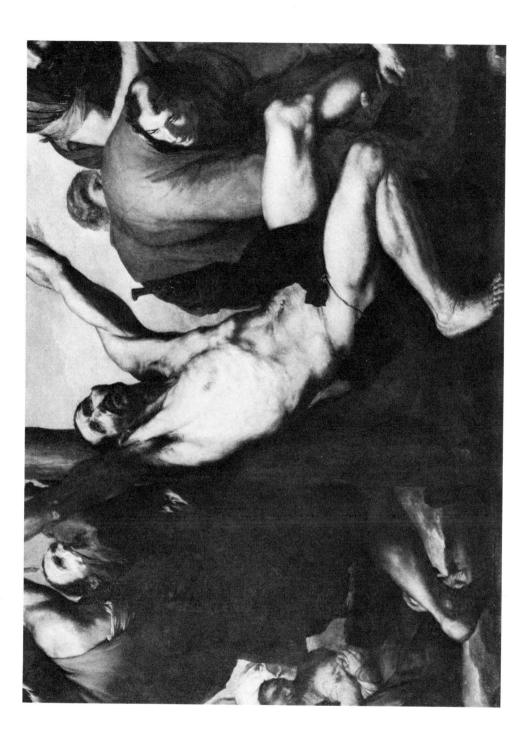

Figure 27. Michelangelo. *Resurrection of Christ.* Royal Library, Windsor Castle. Reproduced by gracious permission of Her Majesty the Queen.

Figure 28. Eakins. *Female Nude.* Philadelphia Museum of Art: given by Louis E. Stern.

Unfinished Water Color—
T. Eakins

that's been napalmed." Another man, of imposing strength and athletic build, used to have a violent temper until his late adolescence and now prefers to exercise strict control—a control which is reminiscent of his fundamentalist upbringing but which he has reimposed knowingly and in concert with his search for equilibrium in his life as much as in his art.

The women control their aggression as much and as universally as the men do; the only one on whom our data are unclear dislikes aggression in art and so suggests that she would reject the expression of her own aggression as well. Unlike the men, they do not appear to be struggling with perceptible impulses; they do not mention having been aggressive as children or feeling aggressive as adults, and whether we should assume that their aggressive drives were weak in the first place or, as is more likely, that they were more easily tamed by parental prohibitions, their control over them is even more complete.

That the control was imposed is certainly suggested by the much stricter upbringing most of the calm subjects have undergone it. It can extend even to the perception of aggression in symbolic portrayals, as when some subjects attempt to formulate an interpretation of the *St. Bartholomew* which denies the obvious: for example, that he is being helped down rather than hoisted up. Those who discuss their parents' handling of aggression make clear that the parents provided a model of avoidance or denial: they might withdraw and pretend to read the newspaper, or laugh rather than admit that they were upset, or simply become very quiet and not talk. The women appear to have seen less parental violence that the men, but their dislike of it is equally pronounced. They may marvel at a colleague who can stand being verbally abused by a superior while they—mere witnesses—are shaking with fright; they may have suffered gastric symptoms from their inability to even feel anger; and they may turn their anger inward and experience depression, and use art in such circumstances to "paint out all their aggressions."

I have suggested that many of the subjects, men included, do not like to experience aggression even in art. But it must be said that for some of them vicarious discharge of aggression is easier than actual discharge, while the contrary is never observed. Some of the subjects can find contexts for aggression which they can accept and even enjoy; those who are given to formal analysis can find that good form can legitimize content which they otherwise reject (which permits them to appreciate a film such as *A Clockwork Orange*), while those to whom such sophistication is unavailable can excuse aggression —or perhaps not even recognize it—when another sentiment can be made to prevail over it (which allows the patriotism of a film such as *Patton* to dominate its obvious theme). Thus the subjects do not accept aggression in life, but some can accept it in art.

The dramatic subjects, on the other hand, are freer in their expression of aggression; in the men, certainly, the difference is noticeable. If I may start with the realm where expression is easier—the symbolic one—there I notice not only acceptance but positive enjoyment. In the first study the men find the *St. Bartholomew* excellent and interesting; those who seem most direct in their mode of expression say something like, "It's got lots of emotion, passion; I like it," while the others couch their praise in more technical

terms, such as the realistic portrayal: "It's complete; he did a fine job on the detail, such as the eyelashes. And the conditions of the body fit the picture; he's going through some sort of trial, he's sagging here." In the second study the subjects reveal a similar acceptance, though of a different object, when they appreciate the *Bozzetto* for its feeling of attack or when they mention liking violent films. But their expressiveness is greater than that of the calm subjects in life as well. In Study I our data are indirect and do no more than fail to show the sorts of defenses shown by the calm subjects, but in Study II, two of the four subjects allow aggressive expression in real circumstances. One says, "Sometimes you can only make yourself heard by violent acts," while the other remarks, "I can be very violent." Only one of the nine men fails to enjoy aggression at least in symbolic form, and in this respect resembles the calm preferrers; I shall refer to him again when I discuss dramatic subjects who do not like to experience emotion.

In the pictures they are shown, the women, too, find it easy to accept aggression, or in the very least its consequences such as suffering. In the *St. Bartholomew* they may find the expression and the body structure "great," and make up a story about it in which the central character had sought power and status but now is being hanged for it; and the people around him, because they love him, are in agony. In the *Bozzetto* they appreciate the higher level of emotionality quite universally, and one goes so far as to enjoy the figure's agony: "She looks as if she had just been run over by a cement truck." But I would be misleading if I suggested that aggression is the specific reason for their enjoyment; the cement truck fantasy is unique, and the general enoyment seems to be of the presence of strong emotion rather than of an aggressive discharge. Nor are the dramatic women as likely to discharge aggression in reality as the men; only two of them give instances of aggressive acts from their lives, the one of beating up her brother's assailant when she was a child, and the other of a preference for pounding and hammering—that is, for sculpture—over the more gentle stroking that goes into painting. In comparison with the men the level of overt aggression is distinctly lower, and it would be an exaggeration to suggest that the dramatic women as a group seek a specific satisfaction of aggression in art; rather, the satisfaction is couched in a heightened emotional arousal.

———

In the matter of sexuality we find a situation which at first seems puzzling. The calm preferrers are the easier to explain in that, as with aggression, they find the expression of sexuality difficult. Of the five men in Study I, three men have very infrequent sexual relationships or none at all, while one has had a few relationships lasting more than several weeks and another has a steady one at the moment. Among the men of Study II, two are generally asexual while the other two are married; of the latter one is quite strictly and even possessively monogamous while the other is now married after considerable promiscuity. Thus with two apparent exceptions the calm men have clamped unusually strong controls on their expressions of sexuality. The two exceptions need to be understood as well, of course; but they are both more apparent than real. The one from the

first study who lives with a "chick," as he puts it, makes clear that he is attempting to subdue what he calls his animal nature with his spiritual one, and leads us to suppose, without saying so specifically, that the sexual relationship—or the sexual part of his relationship—is not important to him. The second, however, values his sexuality unambiguously, and speaks with pride of his skill at picking up and seducing partners; and although he is now married, and by his testimony happily so, he makes one question the depth of his relationship when his description of his wife is limited to her troublesome though not dangerous medical condition. I think his salient characteristic, from the point of view of the role of sexuality in his economy, is the rather polymorphous and sensuous rebellion against the sexual prohibitions of his religion and his overbearing and tyrannical father. That his relationships are homosexual as well as heterosexual suggests a rebellion of sensuousness but not one of emotionality.

The calm women are similarly overcontrolled. Six of the ten have no sexual relation with anyone at present and of these five have never had a close one (or one at all) while the sixth is married, healthy, and living stably with her husband. Another woman lives with a man whom she neither likes nor admires, while two have a stable and satisfactory partner in a traditional relation marked by the woman's fantasy of exclusiveness. The tenth woman has a free and unidealized relation with a man with whom she has lived for several years; she is a genuine exception to her group, not only in matters of sex but also in the others which will be discussed. Her tastes as shown in the interview run toward the dramatic, so I am forced to suspect that some error, or some variability in her tastes, had assigned her mistakenly to the calm group. Thus the calm women restrict their sexuality either by denying it—in one case even in marriage—or by experiencing it but not allowing themselves even a promiscuous fantasy.

Nor do our calm subjects' attitudes toward homosexuality reveal any greater inner freedom. We have clear answers from seven of the nine men, of whom three are clearly intolerant and three tolerant in principle while shying away from contact with homosexuals or accepting their own homosexual feelings; the seventh is, of course, the polymorphous sensualist. The women who were asked the question were a little more tolerant, but again the tolerance was principled; only two of them recognized homosexual feelings in themselves or the possibility of a homosexual experience.

If the calm preferrers constrict their sexual expression, one might expect the dramatic preferrers to be quite free in theirs; but one would be disappointed. No observable difference exists between the two groups of men: only one of the nine has a stable sexual partner, another two have occasional relationships (they treat women by their own admission as interchangeable objects), two have been divorced by wives whom by their report they had loved and felt unable to replace even for a time, and the remainder have no relationships or only occasional ones. Clearly their preference for dramatic nudes is not the consequence of a greater freedom of sexual impulse; not only are they as restrictive as their calm counterparts, but they are restrictive by the standards of their group. I face once again the question of reasoning about these data from a statistical point of view, and concluding that the handling of sexuality has noting to do with calm or dramatic preference, or looking at them clinically, and attempting to see if the

214

restrictions of the dramatic preferrers—who pose the explanatory problem—bear a relation to their preference. If only because the restrictions are atypical of their time and age, I have reason to attempt the latter; but I shall hope to have made this choice plausible after discussing, in sections to follow, the emotional context within which the restrictions operate.

Just as the calm women presented a greater freedom of sexual expression than the calm men, the dramatic women were more expressive than the dramatic men had been—but, again, the two groups of women are quite similar to each other. Three of the dramatic women have a stable sexual relation with a man: one is otherwise unremarkable (a stable boyfriend-girlfriend relation), one is that of a husband-wife with precious little idealization on the part of the wife (we only know that she freely compares an ugly torso in one of the pictures with her husband's), and one only began late in the life of the subject, who, in her sixties, is the oldest subject we had studied; had I known her age beforehand I might have hesitated to include her, but the accident of her selection proved most welcome: her dynamics are so close to those of her much younger colleagues that she seems to deny, by her very age, the effect of psychic conservatism that one might have expected. One woman has been through two divorces and several relationships and makes clear to us that she fears stability; the other five have had brief relationships but are not close to any man now. On the whole, then, while their picture is not as restrictive as the men's, it shows few signs of a need for a stable relation to a man.

In the matter of attitudes toward homosexuality the dramatic subjects show a greater liberalism: among those who provided the information, there are none who condemn homosexuality as a disease or aberration, and there are several who would not rule out the possibility of a homosexual experience. Only one, a woman, has had homosexual experiences; in the others the greater acceptance seems to be a sign of openness to new experiences.

Now if one finds liberalism in the subjects' attitudes toward other people's sexuality but conservatism in the handling of their own, then one must look elsewhere than to sexual attitudes for an explanation of how they behave in reality. If some subjects are tolerant but not expressive, the suspicion grows that they have difficulties in becoming close to others on intimate terms: one senses that their difficulty in being sexual is part of a difficulty in accepting closeness rather than the effect of sexual restrictions in childhood. And one's focus then shifts from the expression of sexuality to the handling of intimacy.

It seems reasonable to define intimacy as the capacity to maintain a close and valued relation to one person over time, and to consider either aloneness or the need for large or varied company as signs of difficulty in accepting intimacy. I am not taking sides for or against one of the solutions; I should perhaps use an expression such as "preference for aloneness" or "preference for gregariousness" in place of a term suggesting "difficulty." Each solution—the intimate, the gregarious, the lonely—has certain emotion benefits and costs, ones for which an optimum might be hard to prescribe. My task is not to declare one solution more or less healthy, but to point out the consequences of one or another emotional equilibrium for esthetic tastes.

If that is my goal, then I must begin with a startling fact: of the nineteen calm preferrers only six may be said to show a capacity for intimacy while among the eighteen dramatic preferrers there are no more than four. It might be objected that these numbers are low because a college-age population would not be expected to have formed close attachments, and that therefore I cannot reach any reasonable conclusions about the subjects' manner of handling intimacy needs. I think there is some merit to the argument, and that the figures may be slightly "depressed" by the subjects' situation. Yet I should be surprised if the distortion were anything but slight; among the non-intimates I counted people in their late twenties and older who had been divorced and were no longer searching for close relationships of any sort, and I noted from the intentions expressed by the younger ones that only one looked forward to having a stable partner of any kind. Most of the non-intimates are, of course, loners, while a few are gregarious in noncommittal ways. Nor can it be said that those who are counted as intimate are the precious few who have passed a rigorous criterion: the intimates include a woman who had married quite late, just when she was about to enter a convent, and a woman who has a relationship which she calmly expects not to last; and they include a man whose need for exclusive intimacy was so strong as to overshadow his capacity for relating to others—as if he had formed an intimate bond which could act as a lonely unit toward the outside world. Among the dramatic preferrers is a woman who had married in her sixties, after a lifetime spent alone. Thus even some of those who are counted as intimate cannot be said to experience intimacy-with ease.

The calm subjects, if I may sum up the differences seen so far, control the expression of their drives rather massively, in that they allow for very little satisfaction of aggression, sexuality, or intimacy; as far as can be determined, their preference for calm nudes functions as a support for their control of drives in general. The dramatic preferrers control their aggression a little less in reality and very much less in symbolic forms; they control their sexuality quite strictly in reality but they allow for a breadth of expression in others; and they show as much of a preference for non-intimate relationships as do the calm subjects. Their tastes in dramatic nudes are therefore no mere mirrors of an ease of drive expression; on the contrary, given their appreciation for symbols of that which in real life they do not express, and given their inability to seek satisfaction of their real needs in intimate relationships, we must begin to think of their tastes as reflections of a cognitive or emotional attraction to that which is denied them in life. Having looked at drives, we must now look at emotions.

Control of Emotions

With respect to an ability to express emotions the calm preferrers are what we would expect them to be: they neither value emotion in life nor give evidence of searching for it in art. (Sixteen of the nineteen calm preferrers may be said to have this little use for their emotions.) On art, one may hear from them statements such as "I like classical music; it doesn't play on your emotions so much," or "I like it because it's peaceful," or "My own art is classically oriented; I try for an equilibrium between the Dionysian and the intellectual," or "Everything I do is traditional," or "I like calm and loving paintings." In their life emotion is viewed with mistrust, as by subjects who say, "I am trying to stay away from the emotional aspects of decisions; I see jealousy, hate, and rage as being wasteful, stupid uses of energies," or "Women affect my emotions too much, so I don't like to get involved unless she's the ideal woman." Instead, the subjects strive for control and the control may be translated—especially among the subjects of Study II, whose established interest in art indicates a well-practiced cognitive differentiation—into the primacy of the intellect. Thus, "I reflect on things rather than doing them," or "I led a model, intellectual existence in school," or "Some of my intellectual friends scare me, but I wouldn't want to be anything but intellectual," or "In school I used to read a lot, and that's the kind of friends I had." But whether the calm subject is intellectual or not, he values control: one with an interest in art history says, "I got my collecting, cataloguing mentality from my stupendous stamp collection," while an artist says, "I have a lot of control over my life." One woman who is striving for lesser turbulence than she has experienced up till now says, "I used to like music that kept me up; now I like more mellow music," while two women make essentially the same comment when they come out in favor of clear colors over murky or slimy ones.

Our information on the development of control is of necessity fragmentary, but it is sufficient to indicate, at least on occasion, that it is instituted because of a fear of what emotions in general might do. One is reminded of Anna Freud's discussion of the adolescent ego having to cope with a sudden onrush of instincts, which it fears not singly or for specific reasons, but as a class; the calm subjects similarly seem almost indiscriminately to fear their drives and the accompanying emotions. Those who stress orderliness in art or in their life make clear that they fear disorder; thus Maillol's *Youth* may be disliked because it is androgynous, falling apart, and dissolving, or Michelangelo's drawing may be too busy, too emotional, too disorganized, and too unclear. Some subjects trace their mistrust of emotions to a destructiveness perceived in a powerful, temperamental, but also overcontrolling father, but such a derivation is not universal. Some subjects—particularly the males in Study I—tell us that they fear and reject aggression and the emotions which produce it or result from it, and prefer to accentuate the positive; in this regard they resemble the sentimental preferrers encountered in the last chapter, and, like them, in accentuating the positive they opt for that which is inhibited and tender, rather than for that which is robust and lustful. In short, the calm

preferrers fear emotions *in toto* and take steps to control them both within and without.

The dramatic preferrers this time present us with a clear contrast. It will be recalled that they did not express their drives; it is all the more remarkable then that they—all but four—are capable of feeling and enjoying emotions. The exceptions need to be understood as much as does the majority, of course, and in fact they will be rather important to my theoretical formulation; but for the present it must be said that the typical dramatic subject enjoys feeling his emotions, is happy to encounter them in works of art, and is fully capable of discerning them in the figures before his inspection.

The emotions felt and sought for are of all kinds, and they are not confined, of course, to the aggressive feelings whose acceptance in symbolic form has already been described. In some subjects one notes an ability to accept any of a variety of emotions while in others one senses a more pervasive and almost voracious need not for any emotion in particular but for emotional variety. In comparing two nudes one subject says, "I prefer this one; it's got more action that the other. I like art that shows some kind of feeling—I don't care what kind of feeling." Another subject, whose interest in matters dramatic is so strong as to have made him choose as a career the directorship of a theater company, says of the *Bozzetto*, "It shows feeling; it's passionate. It communicates passion, extreme feeling," and when he is asked to specify the feeling, he says with his usual dry directness, "Since she's not getting laid, it's probably pain." As the subjects see it, the function of art is to express emotion, and the more intense the emotion the better the art—as is summed up in the comment of one woman who says, "Art should have a lot of emotion. Face emotion really hits you hard; but body emotion is important sometimes, too." And while I have the impression that most subjects search for emotional stimulation from art works which are themselves intense, some can supply intense fantasies even in the absence of obvious provocation. Thus one dramatic preferrer links the *Gladiator* and the *Danaide* in a single scenario; she says that the warrior had put the woman down on that rock. When asked to clarify her fantasy, she shifts from the literal to the metaphorical, chains onto the words she had used and spins out a fairly dramatic fantasy: "He put her down somehow. Yeah, he used her, he made her think he was madly in love with her and then said that she doesn't mean anything to him anymore. He is making fun of her telling her what a bitch she is."

Some of the subjects who prefer dramatic works seek not only greater emotional intensity from art but also a greater emotional richness; and that preference in turn reflects a greater richness of their own emotional experience. By richness I refer to an ability to feel different emotions in turn, to be able to distinguish one from the other, and to be aware of ambivalent feelings toward the same object; such a richness characterizes all of the dramatic women from Study I. Now I am unable to say why it is only this group that shows it, but I can offer an informed guess as to why it should be confined to the first study: the subjects of Study II are generally cognitively more complex and thus make it difficult for any similar difference to emerge there. But as to why in Study I the effect should be limited to women is less clear; it is nevertheless a fact that they are all more articulated than the calm women. And accompanying their emotional articulation is a

greater cognitive complexity—an ability to make all sorts of relevant distinctions, without the benefit of extensive artistic instruction, in their perception of art works. They talk in turn of the artist's intention and the audience's feeling, of the feelings "felt" by the nude as against those felt by the observer, of the expressive qualitites of the body as against those of the face, of content (the thing represented) and form (the manner of its representation). They give evidence at the same time of being able to experience a strong empathetic reaction to the nudes they view, that is, of being able to project a plausible feeling into the figures from what they perceive of their body presentation. I am tempted to suppose that this ability reflects in turn a richer experience of their own body, but on that matter I have no evidence.

I think that it would be useful to bring together what we know of the expression of drives and emotions in our subject groups and attempt an interim formulation of its relation to their esthetic preferences. For the first time in these studies it has proved possible—and necessary—to distinguish between drives and emotions. The distinction has been superflous heretofore because the management of drives and emotions tended to go hand in hand; and indeed the calm preferrers give us no grounds for making that distinction either, since they control both equally tightly. Once again, without intending the slightest disparagement, one can say that the preferences of one of our groups are of little theoretical interest: as those of the shy subjects reflected their impulse inhibition, particularly in body management, so those of the calm subjects mirror their difficulty in expressing drives, relating to others, and experiencing emotions. I have little hesitation in presuming that their preference for calm nudes serves to support the defenses they have erected against expression; and while I cannot say that I know always what had led them to mistrust emotions as much as they inhibit their drives, I do know that they do both.

From a theoretical point of view, the subjects who prefer dramatic nudes are more complicated. Their preference certainly does not serve the needs of impulse expression, since their drives are fairly inhibited; although they are freer in their acceptance of aggression, particularly in its symbolic form, their handling of sexuality is quite constricted and their expression of intimacy very much so. They do, however, experience and value feelings, and one has to ask the question whether there is not a relation between the valuing of emotion and the difficulty in giving expression to the more affectionate drives. The question is not intended rhetorically: it implies that if there is a connection, it is of a compensatory nature, that is, that the valuing of emotion in art serves to fill some void. (And on the contrary the question also implies that successful intimacy may leave no void to fill, thus making a taste for the dramatic unnecessary.) One of our subjects illustrates the mechanism with particular clarity; he is the theater director with many superficial affairs who uses dramatics as a way of "reaching out to people." But the other subjects are not so revealing, and all we can do is to presume that they fill the impulse and intimacy void with some sort of near equivalent. The only requisite of the near equivalent is that it should resemble that which it replaces, that is, that it should have emotional content; but the emotion must be directed at objects which do not raise the problems of intimacy. Nudes will do quite well, as will other forms of art.

219

Now whatever the merits of the construction I have just proposed, it suffers from the defect of being unable to account for four of the dramatic subjects—the four who, in addition to their difficulty with intimacy, do not experience or value emotions. In effect, there is no distinction observable so far between them and the calm preferrers. If the function of their dramatic preferences is not emotion, what is it? The question leads us to the last difference between the groups, as well as the most important one.

Need for Varied Experience

The subjects of Study II were asked in detail about their growing up, their pastimes, and their esthetic preferences; and they were asked about their reactions to surprises. Answers to these questions enabled us to form an idea of how much novelty, variety, and other diffuse stimulation the subjects required of their surroundings. The dramatic subjects differ from the calm ones in a clear manner.

I shall begin for once with the dramatic subjects, if only because they are the ones whom it is the greater challenge to understand. The nine without exception may be said to value stimulation generally, to require variety, disorder, and instability—their symptoms, so to speak, differ, but the underlying predisposition is present in each one. A mild but unmistakable symptom is that of the subject who likes to roam the beaches; not only does he value his solitude, but he always looks at the sand thinking that he might find something, perhaps even a gold bullion. Another subject fantasies that every three or four years he will take a leave of absence from his job, work in an entirely different setting, and then return to his "home area." Several of the subjects enjoy traveling, not so much in order to reach another destination as to discover new things in an unpremeditated fashion. One subject likes both intensity and lack of structure: she likes surprises and wild parties. Michelangelo's *Resurrection* appeals to her because it is nebulous and weak in organization, and movies move her when they "sweep her up" into something new. She also hints at a kind of insatiability of appetite for experience when she mentions among her life goals that she would "like to keep developing and growing; I'd like to see everything I want to see; I would like to be able to do everything I want to do." Her goals are gently worded in comparison with those of one of her colleagues who, to mention but the highlights, loves complicated films whose plots she has to figure out, dislikes staying in one place too long, enjoys painting because setting up the palette gives her the delicious sense of not knowing what will happen as she uses it, and loves "getting into" activities which even she, as voluable as she is, cannot quite finish enumerating; without making too pointed a use of the phrase, she remarks that "there just are a lot of things to be done, a lot of things to know in this world."

If it should be supposed that these are ordinary fantasies of young people of college

age, the calm preferrers show us that they, at least, do not share them. Not one of them seeks out varied experience in any form comparable to that of the dramatic subjects. Thus one, a painter, sets as his life's goal to stop searching and find contentment, while another has given up theater and sports in favor of a career over which he has individual control and which he can further within the context of his valued domestic equilibrium; the career is in painting and sculpture. (My detailing of their need for control and their avoidance of varied experience will not, I trust, be construed as an implied limitation on their artistic creativity. On the contrary, I know enough about the productions of each to hold them in very high regard. My point is to show that control over the emotions, and over disorder and unclarity, predominates in their life as in their art and in their tastes; such control in no way prevents the creation of varied artistic form or fresh ways of representing the visual world, but it does ensure that creation will be channeled through carefully applied processes and standards.) Others object to the busyness of Michelangelo's *Resurrection*, or to its disorganization or crudeness; and one subject illustrates her desire for stability in her preference for using blacks and whites in her paintings rather than colors. One woman, when asked about how she reacts to surprises, says that she prefers to have a little clue first; she notes that she does not react too well to the unexpected and that it is best if she is given a little warning. A few of the subjects, it must be said, do like some forms of variety, as in the form of aimless travel or varied foods, but they integrate such tastes into a life which is more organized and disciplined than loose. Nor do I imply that the calm subjects are incapable of excitement; rather, their excitement is a response not to human events but to their formal representatives such as line, surface, and volume.

I have no firm sense of the sorts of experiences which may have predisposed one person to search for varied experience while another, with the same substratum of difficulty in achieving intimacy or drive expression, prefers experiences to be predictable and controlled. But a hint is contained in the spontaneous descriptions of childhood that our subjects gave us: five of the nine dramatic preferrers remember turbulence of one sort or another. The turbulence may have been perceived as quite benign, as by the subject who was raised in an unconditionally loving but alternately firm and expressive atmosphere, who says, "It was a turbulent home, really, but very pleasant." Or the turbulence may take the form of physical motion and be perceived without much feeling, as by the subject whose first memory is of backpacking: he first remembers being carried and not seeing too well and then recalls that when he began to walk be could see everything going by. Or it may have been less pleasant than otherwise as with frequent moving from city to city to the accompaniment of parental arguments, or moving between the very different households of divorced parents. Or it may be altogether upsetting, as for the subject whose first memory is that of her father's beating down the door of her closet, or for the subject whose mother had married four times and kept the child in an institution for several years. By contrast, only one calm preferrer mentions frequent childhood moves and the consequent feeling of uprootedness; why her eventual preference should tend away from excitement is difficult to say with certainty, but perhaps her finding a secure haven in her relation with her mother, after her father's death, helps—she does, in

any case, equate calmness with love.

I feel reasonably clear now about the dynamics of our subjects' preferences. Those who prefer calm nudes are solitary individuals who control their drives, emotions, and arousal; the matter seems as simple as that. Those who prefer dramatic nudes present a more complicated picture and greater individual differences, but their functioning may still be specified. They are solitary as well and do not discharge their drives, but they do value them symbolically: and if they value them but find it hard to obtain satisfaction, then it may be understood why they should search for emotional gratification more abstractly, that is, independently of closeness and intimacy. And if that mechanism fails, as it does for the four subjects who were singled out earlier for their inability to experience emotion, then the gratification takes the form of a fully abstracted need for varied experience—a diffuse sort of gratification which is removed not only from intimate objects but from emotion as well. The process by which the dramatic nude becomes the object of one's attachment seems to be stepwise. The attachment may be to one's unmet emotional needs or, if those have been met, to the subsequent line of defense: to one's need for varied experience (or, of course, to both). In either case, be it noted, the taste for the dramatic is not without its defensiveness; if one constricted the line of vision sufficiently it might appear as mere congruence with the need for variety or, less insistently, with a need for emotional expression, but as one looks at the individual's broader functioning the underpinning of need denial and deprivation becomes apparent.

Nevertheless, the defensiveness of the dramatic subjects is more or less strong. While for reasons of theoretical clarity I had to take note of its presence, differences in its strength are perhaps of even greater interest. To illustrate them, and to flesh out the somewhat skeletal structure of my discussion of defensiveness, I should like to present a sketch of two of the dramatic preferrers. They both exemplify the generalizations I have drawn but one does so from a base of turmoil and confusion, while the other functions from a substratum of affective stability, economic hardship, and an assertive coping with the world. The first gives one the appearance of never having known stability and being unable to accept it when offered; one is tempted to say that her only security is a constantly renewed sense of change.

A woman I shall call Deborah remembers as her first image of childhood the three years she had spent in a children's institution. What had led her there was her mother's inability to keep a marriage together: the mother's first husband left her when Deborah was but a year or two old and her second husband committed suicide. But before that event her mother had already proved herself unable or unwilling to bring up her daughter and had placed her in the institution. At the end of three years the daughter went to live with her grandparents, and the mother was remarried—this time to a stable man with whom she had a good relation for quite a few years, in fact until his natural death. Deborah remembers having lived in

other homes besides those I had mentioned already, but the vivid memory is really of her mother: she is described as unstable, pretty crazy, witty, and lively. In Deborah's childhood there was a big turnover in everything, men included, and everything seems to have taken place fast and dramatically. When her mother was around, a lot happened quickly; and while it was not always pleasant, when it was it was unusually good.

Deborah had no relation that she can remember with her natural father and she feared her first stepfather's dominance, power, inability to understand children, and the drama surrounding his profession. Only her second stepfather provided a certain amount of dependability and constancy—the sort of constancy that could be seen every morning as he prepared his breakfast and the sort of dependability that came from a perceived joviality and goodness.

Deborah came to lead her life in a disorganized manner. Rebelling against the discipline of a parochial school she experienced a sort of breakdown and became physically ill so as to escape the school altogether. During one of her mother's departures to live with a new husband, Deborah came to identify strongly with minorities and began to confine her friendships to them. As a teenager she found that the Chicanos were the only people who felt alive and warm; the rest of society felt alien. Nor did they only seem alive (and, one presumes, as alienated as Deborah felt)—they also had an attractively strong family life. Deborah soon married one of her friends and lived with him for several years until the marriage broke up.

The marriage was not what she had expected: her husband's rejection of intellectuality, his dark moodiness, his "chauvinistic" dominance, all of which she had admired at first, became liabilities she could not live with. She also felt within her a need to grow and return to her earlier interests. She moved away, had some turbulent affairs, and felt very confused and disconnected for a number of years. She was rescued from this period by a woman friend who introduced her to a greater awareness of herself as a person and to ways of reintegrating her disheveled self. A period of psychotherapy followed but, as Deborah recalls it, her therapist—whose qualifications I may be permitted to doubt—could not cope with her developing dependence upon him and broke down himself. But she remarried and was enough in control of herself to have chosen a fairly stable man; she settled down to living with him in some hopes of happiness. And she achieved it; and yet at the point of finding it she began to question her dependence on his stability and eventually left him, too.

At present she sees herself as a complicated person who would prefer to be simpler; she does not like any pressure or restrictions, she strives for the sort of freedom which would allow her to be herself even if being herself means being unpredictable. But she feels less dependent on others and less afraid of them, and more accepting of who she is.

I think that we may view her preference for dramatic nudes as an obvious extension of the drama she has always experienced. But as true as that statement may be, it ignores the important question, namely, why should she like that which she is experiencing anyway? I think the answer must come from assuming the preference to serve two needs at the same time. There is a very positive, need-satisfying aspect in the reminders of her mother at her exciting best; but there is also, and perhaps more importantly, a need to create chaos in her own right. I cannot have insight into the need from the information at hand, but that the need is there is made clear by Deborah herself when she tells us that she could not stand her second husband's stability. And the needs multiply and intertwine: they press her to escape intimacy, and the escape leaves the sort of void which has to be filled by, among other things, symbolic drama.

The next subject not only shares the preference for drama but is a very vivid person herself. Her intellectual aliveness is shown in her voluminous but precise and insightful diction, in her detailed memory, and in her search for varied and contemporary experience. But there is in her a *need* for such stimulation which goes beyond her capacity for it; and I hope to show in her sketch that it has to do in part with the transformation of an impulse which she perceives her parents not to have adequately satisfied either.

Sarah remembers a vivid incident from the age of eighteen months, a fact which is remarkable not only because it reveals something of her intellectual functioning but also because it concerns self-assertion: she remembers simply refusing to go visit another house. (Early memories can be manufactured by parents who favor their children with treasured incidents concerning them, but her account is so full of details that I am inclined to believe its accuracy.) She remembers her father as a loving man who very much kept painful feelings to himself—dead people or pets were, for example, never again talked about—and who was unassertive and dominated by his wife. Her mother on the other hand was a dominating person—beautiful, keen of intellect, artistic, demanding and executive, and publicly deprecating of her husband. Our subject believes that she took after her father, while her surviving brother took after her mother. There most people's remembered contrast might rest; but Sarah, in thinking back on her parents' relation, and quite without the benefit of psychological training, believes that she and her father by their reticence actually helped an inwardly insecure woman keep up a large measure of self-esteem. She has another plausible recontruction of that relation: her parents' prohibition of sex except for procreation lent a kind of electric charge to their relation which could be relieved only by fighting. Partly as a result of what she observed she became terrified of marriage.

Her family was poor but ambitious and sent her to a very expensive private school in which one of their relatives was a teacher. So as to protect her relative from the charge of favoritism, she had to work twice as hard to

achieve high grades as all her classmates. She rememebrs clearly walking to school with one of her friends and wanting to be blind—literally—to the world around her; her friend would exhort her to open her eyes and take in the details of the street—the colors, the shapes—and recognize how wonderful they were. The process was repeated again, but without Sarah's resistance, when an excellent teacher of art appreciation opened up the world of art. Sarah still marvels at how incredibly rich esthetic perception can be.

She was sent to college in order to become a secretary; after some economic ups and downs she graduated and toyed with the idea of marriage but gave it up because the man most devoted to her was boring. She was tricked into moving back to her hometown, but eventually boredom drove her away again. I am not aware of the details of her life thereafter except for the spunkiness with which she handled various unjust superiors and for the economic success and independence which she eventually managed to enjoy.

At present she is happily married, and has been for the past seven years; she has decided to reenter college and derives great pleasure from it. I should say, too, that she is in her late sixties, and that the vivid interest she shows in life around her would seem voracious in a twenty-year-old. She is the subject who once in a fury started to beat to a pulp one of her brother's classmates and discovered a bit late that in the semi-darkness she had tackled her brother instead; he apparently was charmed and found it the most valiant thing anyone had ever done for him. She likes to have a variety of people around her, to keep up to date, and she has no hesitation, unlike some of her friends, in going to see films where all the speech is in the vernacular (provided they are otherwise interesting); she finds that the shock value of any word wears off quickly. And she makes appropriate references to magazines such as *Ms.* or *Viva.*

I sometimes wonder whether Freud did not have just such personalities in mind when he proposed that sexual energies can become "desexualized" and form the basis of a peppy sublimation. But it is so much more difficult to picture the process of de-sexualization than the process of repression, for example, that one never quite knows from intuition whether Freud's formulation is plausible. Yet in Sarah we see an uncanny concentration of energy, curiosity, and capacity for experience, as well as considerable inhibition of intimacy and sexuality. Whether they are connected in the manner Freud specified cannot be made apparent from a single case; certainly Sarah must have had a large somatic reservoir of energy to begin with. Yet, from what we have seen of the other dramatic subjects' needs, her hunger for experience represents energies which have been well directed and successfully mobilized.

7. Notes

1. The quotes from Clark are taken from two contrasting chapters, the first is from a discussion of Venus (p. 129), while the second is from the chapter on energy (p. 233). The Verne chapter heading is, of course, from his *Around the World in Eighty Days* (1956). For a discussion of the construction of Chinese mystery stories, see the second postscript to Robert van Gulik's *The Chinese Nail Murders* (1961).

2. Study I was in the able hands of Charles Scott, while Study II was capably conducted by Laurie Babka; to both my warm thanks.

3. Three subjects are missing from the theoretical total of forty. One subject, a drama-preferring woman, had been misclassified, and two subjects, a calm man and a drama-preferring man, did not have sufficiently extreme tastes. They were removed by me after their interviews had been completed.

8. BODY PERFECTION AND THE DEFENSE OF STANDARDS

*The sublimation of desire is replaced by shame at its
very existence; our dream of a perfectible humanity is broken
by this cruel reminder of what, in fact, man has contrived to make
out of the raw material supplied to him in the cradle.*

—Kenneth Clark, *The Nude*

Esthetics used to be identified with the study of beauty. But many art objects are more obviously "good" than they are "beautiful"; and if esthetics is to be defined by its objects, the search for beauty can at best be one concern out of many. If esthetics is to be defined not by objects but by the processes which apprehend them, the conclusion must be the same: an observer concerned solely with beauty is bent upon a psychologically limiting task. Openness to the subtleties of experience, rather than a quest for a single one of its qualities, would seem the appropriate task.

But that is not to say that beauty is altogether irrelevant, either to the study of art or to the understanding of everyday life. No group is without criteria of human beauty, nor does any fail to value it as a social asset. At the more instinctual level beauty has something to do with sexual attraction, while at the more sublimated level it seems akin to perfection or to proportion. And because these three therms—attractiveness, beauty, and perfection—are so closely related, I should like to attempt to define them and so specify the problem that this chapter sets out to understand. We understand sexual attraction better from what happens in the observer than from the qualities of the attracting object: the observer's mood is important to his response, and the response consists at least a part of sexual arousal. For a body to be beautiful, however, it must arouse a kind of awed admiration which is neither necessarily sexual nor tied to transient

mood; it may nevertheless be highly compelling and leave the observer feeling helpless to control it. For a body to be perfect it must conform to some standard, however rudimentary, of proportion and tone of skin and muscle, and be free of flaws; but our response to it may be neither sexual nor compellingly appreciative, but rather coolly appraising, and perhaps even envious and possessive.

Of all three desired attributes, that of perfection is the most subject to our tendency to idealize; or, to put it conversely, if we have a need for the ideal, it is better expressed in idealized perfection than in idealized beauty or sexual attraction. And thus through the study of bodily perfection I come closest to what I had originally set out to do, namely, to study the appeal of the idealized nude. If the starting point was too narrow and led me to a greater awareness of how much else about the human nude there is to understand, so much the better; but it is time to return to the question posed at the outset.

It is easy enough to assume that a liking for perfect nudes, however defined, satisfies a need to idealize. But it is another matter to demonstrate that the need exists, and still another to explain where the need comes from. Psychoanalytic investigations offer some help, but not as much as we would wish. Freud (1960) says that one idealizes objects toward whom the original sexual aim has been partly inhibited; as a consequence of repression of the oedipal conflict the child separates tenderness from lustfulness, and during adolescence, when the burgeoning drives require a resurrection and strengthening of childhood defenses, the old separation may widen and produce a view of attractive objects as either erotic, and therefore base, or ideal—and therefore pure, precious, and spiritual. I sense that Freud's view is basically on target but that it is incomplete; because it applies so universally—we all suffer from partly inhibited instincts—we do not know under what conditions idealization would be most pronounced. Would it be the most pronounced under conditions of maximum repression and separation? In such a case we should expect idealization to be complete—but detached from any sexual feelings whatever. And in such a case it would be hard to see how it could refer to the human body; instead, one might expect it to attach itself only to abstract form, as in the love of mathematical perfection or purely formal proportion. Would human idealization then be most pronounced under some *optimal* level of repression and separation? Perhaps; but if so, then we do not know what that level is.

Later analysts have observed certain specific conditions under which idealization of a human being may be produced, but they are so specific as to be encountered perhaps but rarely. Thus Rycroft (1955) presents a case of idealization so extreme that it could only lead to disillusionment: it is that of a woman very much neglected by her mother during significant portions of her childhood, who as a consequence came to form repeated infatuations with older girls and women. These objects were, as one might expect, unattainable, in the sense that they were outside of the family's usual social circle and made it difficult to establish a reciprocal emotional relationship. But the need to idealize them could persist only insofar as they remained unattainable; if they came close enough to make clear that they were going to remain indifferent then the idealization became humiliating, and if they became at all responsive, the discrepancy between their ideal image and their actual self became too great to bear. Clearly this type of idealization

is more extreme than that which we are prepared to encounter here, nor does Rycroft propose it as a general mechanism. But the general mechanism which he does mention—the healthy child's hero worship of his parents which tides him over until he can discover his own powers—is also too general to distinguish those who idealize the human figure from those who do not.

Thus our theoretical preparation is this time meager. We must in effect start afresh, and content ourselves with a listing of themes which might plausibly be encountered in idealizing the human nude. There is, first, the question of idealizing as a tendency, quite apart from its objects. Psychoanalytic theorizing at least prepares us to find it first exhibited toward the parents: toward the parent of the opposite sex for qualities that relate the parent and child erotically, and toward the parent of the same sex for qualities with which one identifies. But because it is difficult to know whether an adult's idealized description of his parents reflects the parent's real qualities or only the tendency to idealize, we must look for, and I think we should expect to find, something about their mode of bringing up the child which either reveals their special qualities or describes some process by which ideals are emphasized. One is reminded that the authoritarians studied by Adorno *et al.* (1950) had also idealized their parents; and while it is difficult to disentangle present view from historical fact, the parents must have upheld fairly rigid standards, imposed a moralistic view by harsh discipline, attempted to hide their faults, and given affection only conditionally.

In addition to idealizing, there is a second question, namely, of the object to which it is directed: why should it be the human nude? A likely possibility is that some experience had made the subjects value their own body—that some concern with their body either as an esthetic object or a functioning mechanism, arose during their life that makes the body an object of feelings, conflicts, and solutions.

Two studies were conducted in which these themes were sought for.[1] As with the first studies of masculinity-femininity and drama-calmness, the results of the first study of perfection-imperfection were clear and seemingly sufficient; but the study had been done without the precaution of keeping the subjects' preferences unknown to the interviewer. The need to replicate the study was combined with the wish to understand subjects who had demonstrated esthetic judgment; therefore the subjects for the second study were selected from the same pool as those of masculinity and drama. The interview schedule in both studies relied most heavily on the standard topics, but the second study profited from the first in examining parental identifications more thoroughly and exploring body image more consistently. As has been standard in all the studies reported here, the subjects were also asked for their reactions to examples of nudes that illustrated the dimension of their preference. The choices of perfect nudes will cause no surprise (the *Hermes* of Praxiteles [Fig. 29] and the *Venus de Milo* [Fig. 30] were among the very high scorers), nor will the first two of the imperfect nudes (Baldung's *Two Men Fighting* [Fig. 31] and the detail from the *Inferno* in the Orvieto Cathedral [Fig. 32], but the choice of Cranach's *Venus* [Fig. 33] as a highly imperfect female body may reveal our greater affinity with the classical than with the Gothic ideal. In what follows it is important to remember that on the average most populations of subjects who have taken the Human

Figure 29. Praxiteles. *Hermes with Dionysos.* National Archeological Museum, Athens.

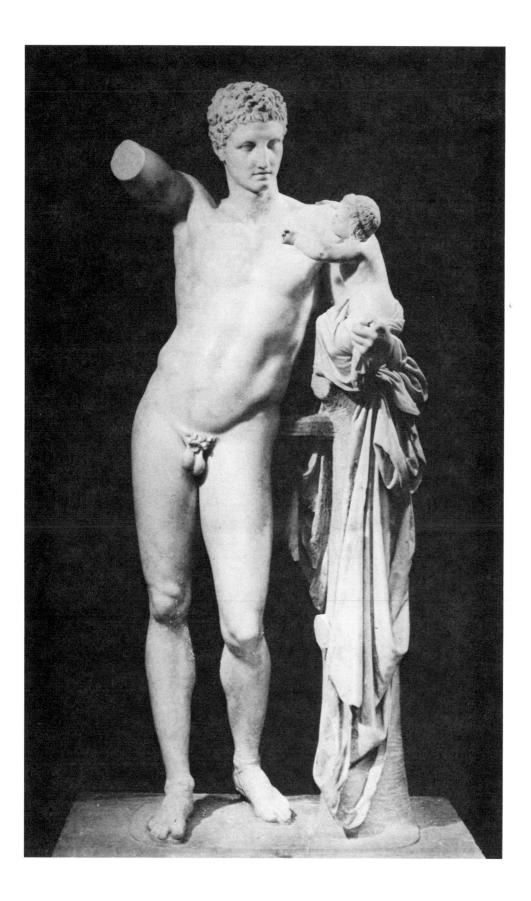

Figure 30. Greek. *Venus de Milo* (detail). Louvre. Cliché des Musées Nationaux, Paris.

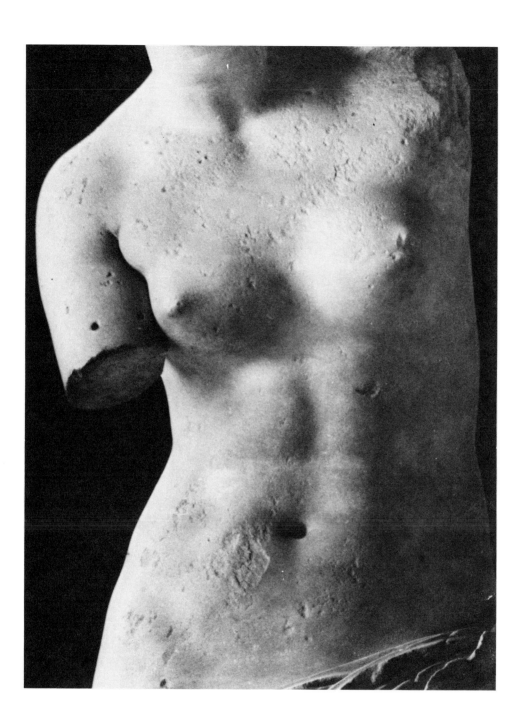

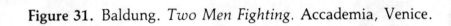

Figure 31. Baldung. *Two Men Fighting.* Accademia, Venice.

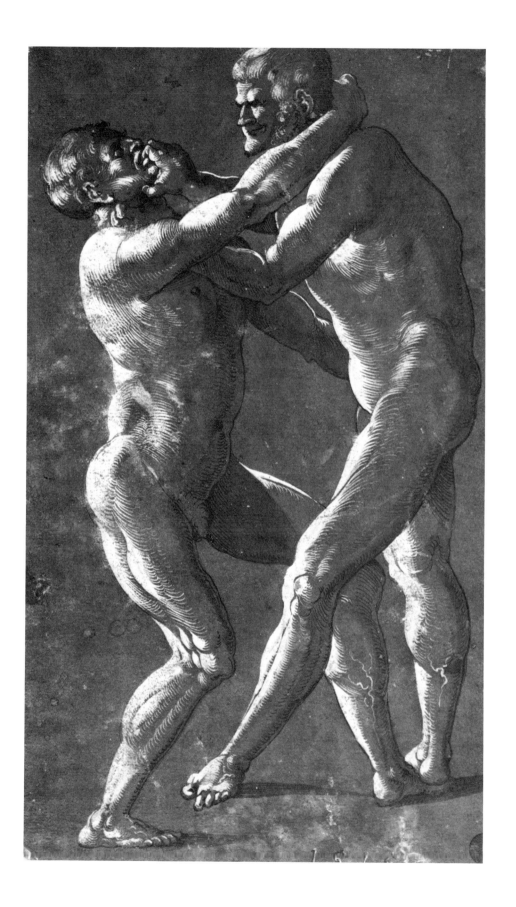

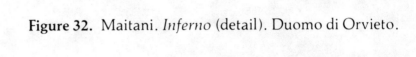

Figure 32. Maitani. *Inferno* (detail). Duomo di Orvieto.

Figure 33. Cranach. *Venus.* Städelsches Kunstinstitut, Frankfurt.

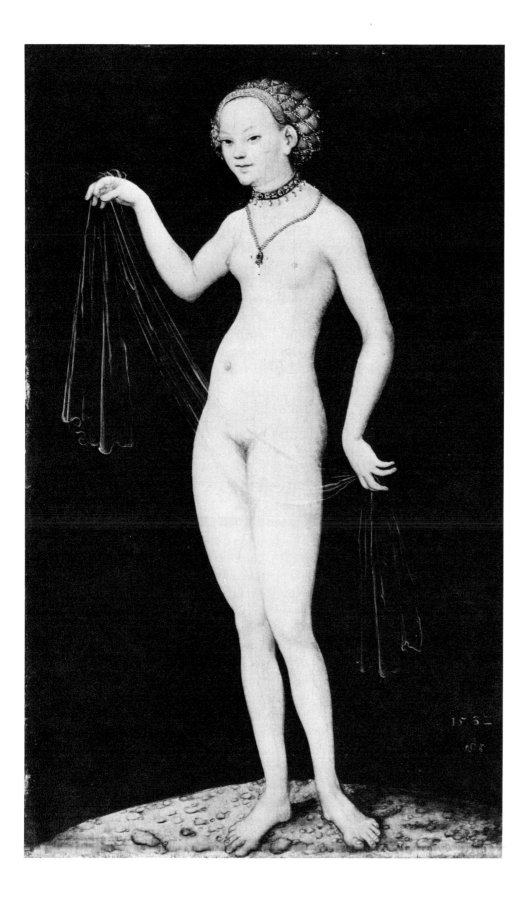

Image Preference Test lean very much in the direction of preferring perfect bodies; and since the pools from which the present subjects were selected are no different in this regard, the extremes are represented on the one hand by subjects who value the perfect nudes very highly indeed and on the other by subjects who accept imperfect ones as much as they like the perfect ones. The contrast that is presented is therefore between perfect preferrers and what should be called imperfect tolerators: there seem to be no imperfect preferrers as such, at least not in the populations that were at hand. For this reason our contrast is between a narrow taste and one which is broad and undemanding.

In presenting the results of the two studies I shall adopt a different procedure. Given their strong taste in art the subjects of Study II were generally more complex than those of Study I; because they had been drawn from the same pools we have seen this difference in Chapters 4 and 7 already. But here the complexity made some differences to the results: the simpler subjects of the first study gave us extremely clear results—results whose simplicity could not be duplicated on more complex subjects. In the main, the two studies arrive at very similar conclusions, but I prefer to treat the results of the second as more definitive because they represent a type of test case; after studying the dynamic and cognitive simplicity of the perfection-preferring subjects of the first study, one turns to subjects who are complex but still like perfection. In this manner some variables are better isolated.

Study I: Non-Artistic Subjects

If I have said that the perfection-preferring subjects of the first study are relatively simple to understand, that is not to say that one or two qualities suffice to describe the manner in which they differ from the subjects who tolerate imperfection. But the several distinctions that can be made add up to a coherent picture. (1) The perfect preferrers are conservative in their political views, and very traditional in their view of male and female roles: the man is the breadwinner and dominant in the household. They have been raised in a religious atmosphere and religion remains important to them—indeed, some remain or have become quite fundamentalist; their morals seem to them given by external sources, that is, either by religion, parents, or contemporaries. (2) They are clear about their goals in life and the goals are quite practical; the education they are receiving currently is viewed as a means to their vocational goals rather than as an end in itself. Their main orientation in life is toward achievement rather than toward experience. (3) They find physical appearance to be important in their current partner or in the ideal fantasied mate: physical appearance is the first characteristic they mention when asked; even the women put musculature and body tone high on the list of preferred male characteristics. When asked what they would change about themselves, physical attributes are

given prominence. The men had been athletic in high school and still emphasize being in shape. (4) They are conservative sexually; a high proportion still live with their parents; a very high proportion, especially of the males, are virgins. The virgin males may have a girlfriend but they place spirituality in the relationship higher than sexuality; nevertheless, they easily picture the physical characteristics of an ideal mate. Those who have a sexual relationship are either married or have an exclusive partner, but they find it hard to conceive of being promiscuous or living out of wedlock; and irrespective of current sexual expression they disapprove of homosexuality. (5) They idealize their parents: most cannot find fault with either parent although the few who do are critical to the exclusion of positive traits. Most of them are first-born or only children and show therefore a strong identification with their parents.

By contrast, those who tolerate imperfection are liberal where their opposites are strict. In the matter of political views they are liberal in the obvious sense of the term; and their views of male and female roles in particular are egalitarian and resistant to definition. Although many were brought up religiously, at least in a formal sense, religion is no longer important in their lives. In their choices of life goals they are uncertain or emotionally expressive; a surprising number expect to drift; some simply have made no decision yet, while a few are artists. In any case they value experience over achievement, and view their education as part of that experience rather than as a means to a goal. As far as physical appearance goes, it is noted but not emphasized; when mentioned as a criterion of the ideal mate it receives a low place. Nor is their own appearance important as a source of satisfaction or self-criticism (with one exception: a woman so totally unhappy with herself that she cannot foresee satisfaction in life or fantasize improvements which would make her happier). In the sexual realm they are considerably freer; not only tolerant of homosexuality, but more expressive of their own needs and more likely to have had several partners or to be living with a partner without being married. As far as their image of their parents is concerned, they are quite differentiated: neither purely positive nor negative, but apparently realistic: and they sometimes value in their parents characteristics which are neither goal oriented nor conventional, such as a sense of humor or an appreciation of the esthetic.

It may be asked why such pronounced differences should give rise to any dissatisfaction; by way an initial answer one would certainly have to admit that the differences seem both important and clear. One senses in them an involvement with the body and a strong identification with standards—characteristics that appeared initially to be required of idealization of nudes. Perhaps theoretically the most satisfactory observation is contained in the separation that the highly repressed men make between women as objects of spiritual attachment and ideal appearance on the one hand, and their hitherto unexpressed sexuality on the other; there is a hint there of a mechanism quite similar to that posited by Freud. (But the women do not make such a separation, and for someone trying to understand why they idealize the nude it is insufficient comfort that Freud may have intended his formulation to apply to men only.) Nor will it have escaped the reader that in most of their characteristics the perfection-preferring subjects resemble the authoritarians made well known by the research of Adorno's group: all the traits

observed here had been noted by the authors of *The Authoritarian Personality*. I sense that the perfect preferrers are not as humorlessly power-seeking as the authoritarians were made to appear, and I certainly do not draw the value distinction explicit in the Adorno comparison, but I do not wish to deny the psychological similarity; and the greater the similarity, the better one grasps the underlying dynamic—which, in the authoritarians, led to prejudice against out-groups as the obverse of idealization of the parents.

But the difficulty is just this: far from not having enough on hand for interpretation, we have too much. We should like to know whether for the formation of a preference for perfection a smaller set of characteristics might not suffice—whether it might not suffice, for example, to idealize one's parents, or to fantasy improvements in one's body, or to view the world in terms of standards to be met. A pervasive difference between our two subject groups may have produced more of a difference than is necessary: although all the subjects had been chosen from one pool, the perfect preferrers turned out for the most part to have fathers with little education, while the imperfect preferrers came from families where the father had been educated. The difference in education has consequences for the setting in which the child will grow up, and may be said to constitute a difference of social class; of course, a social class difference is psychological as well, in that it can be understood through the processes by which the child is brought up and through which the social world is experienced, but it may also have the unfortunate consequence of amassing too many points of difference.

The second study helps us out in this regard, quite without having been intended to do so. Having chosen the subjects for their esthetic judgment, and by implication for their interest in art, we have also managed to reduce the contrast in social class and education. The "purer" difference results, of course, from the characteristics of the subjects rather than from reduced methods; on the contrary, the search for differences was more thorough in the second study than in the first. I shall discuss the differences under three headings, which will be seen to resemble three of the distinguishing traits from Study I: parental idealization, body concern, and the maintenance of standards as a life goal.

Study II: Artistic Subjects

Parental Idealization

Of the ten subjects who prefer perfect nudes seven may be said to idealize at least one of their parents, while another one idealizes an older brother. One wonders, as with the subjects of the first study, whether the idealization reflects the parents' attributes or the children's tendency to idealize. This time the data permit a sufficiently clear answer: it reflects both. Even subjects who neither like nor idealize their parents generally describe them in the same terms as those who do.

Among the men the fathers were seen as imposing and the mothers as nurturant and sensitive, and while for the sake of tightness of definition two men are not counted as idealizers, these descriptions are universal. Thus one man who idealizes his father says of him, "I always looked up to him; he was strict, too. For example, I couldn't touch his garden or his tools. His garden is fantastic. He takes a lot of pride in what he does, and I do, too." Another one, whose admiration for his father's Hemingwayesque manner is perceptible through a distant veil of skepticism, says, "My father was a man's man. He couldn't be bothered with domestic things; he was a heavy drinker, a big guy, and had kind of Victorian ways—no time for children ('Come back when you're grown up'—that sort of thing). He was a very kind person—in a rough sort of way, with a booming voice. I felt cautious with him; he wasn't a man to show affection; to him that was a terrible weakness. . . .He liked to entertain and wanted to be entertained. He was drunk eight months of the year; his view of women was that they were there to serve and please." Yet another says with undisguised pride, and with the authoritarian's penchant for blaming shortcomings on the outside world, "My dad is a blue-collar American; he did well in school, he's very bright, but he never was able to go to college. He was an Eagle Scout, a swimmer, and archer—an all-around gentleman. He couldn't go to college because of lack of money and the current view that college was for people to play instead of learn a trade." The mothers come off very well also, but instead of appearing imposing they are more emotional and nurturant. "My mom—she's sweet, a buffer between dad and the kids, I really love her. Her main interest is childrearing—she loves to cook." Or, "My mother, she's sweet, too sweet for her own good, and soft-spoken. Before her marriage she was a *femme fatale,* a very lively person. She's a very remarkable person; nice; and sweet." Or, "My mother was a good mother. She had a lot broader background than my father because of her travels. She's more broad-minded and cultured than my father; had she lived, she would probably be like her relatives, upwardly moving, socially conscious, striving."

Among the men of this sample, then, one sees an admiration or even distant awe of a father who was either hypermasculine or strict and demanding, and in every case emotionally quite distant. The description resembles that of the masculinity-preferring men, and if one were to ask what has prevented our sample from forming tastes in which masculinity predominates over perfection, the answer would have to reside in the warm feelings felt toward the mother: unlike the masculine preferrers, these men experience an affection which repays the warmth extended by her. These men can admire all of humanity, not just one sex; and the condition of the idealization appears to be a particular mixture of awe of the male and affection for the female.

The perfection-preferring women describe their mothers very much as the men do: as very loving, warm, and nurturant women who cared for their households and supported their daughters in times of difficulty. At least such is the rule; and while the descriptions are not couched in terms of superlatives, a warm admiration of the mother as a mothering figure is there. (That mothering is in question is made clear by the two women who also describe their mothers as overprotective.) Of the four women who so describe their mothers only one cannot be said to idealize her because the qualities were displayed only toward her brother; but she has idealized her grandmother—"Up till now I thought Grandmother was perfection"—and identified with her mother's need for success. The fifth woman constitutes, however, a genuine exception, in that she finds little to admire in either of her cold parents; I shall attempt to account for her need to idealize the nude later in a more detailed discussion.

These women's view of their fathers is, however, puzzling. Even quite apart from the exceptional fifth subject, the view is quite mixed. For one woman the father had the sort of boisterous and blustering self-reliance that we saw in some descriptions by the males, and for another he had been attentive and emotionally close to the children. But for the other two he had been at best no influence at all ("My father didn't play any role in my life; he was an alcoholic who slept all the time. Not a *bad* alcoholic: he was a friendly man, I remember him as a nice man"), or a fairly negative influence ("My father's approach to us was selling his ideas rather than giving them").

As far as I can judge from the data available, it seems that women who will idealize nudes later in life will, with one exception, build from a base constituted by a warm mothering figure, while men are more likely to need a distant but admirable father as well. I note that the admiration for a parent can be heightened by loss, as through death, divorce, the mere threat of divorce, or a subsequent replacement by a step-parent who is viewed critically. The phenomenon of loss was also encountered among those who over-valued male or female figures, that is, in Chapter 4. Here its strength is brought out rather poignantly by a subject who had lost his mother when young and his wife a few years before and who idealizes both; when first broaching the topic he reveals the depth of his feelings in a parapraxis: "Basically, I died—mother died when she was very young, when I was a child."

The subjects who tolerate imperfect nudes confirm the value of parental idealization by showing so little idealization themselves. Their fathers are described positively but not with warmth; among the men the descriptions are those of a dry and distant father,

while among the women there is a sense of admiration—not all-consuming but present nevertheless. But in the descriptions of mothers there is a unanimity which is as striking as the consistency of the perfect preferrers' views but opposed in its direction: all ten mothers are described negatively. One mother is remembered as "scatterbrained, nervous, and religious," another as "superemotional and neurotic," another as "competitive, moody, and stubborn," and still another as "childish, offended, and jealous." These views are among the most negative but the others are disparaging as well; for example, "set in her ways," or "really straight," or a grudging "she was all right," are typical of the other views. It should be remembered that the tolerators of imperfection are not an esthetic extreme in the same sense as those who prefer perfection, and that one should not expect negative excesses in their views of their parents; they tolerate imperfection but do not seek it exclusively, and a realistic view of their parents, which must include some negative traits, would seem a sufficient base. But I had not been prepared to find the mother the more important influence, nor can I think of a reason why a view of her should characteristically be more negative than positive; but the fact, though unforeseen, is there, and it helps these subjects to escape the yoke of turning to the nude for the affirmative satisfactions that seem so much more common.

But two other important characteristics separate the two groups. They are important not only because they are present but because they help us understand the subjects who had to be counted as exceptions to the rule about idealizing parents; it is as if three traits normally determined a preference for perfection, but that two, and on occasion one, might suffice.

Body Concern

In somewhat unanticipated ways the perfect preferrers revealed that their bodies were a focus of concern. We looked for such a concern when we asked them how they saw themselves and then how they saw their bodies, and some of what the subjects had to reveal was contained in answers to the second question. Other information about the body came to us haphazardly. The concern shows itself in three ways : in dissatisfaction with body size, in attention to health, and in an emphasis on nutrition.

The first study had shown us the athleticism of the perfection-preferring males. But it had not prepared us for the minute attention to details of bodily condition represented by a statement such as the following: "It's a great thrill to be involved with track and feel your body and know where it is—feel all your muscles. I do like my body; both my wife and I are nudists, we belong to a nudist camp. It certainly puts a different definition on your body in the sense of liking what you are like. I am very aware of my physical health and I can tell when I'm two-tenths of a degree higher than normal temperature. I am

amazed I can tell that much, but I can tell when I don't feel well very quickly. I am very aware of the interrelationship between the body and mind. I am very involved— very interested in biorhythms and how they affect you." Not every man's bodily concern is that pervasive, but surely a greater than ordinary sense of self-criticism is shown in three of the other four men who wish to be bigger than they are. One says, in response to a question about what he would change about himself, "That's a kind of fantasy, too: if I was 6'3" and weighed 210 pounds, I'd be a football player," and another describes himself by saying, "I always thought I was too skinny and that my clothes never fit; but now of course I can wear sloppier clothes anyway. People always used to say that I sat and walked too straight and that my moves were too deliberate and too stagy; so I've learned to be less deliberate"; he, too, likes going nude. The fifth man, who also sees himself as tall and skinny, shows perhaps the least self-involvement, but his offhanded "When you're healthy, you've got everything" follows an equally unselfconscious statement of appetite, "I could eat a horse."

In late adolescence a large appetite may be physically necessary, but the prevalence of appetitive concerns in our group can only be a psychological fact: and so two of the other males mention cooking ability as one of their parents' virtues (a mother's and the Hemingwayesque father's, respectively). But it is the women who bring the concern about nutrition to the foreground. The mother of one was the dietician for her school district; the mother of another is a home economics teacher who teaches cooking, family living—and, increasingly, self-awareness, alternatives to standard medical care, and finding out how the body really works and what it really needs; the third has clearcut ideals for the human body ("Greek, I guess: not fat at all, well sculptured, in good physical shape from exercise and good food, youthful"), loves reading cookbooks and cooking—and plans to become a nutritionist. That three of the five women should be so enmeshed with problems of nutrition is perhaps a humorous quirk of sampling fate, but if one views them as instances of bodily concern that parallel those of the males then their frequency is not accidental. But in the remaining two women's interviews nutrition does not come up spontaneously; a distinct concern for bodily appearance, as well as a dissatisfaction with one's own, is expressed by one, and a strong sense of bodily inhibition and shyness is mentioned by the other, but to what degrees such concerns organize bodily idealization is not clear. I rather suspect that for these two women they contribute but only in a peripheral manner, and that other concerns are more focal.

The subjects who tolerate imperfection present a clear contrast. Most of them may be said to be satisfied with their bodies or to experience no more than the usual feeling that in some manner their appearance might be improved; above all, none of them express a concern about their health. (I view with amusement the appearance of one mother in this group who had received a degree in nutrition, but amusement does not give way to alarm: she had worked all her life in real estate.) But two subjects are remarkable by the degree of their unhappiness with their appearance—a degree which exceeds any observed in the perfect preferrers. One, a man, sees himself as very skinny and not especially good-looking; and as negative as his view may seem now, it was much more severe earlier when he was convinced that he was distinctly ugly. Good looks in his

view are an advantage in life in that they invite others to approach, smile, and converse, and he would like very much to be in the luxurious position of being able to say no to such an advance. The other, a woman, has contended all her life with a sense of insufficiency and inability to love, and this sense contrasts oddly with her being considered the pretty one in the family while her sister was seen as the smart one. She could no more believe that she was lovable and pretty than that she was capable of touching and caring, and only now has begun to think that it is all right to be pretty; nevertheless she still dresses horribly and cannot experience sensuous feelings. I think that both subjects have, so to speak, ceased to strive for the rewards that might come from good looks, even though no objective reason would prevent the woman from doing so; they have counted themselves out of the competition, and perhaps for this reason bodily perfection in others may seem immaterial.

But as important as bodily concerns may be—particularly those about its health and well-being—they seem insufficient to account for a preference for bodily perfection. Technically speaking, they may not even be necessary, since two of the women had shown them only to a mild degree; but future studies can elucidate the point better. There is a quality which pervades the records at least as frequently as bodily concern and which appears to affect even more areas of the subjects' functioning: it is a concern that standards be maintained.

Maintenance of Standards

The perfect preferrers of the first study taught us the importance of goals and specified that they be practical and tangible. Greater wisdom on my part would have therefore suggested a thorough exploration of the intentions, wishes, and hopes of the artistically inclined subjects of the second study, as well as a close look at the childhood experiences by which they had been fashioned. My attention having been drawn toward authoritarian identification, however, I was not as thorough in pursuing these questions as I would now wish; but merely having asked about goals, and having inquired into parental expectations, I discovered a striking contrast between the perfection-preferring and the imperfection-tolerating. Let me turn to the means before I discuss the ends.

The evidence is clear on eight of the perfect preferrers and of them six were raised in homes where the parents had high though realistic expectations of the children. The expectations were aimed not so much at eventual goals but at the means by which they might be attained, but one presumes that the children could not avoid concluding that, if one bothers with means, the attainment of some high goal is expected. The means being education and hard work, the goals could not help but be related. Thus one man says of his parents, "When they could help us in school, they always did. My older brothers and

sisters were forced to help us: we were always supposed to do well in school." (The same man also learned from his father's example, as had been mentioned, to take pride in his work.) Another man, when asked what sorts of things caused conflict in his family, mentions school work: "My brother and I, we never put too much emphasis on studies, whereas my parents did. Every time the report cards came out, they weren't all that good. But that's changed quite a bit since we've gotten older. Maybe it was the kids we hung around with, but we just assumed we'd go to college." He then adds with a chuckle, "I like it so much I'm back for the second time now." And in response to the same question one woman volunteers immediately, "Not living up to my father's expectations of us. He was very generous with material things, but if we didn't live up to his expectations, like getting A's. . . ." The threat is left undefined, but the force of the expectation is amplified: "Father encouraged me academically; education was primary to him. Mother had a quieting influence on us—she went over our homework and taught me to read and write before I was in kindergarten." Nor were the consequences of disappointing the parents merely material or isolated; one woman was quite aware that her mother's whole investment was in her daughter's performance, and sums up the matter in this manner: "My mother always wanted us to do something with our life; she wanted us to go in certain directions. If we didn't, she dropped us. Now she has dropped my brother, so I am the best; it would go back and forth. For example, to Mother I wasn't ever considerate enough or handled my responsibilities well enough." That such a statement could be made about a mother who in every other respect left the upbringing of the children to their grandmother suggests that the expectations might have formed the only link between them—and that the link was tenuous enough. The expectations are therefore not always remembered with pleasure; they may in fact be recalled in the context of a highly negative view of the parents, but their force need not thereby be diminished in the slightest: "My parents really expected a lot of me; or, I don't know if they really did, but I tended to act as if they did, and I did really well in school and always wanted to impress them."

The expectations were not communicated only in ways that are clearly remembered; in addition to what the subjects specified, one notes more covert and probably more pervasive ways of establishing an atmosphere within which the child would learn what the parents wanted him to. One such way would be to emphasize culture: several subjects noted that their parents were culturally oriented or that one parent was more "cultured" than another. The sense of culture, whether attained or only striven for, was a distinction which, no matter how ambivalently viewed, became a model that the child still values. Another way, probably the more important one in view of its universality, was to surround all behavior with a sense of restraint. It is difficult to be precise about something that is pervasive, just as it is a challenge to draw a picture of fog, but one senses the atmosphere not only from the parental idealizations I have already described, nor only from the standards by which most activities were evaluated, but also from the sexual inhibition which pervades the subjects' lives at present. It is an inhibition which is only partial and which permits the subjects to cope with their sexual needs—this is a point of considerable importance—but it is sufficiently strong to be remarkable. The

men sense their parents' sexual conservatism and have responded by channeling the sexuality into traditional molds, such as going with only one girl at a time, entertaining only the honorable intentions of marriage, and, when married, seeking to make an exclusive relationship work. Of the three who are married none had lived with their wives before marriage, but they wish they had been free enough to do so; the fourth knows that his parents would disapprove if he tried it and will not resist their will. (For the fifth subject sexual needs take low priority, and whether one is to credit this to inhibition or anxiety, or to an indifference born of unambitiousness about anything, is not clear; he is sufficiently puzzling to present in greater detail later.) Three of the women restrict their sexual expression almost totally, another one limits it to contact with a steady boyfriend who lives at some distance, while the fifth, although brought up in a fundamentalist atmosphere, has carved out an expressive and intimate relation with her husband.

Before discussing the ambitions that motivate our subjects I wish to digress—more apparently than in substance—and discuss a trait that seems to me linked to the partial inhibition felt by the men. I am hard put to say why the mechanism should be apparent only in the men; if, as seems likely, its absence in the women is not an accident of sampling, then we are faced with an enigma which needs better information than what I have on hand to solve. The trait, shown by three of the men, is one of extreme idealization of women. The trait is the more remarkable as it does not detract from idealizing the male body in art: none of the subjects prefer feminine figures over masculine ones, nor does their liking for perfection in the two sexes vary; but in life women are the objects of idealization. For the subject who had lost his mother early, his relation to his deceased wife was "extremely good, extremely close, and extremely intimate"; for the one whose sexual needs are secondary, an interest in beautiful women is all-consuming ("I've always had a vision of the eternal female; they pop up all over the place. Whenever I see *The Birth of Venus*—the head—I can look at that for hours and hours"); and for the third subject, the one who admires his burly and boisterous father from a distance, women have always been "holy things, not to be tampered with; somewhat mysterious and angelic." This same subject had been bored with his peers in high school and dreamt of sophisticated but unattainable women such as Joan Crawford; but after his first sexual experience, with a much older woman, he began to view woman "with a totally different reverence now; they are totally woman; they're not angelic beings any longer, any more than I am; they're marvelous, absolutely marvelous creatures." Clearly in each case enough inhibition had to be present to make such an idealization possible: with less inhibition women would presumably not have been put upon a pedestal and with more they might have been ignored altogether. But that seems to me only the necessary condition; one notes in two of the subjects—the third one is unclear on the matter—an emotional closeness with their mothers and a perceived similarity in character. The rough and ready fathers might have been admired but they could not be emulated; instead, the sons felt more bookish, cultured, and inhibited. I would not use the word effeminate, nor would I in any sense view their adaptation as anything but constructive; but they do retain the sense of woman as an extraordinary creature, one who is very much desired

and now, in post-adolescent maturity, attained. By contrast, the only instance of idealization observable among the imperfection-tolerating men goes in the opposite direction; women, too are divided into whores and madonnas, but sexuality prevails over love. And if parental prohibition forms the basis of this split as well—the subject's brother is happily married within the Catholic faith while the subject is busy with his rebellion—the consequence for esthetic preference is a liking for the imperfect.

I now come to the subjects' goals. Their direction is so clear that they may be presented in just a few words: five of the ten plan to be teachers, or are teachers already, or work in a school; one wants to be generally erudite and one plans to become a certified public accountant. Among these seven there is therefore a clear emphasis on standards and order; the teachers are concerned with passing on knowledge and are occupied with matters that can be judged as correct or incorrect, while the one who wishes to become erudite is identifying with the goals of her otherwise disliked parents. The school psychologist is living up to his mother's cultured and intraceptive values and surpassing his father consciously and conspicuously in educational attainment and social status; and the future CPA's need for order needs no elaboration. Of the remaining three subjects only one can be seen as exemplifying a sense of rightness: the woman who wishes to become, like her mother, an interior decorator in spite of dislike for the mother's manipulativeness and conditional love; the sense of rightness is seen in her mother's imposing her own decorating scheme on the daughter's first independent apartment. One subject will put to good use her concern with her body and become a nutritionist; and finally one subject, the one whom I must discuss separately, has no goals whatever. But even he, like two of his better-focused colleagues, has chosen to become educated in art history—unlike the tolerators of imperfection who choose to express themselves in art.

Now it is in no sense a dismissal to sum up the contrast with the tolerators of imperfection in relatively few words; the groundwork for understanding them was laid by the detailed analysis of their opposites. Only two were raised with high parental expectations; the others were raised either with no expectations in particular nor with the means by which they might be met, or, in one case, with expectations that were so high in relation to the family's ability to support them that the child refused to accept them. The home atmosphere was sexually at least as restrictive as that of the perfect preferrers but the restrictions were not perceived as being at the service of occupational achievement. Nine of the ten being Catholics, as opposed to only one among the perfect preferrers, one may suggest that their home atmosphere was one of Puritanism of principle where that of the others was an atmosphere of Weberian salvation through work and perfectibility. The consequence for current sexual expression were on the whole more severe: eight of the ten have no sexual partner at present, which is the more remarkable when one notes that two of them have been married and one still is, and another one has never experienced orgasm. And the subjects' life goals are either more diffuse, or more expressive, or more unattainable: four want nothing specific of life (the extreme being embodied in the man who cannot see beyond the goal of spending two seasons skiing); three want to be artists, using teaching as a means of support; one wants nothing less than to reform the judicial system, without the benefit of means, such as

legal training, by which to do it. But that accounts for eight subjects only, and if I am to show at least some of the virtues of the subjects I am describing, then I will simply admit that even in the world of psychological research imperfection must be tolerated as well. The other two have realistic goals which include education as a means to them: fashion design in the case of one, the teaching of art history—albeit by a subject who identifies with his mother's fertile but scattered mind—in the case of the other.

Let me sum up the description of the perfect preferrers. Most typically they bring three tendencies into play: a warm relation to their mother which, for the men, is joined by admiration for a distant but imposing father; a concern for their bodily welfare; and a pervasive wish to maintain standards of performance. In the theoretical terms of this book their tastes may be said to serve a varying mixture of ego-defense and symbolic need satisfaction. Symbolic satisfactions may be seen in those subjects who derive pleasure from the nudes (something that can be ascertained only as they describe them), and that in turn may be related to the warm regard in which they hold their mothers; ego-defense support is more easily seen in subjects who do not specifically enjoy nudes but when asked to make a choice prefer the perfect ones: they are reacting to perfection by bringing their identification with parental standards into play. As far as their body concern goes, it receives clear support—that is, a defensive support—from their preference: a kind of reassurance about the integrity and goodness of their own bodies.

From the functional point of view, two comments need to be made about those who tolerate imperfect bodies: on the one hand they appear unmoved by standards and have therefore little need for a strong attraction to perfection, and on the other they support a distinct defense against sexual expression when they turn to examples of thinness, corpulence, or deformation. Those few whose body image is a source of pain receive perhaps some further support, of a curiously negative sort, against reminders of unfavorable comparisons.

Since my focus here is on the needs engaged by a preference for perfection, I must carefully specify how the three tendencies of which I had drawn perhaps too ideal a picture function in each of the subjects. Of the ten, six may be said to engage all three tendencies; for another three only body concerns are prominent, and for one only the defense of standards is salient. The preference for perfection may therefore serve one of the prominent needs or the other, but apparently it need not serve all three. How this occurs is best shown by sketching the histories of two subjects, one of whom brings into play only her strong standards while the other brings to bear a powerful fascination with the human body. I am not sure I understand the second subject's fascination as well as I grasp the prevasive standards of the first, but it is already a consolation if the case history serves to bring a theoretical problem into sharper focus.

The first subject, whom I shall call Doris, was referred to earlier in my discussion of parental expectations; she was the one who viewed her parents critically but lived up to their standards nevertheless. She is almost twenty years old and feels that she is gaining some independence from them while away at college. Her childhood is not remembered with pleasure; she

253

does not complain about it, but her narrative contains few mentions of joyful moments. Quite apart from the high expectations of achievement already referred to—which became so much a part of her that she can no longer remember her parents needing to remind her—there was strict supervision by her mother of all her movements, including the first romantic explorations. But the atmosphere was not merely restrictive; it was cold, miserly, and unstable. Very little overt affection was shown between the parents or between them and the children, and what was shown on the outside was a good reflection of what was going on inside; the parents communicated a sense of frugality and selfishness which is resented to the present. Doris would have liked to give more of herself, as by volunteering to do chores, but since no one thanked anyone else she gave up; and she remembers with particular distaste the careful rationing of food that took place at the supper table. But the frugality was not even compensated by stability because the children began to fear quite early that the parents' bickering might be a sign that they would split up. After several years of reassurance that they wouldn't, the parents divorced. The new household established by her father showed her for the first time that careful rationing need not be a way of life, but otherwise the high standards of behavior continued to be expected; in fact, in some ways the standards became both higher and less attainable as the divorced parents began to argue about what courses the children would be allowed to take: there was always the danger that a particular curriculum might bring the children closer to the other parent.

In spite of this thoughtfully described situation, Doris feels close to both of her parents; one suspects each of an inability to let the children become independent if only for fear that they might grow in the direction of the other, and one is reminded that the threat of loss can evoke a defensive identification as powerful as that occasioned by an actual loss itself. So where the parents are "straight" in their moral outlook, Doris is straight; if they disapprove of premarital sex and smoking dope, Doris will not easily yield to temptation; and if they are frugal with everyone else, Doris finds it hard to offer herself even the price of admission to a movie theater. The parents' interest in culture is matched by her wish to become erudite.

She has been interested in art at least since junior high school, when a friend showed her how to use the rules of perspective. In high school art classes the emphasis was upon perfect reproduction and Doris learned easily the techniques that were valued, but it is clear that they were also congenial to her temperament; she still draws and photographs but finds it easier to choose cats and landscapes for her subject matter than people, and finds it particularly difficult to let go of realism as a style; nor is it easy for her to put into practice the ideals which she encounters in college, namely, the expression of feelings. After discussing the reproductions she had been

shown, she says that she likes things to be precise and orderly; she recollects that she was once in a fever in which everything appeared to her out of proportion, and that she was frightened. She assumes that taking drugs must produce a similar loss of reality. It is not too much to say that she fears loss of control; nor can one disagree with her when she says that, given her parents' constant competition for her affection, she can never quite fulfill their expectations of her.

Doris's thoughtful account demonstrates how even well-considered hostility and resentment may be powerless to help obtain independence from parental ideals; and it shows equally clearly how an apparent lack of interest in the body can still lead to an insistence on its perfection. The brief history given by our next subject illustrates what from my point of view is the opposite conclusion: that an apparent lack of standards or ambition can, provided there is a preoccupation with the body, lead to the identical result.

Frank is a third-generation Japanese. He likes the feeling of stalwart, inner strength that his upbringing has given him but cannot attribute it to any specific method by which he was raised. Like most Oriental families, his had been strong and close, not very expressive, and certainly not prone to crises; if any trouble threatened from the outside the family would close like a fist. It is true that his father was the undisputed head of the household but there was nothing he needed to do to prove it; he simply ran things quietly while his mother took charge of managing internal differences and difficulties. Frank cannot be any more specific about his parents' character than that, but he certainly admires his parents for their multiple achievements in the face of a harsh reality. But again, for him to admire them is not necessarily to identify with them; he knows that he is different because he has not had to face the same difficult reality that had faced them. Nor can he remember any attempts on their part to mold him in their image: "I suppose we've been allowed to grow up as we wanted to." To judge from his transcript, Frank is closely observant of reality and not given to denying important aspects of it; for that reason I easily share his sense that the parental influence was perhaps pervasive and strong but incapable of particular description.

If he feels an inward strength then unlike Weber's Protestants he does not attempt to reaffirm it by unrelenting ambition; his ambition is not only not unrelenting, but hardly describable at all. When asked what his goals were he said, "They change week by week. It's hard for me to plan things; I don't worry what's going to happen to me, like a career. (Do you have any ideas?) Oh, I have my fantasies, like being a movie director. Or writing screen plays; I rearrange the dialogue I hear on TV"

So Frank is not without areas of profound interest. In earlier years it

had been biology, which is distantly related to his father's occupation, and for the last several it has been art, which is altogether independent of any interests his parents may have. He has received degrees in literature and art history but finds himself closer to the visual sense: "*Looking* is probably one of my favorite sparetime activities; I like athletics, too, to release all your more primitive instincts. You can move without thought, it's purely instinctual, it's a release for your brain." His interest in the nude combines, then, in one neat form, his interest in his body, his preference for the visual sense, and his avoidance of abstract thought. He says that he is lazy: "Thinking about God is above me; thinking about art and beauty is that much easier to do—I usually take the low road rather than the high one."

He can describe his liking for the nude much better than I; it is tied to his fascination with femaleness, but it is not limited to it. "I've always been intrigued by women. They have always had the biggest influence on my life—like teachers, friends, and lovers. Movie stars—even pictures in magazines. I have always had a vision of the eternal female; they pop up all over the place. Whenever I see *The Birth of Venus*—the head—I can look at that for hours and hours. An embodiment of. . .beauty, I guess, a particularly human, female beauty. My friends call me a chauvinist—maybe I like femaleness for more than it really is, but it seems to me one of the best vehicles for the expression of life. The male figure—it's more difficult to transmit an idea of life; maybe of death. . . .Most of the women I've known are affirmative on life. Maybe they're more complex, perhaps because I talk to them more than guys do."

One would like to understand the source of Frank's fascination much better, but in his case the brief interview method has proved its limitations. I cannot believe that the fascination does not bear a close relation to his experience of his mother, and more distantly of his father, and that glimpses of that experience could not be obtained in further conversations. In some sense his idealization of the nude is a response to his own body which, though athletic, could, by his wishes, be larger; and in a more distant sense his idealization of the female form is a reflection of some idealization of his mother. To what extent it may be defensive I would rather not prejudge; and I marvel at how distant from the original loved image the body type of the later ideal may become.

8. Notes

1. My warm thanks to Loren Steck, who carried out and analyzed the results of the first study, and to Marie Thomas, who was responsible for the second.

9. THE NUDE AS SUCH

Even a pornographic subject might conceivably be handled by a rare artist so as to be beautiful and therefore fail to raise the sensuous suggestion.

—Samuel Alexander, *Beauty and Other Forms of Value*

In its aim this chapter is simple, but in its execution it is complex. Its aim is to study why people like the nude as such, whether it be masculine or feminine, perfect or imperfect, or exhibitionistic or shy; it seeks simply to understand people who attach themselves to representations of the body in art. But it turns out that such an aim cannot be met in any simple manner. What does it mean to say that someone likes the nude as such? That he likes it more than abstract art? That he likes it more than music or literature? Or does it mean that he likes it, *tout court,* although he may like other art equally well?

One might wish fervently for the latter meaning, but the wish is not to be granted. There is simply no way in which a comparison is to be avoided; one reason is theoretical while the other is methodological. From a theoretical standpoint it is difficult to avoid a comparison because any absolute measure of liking can only be ambiguous: if by some measure one person seems to like nudes more than another, he may actually be more sensitive to works of art in general, or he may be using the measure of liking differently. On both counts one would have sufficient reason to reject any measure that purported to be absolute. But the methods used here add an equally decisive basis for rejection; not just the subjects' tastes but also their psychological dynamics are understood by means of a comparison. If the subjects who like sentimental nudes do so in order to help avoid depression, their avoidance can only be confirmed—at least given the present imprecision of the methods of social science—by the nonsentimentalists' tolerance of that same depression.

We must choose, then, to compare a liking for nudes with some other esthetic preference, and the terms of the comparison will determine how we interpret the findings. Because the aim in each of the studies here presented is to study projective functions, the comparison must be between two different types of content within the same medium; thus comparisons with music, or with abstract art, would have no meaning. But a comparison with landscapes or portraits, or *genres* or *bacchanales*, would be interpretable—although not all comparisons would be equally felicitous. If one were interested in the nude's aloneness, one would compare it with *bacchanales*; subjects who like the one would illuminate the need for singularity and detachment while those who like the other would clarify the need for sociable, if not orgiastic, congregation. (I am not sure now why I chose not to make that comparison; hindsight suggests that the comparison would have thrown light on an attribute which is so pervasive that it usually goes unnoticed.) I limited my comparison to two rather obvious qualities: the nude's humanness and its nakedness. To find out how the nude appeals to subjects by its mere humanness, I chose to compare it to landscapes and still lifes; to study the appeal of its nakedness, I compared it to a liking for portraits.

Is there any theoretical groundwork which would tell us what characteristics to expect? There is some, but not much. Barron in his well-known study (1952) had isolated a dimension of personality which he called simplicity-complexity and found that the simple subjects were distinguished by, among other characteristics, a liking for portraits as against the complex subjects' liking for nudes. The liking for portraits was accompanied by a preference for order and a respect for authority, while the liking for nudes went with dissidence and dissatisfaction. Similar correlates must be expected here, but even if found they will be insufficient by themselves to permit a functional explanation. It must be remembered that in one of the studies to be carried out the subjects who like nudes also reject portraits: we must explain both their rejection of portraits, which may well be tied to their rebellion against authority, and their choice of nudes—which may have various purposes of a need-satisfying or defense-supporting kind. Among the need-satisfying functions we may certainly assume a greater capacity for symbolic gratification of sexual needs, and we may expect to find an index of that capacity in a greater readiness for sexual expression. But as I have attempted to show throughout these studies, a readiness is necessary but insufficient: it can explain only why the subjects permit themselves certain satisfactions in art, not why they seek them. There should, in the present case, be a "need" for the human nude that transcends the capacity for sexual expression. Before launching into the study I had not, in all frankness, thought through what that need might be, and it would not do to allow my knowledge of the results at this point in the narrative to masquerade as foresight. I had, however, prepared the way for a clearly interpretable result by gathering information on the expression of affection and intimacy—and it is, in my mind, one of the more important contributions of this chapter to have shown that an overvaluation of symbolic sexuality is a deficit need.

Thus there is some preparation for a comparison of those who prefer nudes with those who prefer portraits. But there is none for the second study, the one which contrasts a preference for nudes with a liking for landscapes and still lifes. We seek again a

double explanation: in those who prefer landscapes and still lifes we need to explain a rejection of the nude as well as a choice of the emotionally safer material, while in those who prefer the nudes we need to understand, obviously, the exact opposite. There is no difficulty in supposing that a preference for landscapes and still lifes serves the negative need of avoiding sexual material, but the positive needs that one might anticipate—such as a need for oral satisfactions that we have seen tied to a liking for still lifes, or some diffuse dependency needs satisfied by landscape images of mother earth—might be too remote and too deeply masked by symbolic transformations to be made apparent by a simple clinical interview. (But since the focus is on the nude, the lack may perhaps be excused in practice, if not in principle.) And as for the preference for nudes, there is the opposite difficulty: we can anticipate the positive reasons better than the negative. In their sexual expression and their surplus need for its symbolic equivalents, the nude pre-ferrers in the second study should resemble those in the first; but why they should reject landscapes is at the moment beyond my capacity to anticipate.

Nevertheless, even a partial prediction seems satisfactory; the aim of methods such as the ones I prefer is to discover new relations and, in any case, a social scientific theory which could anticipate everything would be too complete to need to anticipate anything. The two studies undertaken to establish these comparisons needed a new instrument by which to isolate subjects. A rough but very serviceable preference test was compiled con-sisting of fifteen slides each of nudes, portraits, still lifes and landscapes; all photographs were in black and white and an effort was made to keep the four subsets as similar in style as possible. (None of the subjects eventually selected for an interview mentioned style as a criterion of preference for one content over another.) A choice had to be offered to each subject of more than two types of content; a forced choice between only two types of content, such as nudes and portraits, might have resulted in selected subjects who were choosing by rejection only. With four sets of slides to choose from, any subject chosen for a high score for portraits and a low score for nudes, for example, clearly liked the one and disliked the other. The slides were presented in a random order to large classes in psychology with the instructions that students were to choose purely according to their preference; only one subject subsequently remarked that he was aware of the exact range of choice offered. From 193 subjects tested, ten were chosen for the highest difference between their liking for the nude and their preference for portraits, and ten were chosen for the opposite difference. For the second study, similar differences were calculated between preferences for nudes and the mean of the liking for still lifes and landscapes; again, twenty subjects were chosen. As before, men and women were represented in all the groups in equal numbers and, given the large pool to chose from, there was very little overlap between the two studies: thus only three subjects from the second study came close to being included in the first; they were all preferrers of landscapes and still lifes, and could almost have gone into the group which preferred portraits. But for this near overlap, the two studies were distinct.

The core interview schedule was used again but it was enlarged or intensified by each interviewer[1] in accordance with the theoretical thinking by which we were guided. Thus in both studies the expression of sexuality, affection, and intimacy received detail-

ed attention, while in the first study the acceptance or rejection of the parents' values was explored systematically and in the second the quality of friendships and idealization of loved ones were attended to specifically. In addition, all subjects filled out Gough's Adjective Check List (1965). The interviewers were unaware of the subjects' preferences until after the data had been analyzed, although most subjects had given them good grounds for a guess when, at the end of the interview, they commented on a selection of reproductions from the preference test. The nudes which they were asked to discuss are for the most part familiar already: Raphael's *David after Michelangelo*, seen in Chapter 7, and Valadon's *Two Nudes at Their Toilet* (in Chapter 4) and Maillol's *Youth* (not shown). But Boucher's *Miss O'Murphy* (Fig. 34) has not been seen yet; the portraits, landscapes, and still lifes that figured in the interviews are not of individual concern and are not shown here. In all essentials, then with the exception of the initial instrument of selection, these studies were conceived in the same manner as those which had gone before.

Nudes Versus Portraits

In comparing subjects who prefer nudes with those who prefer portraits, we are searching first of all for their acceptance or rejection of parental authority and second for their handling of sexuality in relation to their capacity for emotional expression and closeness; but we find in the data also a difference in the way they view their bodies. The three areas do not exhaust the observable differences between the groups, but they summarize all that is essential; the remainder are corrolaries and addenda.

Relation to Parents

The portrait preferrers report their relation to their parents to have been good in the past and to be a source of pleasure now. Asked how they would describe their parents they make such statements as, "I never thought about it but they're pretty great people. Yeah, we got along most of the time; I never went through the stage when I hated my parents," or "My parents were excellent parents—very fair," or "The relationship has always been good—we played together and did things as a family." They give one the sense of an admiration for their fathers and mothers as parents, of an identification with their values, and of a conspicuous lack of rebellion. In only one case was there any open conflict over values; in the others there was an acceptance such as the one mirrored in the statement, "They want me to make a contribution to something that would benefit other

people. It's a justified expectation—I agree with them." I do not wish to imply that conflict was next to absent; there was some at times, but what distinguishes it is that the child took the responsibility for it and preserved his admiration for his parents in an intact form. Thus the subject who calls his parents excellent remembers that as a child he was "totally withdrawn" and that as a result his parents almost completely gave up on him; they sent him away to boarding school—a fate which his character apparently justified. Another subject says that she was a drug addict and a chronic runaway; but what we might take as a sign of rebellion, or the acting out of an inner conflict, does not prevent the subject from seeing her parents as "wonderful—we're best buddies; my mother is the most wonderful person in the whole world; all the people love her."

Viewed individually, the parents are admired in different ways. The fathers of the men are invariably quite distant, certainly in the psychological sense and occasionally in the physical one. The fathers of three had been absent during a portion of the sons' lives, but it was aloofness and emotional parsimony that characterized them all whether they had been physically present or not. The men describe them in terms such as, "intellectual, reflective, trying," "argumentative, not emotional or sentimental," "extremely sensitive, intelligent, his work is difficult, and there are a lot of dissatisfactions in it." These are words of admiration but not awe or warmth; and if little warmth pervades the descriptions it is in part because the fathers didn't feel free enough with their sons to have played with them as children. In the women's descriptions there is a greater emotional closeness—and some evidence of paternal attention, as in childhood play—but in objective terms the fathers appear to have been quite similar: "not emotional or sensitive, but he puts a lot of energy into compromise," "emotionally closed up but generous," "very domineering, intelligent, and warm," "kindhearted, strong, not sensitive or perceptive but he tries."

The mothers receive motherly accolades somewhat akin to the superlatives employed by the chronic runaway, and their import is that the mothers were nurturant and loving. Cogent descriptions such as "very emotional and up front with her feelings," "extremely warm—the mother earth type," or "more exuberant, outgoing, she talks to us more," characterize the images held by the men as well as the women, A few of the descriptions see the emotionality as excessive either because it was too forceful or too unpredictable, but the predominant tone is one of praise. Only one subject, to whom I shall refer again, failed to refer to his mother as warm or emotional, or to show the slightest sign of admiration.

Now at first blush these descriptions seem to resemble those of the parents of perfect preferrers and the question may have been asked why in the one case an admiration for the parents leads to a taste for perfect nudes while in the other it leads away from nudes altogether. I am not certain that I can answer the question satisfactorily, but I can make two observations which point in the right direction: the portrait preferrers are considerably more inhibited about sex, and their inhibition would make it difficult for them to turn toward the nude for their principal symbolic needs; and they express their admiration for their parents in more muted terms—they admire their parents but are not awed by them. I would go further and suggest that they admire the parental bond more

Figure 34. Boucher. *Miss O'Murphy.* Alte Pinakothek, Munich.

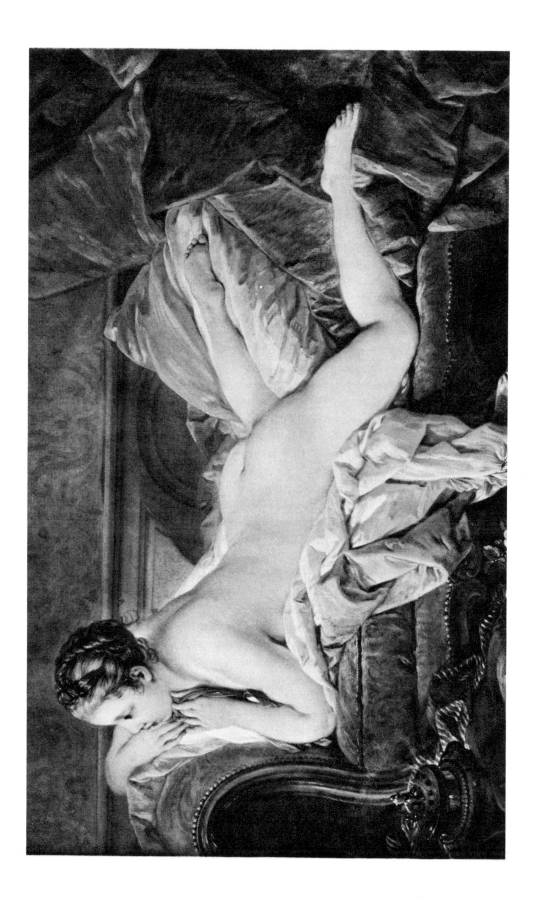

than either parent individually: it is not the perfecting of certain individual ,qualities that they strive for, but rather an evocation of the parents as standard-bearers worthy of scrupulous respect. It is a fact that all but one see their parents' relationship as having been close, and that they feel some reassurance from the closeness whether it had been overtly affectionate or not and in most cases it had not. One woman makes the point succinctly when she says, "I think I am more secure than most people because my parents had a close relationship; I have a little more optimism about marriage."

Admiration for the parental bond seems well symbolized by a liking for portraits—male and female parental equivalents not without a trace of nobility of character and, sometimes, depth of life experience. ("[Renoir's *Portrait of Madame Georges Charpentier*] is strong-minded. I like a portrait in which I get a feeling for the person; the better I like the person the better I like the painting. Even if they're not attractive—there is something distinguished about it.") But one has to ask the tiresome question again and again: why, if they can admire their parents in reality, do they also need their equivalents in art? To ask the question is not to guarantee an answer, particularly in a group whose tastes had not been my primary concern, but I shall show later that the values with which the subjects had identified are too good for them to live up to. They are as a result quite self-critical and unhappy with their performance; and it seems reasonable to suppose that their wish to satisfy the demands of their inner ideal gives portraits their special power.

Now, as far as the relation to the parents goes, the nude preferrers offer a contrast to the portrait preferrers in all respects but one. The one is the parents' character: as far as I can judge, the parents were quite similar to those of the portrait preferrers in the particulars we had looked at. But what differs is the children's relation to them: it is one of hostility and rebellion. The hostility is seen in the subjects' critical or angry descriptions, and the rebellion in the rejection of their parents' values. At the milder end are statements such as, "I was dissatisfied with the way I was brought up; my father had no involvement with the family," but they increase in intensity by degrees: "My relationship with my parents was always bad. I fought with them, mostly with my father, constantly," or "My father died when I was six; his death didn't affect me at all, because we had never been close," or even "My relationship with them was terribly rebellious, I was always hating them—very bad. They had totally different values from me. I don't remember ever hugging or kissing them." In all cases but one the anger and resentment were directed against the father, and in the single exceptional case against the mother; but in all cases one notes a pervasively negative tone which would make it difficult for the child to accept a coherent value system. The marital bond was in all cases but one perceived as weak or pathological: "Their marriage has always been bad," or "I don't see how they get along—I think they're just resigned to the marriage," or "I think my parents must have had a tension-laden marriage even before I was born."

As might be expected of children who live in such circumstances and defend against them in part by a strong adolescent rejection of all that is parental, they describe their parents not only with realism but with persistent hostility. Adjectives such as "rigid, opinionated, pathetic, self-defeating, intolerant, prudish, not affectionate, disloyal, alcoholic," and even "senile and weak" pervade the descriptions. If I have said that the

parents probably did not differ from those of the portrait preferrers, it was because I find it hard to believe that the parents could have fully justified the children's contempt; if they justified it in part, then certainly anger and rebellion did the rest. And again without being able to say whether the rebellion was necessary, I must take note of its force as well as of its probable effect on esthetic tastes. Whether the parents expected too much or too little of the children, the latter are unhappy with it. Where the expectations were clear, the children reject them: "Mostly they want me married; as far as that goes our plans are completely different," and "My mother wants me to achieve and be a success, and she's disappointed that I wasn't artistic like her," or "I feel negative feelings from them about what I am doing. I think my father is insulted that I am doing something he can't help me with." Finally, as might be expected, the values that the children reject most consistently are religious values: most of the nude preferrers had had at least a formal exposure to religion, but only one considers herself religious. In contrast, the portrait preferrers who had had some religion in their upbringing still make it a part of their lives, and one who had had none has become a Catholic.

The contrast I have drawn serves as a background for what is to follow. For the portrait preferrers it provides what already appears to be a sufficient condition for the preference for portraits; it would be difficult to see portraits as having any other function for them than to provide successful images of idealized parenthood. Among the nude preferrers the anger and rebellion produces exactly the opposite effect: a rejection of portraits. Even the seemingly inoffensive *Cavalier* by Hals can draw a nude preferrer's ire: "Yucch! It's so sinister and evil. I am really against power and he seems in a powerful position." But we are interested in why people like or dislike the nude and to pursue that interest we must consider, while keeping this background in awareness, the expression of sexual needs in the context of affection and the capacity for intimacy.

Sexuality, Emotion, and Closeness

Only for the purpose of analytic understanding does one sometimes separate the expression of sex from the ability to experience emotion and from the context of the objects of one's attachments. I had referred earlier to the search for a "need" for the human nude which would transcend mere sexual permission, and I shall try to show here that by studying the expression of sex in relation to emotion and closeness the "need" can become apparent.

But for the portrait preferrers no specific distinctions need be drawn; they are inhibited in all the respects to which we had paid attention. The men, especially, avoid sexual relationships: only one of the five has a sexual partner of any sort at the moment, but his relationship does not appear emotionally very expressive; the others have none. They are not virgins, but they show little interest in seeking a partner. Most had experienced sex in high school, some actively and some passively, as by seduction by an

older woman, but characteristically they have not experienced it since then. When asked about the importance they give to sex they say that it is at the moment quite unimportant. "I think that it is important but at the moment it is at the bottom of my priorities," says one, while another—the one with the exceptional dislike for his mother—says, "At best, I develop little crushes from afar. Sex is sufficiently important so that I think about it, but not so much that I would get involved just for sex. I think that friendship is more important, and sex could ruin it. I wouldn't mind waiting until I am 30 or 35 for a sexual involvement"; he also adds later that the first requirement he would impose on a partner is that she not look like his mother. But no less important than sexual inhibition is an affective one; none of the men feel even reasonably free to express either anger or affection, and the depth or constancy of their relations to others is thereby severely hampered.

The women are sexually somewhat freer than the men but in relation to the nude preferrers they do show inhibition. Two are as constricted as their male counterparts; a third has a steady partner whom she sees infrequently because he lives in another city, the fourth has a sexual relationship with several people at the moment and cannot imagine herself as ever being monogamous, while the fifth—at first sight an anomaly in many respects—considers sex very important in her life and has several partners of both sexes ("I go through men like hot cakes"). Now all of the women except for her are clearly inhibited in their expression of affection and anger, so that one can see limits even in the sexually expressive ones to the quality of the involvement which they permit themselves; but is this fifth subject also emotionally inhibited? According to her statements, in aggression she is, while in affection she is not—but her description of the only man she is really in love with as a prude and a religious fanatic suggests a severe split between love and sex which must be inhibiting to both. Without wishing to belabor the point at the moment, I think her emotional development does show obvious limitations. [2]

The nude preferrers are, as we had foreseen, more expressive sexually. A simple catalog would read like this: three subjects—two men and one woman—have no sexual involvement, four have superficial involvements, and three have fairly deep ones. Of the latter one is happily married and in the realm of sex and intimacy forms an apparent exception to what I have said about the others. [3] I must note that, irrespective of their current activity, they all value sex highly; they say that it is "very important" or "highly desirable." But if they show more of an interest in sex, they show no comparable capacity for expressing emotion or for sustaining intimate relations. The three subjects who have no *current* sexual partner are, predictably, afraid to open up either with affection or anger: one says, "I have never felt intimate with anyone; I am not spontaneous enough." Nevertheless, he finds sex "highly desirable," as does a woman who regrets having waited until she was 21 for her first experience and who, too, finds herself very preoccupied with sex: "Right now it's very important to me; it's new to me, it's a very important part of my life, and I spend a lot of time thinking about it and writing about it." But she, too, finds it difficult to express anger to her friends, and she comes from a family in which affection could not be openly expressed; her current desire to become affectionate with her friends represents, in her own words, a reaction to the earlier inhibition.

The four subjects who have found a sexual partner experience similar inhibitions in affect and intimacy. Two of them are clear about not being in love (one says, "It's just friendly, sexual, nonemotional"), while the other two have doubts about the relationship's permanence; one is afraid of marriage because it had ruined her mother—in the subject's view by throttling her creativity and killing her at an early age—while the other notes laconically that women have always left him, for reasons best known to themselves, and that this one probably will as well. They all say, as one might expect, that the expression of anger and affection is difficult for them; knowing this about them, one will not be surprised to find that their parents found it as difficult to be affectionate with the children as with each other. And the subjects who, with the one exception already noted, consider their relationship quite deep are no different in their ability to be expressive and intimate either; both take note of an unaffectionate family and of their current lack of expressiveness as well. One subject finds that her relation with her partner has become almost too sexual, to the exclusion of getting to know him as a person, while the other says, in words my narrative could not improve upon, "I am usually involved with pretty surfer boys; I am very attracted to good-looking men. I base my life on relationships."

It seems to me that our nude-preferring subjects have made their dynamics quite clear. Inhibited in their emotional expression and restrained in their capacity for intimacy, they have come to overvalue sex; and if not sex, then the very idea of relationships in place of a good relationship itself. Not all feel free enough to idealize sex in practice, but all of them overvalue it in symbols. It is not necessary that they be aware of what motivates them; even the nude preferrers may find it necessary to disguise their liking. One subject remarked, when describing Boucher's *Miss O'Murphy*, that he was attracted to the picture's mystery: "This reminds me of the still lifes; you had one where the apples were messed up and things were spilled, and that looks like something's been there that you can't see. And the same with this. You don't know what's happened, what's going to happen; it's just very exciting. (Do you find her erotic?) I guess. . .yeah. Sure!"

The portrait preferrers, equally inhibited in emotion and intimacy, naturally prompt us to ask why they have not similarly discovered sexual overestimation as a defense; but if we recall that they have accepted their parents' conservative values, then we can understand that they turn for emotion satisfaction in part to the parents themselves and in part to their surrogates in paintings. We know from their statements that they value portraits for the character of nobility which they represent; and we have no difficulty in seeing their wish to avoid the erotic suggestion contained in the nude. That the two motives intertwine is brought out cogently by the subject who remarks, apropos of *Miss O'Murphy*, "It's not very appealing to me. It's a pretty sensuous picture, but it's hard to get an idea of her character, or to get *some* idea of character from the picture, because it's so sensuous." But the nude preferrers, on the contrary, having rejected the parents, turn to symbols representing their own contemporaries; and in choosing nudes as their preferred esthetic objects they serve their rebellion in yet another way—by demonstrating the low regard in which they hold their parents' sexual conservatism.

The characteristics that the interviews permitted us to discern are corroborated by

the self-image we can reconstruct from the Adjective Check List: taken as a composite profile, the portrait preferrer emerges as having energy, ambition, and self-sufficiency, but also mildness, reserve, and lack of confidence. The nude preferrers, on the other hand, see themselves as quite free of repressive tendencies:. as emotional and adventurous—but also anxious and critical; as headstrong and individualistic—but also arrogant and impulsive; and as spontaneous and complex—but also valuing change and disorder. But, as might be expected of subjects who are single-minded in their tastes, *neither* group appears as a model of self-acceptance or stability: their high scores on "counseling readiness" suggest individuals who are worried about themselves, ambivalent, left out, unable to enjoy life, and unduly anxious.

Having found a formulation which makes sense, one is little tempted to search for additional complications. But if one has learned at all well the lesson about overdetermination in psychic life, then one must be prepared, especially where extreme tastes are concerned, to find independent influences which contribute to those that have already appeared sufficient. In our subjects' case such an influence is the image of the body and the degree to which it is a source of satisfaction.

Body Image

The subjects were asked how they would wish to change their bodies; almost all had some fantasy by which their bodies might be improved and many added changes of character which they desired as well. But the changes mentioned by the portrait preferrers were more far-reaching—often quite impossible—and revealed a self-critical attitude which might make it hard to take pleasure in the bodies of others. Having accepted their parents' values, they seem to be oppressed by their inability to live up to them; small wonder that the most common character change they can fantasy is to have greater willpower. In the realm of the body, the men would without exception wish to be either stronger or of a different size—most would rather be taller but one would wish to be shorter—and they had individual wishes whose origins were not always clear. For example, one would like to be able to grow a mustache, another would like to change his walk, while another would like both new lungs and new eyes. The women, in addition to the usual and banal desire to lose a bit of weight, also had specific cosmetic or somatic improvements at the tip of their tongues: a thinner and smaller nose, better eyesight, weight gain, drastic weight loss, larger breasts, or the loss of a troublesome heart condition. One woman reeled off a catalog of changes which strained the imagination, no less by its length than by its inconsistency: to become Asian, have long fingers and a long, sharp nose, grow thicker and darker hair, become larger in the bust and smaller in the hips, and lengthen the legs by four inches. That such fussiness indicates a defensive investment in the body may be safely presumed, but dissatisfaction with the body's appearance or functioning may also have somatic origins. All but two of the subjects

recall having suffered illnesses or injuries, or at least having experienced a severe illness of a brother or sister; and while it could reasonably be objected that such is the condition of childhood, the nude preferrers' surprising freedom from such early difficulties shows that their counterparts' experiences were special. Among the portrait preferrers there were kidney malfunctions, asthma, polio, gynecological problems, cardiac conditions, nearly crippling accidents, and siblings' mental retardation. One suspects that they have never formed a sense of the body as a benign object or mechanism—and that as a consequence they had too little robustness or bodily self-confidence to resist their parents' sexual prohibitions. These facts are too sketchy to permit a more elaborate or firm conclusion, but they are sufficient to suggest the contributing involvement of bodily experience—and to invite its study in future work.

The nude preferrers were, on the contrary, relatively free of illnesses or accidents; although the question was posed systematically, only three mention having had any. Whether for that reason or another, their body image is likewise less encumbered with a sense of insufficiency. Six of the subjects say that they are perfectly satisfied, although when pressed two of them mention changes which they could consider. The others mention changes, but not ones that they could not attain by diet or exercise; and two of them are among those who had had an illness in childhood which was severe enough to have been remembered. They do not seem oppressed by their superego either; we know, of course, that they take the parents' values scrupulously into account in their detailed rebellion against them, but by rebelling they are staving off major self-criticism. And it may perhaps be suggested that their sense of bodily goodness may have helped them find in sex the right focus for their resistance.

Nudes Versus Lifes
And Landscapes

I come now to the contrast between subjects who like the nude and those who like still lifes and landscapes. One's curiosity is aroused doubly, in part about the nude preferrers (will they resemble those we have described already?) and in part about their opposites (aside from rejecting the nude, what satisfactions do they obtain from their choice?). One is curious about the nude preferrers not because of an anxious wish to replicate the earlier results, but because one knows that they are not motivated by a rejection of the symbols of parenthood; as a matter of fact, it so happens that they like portraits about as much as they like nudes. If rebellion is not in question, then one needs to find other sources of their sexual overestimation. The observations we have made on our subjects are best grouped as before, with but one change: the data on body image were gathered too inconsistently to permit a comparison, but they may be replaced by the highly distinct and consistent overall impressions the subjects had made on the interviewer.

Relation to Parents

If a subject likes landscapes, he also likes still lifes; in our extreme subjects the correlation was guaranteed. So as to avoid a clumsy expression, I will refer to them as landscape preferrers; and so as to avoid implying that rebellion or acquiescence is the issue in relation to the parents, I need to discuss how the parents were perceived. The picture is not as clear as I would wish. The males among the landscape preferrers remember their parents as sensitive and warm and use this description for their fathers as often as for their mothers; but I shall point out later that the parents were not demonstrative with their affection, either toward the children or toward each other, and that the children in a way reassure themselves that affection has been there. Still, the men feel that their mothers had dedicated themselves to their children or, less often, to their husbands; they like their parents, and the relation they have with them, but the liking takes on the flavor of dutifulness or filial piety. They give me the impression that they would like to remember having been loved; and indeed one subject finds a curiously negative manner of putting the issue when he complains that his mother doesn't care about him any longer. The women invariably had distant fathers—uncommunicative or absent—and mothers who were emotionally too close and controlling; I am unsure what significance this configuration may have had. I sense in the men a bit of that wish for parental love which one might see in a very distant form in the image of a comforting landscape, but the evidence is slim, and even slimmer among the women, and there is no point in doing more than taking note of this as a suggestion.

The parents of the nude preferrers are not drastically different. The men are fairly consistent in liking their easygoing fathers, but dislike their mothers (usually for their dominance); they give one the sense of having felt inhibited by their mothers' dominance and oppressed by their manipulative closeness. The women's fathers were dominant, quite violent, and at the same time not very effective as husbands or fathers; the mothers were excessively dependent on their husbands and, with one exception, seemed to manipulate their children by means of love given conditionally. I think I have captured the negative undertone of the descriptions, but it exists side by side with a reluctance to criticize fully or to reject and rebel; such rebellion as occurred was confined to isolated periods of life or to isolated issues, or took a more symptomatic turn. One subject repeatedly acted up as a child by running away (naked!) when left alone by his mother, while another rebelled by having an early sexual affair; the one whose feelings took on a symptomatic form remembers his reaction in this manner: "I can't remember any distinct feelings toward by parents; they were my parents and I loved them. I was afraid they would die and I would be without them." Unlike the nude preferrers in the first study, then, these subjects retain a measure of respect in combination with their resentment and more isolated acting out; and while I cannot offer anything better than a suggestion to be explored in the future, I have the impression that in their upbringing one can see some disturbance in the handling of affection, and in their ambivalence one senses a prelude both to their need for portraits and their attraction to nudes.

But we come closer to understanding their dynamics as we look at their current functioning; the impression they give to the interviewer, particularly in relation to their self-image, distinguishes the subjects quite clearly.

Interviewer's Impressions

At the end of the interview Miss Bier recorded her impression of each subject. With only one exception, the landscape preferrers were seen as cautious, controlled, and reluctant to volunteer information; asked to describe themselves, they said they were shy, introverted loners. Their self-image is highly consonant with the way they behaved in the interview and underscores their timidity in social relations. We shall see presently that it is also consistent with their difficulty in expressing emotions.

The nude preferrers, on the other hand, hold an image of themselves which differs markedly from the interviewer's. Their own image is that of a shy introvert; they use various expressions all amounting to the same characteristic: a social retard, a neurotic weirdo, a goodie-goodie, as well as the more usual adjectives "shy" and "introspective." Three women say that they had been tomboys, though being one was in no case irreconcilable with shyness. Except for the tomboyishness, then, the nude preferrers believed themselves as asocial as their counterparts; and their view is consistent with other information we have about their capacity for emotional expression. But the interviewer's notes indicate that with only one exception they had communicated freely, talked about their lives with frankness, and seemed quite at ease. This seems a remarkable discrepancy.

As usual, both sets of observations are correct and the question is exactly how they will be reconciled. It seems to me that the nude preferrers simply *are* more open than their counterparts, particularly in their awareness of their psychic life, and that they are relatively free of social anxiety and mistrust; they do not need to wall themselves off from a new encounter such as that represented by the interview, and they have available to them a greater inventory of memories and observations. They are also freer with their expression of aggression, and while there was no need to exercise that freedom with the interviewer, it probably gives them a greater sense of social presence. But in relation to their behavior in more intimate settings—especially in relation to establishing friendships and expressing affection—they see themselves as lacking. In their suggestion that they have problems with intimacy they remind us of the first sample of nude preferrers, and it is to that aspect of their functioning that we must turn.

Sexuality, Emotion, and Closeness

Once again the landscape preferrers are transparent: with two exceptions to which I shall refer again later, they find sex unimportant, they have severe difficulties with being close to people, and they find it hard to express either affection or anger openly. Seven of the subjects have no sexual partner now; of these four have had at least some experience but it was casual and for the most part not repeated since high school. Three have a partner at present but one could easily, in her words, survive without sex; the other two are the exception I shall discuss later. If by "friend" we understand someone with whom one can be emotionally close and intimately open, then none of the ten subjects, not even the three with a sexual partner, can make friends easily; nor do any of them find it easy to express affection. In view of most of the parents' undemonstrativeness, either with each other or toward the children, the inhibition is understandable; but it is even more interesting, and certainly less comprehensible, that three of the subjects believe that if their parents had been demonstrative, they would have found it hard to accept. One subject actually discovered her own inhibition in the face of her mother's attempts to become affectionate.

Why a child would develop greater inhibitions than the parent is not clear from the information at hand, and perhaps only in a situation resembling psychotherapy in its ability to undermine defenses would we find what we need; but it is possible that the present subjects were, by virtue of an unusual social sensitivity and timidity, too easily cowed or provoked into resentment. Nor is their ability to express anger any different: most of the parents preferred to suppress their own aggression and thereby provided an inhibited model for the child, but the few who could argue or shout openly also turned out to have inhibited children: as one of them put it, "They didn't have to tell me much; I was pretty sensitive." Such cases are a necessary corrective to our assumption of parental responsibility for the formation of children's character, and suggest, from the present point of view, that whatever the mechanism of the formation of inhibitions, their current role in the whole psychic economy is what counts.

It will be recalled that the nude preferrers of the first study had overvalued sex because of the difficulties they experienced with affection and intimacy, and because it provided a convenient focus for their rebellion. The present nude preferrers are equally inhibited: in affectionateness their parents were very restrained and the few who were not nevertheless produced restrained children: here, too, subjects are found who can say, "Mother would ask me to kiss her but I would go 'No.' " I would be exaggerating if I claimed a clear understanding of the inhibitions of children with affectionate parents, but the interviews with the nude preferrers contain more than a hint of resentment for some form of emotional abandonment. One subject uses the very term to describe a mother who had considered him retarded, while another, the one who had refused to kiss his mother, remembers his angry escapes, without clothes, when his mother left him to go to work; yet another fought with her mother over the latter's remarriage and resented the greater affection the stepfather had always received; still another, who first says that her

family had been very affectionate, recalls that the affection had always been withdrawn when the parents were displeased. Thus, but for one subject, there seemed sufficient reasons for a disturbance in the experience of affection. Nor is their capacity for intimacy any better developed: essentially the same difficulty in forming a genuinely close relationship to a person is seen here as among the portrait preferrers. The ability to make casual friendships varies—most being loners while a few at least had a group of friends in high school—but the absence of an intimate friend is invariant. Only in ability to express anger are the nude preferrers noticeably freer than their counterparts; and we have seen that it helps those who have it—six of the ten—to maintain a modicum of self-assertion in their more superficial encounters.

But the surprise has been reserved for us in the realm of sex: the nude preferrers suffer from severe inhibitions. All in all their capacity for sexual expression is about the same as the landscape preferrers'. The men are again the more inhibited: two are virgins who feel very shy with girls, and another has been seduced by a girl once and has also visited a prostitute but has not had relations with any girl he considered a girlfriend. Another fears that falling in love would turn him, as it had his friends, into a "slobbering idiot" who would become passive, subservient, and (in his metaphor) limp; and the fifth, a homosexual, is also without a partner. The women are only a shade less inhibited: three have had occasional sex experiences in the past but are without partners now, and they regret both their late starts and infrequent relations; because the boyfriend of the fourth is quite immature sexually, she feels, in her words, quite starved for love—but she seems unable to take matters into her own hands, and she awaits the arrival of the "perfect guy." Two women are somewhat more complex; of these the first is quite sexual and monogamous, but there is little feeling underlying what she recounts, either of her current life or of her violent relation to her parents. She seems to sexualize most of the relations she describes and yet her experience of the world seems to be one of blandness; one need not hesitate to find in her a severe inhibition of affect.[4] The other woman is, however, capable of a full range of emotional experience; if there is inhibition, it may perhaps be seen in her divorce and subsequent difficulty in forming a partnership. But I prefer not to stretch that point and concentrate instead on a succinctly worded description of the beginnings of the sexuality: a lasting and exciting affair with a "wild" man at fifteen years of age whose purpose was to "get back" at her oppressive parents. Her particular version of sexual overestimating bears the mark of a well-savored rebellion against parents who nevertheless remain admired.

But the usual formula is quite simple: the nude preferrers—extreme instances of their kind—overvalue sex because of an inability to achieve the emotion gratification of an affectionate intimacy. If they had rebelled against their parents as adolescents, as had the subjects of the first study, then they seek out sexual relationships in reality and thereby prolong the rebellion—but in no way lessen their symbolic attachment; if such a revolt is absent, as it is in the second, then sex is overvalued merely symbolically. Of course, inhibition can be so complete that even symbolic attachment to sex is prohibited; but there not only parental prohibitions play their role but also the collaboration of a

compliant and shy nature; and depending on the degree to which the parents are idealized, the esthetic alternative will be either a preference for landscapes or for portraits.

I had begun these studies with the expectation that the motives satisfied by the nude were for the most part independent of, or added to, the obvious one of sex. Although I could not foresee most of the details which gave the studies substance, I was not wrong in the global presumption. But if I was not wrong, it was, again, in an unanticipated manner: particular qualities of the nude carried symbolic meanings in which sex need not be apparent at all, but the nude as such, abstracted from its particulars, turned out to serve as a symbol of unattainable and perfect union. It seems a fitting accident that the one nude it remained for this chapter to illustrate was Boucher's *Miss O'Murphy*. To be sure, such a union is not only sexual; it is tender, affectionate, erotic, and perhaps vaguely reassuring, all at once. And if it be asked why for those who most desire such union, male and female nudes can serve as equally good symbols of it, I am unable to answer with certitude; perhaps the one serves as an object of identification while the other functions as an object of erotic choice. But such questions are appropriate subject matter for future work.

9. Notes

1. The two studies were carried out by Nita Eder and Michelle Bier, respectively; I am grateful for their patient and energetic pursuit of the necessary (and often enough sufficient) information.

2. This subject has in essence a very movemented life and a barely developed capacity for knowing what she is feeling. Her style would be termed hysterical. For the relevance of her mode of dealing with the world for her tastes, see below, and also footnote 4.

3. One occasionally encounters a subject whom one cannot explain in the terms that apply to the others; such is a limitation with which one must try to make peace. More profound acquaintance with the details of his life and fantasy might uncover illustrations of the same general points, but that cannot be claimed with certainty. There is one aspect of this man's relation to his wife that catches our attention, but it is only suggestive: she is, by photographic evidence, as beautiful as he says, but does not give him all the sexual attention he would like. Whether this indicates something about his motives in choosing her is not clear.

4. It is one of the unsolved puzzles of this study that the identical discrepancy between a disordered reality and ability to experience it has occurred in two subjects who belonged to groups opposed in their tastes. Besides sexualizing their current existence, they deny the importance of several important memories of their parents. In particular, they minimize the aggression that they had experienced; for the one an atmosphere of bickering and incipient divorce is remembered as loving, while for the other quite extraordinary violence is recollected in tranquillity. The first subject is a portrait preferrer while the second is a nude preferrer. Perhaps the explanation for their different tastes resides in this: the first subject's denial results in idealizing her parents, while the second subject's denial results only in being unaware of the meaning of their destructiveness and her father's seductiveness. But I sense that such an attempt only brings me part of the way toward an explanation.

10. SUBJECT AND OBJECT

. . .the human body is, in fact, inexhaustibly complex
and suggestive, and to a Greek of the fifth century
it stood for a set of values of which restraint,
balance, modesty, proportion, and many others would
be applied equally in the ethical and in the aesthetic sphere.

—Kenneth Clark, *The Nude*

If it is a truism that the aim of all intellectual endeavor is understanding, then it is no less true that in very closely related disciplines the common aim divides people instead of uniting them. People become rivals for the same object, as it were; and so it is that in esthetics one discipline's understanding is another's ignorance. But not all that divides is a feeling of possessiveness; there are also legitimate differences in deciding what one should appropriately attempt to understand.

I do not wish to review the many points of difference that distinguish the various ways of studing the arts, nor to attempt to separate the well-founded grounds from ill-founded ones. Nor do I wish to defend the social sciences against the charge that they are so preoccupied with what *is* that they lose sight of what *ought to be*; the charge is completely true. There is no way of going from the descriptive to the prescriptive: and it is only by entertaining the fantasy that there should be a way, or by assuming that it is necessary to prescribe anything, that the charge can be understood as having substance. The charge is true but inconsequential. But there are ample enough differences between the various approaches to studying what *is*—approaches which are not limited to the social sciences—to give us a sense of perspective on ways of understanding the arts. The major distinction is the one I spoke of earlier between studying art *objects* and the *subjects* who perceive them. It is sometimes thought that studying art objects is the only appropriate esthetic concern; or that, if the study of subjects is to be admitted, ultimately

it has to illuminate the objects. I should like to argue instead—more explicitly than I have implied throughout the book—that the study of subjects stands in its own right as a full esthetic discipline; and that by knowing whom the nude appeals to we understand what sort of symbol it has become.

The Role of Psychoanalytic Theory

In my opening chapters I distinguished between projective and perceptive functions of art. The distinction was useful for specifying the observer's relation to the work of art, but it is also a distinction which describes a division within the field of psychology. For me it divided the observer's dealings with the art object into a twofold attitude, one in which the work is perceived and valued for what it can do to satisfy needs which exist beforehand, and one in which the work is attended to in its own right. Within psychology—or that part of psychology which deals with esthetics—the parallel division is between those who attend to the esthetic object and those who are interested in the subject who does the perceiving and evaluating. That distinction is actually too coarse: in the object-directed approach some interest is shown as well in the process by which the art work is apprehended, and in the subject-oriented schemes some attention is paid to the objects to which observers become attached. But the emphasis certainly differs, and so does the aim of the inquiry. In the first approach the object is taken as the given and the question becomes how the observer works his way toward it. In the work of Arnheim, for example, especially in *Art and Visual Perception* but in later works as well, principles of perception are carefully applied to show how the work of art is apprehended and understood: but although perception is discussed as a process, the aim of Arnheim's inquiry is to see how the object is attained. Nowhere does one encounter the notion that the object could legitimately be different things to different observers, nor does one picture the process as anything but an analogue of the structure of the object: if the object has certain tensions, then in the successful case of perception the tensions become also the observer's own. But Child, too, in spite of different assumptions and methods, is oriented toward the object. If a test can be constructed which distinguishes the quality of works of art, the research question becomes how the distinction is made—through what personality processes, by means of which learning experiences, with what degree of agreement between unrelated peoples; but the focus remains the object, that is, the work's goodness. And in the work of the founder of psychological esthetics, Fechner, the object reigns no less supreme: his question always seems to be, which one of a series of objects is the most beautiful?

On the other hand, the aim of an inquiry such as Freud's is to unravel the multiple pathways by which the person comes to value objects. The inquiry has only the observer

as its topic; the art object is, as it were, only the terminus of a fascinating psychic activity. It is immaterial whether it be the terminus *ad quem* (the work one has produced) or the terminus *ab quo* (the work one is viewing); the one is the product of psychic activity, the other the start of the process, but the activity which follows or precedes is what Freud is interested in. To unravel complex pathways one has to pay painstaking attention to each individual; one is as a result more secure is understanding an individual's sytem of thinking, feeling, and symbolizing, though one pays a price in the ability to generalize. But if the individual has really been understood, then the art object to which he may be attached is almost unimportant; different objects might well serve the same needs.

If I have drawn the distinction perhaps more sharply than it merits, it is because I wanted it to be clear; in no sense am I suggesting that one of the approaches is dispensable. On the contrary, it seems to me that no psychological understanding of esthetic choice or artistic production will be satisfactory until several bridges are constructed between the two. One of the more distant aims of these studies is to suggest one such bridge, that of understanding the esthetic object through the subject. Before that aim can make sense, it is appropriate to look at how I have chosen to look at subjects and what that manner of looking at them has achieved; it is necessary, in other words, to look critically at psychoanalytic theory and to summarize what its assumptions have helped us discover.

There are unquestioned difficulties with certain aspects of Freud's theory. They include questions about drives, the relation of drives to art objects, the articulation of need and defense, the differences between neurotic and healthy processes, and other matters. As far as esthetics is concerned, the difficulties are even greater because they have to do with Freud's fairly casual, and not always well informed, statements about what impels artists to create. The second set of difficulties is dealt with more easily, because it can be agreed that, however feiicitous or unfortunate Freud's observations may have been, they are at best a starting point for more complex theorizing by artistically better trained psychoanalysts, such as Kris (1952). And the observations are not on a theoretical level with Freud's contributions to the clinical understanding of people's functioning. To handle the second set of difficulties then, one must simply decide to hold psychoanalytic theory accountable for other statements about human functioning than Freud's views on the artist or the viewer.

But the first set of difficulties is the more serious because it deals with the core of psychoanalytic theory. If one is going to rely on the core of the theory rather than on Freud's peripheral statements about art, then the core had better be in good shape. Of the difficulties I have mentioned the central one is with the conception of drives; once the problem of drives has been handled, the others either resolve themselves or can be put into a context where resolution is easier.

What many observers, including those who are sympathetic to psychoanalysis, find it difficult to accept is the principle of drive discharge as the chief motive of action, and specifically of sexuality as the primary drive which, no matter how opaquely disguised, is ultimately the force which is discharged. The issue is important for psychoanalysis

generally, quite apart from esthetic problems, but it has also been raised by estheticians who cannot believe that the value of most literature—to take the clearest example—reduces to its ability to deal with the Oedipus complex. By showing that such a reduction cannot seriously be intended, I shall argue that there is no need for the objection.

Drive "discharge" offers as much difficulty to the psychoanalyst as drive "reduction" does to the learning theorist: evidence for it is thin and evidence against it is substantial. For the learning theorist the evidence for and against it is at least directly relevant to the issue, and while it may be disappointing (to some) that it does not argue in favor of the importance of drive reduction for learning, it is clear; but the psychoanalytic theorist is faced with the more severe difficulty of the clinical evidence on which the theory had originally been based being irrelevant to drive discharge. Those of us who value psychoanalytic theory for its contributions to the understanding of the complexities of "meaning"—meaning which is built up through time and made up as much of feelings and needs as of thoughts—find ourselves ill at ease when faced with the simple and overriding principle of sexual drive discharge. But the way out of the dilemma is simpler than might have been thought.

G.S. Klein, who was trained in experimental psychology as well as in psychoanalysis, has recently (1976) analyzed the problem of drive discharge in relation to clinical data, and in a few cogent pages helped me clarify my own thinking. He argues that, without being aware of it, Freud had constructed two theories of sexuality: the clinical theory and the drive discharge theory. The first is rich, complex, sensitive to individual meanings, and, when applied in the manner so carefully worked out over the years, therapeutic; the second is irrelevant to the first. Perhaps worse than irrelevant, the second sometimes goes counter to the evidence on which the first is based. The evidence—the real stuff of which a better motive theory will need to be formulated—consists of several kinds of observations which, it turns out, are also of use to the approach I have taken in this book. For example, the overinclusive term "sexual" when applied to what is common to infantile and adult sexuality really refers to a capacity for powerful pleasure; in Klein's words, "This invariant—the shared factor of infantile and adult sexuality—is a capacity for a *primary, distinctly poignant, enveloping experience of pleasure* (italics his)." The consequence of making a more appropriate distinction between the sensual and the strictly sexual is that one can understand how, as sufficiently sensitive observations of analysts and others would attest, sensual pleasures can serve functions which are not in themselves primarily sexual—as when sensual pleasure is used to eliminate the pain of an experience of failure. Another observation that must be taken into account is that sensuality does not have its own bodily structures; it is, of course, elicited by bodily sensations, but those sensations come from bodily experiences which have other uses as well—for example, entirely practical ones such as ingesting food or manipulating doorknobs. The consequence of this observation is that using bodily structures in such a way that pleasure *also* results from them leads to sensual connotations of purely nonsensual acts; put another way, and one which better shows the possibilities of eventual neurotic difficulties, the pursuit of nonsexual ends

tends to become complicated by sensual connotations. As the third important observation, one again made in clinical practice but not in the formal theory, I should like to mention that, in Klein's words, "pleasure is such that once experienced it continues to be savored; the record of its occurrence is hard to relinquish." The occasions of sensual experience easily become recorded with their attendant circumstances—one's other aim at the time, other individuals present, the emotional meanings given by others to the situation—and this complex recording affects subsequent experiences which involve any one of its components.

In the clinical theory, then, there is no primacy of "discharge"; the connections between erotic sensibility and nonsexual functions are not simply so many discharge opportunities. Sexuality, on the contrary, may be a response to many other motives; [1] for example, it may easily come to be involved in the core organizing experience one has of oneself, that is, one's identity. When another motive is involved, the index of that motive is frustration; if the motive—or need, or structure—is one's identity, then sexual frustration is painful or disturbing not because of unreleased sexual energy but because of an unsatisfied self-conception which has come to be dependent upon sexual accomplishment.

Now if we use the clinical theory rather than the formal theory as a guide, then many of the well-taken objections to the psychoanalytic view of the creative or esthetic process become irrelevant; they lose their relevance because they were objections to the formal theory rather than to the richer clinical theory. It is no longer necessary to say, as for example Arnheim does in his cogent critique, [2] that other motives besides frustration impel the artist to create—to create even so obviously fulfilling a figure as the nude; of course there are other motives, and they may include joyful celebration, the desire to give body to ethical ideals, the wish to show the universe to be bountiful, and a host of others. For that matter, the artist's motives may be complex enough to include the anticipation of the viewer's motives, and to create the work in part for the pleasure of the viewer. The clinical theory of sexuality prepares us for a number of eventualities, and it most emphatically makes us anticipate a multiplicity of motives operating concurrently. But it should be noted that the clinical theory does not deny the importance of frustration; what it helps us do is to look for frustrations of a variety of needs, not only or even principally the sexual ones. Nor does it insist on frustration as a precondition; which is not to say that, whenever a *pronounced* attachment to a theme is seen, whether that theme be symbolically sexual or something quite different, frustration of some need is not prominent. The studies in this book are ample illustration of the power of frustration to keep a theme alive—almost obsessively alive—in the viewer with one-sided tastes; and in the case of an attachment to the nude as such, the frustration seems to be primarily that of needs for intimacy.

There is yet another consequence of being guided by the clinical rather than by the formal theory. If we do not depend on the formal model, then it is possible not to insist on too clean a separation of wish and defense; or to put the matter more precisely, it is possible to anticipate that the function of esthetic preference is—most often, in any case—simultaneously wish-satisfying and defense-supporting. In an earlier work Klein

himself (1970) has shown that it is very difficult, if not impossible, experimentally to separate a need from the manner in which it is expressed; if one takes a need which is easily manipulated, such as thirst, changing its intensity will have no consistent effect on the intensity of actions and thoughts related to thirst. The reason is that a need is not perceived or acted upon except through the usual mode of handling it; by increasing its strength one only succeeds in intensifying the mechanism by which it is usually regulated. For our purposes that finding suggests that "defense," a term which I have often used loosely to indicate the manner of channeling one's needs, operates simultaneously with the wish. Conceptually the two terms are, of course, distinct, and they can be distinguished in the clinical context as well—particularly when the one is much more prominent than the other. But it seems always more correct to say that a given esthetic preference is a product of a particular *relation* between need and defense than to speak of certain needs and specific defenses.

How Do We Choose Objects

I have argued for the usefulness of the clinical psychoanalytic theory of motives for studying the functions of taste, and have hopefully removed some of the impediments that the formal theory is frequently felt to pose. To the extent that the argument has been successful, a case has been made for multiplicity of motives and inevitable interplays with defenses; and at the same time the simplicity of a single-need theory has been sacrificed. Although that particular simplicity was undesirable, one may ask whether in aiming for suitable complexity one has not overshot and opted for a system which gives up all regularity and allows anything to happen at any time. I do not think that that has occurred, and believe on the contrary that order emerges nevertheless; but the order is less tidy. To outline that order, I should like to touch upon some of the study's principal findings and set them in the context of a broader view of the mechanisms by which esthetic preferences serve personal dynamics.

In abandoning the formal theory of sexuality one does not at the same time reject the notion of "need"; if one no longer accepts the notion of energy buildup and discharge, one does not also jettison the idea that people experience needs (however they may have been formed) which they go about satisfying (whatever "satisfaction" may mean physiologically). I think the principal finding of this series of studies is one that cuts across all of them; it may be formulated in two parts. The first is the simpler and says merely that the tastes of all the subjects were thematically tied to issues, conflicts, or schemata which occupied their psychic life. The second is the more important: the themes may be understood as needs which, because of internal impediments, cannot be satisfied in reality. They are a kind of *deficit* which sends the subject in search of

replenishment, and encountering the right sort of art works can be a symbol of that replenishment. Of course, replenishment never really takes place. The term is being used only metaphorically, and perhaps unfortunately so; but however the deficit is conceived—one's metaphor could be taken from cybernetics or computer terminology or from models yet to be invented—it leads to a search for *symbols of its diminution.* In the various studies examples of the deficit abound; in Chapter 4, a preference for femininity was heightened through a loss of the mother or through a sense that both parents had been inadequate and that a fantasied bountiful female would make up for the lack; in Chapter 9, sex became overvalued—sometimes in reality but always in symbols—when the subject perceived a block to an intimate union with another. But these are only two examples of a pervasive finding.

Because these studies were conceived so as to clarify personality dynamics by opposition, we found the deficit motives to operate at one pole (the pole which in correlational studies would be understood as the more "expressive" one) but not at the other; at the other the inhibitions were usually so strong that art was used only for the inhibitions' support. Thus the deficit motivation observable at the first pole is not being presented as a general principle of esthetic choice; its importance is rather that it helps us reformulate what seemed a motiveless theory of esthetic choice implicit in previous correlational research. In that theory the level of expressiveness of the viewer was understood as congruent with that of the art work he chose; we now see that the more expressive viewer chooses such a work because his capacity for expression, in a specific modality, is incomplete.

Although the deficit must always be specific to the esthetic preference in question, there is a puzzling and quite unanticipated regularity in several of the studies: one of the observable deficits occurs in the realm of intimacy. In studies where one preference could be seen as the more expressive of the two, the inability to form an intimate relation was seen as a sort of dynamic underpinning of the preference; the emotional force of *blocked intimacy* seemed to lend urgency to the more specific themes with which the subject was occupied. In studies where the two poles were similar in expressiveness—and, of course, in deficit—the inhibition of intimacy seemed similar as well; such was the case especially in preferences for masculinity and femininity. It is difficult to assimilate a finding the first time it occurs, and I am not certain I can adequately evaluate the importance of this one. But in the very least it can be said that there is present here an important emotional substratum which can be without a focus of its own but which can be readily attached to other issues; once attached, it can give them a degree of intensity which is experienced as a repetitive need in "need" of symbolic gratification.

Cutting across the individual studies is another finding: that tastes can serve the function of *confirming or bolstering a self-image.* In one respect the affirmation of a self-image can be viewed as another instance of deficit motivation, in particular because the self-image is infirm to begin with. Thus the masculine preferrer who, to choose one example, has a self-image which is uncertain specifically in the realm of masculinity seemingly makes himself feel more masculine by his esthetic choice; or, even more clearly, the preferrer of exhibitionism chooses examples of nudes which flaunt their

bodies in order to confirm his masculinity or her femininity. To the extent that the self-image is perceived as infirm—especially in realms which receive so high a social valuation as maleness and femaleness—an act or a choice which bolsters it has some relation to the deficits I had spoken of earlier. But not all components of a self-image are of this kind; the emotional components of other self-images may be integrated more closely with cognition and even self-denial. Thus, again in the study on masculinity-femininity, the choice of the same-sex object was seen as helping one handle problems in relating to the opposite sex—but by a sort of willful affirmation that the other sex is dispensable. This, too, seems a part of a self-image—that of a self-sufficient individual—but it seems less well designed to make up for a deficit than to deny that the deficit is of consequence—or perhaps even that the deficit exists. Thus the affirmation of a self-image has complexities as a process which go beyond mere deficit motives.

When one speaks of a self-image one remains close to the phenomenological experience of the subject; one is not translating or abstracting but either quoting the subject directly or merely bridging two realms of his accessible experience. But looked at somewhat more abstractly, confirmation of a self-image seems but one instance of a broader phenomenon, that of *control of conflict*. Rather than start with a definition, I would prefer to cite two examples. The preferrers of exhibitionism had been raised with much the same sexual prohibitions as their counterparts; but they formed different esthetic preferences because they had been able to rebel. Put another way, their rebellion continues to need their exhibitionistic preference; if it had been completed and was no longer an issue, there would be no need to continue protesting so much. In the conflict between inhibition and rebellion against it, then, the esthetic choice takes a helping hand. This mechanism is similar in principle to that observed in the dramatic preferrer who lived all her life in the midst of turbulence; what had begun as turbulence passively experienced—at the hands of an unstable mother who never provided a constant or reassuring home—became for the subject a way of life. She, too, either chose disastrous marriages or escaped those which promised stability. One might puzzle about the reasons which had impelled a person to continue what must have been an unpleasant experience were it not for psychoanalytic observations in which just such a mechanism is recorded. Freud was the first to note it, in *Beyond the Pleasure Principle* (1920), and it has received increasing attention since then, most recently in the work of G.S. Klein already cited. Freud's original observation was of a young child who repeatedly played a game called *fort* ("gone"); he would throw objects away to the accompaniment of a satisfied expression signifying *"fort"* and, if they were attached to a string, hail their reappearance. For Freud the game signified an attempt at mastery of the passive experience of watching his mother leave: "At the outset he was in a *passive* situation—he was overpowered by the experience; but, by repeating it, unpleasurable though it was, as a game, he took an *active* part." What interests the later psychoanalysts is that the original experience had been unpleasant; its repetition calls for the operation of something quite distinct from the pleasure principle. Thus the child who is frightened the first time his throat is looked at by means of a tongue depressor may, after the doctor has left, begin to play doctor and depress other children's tongues; he masters actively what he had at first

suffered passively.

Turning to nudes which portray drama serves the same function for the subject who had been the victim of early turbulence: that of active mastery or control. This much seems clear, but a question remains: why had the subject chosen this defense rather than another? Why had she not become, as had others with similar histories of childhood moves, one of the hunters after a nostalgic evocation of an artificially benign past? To this I certainly have no answer, but then the choice of defense, or even of neurotic symptom, is a mystery as well to those most qualified to deal with it. My own task is to find a functional relation between esthetic choice and the interplay of needs and defenses, and in the victim of a turbulent childhood I have found a clear continuation of the defense used in her everyday life. But the defense that she uses is meant as but one instance of a more general phenomenon, that of control of conflict; active reversal of passive experience is but one way in which control is exercised. As an example it is useful because it shows that the concept of "control" is broader than that of the classical "ego defense"; control implies something other than the mere channeling of drives. And the other example, that of the support of adolescent rebellion by means of a preference for exhibitionism, makes a broad conception of control equally necessary. Here one sees a "defense," so to speak, against a prohibition; the symbolic exhibitionism is not an extension of a childhood impulse but rather an adult protest against parental restrictions.

Difference Among Observers

Looking across the individual studies one finds, then, four general mechanisms which tie personal dynamics to esthetic choice: satisfaction of deficit motives, the handling of blocked intimacy, the confirmation of a self-image, and the control of conflict. I have picked these four because they help complete the theoretical material presented in the early chapters; they do not represent a complete statement in themselves, but rather additions to the one contained there or new ways of looking at it. If this represents my view of the manner in which subjects choose objects, in what sense can it be said that by understanding subjects we can better understand the nude—the object of their attachment?

To clarify the question we need to turn it around and ask how it is possible to understand an object without understanding how the observer relates to it. In esthetics there are two conditions under which the observer is usually ignored: one occurs in the study of esthetic perceptions and the other in the study of choices. In the first the object is assumed to have a structure of its own and on the basis of that assumption certain questions can be asked, such as, what is the structure? how do we perceive it? how do we learn to perceive it? and any number of others. Implicit in this approach is the primacy of

perception over esthetic choice; [3] if there is a conflict between the two, structure (or perception) wins out. If the painting you are working on requires a brunette for the completion of a color scheme, then your preference for blondes will have to be sacrificed. And perception is primary for the viewer as well: meaning in a work is conveyed much less by its content—what it represents—than by its structure—the manner in which its representation gives rise to perceptual forces.

The second situation in which the observer is ignored occurs in the study of esthetic choices upon which there is agreement. In Fechner's pioneering work, for example, the golden section rectangle was preferred to all the others and Fechner concluded, as seems reasonable, that that particular ratio was indeed the most pleasing. He paid no attention, as far as I am aware, to the numerous subjects whose choices did not correspond to the plurality; to him they seemed to represent random variation or error.

It seems to me that whether one decides that the observer is important or not hinges on just this seemingly trivial question: whether there is significant agreement among observers or not. To say that something—"beauty" or even "structure"—resides in the object is to say that it is unmistakably seen there; either everyone sees it, in which case the property is self-evident, or the "right" observers see it, in which case it is available to those who would be sensitive to it. But to the extent that there is disagreement, one must decide whether it is "significant" or not. Disagreement is usually considered insignificant when it can be understood as random deviation, that is, the sort of variation which must occur by chance, or when it can be dismissed as the product of insensitivity—the sort of variation which leads some people to be bad observers by nature or experience. But here is the problem: object-oriented approaches usually assume disagreement to be insignificant and therefore do not search for it; and that is the best guarantee of not finding it. In matters of perception, such an assumption is not unreasonable: but being reasonable is not the same as being true. In matters of esthetic choice disagreement is, of course, significant.

A way out of some of the impasse between object-centered and subject-centered systems is to treat as significant any disagreement which can be systematically related to some other variation. If the people who disagree are different in some manner, then that manner may explain the disagreement; thus, if those of Fechner's subjects who did not like the golden section rectangles had also scored low on a measure of esthetic sensitivity, then their dislike could have been seen as but one instance of their insensitivity.[4] By studying the correlates of disagreement, one would have maintained a simultaneous focus on the object and on the subject.

Now, the approach taken in my own studies was clearly an exaggerated version of the latter principle: I had studied only subjects who departed radically from the average and most frequent response. In this way I made it likely that their choice would bear a strong relation to personal dynamics; it is just another way of saying that their projective needs would come to the fore. But my emphasis was reversed, in that I treated the variation as the phenomenon of interest while ignoring the central tendency. Within the limits of these methods for understanding the subjects' personality, I had come to understand why they had made their choices. And now I must ask again whether under-

standing their choices says anything about the object they have chosen.

By referring back to the interplay of needs and coping mechanisms isolated in the various studies one can describe the sort of object that the nude can become. In each chapter the nude stands as a symbol for a prominent conflict or for that conflict's resolution. Thus in the chapter dealing with choice of gender the nude acts, for those who prefer it to be of the same sex as themselves, as a symbol of sexual identity and emotional self-sufficiency—while for those who prefer it of the opposite sex it serves as a symbol of the idealized partner. In the following chapter the nude becomes the symbol of a successful rebellion against parental sexual restrictions, or, on the other hand, an image of an unquestioned or unavoidable compliance with them. In another context the nude—the sentimental nude—becomes the reassuring image of a world free of depression and loss of love, or, on the contrary, a nonsentimental symbol of a world in which mistrusted affection is successfully avoided. The calm nude stands for a desired control over all impulse, affect and arousal, while its opposite, the dramatic nude, is a symbol of overdriven impulse expression—of a tension in life which actively recreates and masters an excitement felt passively at an earlier time. The nude of perfect bodily proportions becomes the admired image of an idealized parent: of a parent endowed with power and virtue and of the standards of achievement which he can define; and it embodies, as well, a goodness and integrity which the viewer's own body never quite attains. And finally the nude as such, irrespective of its proportion, gender, pose, or action, becomes the emblem of an intimate union devoutly wished for but never attained—or again, for those who reject it, of a union whose intimacy, sexuality, and emotional intensity need to be feared.

Thus the motives with which the nude is approached, or by which it is chosen, help define what it "is—provided that our definition of what "is" includes emotional significance as well as the usual perceptual qualities by which it is identified and recognized. From the point of view of mere recognition, it must be confessed that most subjects in all likelihood perceive the nude in very much the same manner. However, while all can attend to qualities by which the nude is identified, not all subjects can attend to subtler aspects of its form; not the least of the contributions of this analysis seems to me the finding that certain kinds of emotional involvement allow a greater sensitivity to form than others.

Among the artistically untrained masculinity preferrers there was little capacity to attend to form, while among the femininity preferrers there was some; it is as if the greater emotional freedom of the latter allowed them to be affected by form, or in the least allowed them to attend to form's emotional meanings. But that is only one illustration of the effect of emotional choice on form perception; among the artistically sensitive subjects, the masculinity preferrers attended to the form of the object in a drier manner, as if the nude were an object with attributes discernible from its place in art history, while for the femininity preferrers form gave rise to emotion and was attended to for its promise of emotional arousal. Both approaches are ways of attending to form; and the study suggests therefore that in the future form perception be studied in the context of what the subject normally attends to and wishes to obtain. Perhaps I may go further and

suggest that attending only to form perception is an unwelcome act of abstraction: it is unwelcome because it simplifies a more complex perceptual reality. Form perception—buttressed by certain kinds of emotional concerns—can even be quite limiting.

But if we turn to emotional value and symbolic meaning, then this study has contributed to understanding the nude. To paraphrase the epigram from Clark, the nude does, indeed, stand for a set of values; but the span of those values is surprisingly broad, and the values embodied in any single nude vary with the viewer's needs. Not the least of the firm findings here is that so few of the values have to do with sex; but that will surprise neither the esthete who values the nude nor the psychoanalyst who helps people sort out the tangle of needs they call sexual.

Of this much we can be quite certain, but it is also important to see that any study of symbolic meaning is limited; one can never exhaust all the meanings there might be. In the present work there are two obvious limitations. First, because the subjects were college undergraduates, it is difficult to guess to what extent they are representative of any other population. We do know that training in art or art history makes little difference for the way in which projective needs will be engaged, but we do not know whether age or nationality, for example, would also matter as little; it seems likely that they would matter more. Nor do we conclude from the motives of the viewer what the motives of the artist may have been; that is always an unjustified extrapolation, and also an irrelevant one. Second, the subjects were extremes of their kind; we would like to know whether the meanings of a given nude are similar for people who are less preoccupied with it. The present methods cannot be used to answer the question, but other methods readily come to mind.

Perhaps the reader who has been making his own sense of some of the nudes illustrated here will have discovered symbolic values in himself which our subjects did not share. If so, then his experience is no different from mine. I was surprised, for example that the appeal of perfection of form seemed so defensive—that it should have here stood for parental standards and concerns about bodily integrity. Where was the breathtaking joy that the *Knidian Aphrodite* can convey? Where was the sense of life glorified, of death momentarily denied, of decay and accident made irrelevant? Perhaps there was a hint here and there, but it was not pervasive. Yet had more been found, and had more obvious joy burst through, it might not have changed our view of the process very much; there is no guarantee that at bottom such concerns can escape our needs to cope.

10. Notes

1. Just as in the introductory chapter I had stressed the infinite disguises of which love is capable, here I emphasize the opposite; the number of other motives which can masquerade as love. For examples of the latter it is difficult to improve on the description of Buber's (1929), cited by G.S. Klein:

> Many years I have wandered through the land of men, and have not
> yet reached an end of studying the varities of the "erotic man"
> There a lover stamps around and is in love only with his passion.
> There one is wearing his differentiated feelings like medal-ribbons. There
> one is enjoying the adventures of his own fascinating effect. There
> one is gazing enraptured at the spectacle of his own supposed surrender.
> There one is displaying his "power." There one is preening himself with borrowed vitali-
> ty. There one is delighting to exist simultaneously as himself
> and as an idol very unlike himself. There one is warming himself at
> the blaze of what had fallen to his lot. There one is experimenting. And so on and
> on—all the manifold monologists with their mirrors, in the apartment of the most
> intimate dialogue!

2. For a discussion of the esthetic object and the pull it can exert upon the creative process, see Arnheim's "What Is Art For?" (1971).

3. Again it is Arnheim (1971) who most convincingly presents the argument for the primacy of perception.

4. Three studies that I am aware of attempt to explain individual variation as a systematic phenomenon. In each of them the independent variable is the degree of agreement with the group's average; it is calculated by correlating each individual's scores with the group mean. For the followers of Eysenck the group's mean judgment is the *only* estimate one can obtain of the "true" judgment; if an individual agrees with the group, his judgment must therefore be good; he should therefore also score high on measures of esthetic sensitivity. The prediction is borne out by two studies done by Granger (1955a and b), who worked in the Eysenck tradition; Granger found that subjects who agree with their group's preferences for colors—either single colors or color harmonies—also score high on the Maitland Graves Design Judgment Test. However, the test has never been shown to measure esthetic sensitivity; I incline therefore toward the results of the third study, carried out by Child (1962), which shows that agreement with the group has no particular psychological meaning. He measured the degree of correlation between individual preferences and either the mean group preference or the judgments made by experts. The judgments by experts were essentially the same as those that eventually made up his test of esthetic judgment. Agreeing with the *group*, he found, had no relation to any of the personality variables that he looked at; but agreement with the *judges* did. Those who agree with experts have the sorts of personality characteristics that were described in detail in Chapter 2; those who agree with their group do not differ from those who disagree. For Child the group mean therefore need not in any sense constitute a measure of taste or sensitivity. The sum total of his other research leads me to agree with his conclusion.

Appendix A : Construction of the Human Preference Test Image

To construct a test of preference which can reveal the dimensions to which an observer becomes attached, one needs to start with a large number of objects of potential interest and to know reliably how they are perceived. Accordingly, 262 black and white 35mm slides representing free-standing figures in painting, drawing, sculpture were collected; an effort was made to include only single figures (some exceptions had to be permitted) and to span the modes of representation in the Western tradition since the sixth century B.C. (but highly abstract nudes which make a response to the body difficult were omitted). This initial collection was intended to represent a wide variety of degrees of sensuality, perfection of proportion, sentimentality, sexual ambiguity, and degree of mutilation.

This collection then had to be carefully described for the dimensions on which the slides actually varied, and redundant or useless slides had to be eliminated. Ten judges who might be expected to rate the slides reliably (graduate students and instructors in the fine arts) were asked to rate each slide. The rating dimensions were also at first excessive in number: they included twenty-six descriptions—of the body (ascetic-sensuous, imperfect-perfect, and others; see Appendix B for the full list), the pose (for example, austere-sensuous, trifling-majestic), the face (controlled-emotional), and the work as a whole (warm-cold, nonsentimental-sentimental, poor art-good art, and others). The ratings were presented in the form of a Semantic Differential, that is, of a list of adjective opposites with a space divisible into seven segments in between them; the task for each judge was to rate each slide on each of the twenty-six dimensions, which were defined in writing before the rating sessions began. This laborious task was carried out over two weeks' time. In addition I myself rated each slide on an additional twenty dimensions which were emotionally neutral and perceptually obvious; these twenty were seen as potentially important because in Spiegel's and my research reported in *Messages of the Body* they (and dimensions similar to them) helped determine the body's expressiveness. In Appendix B these dimensions are numbered 27 through 46, and they refer to the body's orientation toward the viewer, to the disposition of the limbs, and to certain obvious facts such as the figure's sex, the artistic medium, and the art work's state of preservation.

The judges' ratings were first tested for repeat reliability. Five figures were inserted into the series twice at some distance from each other; they had a mean repeat reliability (r) of .82, .93, .87, .88, and .59 over the first twenty-six dimensions. (The last of these co-efficients is unacceptably low; but it results from two different views of the figure having been presented.) Given what appeared to be an acceptable level of reliability over the judges as a whole, the reliability of the individual judges on these figures was then examined; two judges proved to be quite unreliable, and in addition were found to have

very low correlations with the average judgments of the group (on all 262 figures); their ratings were therefore eliminated altogether.

The ratings of the remaining eight judges were then combined; as a result each slide could now be characterized by twenty-six properties of an expressive, emotional, and sometimes global nature, and twenty ratings on some obvious descriptive properties. This was a rather large number, one which it would be difficult to work with in practice. To see if they could be reduced to a smaller number of underlying clusters the forty-six dimensions were cluster analyzed (using the BCTry system), and five clusters (numbers 47 through 51 in Appendix B) were extracted. While they appeared likely to replace most of the initial twenty-six dimensions (but only a few of the next twenty), for the time being they were added to the initial list of forty-six. The total number was then further swelled by two clusters constructed artifically: idealization (composed of ratings on perfection of body, emotional control, and unaffected quality of the whole work), and bisexuality (rated from high masculinity on cluster forty-seven for female figures, and high femininity on the same cluster for male figures.)

By inspection, fifty of the 262 slides were eliminated; slides whose scores on the first twenty-six dimensions resembled each other were too redundant to retain, and slides whose scores were too flat (no scores below two or above six on a seven-point scale on the same twenty-six dimensions) were too inexpressive to be useful. To shorten the remaining collection of 212 figures into a workable test of preference, it was randomly divided into two sets of 106 slides each. These halves were tested for equivalence of means and variances on all the fifty-three characteristics; remarkably, no significant differences appeared on the first division. The two halves were called Version A and Version B. In the research reported here only Version A had been used. (Version B was used along with Version A in initial testing for preferences as well as personality correlates of preference; with no signficant differences resulting from their use, only the one was retained in subsequent research.)

The test is admininistered to the subjects with instructions to the following effect: the subjects are told that the test they are about to see is one of esthetic preference and that their task is merely to indicate to what degree they like each slide. They are told that their preferences are to be expressed by ratings on a seven-point scale with seven to indicate highest liking and one to indicate the lowest. Their liking is to reflect any criteria they wish: the quality of the work, the appeal of the figure, or whatever may strike them. The ratings should be spontaneous and quite rapid, since each slide is to be exposed for fifteen seconds.

The subjects' ratings are then analyzed in a simple manner: their liking for each slide is correlated with each of the slides' fifty-three characteristics. For each subject, then, fifty-three correlation coefficients exist which indicate the characteristics that had determined his preference. Normally only a small subset of these turns out to be statistically significant; but for the type of research reported here it is not the statistical significance as such that matters but the subjects' position in relation to others. Nor are all fifty-three characteristics looked at; of the clusters, masculinity-femininity (47), drama-calmness (49), and intactness-brokenness (50) are normally studied, while attraction of figure (48) is

seen as too global in relation to two of its components (ascetic-sensuous [1] and imperfect-perfect [2]) and attraction to the art work (51) is too global in relation to two of its components (nonsentimental-sentimental [22]). The artificial clusters (idealization and bisexuality) have not proved useful in initial correlational research attempting to isolate personality determinants of their preference. Exhibitionistic-shy (15) stands alone and is therefore a good candidate for study. But the dimensions which have been examined in this book are not meant to be exhaustive; their advantage for this research is that each raised a theoretical question of importance. Only the complexity of the clinical methods used prevented the examination of such other potentially interesting dimensions as straightforward-coy, real-stylized, and perhaps others.

Appendix B: Descriptive Dimensions of the Human Image Preference Test

Body	Dimension	Part of Cluster No.
1	ascetic-sensuous	48
2	imperfect-perfect	48,52
3	real-stylized	48
4	masculine-feminine	47
5	strong-weak	51
6	muscled-unmuscled	47
7	emaciated-corpulent	47
8	firm-flabby skin	47
9	attractive-repulsive	48, 51

Pose		
10	austere-sensuous	48
11	trifling-majestic	50, 51
12	masculine-feminine	47
13	yielding-unyielding	47
14	straightforward-coy	
15	exhibitionistic-shy	
16	natural-unnatural	51
17	active-passive	49
18	controlled-uncontrolled	52
19	angular-graceful	48
20	dramatic-calm	49, 52

Face		
21	controlled-emotional	52

Work as a whole		
22	nonsent.-sentimental	51
23	warm-cold	48
24	dramatic-calm	49, 52
25	affected-unaffected	51, 52
26	good art-poor art	51

Appendix B: [Cont'd]

Physical description	Dimension	Part of Cluster No.
27	drawing (no-yes)	
28	painting?	
29	sculpture?	
30	broken or truncated?	50
31	partial?	
32	whole?	
33	view from front	50
34	view from ¾ front	
35	view from side	
36	view from ¾ back	
37	view from back	
38	male	47
39	female	47
40	hermaphrodite	
41	chest exposed vs. covered	
42	legs crossed vs. splayed	
43	legs both crossed and splayed	
44	sex covered by limb	
45	sex covered otherwise	
46	penis broken	50

Natural clusters

47	masculine-feminine	
48	unattractive-attractive figure	
49	dramatic-calm	
50	intact-broken	
51	unattractive-attractive work	

Artificial clusters

52	unidealized-idealized	
53	standard-bisexual	

Appendix C: Preference Correlates of Various Personality Variables

TABLE 1

Preference Correlates of Superego Strength (Questionnaire Measure)

		Male Subjects (N = 56)			Female Subjects (N = 67)		
		All Figures	Male Figures	Female Figures	All Figures	Male Figures	Female Figures
Body	ascetic-sensuous	-.28*	-.19	-.23	.07	.10	.07
	emaciated-corpulent	-.19	-.24	-.08	-.04	-.15	-.02
Pose	austere-sensuous	-.32*	-.30*	-.29*	.00	.02	-.05
	exhibitionistic-shy	-.22	-.29*	-.04	.13	-.15	.12
	nonsentimental-sentimental	-.33*	.05	.23	.03	-.08	.05
	chest exposed-covered	-.14	-.16	-.13	.00	.06	-.09
	legs crossed-splayed	-.06	-.01	-.26	-.11	-.16	-.04
	sex covered by limb	.15	***	.24	.05	***	.02
	sex covered otherwise	.07	.28*	-.06	-.06	.12	-.16
Cluster	masculinity-femininity	-.13	-.09	-.08	.00	-.10	.00
	unattractive-attractive figure	-.30*	-.24	-.21	.13	.19	.09
	drama-calmness	-.14	-.21	-.08	.11	.07	.15
	intactness-brokenness	-.30*	-.11	-.30*	.17	.17	.10
	unattractive-attractive work	-.25	-.21	-.29*	.05	.20	-.02
	unidealized-idealized figure	-.19	-.19	-.10	.20	.17	.21
	bisexuality	.09	.10	.05	-.15	.15	-.03

*$P < .05$
***Null Set

298

Appendix C: [Cont'd]

TABLE 2

Preference Correlates of Superego Strength (Clinical Measure)

		Male Subjects (N = 44)			Female Subjects (N = 42)		
		All Figures	Male Figures	Female Figures	All Figures	Male Figures	Female Figures
Body	ascetic-sensuous	-.23	-.31*	.02	.14	.18	.03
	emaciated-corpulent	-.21	-.23	.15	.05	.24	-.11
Pose	austere-sensuous	-.38*	-.45**	-.08	.14	.18	.05
	exhibitionistic-shy	-.18	-.06	-.09	.42**	.36*	.36*
	nonsentimental-sentimental	-.04	.01	.09	.05	.20	-.08
	chest exposed-covered	.12	-.28	.22	-.38*	-.19	-.34*
	legs crossed-splayed	.01	.05	-.22	-.11	-.17	.04
	sex covered by limb	-.03	***	.02	.11	***	.09
	sex covered otherwise	.25	.34*	.08	.09	.19	-.02
Cluster	masculinity-femininity	-.32*	-.18	-.26	.07	.12	-.02
	unattractive-attractive figure	-.19	-.25	-.02	.14	.14	.06
	drama-calmness	-.52**	-.52**	-.36*	.13	.05	.18
	intactness-brokenness	-.11	.18	-.07	.31*	.44*	.03
	unattractive-attractive work	-.03	-.06	-.12	.06	.03	.11
	unidealized-idealized figure	-.37*	-.38**	-.26	.16	.09	.20
	bisexuality	.17	-.03	.24	.03	.02	.04

*P < .05
**P < .01
***Null Set

Appendix C: [Cont'd]

TABLE 3

Preference Correlates of Control of Heterosexuality (Clinical Measure)

		Male Subjects [N=44]			Female Subjects [N=42]		
		All Figures	Male Figures	Female Figures	All Figures	Male Figures	Female Figures
Body	ascetic-sensuous	-.13	-.37*	.09	.07	.07	-.09
	emaciated-corpulent	-.10	-.33*	.17	.16	.20	-.03
Pose	austere-sensuous	-.22	-.45*	-.04	.11	.15	-.19
	exhibitionistic-shy	-.11	-.18	-.01	.35*	.19	.28
	nonsentimental-sentimental	.07	-.02	.14	-.06	.19	-.32*
	chest exposed-covered	.12	-.08	.21	-.45**	-.30*	-.36*
	legs crossed-splayed	-.25	-.06	-.40**	.02	-.08	.19
	sex covered by limb	.08	***	.07	-.14	***	-.20
	sex covered otherwise	.18	.17	.07	.09	.13	.01
Cluster	masculinity-femininity	-.06	-.09	-.11	.11	.03	-.21
	unattractive-attractive figure	-.10	-.29*	.05	-.02	-.06	-.09
	drama-calmness	-.22	-.30*	-.12	.04	-.11	.08
	intactness-brokenness	.01	-.06	.11	.29	.20	.12
	unattractive-attractive work	-.12	-.14	-.11	.06	-.05	.23
	unidealized-idealized figure	-.17	-.24	-.06	.02	-.10	.12
	bisexuality	.16	-.02	.22	.15	.05	.23

*\underline{P} < .05
**\underline{P} < .01
***Null Set

Appendix C: [Cont'd]

TABLE 4

Preference Correlates of Control of Homosexuality (Clinical Measure)

		Male Subjects [N = 44]			Female Subjects [N = 42]		
		All Figures	Male Figures	Female Figures	All Figures	Male Figures	Female Figures
Body	ascetic-sensuous	-.18	-.22	.07	.02	.11	.28
	emaciated-corpulent	-.18	-.21	.28	-.12	.04	.02
Pose	austere-sensuous	-.33*	-.31*	-.04	-.10	.02	.21
	exhibitionistic-shy	-.25	-.09	-.13	.12	.34*	.13
	nonsentimental-sentimental	-.27	-.06	-.11	-.24	-.06	-.19
	chest exposed-covered	.06	-.03	-.05	-.01	.08	-.19
	legs crossed-splayed	.11	-.04	-.05	.18	-.08	.15
	sex covered by limb	-.25	***	-.14	-.15	***	-.02
	sex covered otherwise	.05	.20	.07	-.03	-.01	.14
Cluster	masculinity-femininity	-.35*	-.19	-.20	-.26	-.08	-.08
	unattractive-attractive figure	-.13	-.11	.00	.10	.19	.22
	drama-calmness	-.37*	-.30*	-.19	-.25	-.17	-.08
	intactness-brokenness	-.02	.21	.12	-.05	.14	.13
	unattractive-attractive work	.22	.06	.14	.31*	.25	.22
	unidealized-idealized figure	-.20	-.20	-.10	-.02	.02	.06
	bisexuality	.07	-.21	.25	-.17	-.29	.02

*P < .05
**P < .01
***Null Set

Appendix C: [Cont'd]

TABLE 5

Preference Correlates of Paranoia (Clinical Measure)

		Male Subjects [N = 44]			Female Subjects [N = 42]		
		All Figures	Male Figures	Female Figures	All Figures	Male Figures	Female Figures
Body	ascetic-sensuous	-.36*	-.41**	-.20	-.13	-.04	.09
	emaciated-corpulent	-.30*	-.38**	-.10	.00	.01	.20
Pose	austere-sensuous	-.43**	-.46**	-.26	-.28	-.06	-.11
	exhibitionistic-shy	.07	.00	.15	.09	.09	.20
	nonsentimental-sentimental	-.03	-.10	.02	-.34	-.21	-.23
	chest exposed-covered	-.11	-.03	-.18	.00	.07	-.17
	legs crossed-splayed	-.03	-.03	-.11	.21	-.03	.14
	sex covered by limb	.06	***	.08	-.40**	-.24	.18
	sex covered otherwise	.12	.37*	-.11	-.11	***	-.24
Cluster	masculinity-femininity	-.18	-.02	-.17	-.41**	-.35*	-.40**
	unattractive-attractive figure	-.30*	-.30*	-.22	-.09	.06	.02
	drama-calmness	-.26	-.39**	.01	-.38*	-.17	-.36*
	intactness-brokenness	-.14	-.02	-.13	-.05	.17	-.10
	unattractive-attractive work	-.14	-.20	-.15	.35*	.32*	.20
	unidealized-idealized figure	-.25	-.35*	-.08	-.12	.01	-.15
	bisexuality	.16	.02	.15	-.22	-.35*	.18

*P < .05
**P < .01
***Null Set

Appendix D: Core Interview Content

Note to interviewers: These are not detailed instructions for conducting your interviews. The details of style, of theoretical rationale, and of elaboration of these topics have been discussed in seminar. This is merely an outline of the minimal topics that have to be covered by every interviewer. The sample questions may vary depending on the information provided spontaneously by the interviewee; additional areas relevant to your concerns should be explored in accordance with your individual outline.

CURRENT HANDLING OF AFFECT, IMPULSE, ETC.

Expression of aggression
sample questions:
What do you do when you get angry?
Do you ever wrestle with your (family, friends, lovers)?
Do you ever tickle your (family, friends, lovers)?
Do you express your feelings physically? How much? To whom?
Have you seen any violent movies lately? What do you think of them?

Expression of love
sample questions:
Do you have a boyfriend (girlfriend)?
Can you describe your relationships (close-loose, expressive-subdued, exclusive-promiscuous, sexual-spiritual)?

What sorts of things do you talk about with him/her?
What sorts of things do you do together?

Expression of sexuality (apart from the above)
sample questions:
Do you have a sexual relation with anyone now? in the past?
How would you describe it? How important is it to you?
What do you think about homosexuality? (Note: push for how accepting the subject is; i.e., would he/she accept it in relatives? children? males? females? bisexuality?)

Religion
 sample question:
Does religion play any role in your life?

Spare time
 sample questions:
What do you do in your spare time? (Note: pay attention to the order in which
 activities are elicited; probe for details, subjective importance, etc.)

Athletics?

ROLE OF ART IN PERSON'S LIFE
 areas to cover:
 What sorts of music do you listen to?
 What TV programs do you watch?
 What type of movies do you go to?
 What visual media in art do you prefer?
 Is there any art in your house?
 Do you go to art shows?
 Do you enjoy creating art? (Note: try to ascertain the importance
 of art in subject's life. Is it used to kill time? Is it used
 actively? Are the form and technique ever talked about, or
 does the subject limit himself to statements like,
 "I go to all of Steve McQueen's movies"?)

 Are distinctions made between the object and the thing represented?
 between the artist's intentions and the viewer's experience?
 between the "feelings" of the artistic object and
 of the viewer?
 Is the subject open to "new" art, or are his tastes set?
 Does he like surprise?

HISTORICAL (DEVELOPMENTAL)

 Birth order (sex and age of siblings)
 Identification with father and mother
 sample questions:

304

What was your father/mother like?

What is he/she like now?

What sorts of things did you like about him/her? dislike?

In what ways do you resemble him/her?

In what ways are you different?

Were you (are you) close to either of them?

(ascertain current parental status such as death, divorce, etc., with dates)

Expressiveness in family

 sample questions:

Were your parents physically expressive? (Did they fight? etc.)

Were your parents emotionally expressive? (Did they show affection, cry? etc.)

Did they restrict your own expressiveness (your aggressive behavior, loving, crying, etc.)?

Art in parental home

 sample questions:

What kind of art did they have, if any?

What attitudes did your parents have toward it?

Parental expectations

 sample questions:

What parental expectations were directed at you (goals in life, character, etc.)?

What are your goals?

What is your picture of the ideal character (male, female)?

Appendix E: Preference for Broken Sculptures

Sculptures are fragile and more often than not meant for outdoor display; of those which survive from antiquity at all many have lost their limbs and heads and even smaller protruberances such as noses, penises, and nipples. But their present state can make one either disappointed, as when one deplores the loss of their integrity and perfection, or enchanted, as when one is aroused by the concentration of their power in the parts that survive. How do we explain their powerful effect—especially when the effect is one of arousal and admiration?

A study was conducted by Robert Kubey to uncover the functions of attachment to broken or intact sculptures. The study failed to yield results as clearcut as those reported so far, but their direction is clear enough to set them down here as guides for further research. That they are not as incisive as those of the other studies is due entirely to one isolated but troublesome fact: a sample of about 200 students (the same as the pool from which the subjects of Chapters 5 and 6, for example, had been drawn) was insufficient to give us a broad spread of preferences. Students were easily found with an extreme preference for intactness, but on the opposite end one had to work with students who *tolerated* brokenness rather than actively seeking it (their preference correlations were, with the exception of two males, only very slightly positive). In all other respects the study was very carefully conceived and carried out.

The study was guided by the following broad assumptions: (1) In males, extreme preference for either brokenness or intactness would, in principle, have some relevance to castration anxieties. Those who are most attached to intact sculptures might handle their anxieties by denial (a fact which is very difficult to prove outside of a psychotherapeutic setting), while those who most like the broken sculptures would handle similar anxieties by hyperawareness. Since such anxieties would be difficult to find directly they would at least be signaled by difficulties with both sexuality and aggression; but the signal would of course be clear in those who are hyperaware, not in those who "deny," since the latter would have little reason to reveal in a mere interview what they had controlled so well all their life. (2) But this formulation cannot apply to females—at least not in the narrow sense of castration fears. Conceivably it could apply to a fear of injury or more generally to a fear of aggression; thus the brokenness preferrers would again handle their fear by hyperawareness while the intactness preferrers would deny and suppress. In women it would seem unnecessary to anticipate a specific tie between sex and aggression, since, unlike in males, a fear of injury to a bodily protruberance is less clearly a sexual fear. (3) A purely cognitive difference might explain the preferences as well: the intact sculptures are more "real" and simpler to comprehend. As a consequence they should appeal to more conventional people, ones who prefer straightforward

conclusions to hypothetical, complex uncertainty. (If this turned out to be the case, it would not establish the taste for intactness as functional in the sense in which I have used the term in this book; the function would be seen, however, in their rejection of the broken—in the need to avoid having a conventional view of reality jolted in this most unconventional manner.) (4) Focusing specifically on the torso as the locus of bodily expressiveness, as can happen when viewing the Louvre *Torso of Miletos,* for example, may serve to control wishes or fears connected with the integrity or functioning of the organs contained therein. Perhaps the heart, the lungs, or the digestive tract find themselves reassuringly portrayed in the well-formed torso unencumbered by distracting limbs and head, and thus again the portrayal may serve the defensive function of protecting one against concerns with malfunctioning. To study such an appeal one would have to abstract an attachment to torsos from the more general liking for broken sculptures, however; since the Human Image Preference Test did not permit such refinement, the hypothesis must here remain speculative.

The study by which we hoped to find information on the first three of these assumptions, as well as to test for differences we had not anticipated, was carried out exactly as those reported here at greater length. The twenty extreme subjects underwent an interview which covered the standard topics in detail, as well as asking point-blank about their esthetic preference and the possible reasons for it. Except for this more or less exact revelation at the end the interviewer was unaware of whom he was testing. The results are different for men and women and will therefore be presented separately.

Men

Intimacy. The brokenness preferrers are distant from people: they had felt distant from their parents and now are distant from their peers (as well as remaining distant from the interviewer himself). They remember their families as undemonstrative, uncommunicative, and inexpressive; they were shy as children and continue to be shy now; they call themselves introverted. The intactness preferrers, on the other hand, felt close to their families and continue to find them a source of contact and pleasure now; the families were emotionally expressive. At present the subjects are close to their peers and have easy relations with them; they call themselves extraverted.

Sexuality. The brokenness preferrers are all sexually quite inexperienced. Although one has established a sexual relation with a girl (more experienced than himself), the others have none and three of them are virgins. The intactness preferrers, on the contrary, are sexually expressive: four have stable sexual relations and only one is a virgin.

Self-image. The broken preferrers are quite self-critical. All but one find something about themselves to criticize (for example, procrastination, hypersensitivity, sexual identity, tendency to scapegoat, depression, "everything," and so on), and two express

strong dissatisfaction with their bodies; of the latter, one confesses to suicidal rumination. The intactness preferrers are much less self-critical: two express no self-criticism at all (nor does one detect any boasting in them), and the three who can criticize themselves do so in the context of a positive view of their good qualities. There are no depressions or suicidal thoughts among them, and their body image is basically good and of little salience.

Aggression. The brokenness preferrers find aggression to be a problem to be handled, although between them they handle aggression somewhat differently. They all dislike the expression of aggression in real life but they show a continuous struggle with it. Thus a conscientious objector who detests violence likes it in films; others who dislike violence even symbolically confess to finding it exciting (the best example being the subject who professed extreme dislike of film violence but reveled in describing it: "It just isn't very pleasant to see some long string of someone's bloody intestines dragged across the screen"). For the intactness preferrers aggression seems much less of a problem; three get angry quite easily, two less so; two like action-packed aggression in films and three do not, but none show signs of a struggle with it.

Awareness of preference. Most subjects know quite well what their preference is (but those who like broken figures are less sure, since their taste is less extreme.) The brokenness preferrers believe that their opposites' preference might be due to insecurity; to the extent that they are aware of their own taste they ascribe it to (for example) anti-authoritarianism which finds beauty in chaotic things and flaws, or to a liking for abstraction (as with the subject who likes things of the mind and can do "more" intellectually with broken sculptures—particularly when the head is missing). The intactness preferrers explain their preference by saying, for example, that they are perfectionists; or that they are made sad by seeing an artist's work damaged; one says about broken sculptures that "the spectrum of imagination is too wide; I like to speculate within limits"—and, in addition, he experiences revulsion at physical disability. Some of these subjects are so literal in their attachment to the intact body that they fail to recognize a broken one: a subject simply asked, "What's that, some driftwood?" when shown the poorly preserved *Illisos* from the Parthenon.

Although these differences have been presented quite schematically, they are pronounced enough to suggest an interpretation. The subjects with an attachment to brokenness were the original focus and pose the greater challenge to functional explanation. One observes easily that they are preoccupied with aggression and that they turn part of it inward in the form of self-criticism; to an extent, then, their preference appears to serve the needs of aggression control. The mechanism of control is by no means clear; perhaps they are attaching themselves to figures which show the sort of damage that their inwardly turned aggression inflicts on them in fantasy, or perhaps they are choosing figures which make good objects for their outwardly turned anger—the present evidence is insufficient to say. But it cannot be enough just to speak of anger; the anger is *about* something. While one cannot know its antecedents or its objects, one senses that it is connected with their inhibited sexuality and intimacy; and again while one cannot know whether castration fears underlie the inhibition, the inhibition is at least consistent with

the presumption of such fears. But the damaged body in art also serves as an escape from involvement with the whole and sensuous body: it is a safe abstraction of it; and, finally, the broken body is more complex by being a greater challenge to understanding—hence its appeal to their own sense of struggle. (Parenthetically, it should be noted that not only are these subjects more complex as such, but that they use their complexity to achieve a sense of mastery over their conflicts; thus the complexity itself does not serve to explain their preference, but the use to which they put it appears to.) It seems to me that all four of these mechanisms seem to be operating here; but further research with subjects whose preference is more extreme is required to see if they all need be present and to help clarify the functional interpretation advanced here.

The opposite end of this spectrum (attachment to intactness) is described by the opposite facts—but its function seems by no means a simple inverse of the preference for brokenness. As a background one notes that these extraverted and expressive people seem to have no need for any engagement with the more challenging brokenness, but that is only a negative reason; what motivates them to choose intactness seems not only a greater psychological simplicity but a fear of the abnormal, the incongruous, the imperfect—and the injured. But in what manner such fears may have been established escapes us here altogether; at least we know what needs looking into in greater depth.

Women

The contrast between the women's groups is reduced to cognitive style only; nowhere does one observe the struggle with aggression, sex, and intimacy that separates the two groups of men. The women who prefer brokenness do so, as far as can be judged, purely because of their greater cognitive complexity. They talk about art in ways that show an ability to draw differences between people and the statues and their own reactions to them, and between their reactions and the artist's intentions. One has the impression that they have no special attachment to brokenness but that they tolerate it well; and, indeed, their preference scores turn out to be only very slightly positive, closer to the neutral point than were those of males. Their preference seems to have no special dynamic underpinning; unless one assumes a greater need for varied experience (for which there is no specific evidence), then they differ from their intactness-preferring counterparts primarily in not needing the more literal intact nudes for their pleasure. The intact preference, while clearly linked to cognitive simplicity, is not thereby dynamically explained either, but perhaps an explanation tied to cognitive style may turn out to be sufficient.

The study leaves us with two uncertainties, then: preference for brokenness is not sufficiently extreme in either sex for us to conclude that we have understood it, and men and women appear to have different reasons for their esthetic choice. Such a result is perfectly possible, of course; but until the study is replicated on a more carefully chosen sample (one which, in order to provide greater extremes, relies on a pool considerably larger than the 200 subjects we had tested) the needs which may be served by a preference for brokenness or intactness will have to remain speculative.

References

Alexander, S. *Beauty and Other Forms of Value*. New York: Crowell, 1968.

Adorno, T. W., Frenkel-Brunswik, Else, Levinson, D. J. and Sanford, R. N. *The Authoritarian Personality*. New York: Wiley, 1950.

Arnheim, R. *Art and Entropy*. Berkeley: University of California Press, 1971.
———. *Art and Visual Perception*, 2nd ed. Berkeley: University of California Press, 1974.
———. *Toward a Psychology of Art*. Berkeley: University of California Press, 1966.
———. *Visual Thinking*. Berkeley: University of California Press, 1969.
———. "What Is Art For?" In R. A. Smith, ed., *Aesthetics and the Problems of Education*. Urbana, Ill.: University of Illinois Press, 1971, pp. 231-242.

Bandura, A. *Aggression: A Social Learning Analysis*. Englewood Cliffs, N.J.: Prentice-Hall, 1973.

Barron, F. "Personality Style and Perceptual Choice." *Journal of Personality*, 1952. *20*, 385-401.
———. "Complexity-Simplicity as a Personality Dimension." *Journal of Abnormal and Social Psychology*, 1953, *48*, 163-172.

Berkowitz, L. and Rawlings, E. "Effects of Film Violence on Inhibitions Against Subsequent Aggression." *Journal of Abnormal and Social Psychology*, 1963, *66*, 405-412.
———. *Aggression: A Social Psychological Analysis*. New York: McGraw Hill, 1962.

Berlyne, D. E. *Aesthetics and Psychobiology*. New York: Appleton-Century-Crofts, 1971.
———. *Studies in the New Experimental Aesthetics*. Washington, D.C.: Hemisphere Publishing Corp., 1974.

Brown, R. "Development of the First Language in the Human Species." *American Psychologist*, 1973, *28*, 97-106.

Bryson, J. B. and Driver, M. J. "Cognitive Complexity, Introversion, and Preference for Complexity," *Journal of Personality and Social Psychology*, 1972, *23*, 320-327.

Buber, M. *Between Man and Man* (tran. R. G. Smith). London: Routledge & Kegan Paul, 1929.

Burnham, R. W., Hanes, R. M. and Bartelson, C. J. *Color: A Guide to Basic Facts and Concepts*. New York: Wiley, 1963.

Burt, C. "The Factorial Analysis of Emotional Traits." *Character and Personality*, 1939, *7*, 285-300.

Buswell, G. T. *How People Look at Pictures*. Chicago: University of Chicago Press, 1935.

Cahill, J., ed. *The Restless Landscape: Chinese Painting of the Late Ming Period.* Berkeley: University Art Museum, 1971.

Cardinet, J. "Préférences esthétiques et personnalité." *Année Psychologique,* 1958, *58,* 45–69.

Child, I. L., "Personality Correlates of Esthetic Judgment in College Students." *Journal of Personality,* 1965, *33,* 476–511. (a)
———. "Personal Preferences as an Expression of Aesthetic Sensitivity." *Journal of Personality,* 1962, *30,* 496–512.

Child, I. L., and Iwao, Sumiko. "Personality and Esthetic Sensitivity: Extension of Findings to Younger Age and to Different Cultures." *Journal of Personality and Social Psychology,* 1968, *8,* 308–312.

Child, I. L., and Schwartz, Rosaline S. "Exploring the Teaching of Art Values." *Journal of Aesthetic Education,* 1966, *1,* 44–54.
———. "Exposure to Better and Poorer Art." *Journal of Aesthetic Education,* 1968, *2,* 111–124.

Child, I. L., and Siroto, L. BaKwele and American Esthetic Evaluations Compared." *Ethnology,* 1965, *4,* 349–360.

Clark, K. *The Nude: A Study in Ideal Form.* Garden City, Doubleday, 1959.

Dickie, George. "Is Psychology Relevant to Esthetics?" In F. J. Coleman, ed., *Contemporary Studies in Esthetics.* New York: McGraw-Hill, 1968, pp. 321–335.

Dorfmann, D. D. and McKenna, H. "Pattern Preferences as a Function of Pattern Uncertainty." *Canadian Journal of Psychology,* 1966, *20,* 143–153.

Duncan, E. H. "The Ideal Aesthetic Observer: A Second Look." *Journal of Aesthetics and Art Criticism,* 1970, *29,* 47–52.

Eysenck, H. "The General Factor in Aesthetic Judgments." *British Journal of Psychology,* 1940, *31,* 94–102.
———. "Type-factors in Aesthetic Judgments." *British Journal of Psychology,* 1941, *31,* 262–270.

Fechner, G. T. *Vorschule der Aesthetik.* Leipzig: Breitkopf and Härtel, 1897.

Fenichel, O. *The Psychoanalytic Theory of Neurosis.* New York: Norton, 1945.

Feshbach, S. "The Stimulating versus Cathartic Effects of a Vicarious Aggressive Activity." *Journal of Abnormal and Social Psychology,* 1961, *63,* 381–385.

Feshbach, S., and Singer, R. D. *Television and Aggression.* San Francisco: Jossey-Bass, 1971.

Flugel, J. C. *The Psychology of Clothes.* New York: International Universities Press, 1969.

312

Ford, C. S., Prothro, E. T., and Child, I. L. "Some Transcultural Comparisons of Esthetic Judgment." *Journal of Social Psychology*, 1966, *68*, 19-20.

Freud, Anna. "The Relation of Beating Fantasies to a Daydream." *International Journal of Psychoanalysis*, 1923, *4*, 89-102.
———. *The Ego and the Mechanisms of Defence*. New York: International Universities Press, 1946.

Freud, S. *Wit and Its Relation to the Unconscious*. In A. A. Brill, ed. *The Basic Writings of Sigmund Freud*. New York: Modern Library, 1938.
———. *A General Introduction to Psychoanalysis*. New York: Perma Books, 1953.
———. "The Relation of the Poet to Daydreaming," *Collected Papers*, Vol. 4, New York: Basic Books, 1959(a). (Originally published in 1908)
———. "Dostoevsky and Parricide." *Collected Papers*, Vol. 5. New York: Basic Books, 1959(b). (Originally published in 1928)
———. "The Economic Problem of Masochism." *Collected Papers*, Vol. 2. New York: Basic Books, 1959(c). (Originally published in 1924)
———. *Group Psychology and the Analysis of the Ego*. New York: Bantam, 1960.

Fry, R. *Cezanne: A Study of His Development*. New York: Noonday, 1958.

Gardner, H. "Style Sensitivity in Children." *Human Development*, 1972, *15*, 325-338.
———. *The Arts and Human Development*, New York: Wiley, 1973.

Gordon, D. A. "Individual Differences in the Evaluation of Art and the Nature of Art Standards." *Journal of Educational Research*, 1956, *50*, 17-30.

Gordon, Laurie. *Material Nostalgia: the Presence of the Past*. Unpublished senior thesis, University of California, Santa Cruz, 1973.

Gough, H. G. and Heilbrun, A. B., Jr. *The Adjective Check List Manual*. Palo Alto: Consulting Psychologists Press, 1965.

Granger, G. W. "An Experimental Study of Colour Preferences." *Journal of General Psychology*, 1955, *52*, 3-20. (a)
———. "An Experimental Study of Colour Harmony." *Journal of General Psychology*, 1955, *52*, 21-35. (b)

Green, R. T. and Courtis, M. C. "Information Theory and Figure Perception: The Metaphor That Failed." *Acta Psychologica*, 1966, *25*, 12-36.

Guilford, J. P. "The Affective Value of Color as a Function of Hue, Tint and Chroma." *Journal of Experimental Psychology*, 1934, *17*, 342-370.

Harlow, H. F. "Mice, Monkeys, Men and Motives." *Psychological Review*, 1953, *60*, 23-32.

Helson, H. "Adaptation Level as a Basis for a Quantitative Theory of Frames of Reference." *Psychological Review*, 1948, *55*, 297-313.

Hume, D. "Of the Standard of Taste." In K. Aschenbrenner and A. Isenberg, eds., *Aesthetic Theories: Studies in the Philosophy of Art.* Englewood Cliffs, N.J.: Prentice-Hall, 1965. (First published in 1757)

Katz, E. and Lazarsfeld, P. F. *Personal Influence.* Glencoe: Free Press, 1955.

Klein, G. S. *Perception, Motives and Personality.* New York: Knopf, 1970.
——. *Psychoanalytic Theory.* New York: International Universities Press, 1976.

Knapp, R. H. "*n*Achievement and Aesthetic Preference." In J. W. Atkinson, ed., *The Assessment of Human Motives.* Princeton: Van Nostrand, 1957.

Knapp, R. H., McElroy, L. R. and Vaughn, J. "On Blithe and Melancholic Aestheticism." *Journal of General Psychology,* 1962, *67,* 3–10.

Kris, E. *Psychoanalytic Explorations in Art.* New York: International Universities Press, 1952.

Kubie, L. *Neurotic Distortion of the Creative Process.* New York: Farrar, Straus and Giroux, 1961.

Lawlor, Monica. "Cultural Influences on Preferences for Designs." *Journal of Abnormal and Social Psychology,* 1955, *61,* 690–692.

Machotka, P. "The Development of Aesthetic Criteria in Childhood." *Child Development,* 1966, *37,* 877–885.

Malinowski, B. *Sex and Repression in Savage Society.* New York: Meridian, 1960.

McClelland, D. C., Atkinson, J. W., Clark, R. A., Lowell, E. L. *The Achievement Motive.* New York: Appleton-Century, 1953.

McElroy, W. A. "Aesthetic Appreciation in Aborigines of Arnhem Land: A Comparative Experimental Study." *Oceania,* 1952, *23,* 81–95.

Meyer, L. B. *Emotion and Meaning in Music.* Chicago: University of Chicago Press, 1956.
——. "Meaning in Music and Information Theory." *Journal of Aesthetics and Art Criticism,* 1957, *15,* 412–424.
——. "Some Remarks on Value and Greatness in Music." *Journal of Aesthetics and Art Criticism,* 1959, *17,* 486–500.

Michelson, P. "What Disney Teaches." *The New Republic,* July 6, 1968, *159,* 31–33.

Munsinger, H. and Kessen, W. "Uncertainty, Structure and Preference." *Psychological Monographs,* 1964, *78,* no. 9 (whole no. 586).

Murray, J. P. "Television and Violence: Implications of the Surgeon General's Research Program." *American Psychologist,* 1973, *28,* 472–478.

Nietzsche, F. *The Will to Power* Vol. II. London: T. N. Foulis, 1910.

Prelinger, E. and Zimet, C. N. *An Ego-Psychological Approach to Character Assessment.* New York: Free Press, 1964.

Reff, T. "Cezanne: The Enigma of the Nude." *Art News,* 1959, *58,* 26–29.
———. "Cezanne, Flaubert, St. Anthony, and the Queen of Sheba." *Art Bulletin,* 1962, *44,* 113–125. (a)
———. "Cezanne's Bather with Outstretched Arms." *Gazette des Beaux-Arts,* 1962. (b)
———. "Cezanne's Dream of Hannibal." *Art Bulletin,* 1963, *45,* 148–152.

Rycroft, C. "Two Notes on Idealization, Illusion and Disillusion as Normal and Abnormal Psychological Processes." *International Journal of Psycho-Analysis,* 1955, *36,* 81–87.

Schoen, M., ed. *The Effects of Music.* New York: Harcourt, Brace, 1927.

Segal, Hanna. "A Psycho-analytical Approach to Aesthetics." *International Journal of Psycho-analysis,* 1952, *33,* 196–207.

Slobin, D. I. "Developmental Psycholinguistics." In W. O. Dingwall, ed. *A Survey of Linguistic Science.* College Park: Linguistics Program, University of Maryland, 1971.

Spiegel, J. P. and Machotka, P. *Messages of the Body.* New York: Free Press, 1974.

Steck, L. and Machotka, P. "Preferences for Musical Complexity: Effects of Context." *Journal of Experimental Psychology: Human Perception and Performance,* 1975, *104,* 170–174.

Stokes, A. *Art and Science.* London: Faber and Faber, 1949.
———. *The Invitation in Art.* New York: Chilmark Press, 1965.
———. *Reflections on the Nude.* London: Tavistock, 1967.
———. "Form in Art: A Psychoanalytic Interpretation." *Journal of Aesthetics and Art Criticism,* 1959, *18,* 193–203.

van Gulik, Robert. *The Chinese Nail Murders.* New York: Avon, 1961.

Verne, J. *Around the World in Eighty Days.* New York: Dodd, Mead and Co., 1956.

Wallach, M. A. "Two Correlates of Symbolic Sexual Arousal: Level of Anxiety and Liking for Esthetic Material." *Journal of Abnormal and Social Psychology,* 1960, *61,* 396–401.

Wallach, M. and Greenberg, Carol. "Personality Functions of Symbolic Sexual Arousal to Music." *Psychological Monographs,* 1960, Vol. 74, No. 7 (whole No. 494).

Yarbus, A. L. *Eye Movements and Vision.* New York: Plenum, 1967.

Index

(Italicized numbers refer to pages on which illustrations appear)